EMERGING FROM THE SHADOWS

A SURVEY OF WOMEN ARTISTS WORKING
IN CALIFORNIA, 1860–1960

Volume IV: S–Z

Maurine St. Gaudens

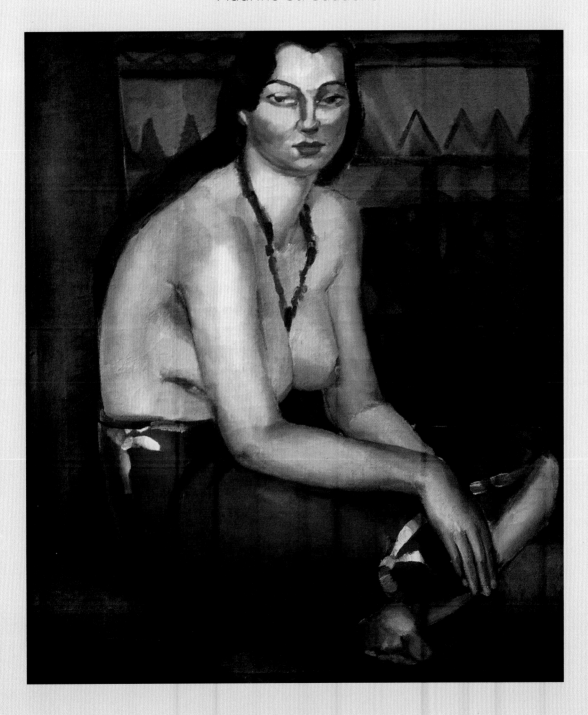

Schiffer Publishing Ltd

4880 Lower Valley Road · Atglen, PA 19310

Cover Designed by Danielle D. Farmer
Designed by Maurine St. Gaudens

Type set in Perpetua/Times Roman

ISBN: 978-0-7643-4887-7
Printed in China

Published by Schiffer Publishing, Ltd.
4880 Lower Valley Road
Atglen, PA 19310
Phone: (610) 593-1777; Fax: (610) 593-2002
E-mail: Info@schifferbooks.com

For our complete selection of fine books on this
and related subjects, please visit our website at
www.schifferbooks.com. You may also write for
a free catalog.

Cover Images

Vol. 1 Front: Marian Curtis, Untitled (Female Figure).
Spine: Dorr Bothwell, Untitled (Surrealist Drawing).
Back: Ruth Alexander, *Fishing Boats - San Pedro*.

Vol. 2 Front: Ruth Miller Kempster, *Housewife*.
Spine: Helen Klokke, Untitled
(Chinatown - Los Angeles, California).
Back: Jason Herron, *Winged Male Figure - Apollo*.

Vol. 3 Front: Agnes Pelton, *Spring Moon*.
Spine: Bertha Lum, Untitled (Japanese Marionettes
Crossing a Moon Bridge).
Back: Ella Moen, Untitled (Abstract Female).

Vol. 4 Front: Lucretia Le Bourgeois Van Horn,
The Gatherer.
Spine: Vivian F. Stringfield, *Monterey Cypress*.
Back: Cora A. Van Epps, Untitled (Russian River,
Sonoma County, California).

Title Page Image: Patty Scratch, Untitled
(Woman Wearing a Hawaiian Sarong).
Collection of Alex Lopez.

At Right: Vivian F. Stringfield, *Tree Panel
for George*. Courtesy of the Stringfield family.
Photo: Martin A. Folb, PhD.

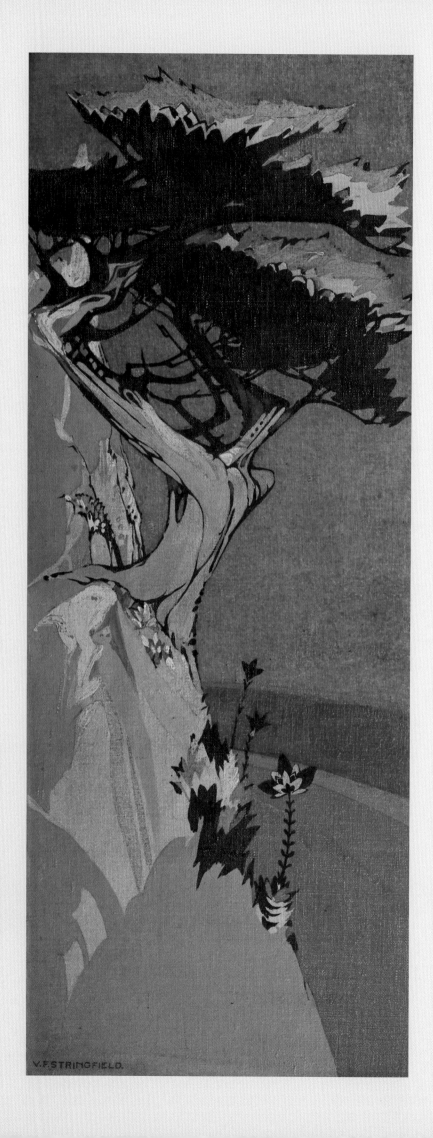

CONTENTS

Edited by Maurine St. Gaudens
Assisted by Joseph Morsman
and Martin A. Folb, PhD

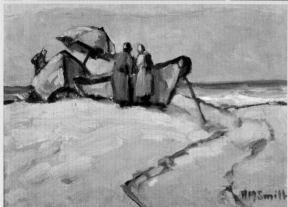

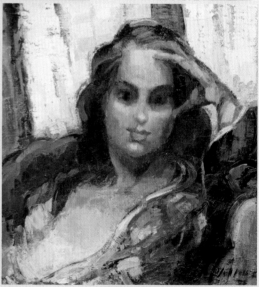

THE ARTISTS
S–Z

Nina Saemundsson
1892-1965

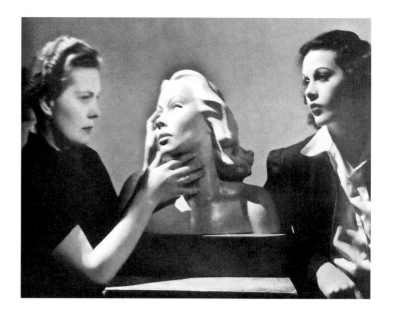

Nina Saemundsson (left) photographed with the actress Hedy Lamarr (1914–2000) and the white granite sculpture Nina created of Miss Lamarr in 1939. Photographer unknown. The sculpture was exhibited at the 1939 New York World's Fair. Private collection.

Jonina Saemundsdottir was born in Nikulasarhus, Fljotshlio, Iceland, on August 22,1892, the youngest of fifteen children. Raised on a farm in rural Iceland, the artist recounted in a 1935 *Los Angeles Times* interview how she would sit up in bed molding little clay figures while the household slept. While living with an aunt in Copenhagen, Denmark, she enrolled at the Royal Danish Academy of Fine Arts and began professionally working in clay. Upon graduating in 1920, Nina traveled and studied in Rome, London, and Paris. During her time in Paris, she started working in marble, just one of several mediums, including plaster, terracotta, wood, concrete, and bronze, that she would employ throughout her career. She also painted.

In 1926, working under the name Nina Saemundsson, she came to the United States and settled in New York City. By this time she started to receive the attention of both critics and collectors, and in 1928, while living in New York, her sculpture *Maternal Love* (a.k.a. Mother Love or Sleeping Boy) was purchased by the government of Iceland and installed in the Parliament buildings at Reykjavik. It became the first independent work of art to be placed on public display in Iceland. In 1931, a national artist's competition was held for a statue to be placed in front of the new Waldorf Astoria Hotel in New York. The winning work was meant to symbolize human ambition and achievement and match the themes of progress and innovation inherent in the hotel's architecture and design. Of the 400 artists who entered the competition, Nina's sculpture *The Spirit of Achievement* was chosen and installed above the Park Avenue entrance of the iconic hotel, where it remains today. She was as comfortable creating large-scale public figural works as she was sculpting smaller, more personal portrait busts and figures.

By the mid-1930s, Nina was living in Los Angeles, California, and had established a studio at 3357 Oak Glen Drive, Hollywood. In 1935, working under the aegis of the Public Works of Art Project, her nine-foot statue *Prometheus Bringing Fire to the Earth* (concrete composition, later coated in a metallic bronze) was dedicated in Westlake Park (present day MacArthur Park). In 1936, Nina's bust of Leif Erikson, commissioned and gifted to the city by the Los Angeles Nordic Civic League, was erected at the Western Avenue entrance of Los Angeles's Griffith Park.

In 1939, Nina's granite sculpture of actress Hedy Lamarr was exhibited at the New York World's Fair. That same year, her sculptures were included in the Scandinavian-American Art Society exhibition at the Stendahl Galleries in Los Angeles. She followed with a solo show at Gump's of Los Angeles at the Ambassador Hotel. In 1941, a solo show of her work was held at the Grace Nicholson Galleries in Pasadena; the show was comprised of fifty works, including her busts of Hedy Lamarr and actor Richard Cromwell. The critic Arthur Millier, in the *Los Angeles Times*,

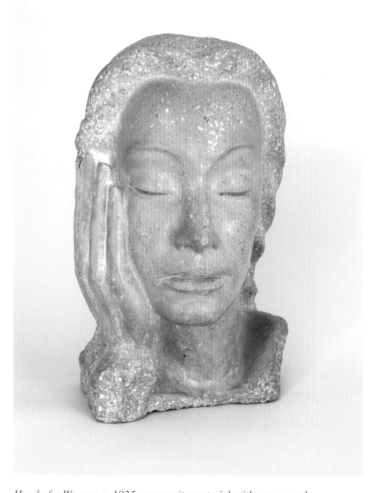

Head of a Woman, c. 1935, composite material with green wash, 12.5 × 7.5 × 6 in., unsigned. Courtesy of Spencer Jon Helfen Fine Arts, Beverly Hills, California.

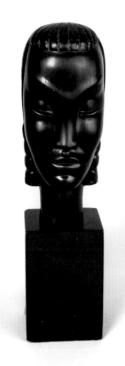

Untitled (Head of a Woman), c. 1935, hand-carved and finished wood on square base, 5.5 × 2.5 × 2.5 in. (base: 3.5 × 2 × 2.5 in.), initialed "n" and "s." Courtesy of Spencer Jon Helfen Fine Arts, Beverly Hills, California.

remarked that Nina was "among the very few good sculptors working west of the Mississippi." During this period the artist began creating sculpture for use in feature films. Along with her partner, scriptwriter Polly James, Nina maintained close friendships within the Hollywood film community.

In 1943, Boris Lovet-Lorski selected her sculpture *Awakening* for the *Artists of Los Angeles and Vicinity* exhibition at the Los Angeles County Museum of History, Science, and Art. In 1947, Nina traveled back to Iceland as a guest of the government. Seventy-five of her sculptures were shipped there for a solo exhibition of her work which was held in Reykjavik. During this visit, she was decorated with the Order of the Icelandic Falcon in recognition of her artistic achievements.

Active in the Los Angeles art community, she continued exhibiting throughout the 1950s, including a solo show of her sculpture and paintings in 1953 at Los Angeles's Felix Landau Gallery. In 1955, she was included in The California Art Club's 46th annual exhibition. In 1956 she was given a solo show at Iceland's National Museum of Art in Reykjavik. She returned to Iceland in the late 1950s and remained there for the rest of her life. She is considered one of Iceland's most revered artists, and although nearly half her life was spent in the United States, Nina is known in her native Iceland as that country's first professional woman sculptor.

Nina Saemundsson passed away on January 29, 1965, in Iceland. In the words of the art critic Arthur Millier, "she brought a rare capacity to feel deeply and to express emotions with strength and clarity."

Biography, with thanks, from: Spencer Jon Helfen Fine Arts; *Los Angeles Times*, March 24, 1935, October 4, 1936, February 14, 1939, and May 28, 1944.

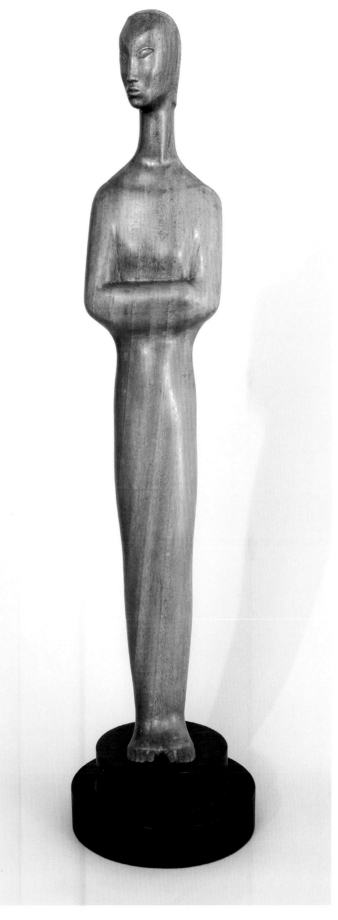

Standing Figure - Wood (Female), c. 1935, hand-carved and finished wood on circular base, 26 × 6 × 3 in. (base: 3.25 × 7 in.), unsigned. Private collection. Courtesy of Spencer Jon Helfen Fine Arts, Beverly Hills, California.

Elaine Sagerhorn
1915–2004

Helene Elaine Schneider was born on May 15, 1915, in San Diego, California, the daughter of Raymond and Mary Lee (Gilstrap) Schneider and the niece of noted California artist Rose Schneider. As a child, Elaine grew up in Long Beach but spent her summers in San Diego with her Aunt Rose, who was her earliest instructor and instilled in her a love of art. They explored San Diego and its environs, enabling the two to sketch and paint as Elaine produced her earliest works. During her teen years, Elaine assumed her stepfather's surname, Jacobs, and did not resume using the Schneider surname until she entered high school. She continued to paint and draw during her teen years in Long Beach, California. She graduated from Long Beach Polytechnic High School in 1933. In June of 1933, she married Milo Leland Sagerhorn. The couple remained in Long Beach and in 1955, they had a daughter, Jo, who also became an artist.

Elaine Sagerhorn, c. 1940. Courtesy of Jo Jay.

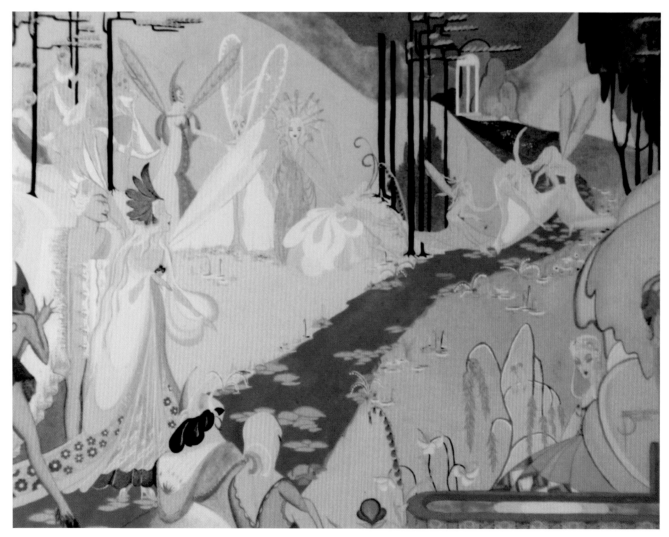

Untitled (Fantasy Landscape), c. 1932, mixed media on paper, 20 × 26 in., signed l/r: "Elaine Jacobs." Courtesy of Jo Jay.

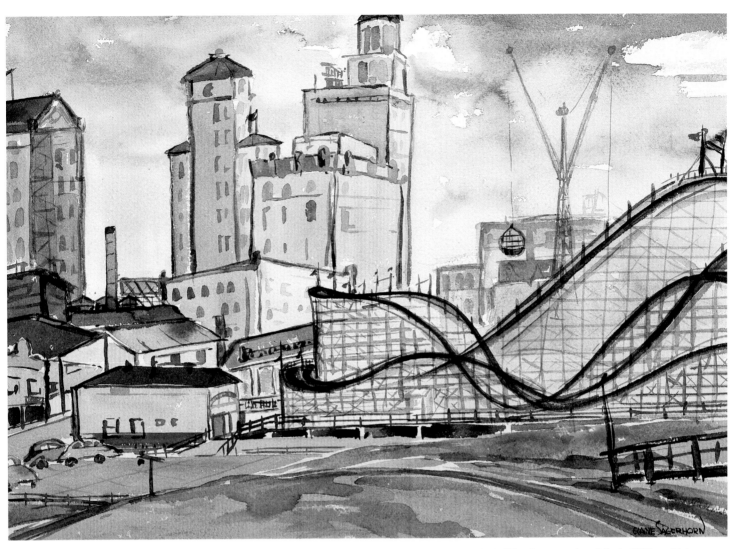

Pike (Amusement Park - Long Beach, California), c. 1939, watercolor on paper, 15.5 × 22 in., signed l/r. Private Collection. Photo: Dr. Martin A. Folb.

The Pike Amusement Park in Long Beach, California, opened on July 4, 1902, and it became one of the most popular amusement parks on the West Coast. The most prominent attraction at the park was the dual-track rollercoaster ride called The Cyclone Racer. Another popular ride consisted of globe cages suspended by a crane which offered the rider a panoramic view as the cage was raised and quickly lowered. Much of the park was destroyed by fire in the 1940s and eventually closed in 1979. *Pike* includes images of The Cyclone Racer, the globe Cages, and the historic Breakers Hotel, which is the prominent building depicted in the center of the painting.

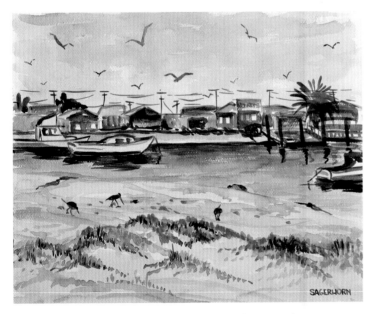

Wilmington Harbor (Long Beach, California), n.d., watercolor on paper, 15 × 22 in., signed l/r. Private collection. Photo: Martin A. Folb, PhD.

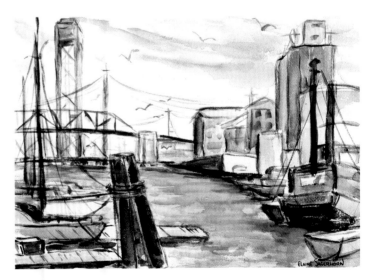

Newport Bay (California), n.d., watercolor on paper, 15.25 × 18.5 in., signed l/r. Courtesy of Jo Jay.

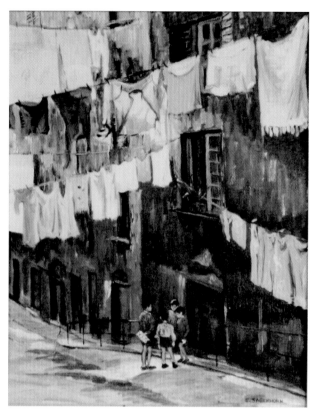

Clothesline Alley, n.d., oil on canvas, 20 × 16 in., signed l/r. Courtesy of Jo Jay.

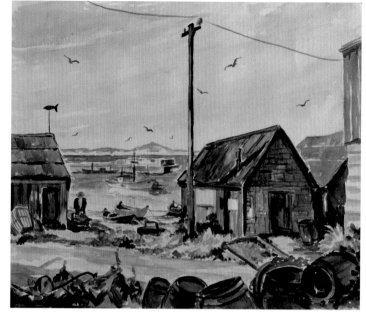

Untitled (Seaside Shack), n.d., watercolor on paper, 15 × 17 in., signed l/r. Courtesy of Jo Jay.

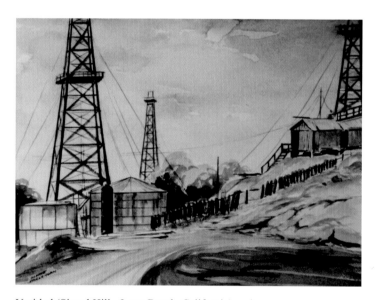

Untitled (Signal Hill - Long Beach, California), n.d., watercolor on paper, 14 × 20 in., signed l/l. Courtesy of Jo Jay.

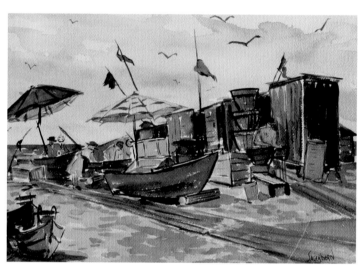

Newport Fish Market (Newport Beach, California), n.d., watercolor on paper, 15 × 20 in., signed l/r. Courtesy of Jo Jay.

Elaine continued to paint throughout the 1930s and 1940s, while working as a photo re-toucher at Long Beach area photography studios. Using her surroundings as her inspiration, she captured the scenic and oftentimes historic imagery of California. Her earliest work centered heavily on watercolor, but by the late 1940s, she concentrated more on oils and then acrylics and her subject matter evolved from genre works to abstractions in the 1950s and 1960s. In the early 1970s, she worked with another artist to restore all of the original paintings in the RMS *Queen Mary*, which is moored in Long Beach harbor.

An active member of both the Long Beach Art Association and the Seal Beach Art Association, she frequently exhibited with the two groups, and with others throughout Southern California, receiving numerous awards in many juried exhibitions. Elaine Sagerhorn passed away on March 31, 2004, in Long Beach, California.

Biographical information compiled from: *Independent Press-Telegram* (Long Beach, California), June 20, 1954, November 7, 1954, July 22, 1962; and *Los Angeles Times*, November 1, 1964. Special thanks to Jo Jay, daughter of the artist, and the Jay/Sagerhorn family.

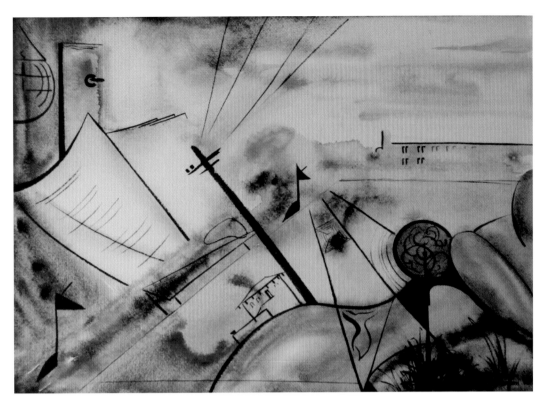

Untitled (Abstract Landscape), n.d., watercolor on paper, 14 × 20 in., signed l/r. Courtesy of Jo Jay.

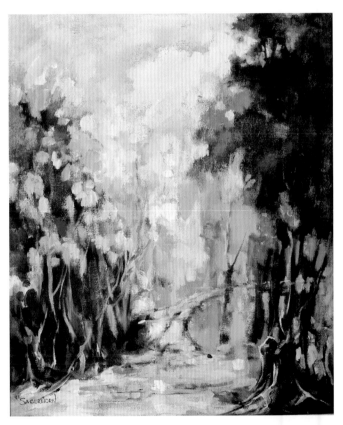

Untitled (Landscape), n.d., oil on canvas, 24 × 20 in., signed l/l.
Private collection. Photo: Martin A. Folb, PhD.

Pipeline (Abstract Composition), n.d., watercolor on paper,
15 × 21 in., unsigned. Courtesy of Jo Jay.

Genève Rixford Sargeant
1868–1957

Genève Rixford was born on July 14, 1868, in San Francisco, California, the daughter of Gulian Pickering Rixford and Caroline (Corey) Rixford. She was the sister of the artist Caroline P. Rixford, artist/architect Loring P. Rixford, and noted physician Emmett Rixford. Genève began her art studies at the San Francisco Art Association's California School of Design under Emil Carlsen; she then studied at the Art Students League in New York under William Merritt Chase. Returning to San Francisco in 1891, she established her own studio and two years later on February 10, 1893, she married Winthrop W. Sargeant, a marriage that produced three sons.

Around 1900, the family spent several years living in Chicago, Illinois, where she exhibited and was awarded the Martin B. Cahn prize in 1903 from the Chicago Art Institute. They returned to California in 1904 and settled in Monterey. From 1906 to 1911, she lived in Southern California. After 1911, the family returned to San Francisco and then around 1925 moved to Paris, France. During the next five-year period, she studied with the artist André Lhote and her work was included in the Salon exhibitions of the Société des Artistes Français, the Salon d'Automne, the Salon du Printemps, and the newly formed Salon des Indépendants. Upon her return to California, she exhibited her lithographs for the first time with exhibitions at the Braxton Gallery and at Jake Zeitlin's Bookshop and Gallery, both in Los Angeles.

After her return to San Francisco in the 1930s, she reestablished a studio on Montgomery Street and then taught at the San Francisco School of Fine Arts and served as the director of the San Francisco Art Association for six consecutive years. Her work includes portraits, landscapes, still lifes, and figures in watercolor, oils, pastel, and lithography.

An early member of the San Francisco Art Association, she exhibited with them throughout her career. Additionally, she was a member of the San Francisco Sketch Club (later the San Francisco Society of Artists) and the Chicago Society of Artists. Genève exhibited her work extensively in many venues throughout her lifetime in California and nationally. A retrospective of her work from 1887 to 1947 was seen in the exhibition *Sixty Years of Painting: A Retrospective Exhibition of the Work of Genève Rixford Sargeant*, which was held at the M. H. de Young Memorial Museum in San Francisco in 1948.

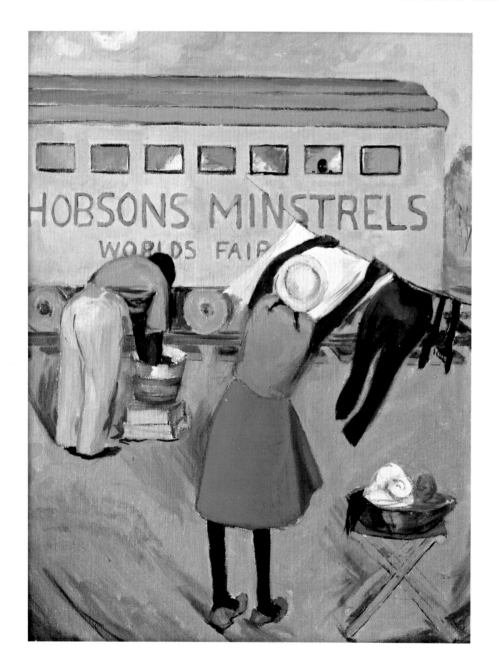

Hobsons Minstrels - Worlds Fair, c. 1939, oil on canvas, 24 × 18 in., signed l/r. Collection of Andrew Herrera II. Courtesy of Calabi Gallery. Photo: Camille M. Palmer.

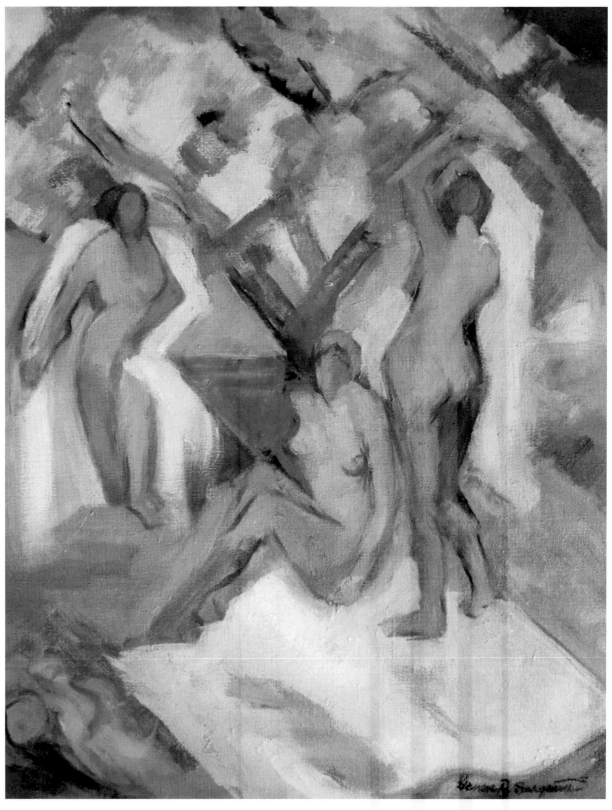

Untitled (Landscape with Three Nudes), n.d., oil on canvas, 16 × 20 in.,
signed l/r. Courtesy of Naim I. Farhat and the Farhat Art Collection.

Her work is in the permanent collections of the San Francisco Museum of Art; the California Palace of the Legion of Honor, San Francisco; Mills College, Oakland; M. H. de Young Memorial Museum; San Diego Museum of Art; the Neville-Strass Collection, Florida; and the Virginia Museum of Fine Art (now the Academy of Science & Fine Art), Richmond, Virginia,

Genève Rixford Sargeant passed away on August 10, 1957, in Palo Alto, California.

Biographical information compiled from: *Who's Who in American Art, 1947; Who's Who in American Art, 1953; Artists of the American West: A Biographical Dictionary*, Doris Dawdy; California State Library, Biographical Index Card, 1907; *Oakland Tribune,* October 14, 1914, April 14, 1948; *Los Angeles Times*, December 12, 1920, April 13, 1930, January 31, 1932, March 30, 1941, August 12, 1957 (obituary).

Rose Schneider
1895-1976

Rose Schneider photographed holding an
unidentified child, c. 1955. Private collection.

Sara Rose Schneider and her twin brother Edwin were born on
October 15, 1895, in La Grange, Missouri. They were the youngest
of the seven children, with Rose the only daughter of Louis and
Carrie (Strouse) Schneider. In 1898, the family left Missouri and
moved to San Diego, California, where her father established
himself as one of the city's early pioneer merchants. According
to her family, Rose was artistically inclined from an early age.
She graduated from what was then Russ High School (later renamed
San Diego High School), though it is unknown at what age she
seriously began her art studies. By 1930, she was studying locally
with the artist Charles Reiffel, and she continued to work with
him for a number of years. Rose may have also studied with San
Diego artist and teacher Maurice Braun.

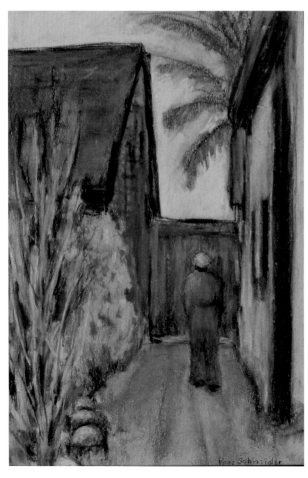

Untitled (Alley Way with Figure), n.d., pastel on paper, 8 × 5.75 in.,
signed l/r. Private collection. Photo: Martin A. Folb, PhD.

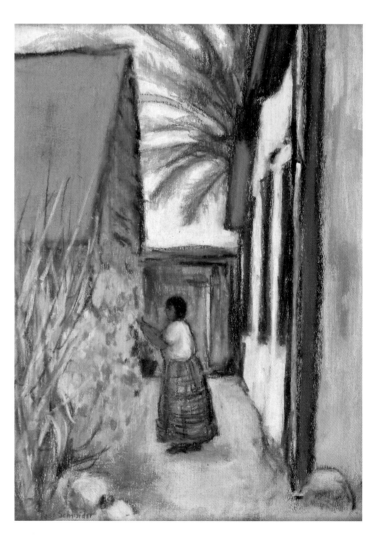

Untitled (Alley Way with Female Figure), n.d., pastel on paper,
7.75 × 5.75 in., signed l/l. Private collection. Photo: Martin A. Folb, PhD.

Untitled (Early View of Coronado and North Island from San Diego, California), c. 1935, oil on canvas, 20 × 24 in., signed (faintly) l/r. Collection of Gary M. Lang. Photo: Martin A. Folb, PhD.

An interesting and unusual early view of Coronado and North Island from the San Diego mainland. North Island was originally used by the Hotel Del Coronado as a spot for jackrabbit hunting. In 1911, the famed aviator Glenn Curtiss found the area ideal for experimenting with his newly developed seaplane and leased the land for three years from John D. Spreckels. After the government bought the land from John D. Spreckels for five million dollars in 1917, North Island functioned as a jointly used Army and Navy base. North Island was the site of the first seaplane flight and the first successful aerial (mid-air to air) refueling took place here on June 27, 1923. The first nonstop transcontinental flight also originated from here when Charles Lindbergh flew from North Island on the first leg of his celebrated New York to Paris flight in 1927. History of Coronado, California, Coronado Historical Association, Museum of History and Art.

Rose was a longtime member of the San Diego Art Guild. She first exhibited with them in 1930 and continued for the remainder of her life. Also in 1930, her work was shown in a group exhibition at Von Briesen's (furniture gallery) in San Diego. This was a frequent exhibition space for many of Reiffel's students. An active participant in many local San Diego gallery exhibitions, her work was included in shows at Holzwasser's Gallery, 1932, 1933 and 1934, and Pieter Smoor's Gallery (solo exhibition) in 1934. She was also included in the Annual Art Exhibition at Santa Cruz (California), 1934; California Pacific International Exposition, San Diego, 1935; Golden Gate International Exposition 1939; and California State Fair, 1934 (third prize), 1939 (third prize), 1940 (honorable mention), and 1947. Her work is in the permanent collection of the San Diego Historical Society, San Diego, California.

Untitled (Artists Painting in Nature -
Possibly a group of students with
artist/teacher Charles Reiffel), c. 1935,
oil on board, 20 × 23.25 in., signed
verso. Private collection. Photo:
Martin A. Folb, PhD.

Untitled (Landscape with Creek), n.d., oil on
board, 20 × 24 in., signed verso. Collection of
Moe Parniani. Photo: Martin A. Folb, PhD.

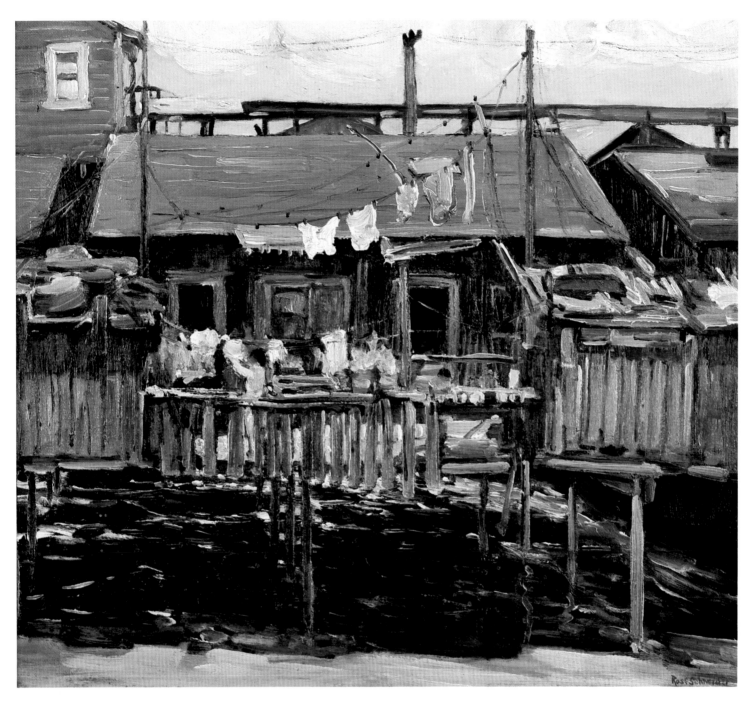

Untitled (Shack - San Diego Harbor), c. 1935, oil on board, 12 × 16 in., signed l/r. Collection of Moe Parniani. Photo: Martin A. Folb, PhD.

Young and inquisitive, Rose Schneider experienced many adventures, frequently with her traveling easel and art supplies in hand. She became enamored with the Japanese immigrants living in the shanty community adjacent to the harbor near her home. Unfortunately, these Japanese immigrants were discriminated against, and they could not own land. The local canneries, owning much of the harbor front real estate, built extremely low-budget dwellings, some constructed of only plywood and studs, and many void of electricity. Nonetheless, the dwellings became home to the Japanese fishermen and their families who were so instrumental in the success of the canneries. Rose became a regular visitor at the fish camps, even learning to speak the language and embracing some of the Japanese customs. For that reason, plus her jovial nature, she was always welcome within the community and began an amazing series of rich oil paintings depicting the lives of the people. Because the scenes were painted from life, they have a wonderful spontaneity. Detailed modeling, precision, and struggling with illusions was not her concern. Rose wanted to capture the realism of the moment on her canvases. The fish camp paintings were very much her own inspiration and opened the door to a new and powerful way to create with intense color saturations and strength throughout the compositions. —Gary M. Lang.

Untitled (Valley and River Landscape - San Diego County), n.d., oil on board, 12 × 16 in.,
signed l/r. Collection of Gary M. Lang. Photo: Martin A. Folb, PhD.

Untitled (Hobo Camp - San Diego County), n.d., oil on board, 18 × 20 in.,
signed l/r. Collection of Gary M. Lang. Photo: Martin A. Folb, PhD.

Untitled (Longshoremen), n.d., oil on board, 20 × 24 in., signed l/r.
Collection of Gary M. Lang. Photo: Martin A. Folb, PhD.

Primarily she worked in oils, mostly painting and sketching the environs of San Diego County and Southern California. Her non-art-related associations included the San Diego Council of Jewish Women and the Theosophical Society, each of which served as venues for exhibitions of her work. For many years, she was a frequent lecturer on a myriad of topics (art and non-art related) with the Theosophical Society. Rose never married and spent many years living with her unmarried elder brother Harry.

Rose Schneider passed away on February 20, 1976, in San Diego, California.

Biographical information compiled from: "Painting Ladies," Bruce Kamerling, *The Journal of San Diego History*, San Diego Historical Society Quarterly, Summer 1986; *San Diego Union*, December 24, 1926, September 21, 1930, February 21, 1935, February 26, 1976 (obituary); and *San Diego Evening Tribune*, September 22, 1934, February 15, 1936. Additional information provided by Jo Jay, Rose Schneider's niece and the daughter of artist Elaine Sagerhorn.

Donna Schuster
1883–1953

Donna Norine Schuster was born on January 26, 1883, (although some sources indicate 1884) in Milwaukee, Wisconsin, the daughter of tobacco dealer/manufacturer George J. Schuster and Nora L. (Devendorf) Schuster. Donna grew up in Milwaukee and attended school locally before enrolling at the School of the Art Institute of Chicago, Illinois, where she graduated with honors. Afterwards she moved to Boston, Massachusetts, where she enrolled in the School of the Museum of Fine Art, where she studied under the artists Edmund Tarbell and Frank Benson, each known for their impressionistic style of painting. In the summer of 1912 she traveled to Europe on a painting tour of Belgium with a group led by artist William Merritt Chase. Her work from this period strongly reflected the influence of the Boston School and the impressionistic style of Chase and his idol Claude Monet.

Around 1913, after her parents' divorce, Donna moved with her mother to Southern California. The next year, in 1914, she joined William Merritt Chase's summer art class in Carmel, California; this was one Chase's last teaching endeavors as he was ill and passed away in 1916. That fall, Donna remained several weeks in Northern California to carry out a commission to paint scenes of the various buildings under construction for the planned 1915 Panama-Pacific International Exposition in San Francisco. Of the resulting paintings, which were featured in a solo exhibition at the Los Angeles County Museum of History, Science, and Art, Antony Anderson wrote in the *Los Angeles Times*: "The vivid impressionism of these quick sketches is delightful. They glow and sparkle like jewels, and have caught, as it were, the very spirit of the great exposition-the élan of San Francisco, its joyous life, its glamorous sunshine. These things, translated to paper charged with fluent color make fascinating pictures." Her skill was

also rewarded with a silver medal for three of the watercolors from the series she exhibited at the 1915 Exposition and another silver medal for watercolors from the series that she exhibited at the Panama-California Exposition in San Diego later that same year.

In 1923, she and her mother moved into a newly built home in Los Angeles's Los Feliz neighborhood in the hills overlooking nearby Griffith Park. Immersing herself in Los Angeles's arts community, she worked as an instructor at the Otis Art Institute while maintaining memberships in multiple organizations, including the California Art Club; Society of Independent Artists; the California Watercolor Society, for which she served as president; and West Coast Arts, Inc., which later evolved into Women Painters of the West, an organization she co-founded. She was also a member of the Laguna Beach Art Association in Laguna Beach, California; she purchased a small house in the seaside village and painted there in the summers, maintaining her activity within the community's artist colony.

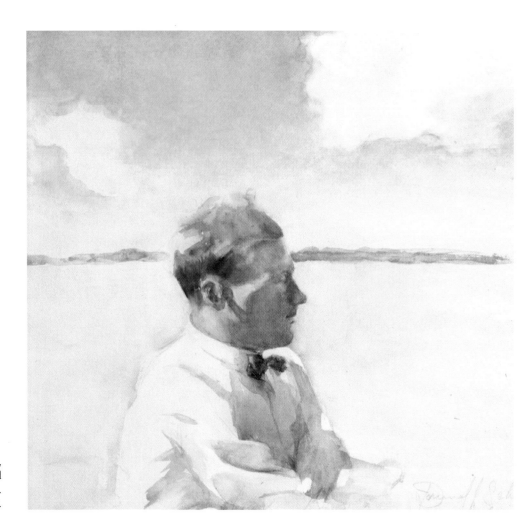

Untitled (Man in Landscape), July 1911, watercolor on paper,13.5 × 13.5 in., signed and dated l/r. Private collection. Photo: Martin A. Folb, PhD.

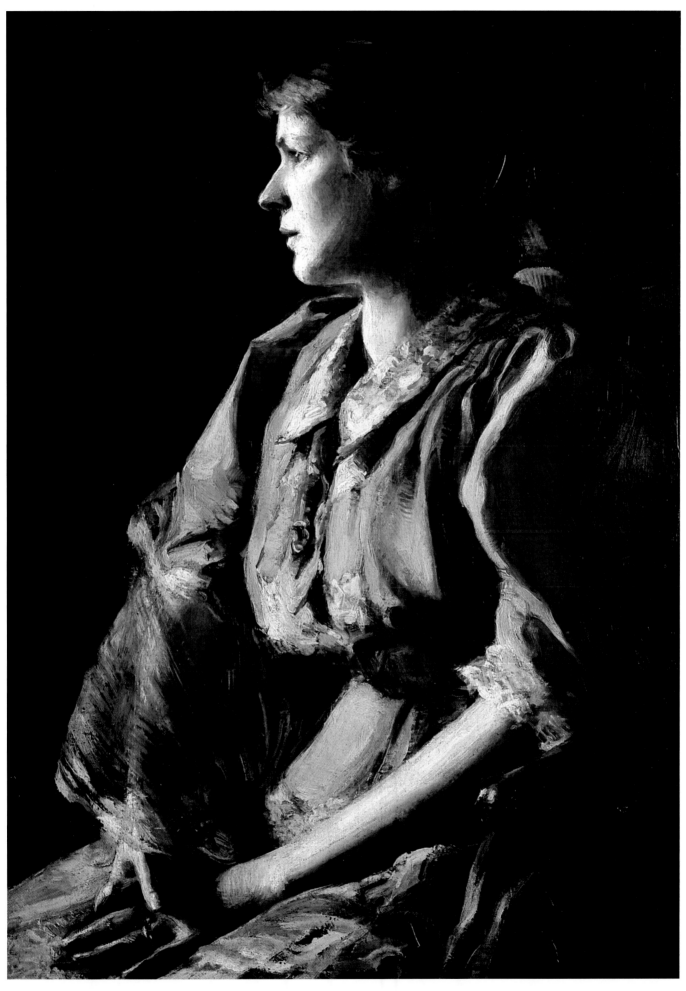

Portrait of Mrs. Waldo Chapman, c. 1915, oil on canvas, 30 × 22 in., signed l/r.
Private collection. Photo: Martin A. Folb, PhD.

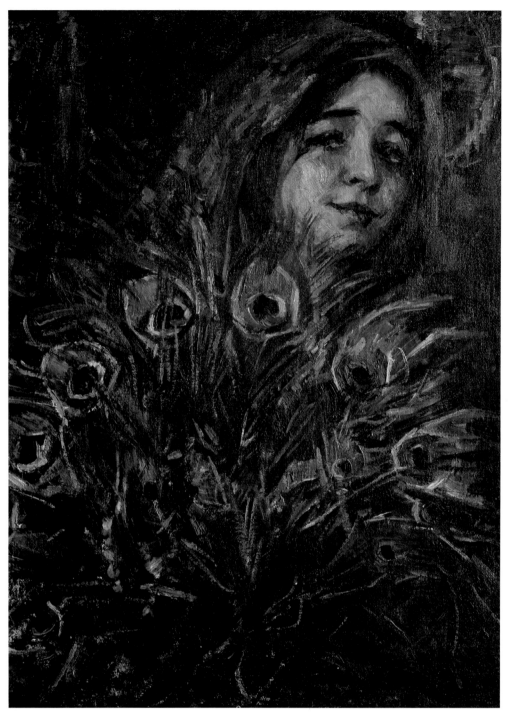

Self-Portrait with Peacock Feathers (painted verso: *Girl Seated on a Rock by the Ocean),* c. 1918, oil on canvas, 26 × 20 in., signed. Private collection. Photo: Martin A. Folb, PhD.

Another artists' group in which she was a member was the Group of Eight in Los Angeles. From its formation in E. Roscoe Shrader's studio in 1921 to its dissolution in 1928, the Group of Eight held exhibitions in several venues, including the Los Angeles County Museum of History, Science, and Art in 1927. Of that exhibition, critic Antony Anderson in a *Los Angeles Times* art review of July 31, 1927, wrote, "They are not traditional painter[s] of Southern California landscape; all of them use color freely and generously; all are more or less open to new ideas in painting; all of them paint the figure. While most of them may be described as progressive, none works in a manner which is not comprehensible to a moderately educated mind." The Group of Eight consisted of Los Angeles artists Mabel Alvarez, Clarence Hinkle, Henri de

Kruif, John Hubbard Rich, Donna Schuster, Shrader, and Edouard and Luvena Vysekal. The product of these artists reflects a period in California painting that straddled the edge of impressionism and new modernist concepts.

Donna's oeuvre includes watercolor and oils, in which she continually experimented, varying subject matter and style. She produced numerous paintings of water lilies and lily ponds, showing a Monet influence, but often achieving a more decorative, flattened, two-dimensional effect, reminiscent of Far Eastern prints and aspects of art nouveau. About 1928 she began her study with the artist Stanton MacDonald Wright. In his discussion of her work, Leonard De Grassi describes how Wright's influence can be seen in Donna's series of paintings titled *Pasionata,* which include the

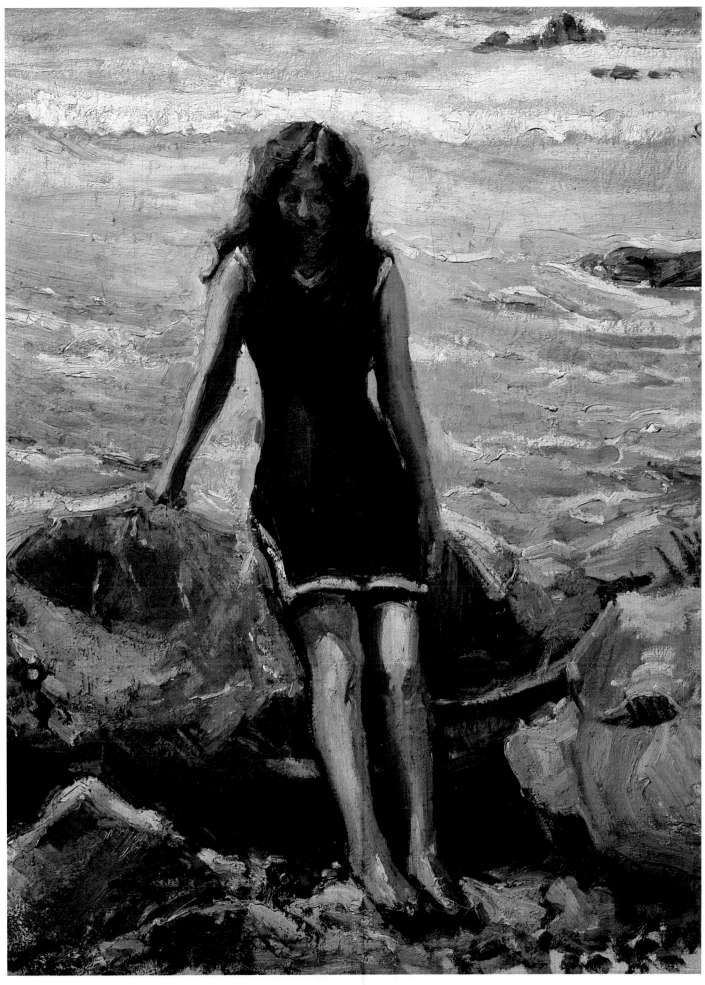

Girl Seated on a Rock by the Ocean (painted verso: *Self-Portrait with Peacock Feathers),* c. 1918,
oil on canvas, 26 × 20 in., signed. Private collection. Photo: Martin A. Folb, PhD.

Donna Schuster's personal Christmas card,
which she designed and illustrated, c. 1920.
Private collection. Photo: Martin A. Folb, PhD.

hot color range and Cézannesque approach to forms often found in Wright's work. Her California scenes included mission and harbor studies, one of which was reproduced on the cover of *Touring Topics* magazine in May 1929. Though she experimented with many styles, the impressionists were overall the most influential in her work. And though she favored figural studies she painted landscapes depicting many areas of California, including her beloved Griffith Park. Through the 1930s she was somewhat influenced by the rise of cubism, and later her style reveals an awareness of abstract expressionism particularly noticeable in a series of watercolors done in and around Yosemite National Park in the late 1940s and early 1950s. By 1952 she was an instructor at the Los Angeles Art Institute.

Her numerous exhibitions and awards include: Pennsylvania Academy of the Fine Arta Annual, 1912–1915; Minnesota State Art Exhibition, 1913 (gold medal), 1914; Los Angeles County Museum of History, Science, and Art, 1914, 1917, 1920, 1927, 1929; St. Paul Institute, Minnesota, 1915 (silver medal); New York Academy of Fine Art; New York Watercolor Society; American Watercolor Society; Society of Independent Artists, 1917; Art Institute of Chicago; Phoenix, Arizona, 1918 (prize), 1919 (prize), 1920 (prize); California Art Club, 1921 (first prize), 1931 (prize); Corcoran Gallery biennial, 1919; California Watercolor Society, 1926 (first prize); West Coast Arts, Inc, 1926 (prize), 1929 (prize); Los Angeles County Fair, 1929 (prize), 1930 (prize); Riverside County Fair, 1930 (prize); Orange County Fair,

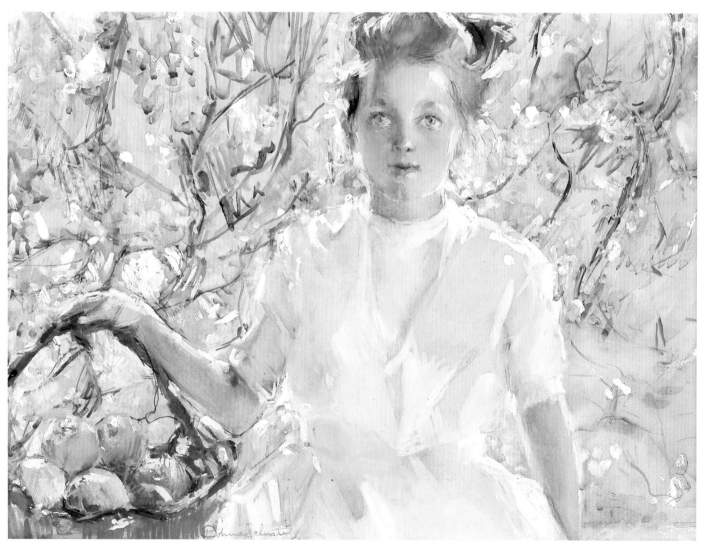

Untitled (Girl with a Basket), n.d., watercolor and mixed media on paper, 19 × 14 in., signed l/m.
Private collection. Photo: Martin A. Folb, PhD.

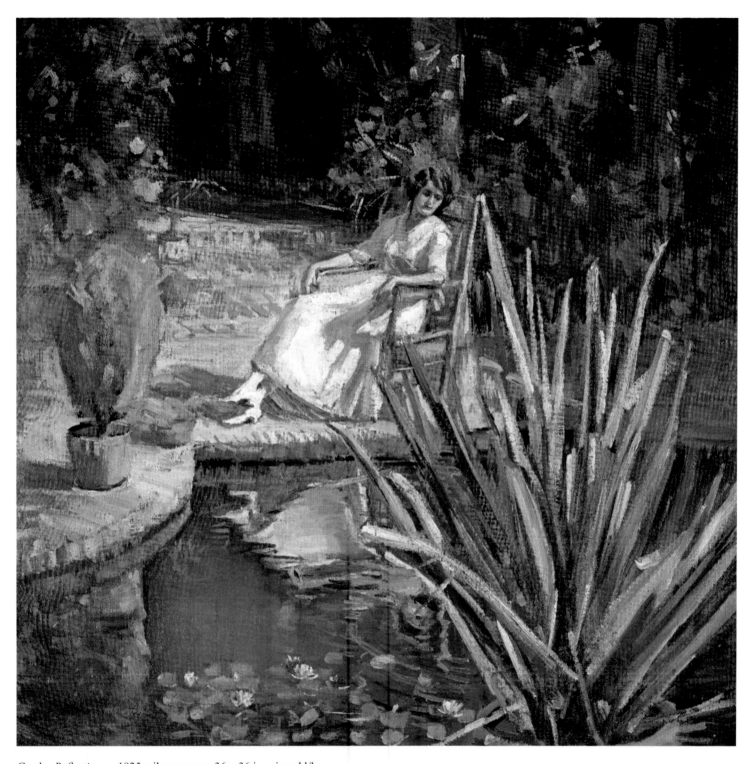

Garden Reflection, c. 1925, oil on canvas, 36 × 36 in., signed l/l.
Crocker Art Museum (Sacramento, California),
gift of Melza and Ted Barr, 2008.103.

1930 (prize); Santa Cruz, 1931; Art Teachers Association, Los Angeles County, 1933 (medal); Golden Gate International Exposition, 1939; and San Francisco Art Association. Her works are in the collections of the Downey Museum of Art; Laguna Beach Museum of Art; Los Angeles County Museum of Art, and The Oakland Museum, all in California, and others.

Donna Norine Schuster passed away on December 27, 1953, in Los Angeles, California, at the age of seventy when a massive wind-driven brushfire swept over her hillside home, as she attempted to save her dogs.

Biographical information compiled from: *Who's Who in American Art*, 1953, Dorothy B. Gilbert, ed.; *Plein Air Painters of California: The Southland*, Ruth Lilly Westphal, 1982; *Donna Norine Schuster* (exhibition catalog), Leonard De Grassi, Downey Museum of Art, 1977; *Circles of Influence* (exhibition catalog), Sarah Vure, Orange County Museum of Art, 2000; *Los Angeles Times*, December 6, 1914 and July 31, 1927; United States Census, 1900, 1910, 1920, 1930, 1940; and California Death Index.

Patty Switzer Scratch
1903–1972

Patty J. Switzer was born in Chicago, Illinois, on August 22, 1903 (although varying data reference the years of 1902 and 1904 as possible birth years), the daughter of Karl S. Switzer and Medora (Shaffer) Switzer. Patty studied at Cooper Union, the Art Students League, and the American School of Miniature Painting, all in New York City. The Switzer family moved to Los Angeles, California, around 1920 and Patty is listed as an artist in the 1921 Los Angeles telephone directory. She would continue to be listed as such throughout the ensuing decade.

In the late 1920s, after a move to Honolulu, Hawaii, Patty married writer and journalist Walter Leonard Scratch. The couple remained in Hawaii until the late 1930s when they returned to California and the San Francisco Bay Area, where their son was born in 1938. In the 1940s, another move within California brought them to Los Angeles, where they remained.

Patty began her career as a painter of miniatures and exhibited her work in various shows on the East Coast, including the 1924 Baltimore (Maryland) Miniature Show. She exhibited while in Hawaii, as well as upon her return to the mainland. A member of the California Society of Miniature Painters and the Bay Region Art Association, San Francisco, she was also a member of and exhibited with the National League of American Pen Women, 1960–1966, and the Painters & Sculptors Society (Washington, DC), 1964.

Patty Scratch passed away on February 6, 1972, in Los Angeles, California.

Biographical information compiled from: *Dictionary of Art and Artists in Southern California before 1930*, Nancy Dustin Wall Moure; *Los Angeles Times*, March 2, 1924, August 10, 1933, *Who's Who in American Art, 1929*; United States Census, 1930, 1940; California Death Index; and Scratch family archives.

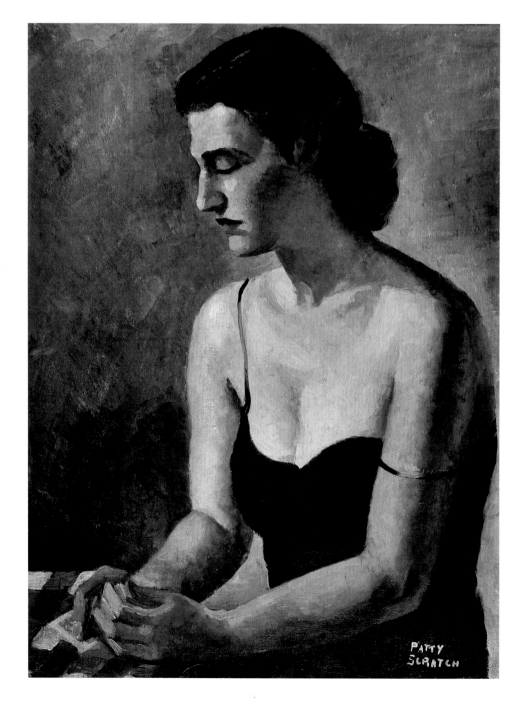

Untitled (Portrait of a Woman), 1940, oil on canvas, 24 × 20 in., signed l/r. Courtesy of Thomas Royal and Louis Cantabrana.
Photo: Martin A. Folb, PhD.

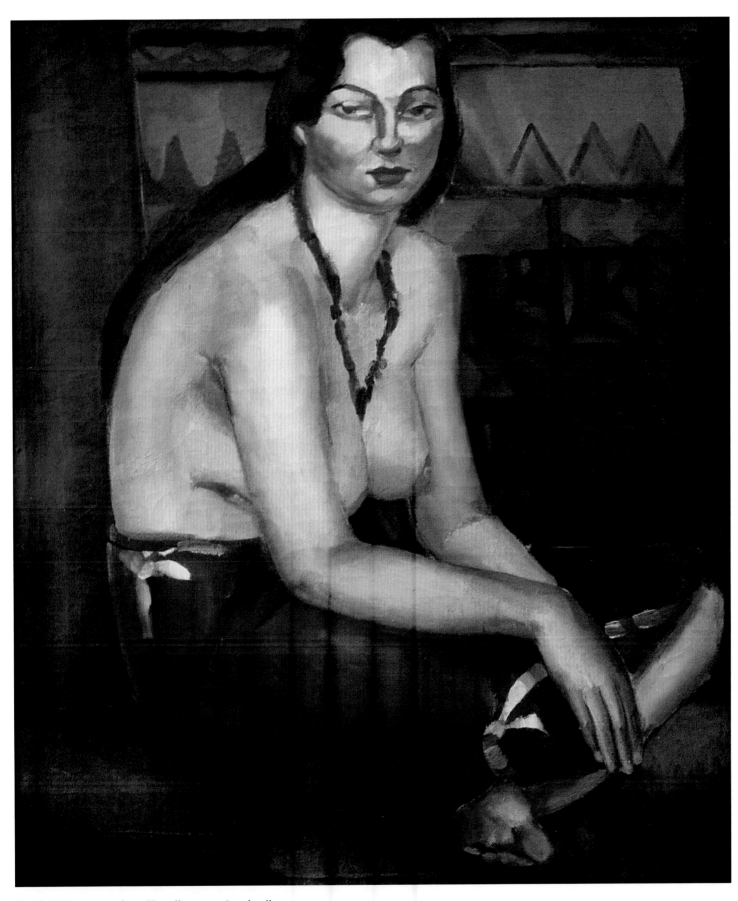

Untitled (Woman wearing a Hawaiian sarong), n.d., oil on canvas,
41 × 34.5 in., signed verso. Collection of Alex Lopez.

Elise Cavanna Seeds
1902–1963

Alyse Cavanna Seeds was born on January 30, 1902, in Germantown, Pennsylvania, the daughter of Thomas M. and Sallie B. (Cavanna) Seeds. After her early studies at St. Mary's Hall, a boarding school in Burlington, New Jersey, she studied at the Pennsylvania Academy of the Fine Arts with Arthur Carles, Daniel Garber, and Hugh Breckenridge. In the 1920s, she studied dance under modernist Isadora Duncan. She performed in New York and in Europe and later worked with comedian W. C. Fields as his comic partner in the Ziegfeld Follies. In 1926, in New York, she began a career as an actress in motion pictures. It was Fields who convinced her to move to California to continue her acting career and appear with him in motion pictures; she continued acting in motion pictures until 1945. By now she had changed the spelling of her first name and was professionally using the name of Elise Cavanna.

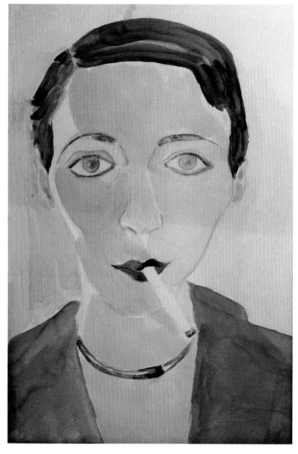

Self-Portrait, 1936, watercolors and graphite on paper, 11.75 × 5.25 in., annotated verso. Courtesy of Tobey C. Moss Gallery, Los Angeles, California.

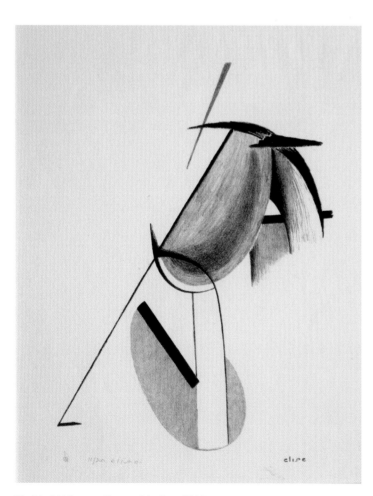

Untitled (Abstract Composition), c. 1935, lithograph on paper, 19.75 × 13 in., ed. 20, signed l/r: "Elise." Courtesy of Tobey C. Moss Gallery, Los Angeles, California.

Known for her unorthodox and eccentric persona, she also had a striking physical appearance, as she was six feet tall and had purple-tinted hair. After settling in Los Angeles in the early 1930s, she became increasingly active in the local art scene. In California she met and married the writer and noted bon vivant Merle Edgar Armitage. By now her work as an artist intensified and under the Public Works Administration, she reportedly executed two murals depicting pre-historic animals for the Los Angeles County Museum of History, Science, and Art. Around 1935 she was awarded a commission under the Federal Art Project to create a mural for the Oceanside, California, post office. The sixteen by six–foot mural, *Air Mail*, depicts a mail plane flying over the California landscape. A painter, illustrator, lithographer, and muralist, Elise is considered one of the early California modernists.

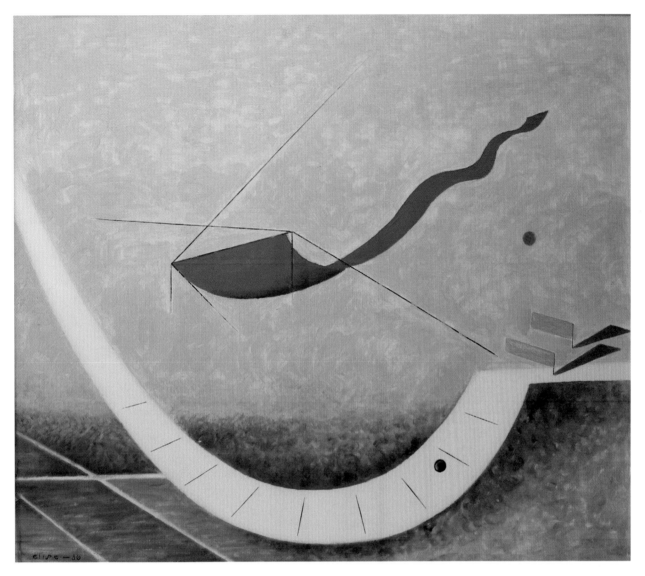

Open Sky (Abstract Composition), 1936, gouache and ink on board, 12 × 14 in., signed and dated l/l. Courtesy of Tobey C. Moss Gallery, Los Angeles, California.

Her oeuvre consists primarily of abstractions, a style she adopted in the 1930s, producing lyrical paintings, drawings, and lithographs, the latter under master printmaker Lynton Kistler, with whom she worked from 1932 to 1936. Her later works were done in a pure nonobjective style. In the early 1950s in Los Angeles, Elise was a founding member, along with Lorser Feitelson, Helen Lundeberg and Stephen Longstreet, of the artists' group known as the Functionists West. Although she primarily signed her works Elise, she at times used and appeared under her maiden and various married names, including Elise Cavanna, Elise Seeds, Elise Armitage (Mrs. Merle Armitage, during the 1930s and 1940s), and Elise Welton (Mrs. James B. Welton, during the 1950s until her death).

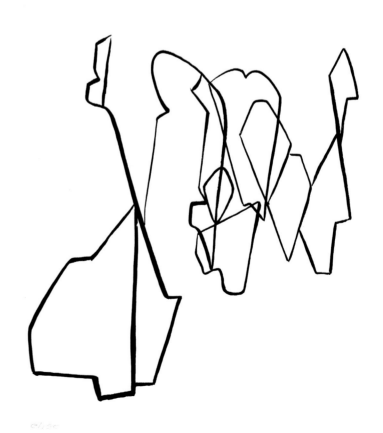

Vertical Procession, c. 1942, ink on paper, 11 × 9.5 in., signed l/l: "Elise." Private collection. Photo: Martin A. Folb, PhD.

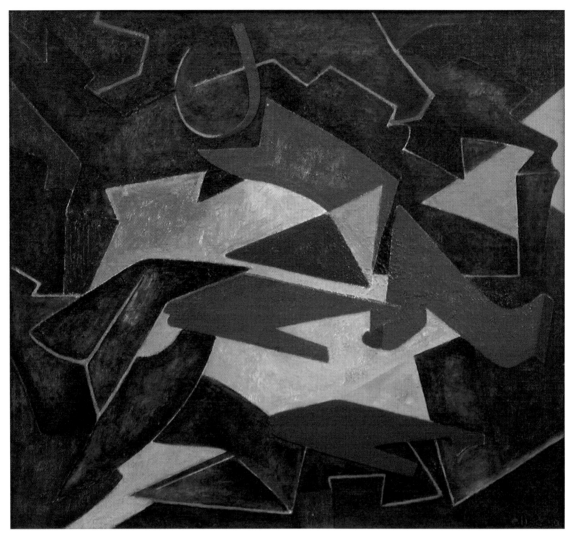

Jitterbugs, 1950, oil on canvas, 21 × 23 in., signed and dated l/r. Courtesy of Tobey C. Moss Gallery, Los Angeles, California.

Her exhibitions included Salons of America, 1927; Society of Independent Artists, 1927; Fifty Prints of the Year, 1933–1935; Stendal Galleries, 1933, 1936; Ebell Club, Los Angeles, 1935 (first prize); California Pacific International Exhibition, San Diego, 1935; Antheil Gallery, Hollywood, 1938 (solo); World's Fair, New York, 1939; Forsythe Gallery, Los Angeles, 1950 (solo); John Heller Gallery, 1954; Los Angeles Art Association; Whitney Museum of American Art, New York, 1955; São Paulo, Brazil, 1956; and more. Her work can be found in the collections of the Los Angeles County Museum of Art; the Louise and Walter Arensberg Archives, Chicago Art Institute, and the Francis Bacon Library, Claremont, California.

Elise Cavanna Welton passed away on May 12, 1963, in Los Angeles, California.

Biographical information compiled from: *Los Angeles Times*, May 13, 1963 (obituary); *Who Was Who in American Art, 1564–1975*, Peter Hastings Falk, ed.; United States Census, 1910, 1920, 1930, 1940; California Death Index; and George Stern Fine Arts, Los Angeles, California.

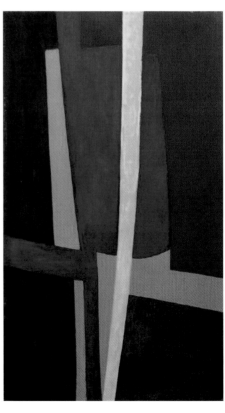

Yellow Line, 1953, oil on canvas, 48 × 27.75 in., signed l/r. Courtesy of George Stern Fine Arts.

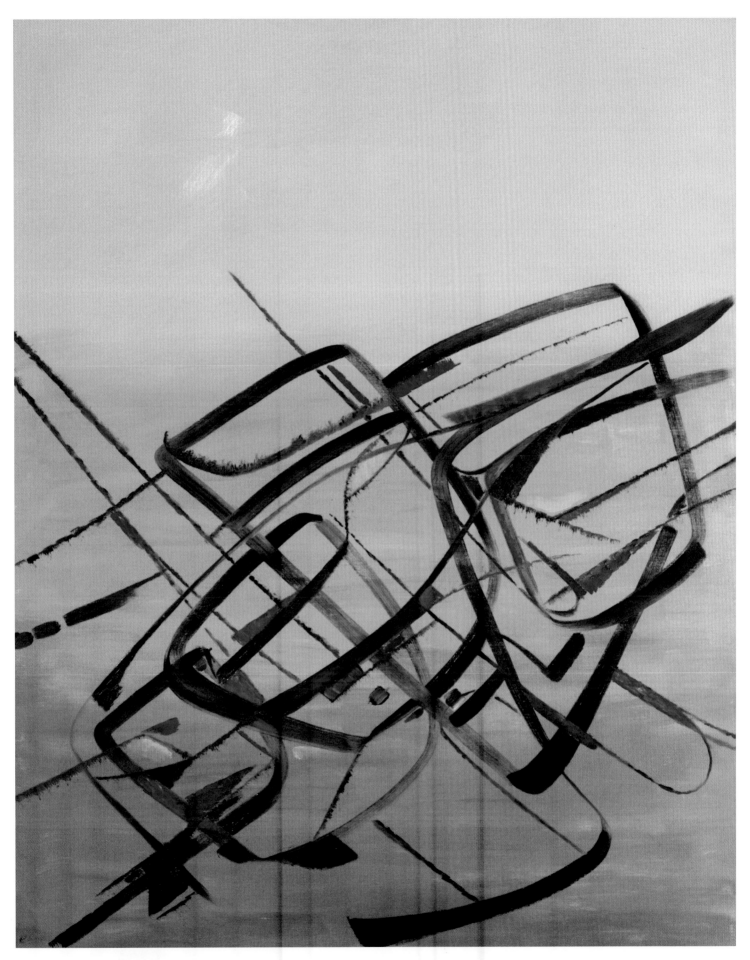

Perception, c. 1959, oil on canvas, 50 × 40 in., signed l/l.
Collection of Donald Allen Merrill.

Helen M. Seegert
1907–1975

Helen Maye Gould was born on January 12, 1907, in Carpenteria, Santa Barbara County, California, to George H. and Sarah (Luick) Gould. She appears to have spent her childhood in the Summerland area of the county and may have attended Santa Barbara High School. In her youth she acquired the nickname "Tommie," a name used even after her marriage, but she also seems to have gone by the names Helen, Helena, and Helene according to some census records.

In 1926, she enrolled at the Santa Barbara State Teachers College, which later became the University of California at Santa Barbara. It was at school that she met Frederick A. Seegert, a fellow artist and, like Helen, a sculptor. They were married on May 14, 1927, while still students. Both continued their studies at the Santa Barbara School of the Arts under Archibald Dawson, Amory C. Simons, and Frank Morley Fletcher. Eventually, Helen joined her husband as an instructor at the Santa Barbara School of the Arts, which was founded in 1920 by artist Fernand Lungren and closed in 1933. After the school closed, Helen continued to teach art locally and for brief periods in Pasadena and Los Angeles.

Helen M. Seegert, photographed by Frederick Seegert, c. 1928. Courtesy of Betsee Seegert Talavera.

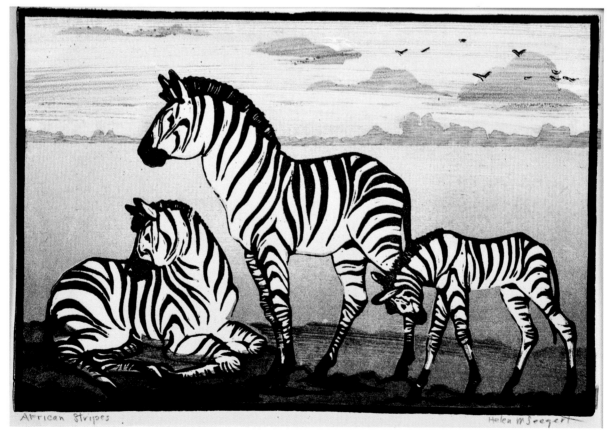

African Stripes, 1936 (WPA), color woodblock on soft fibrous cream wove paper, 6 × 9 in., signed l/r. Courtesy of Roger Genser and The Prints and the Pauper. Photo: Martin A. Folb, PhD.

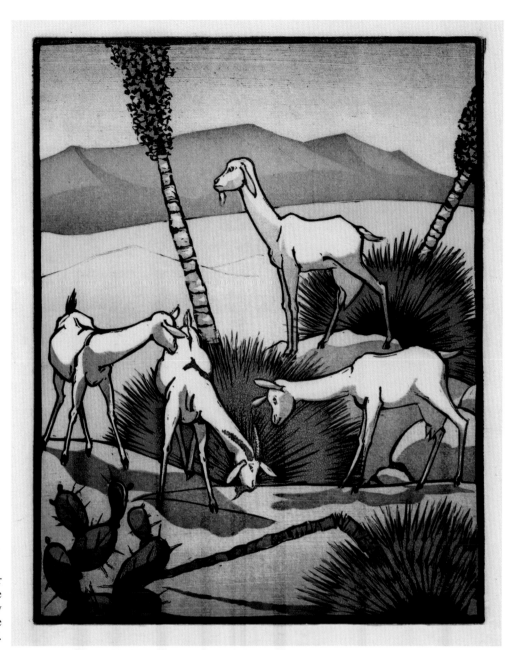

Plain Summer, 1936 (WPA), color woodblock on soft fibrous cream wove paper, 10 × 8 in., signed verso. Courtesy of Roger Genser and The Prints and the Pauper. Photo: Martin A. Folb, PhD.

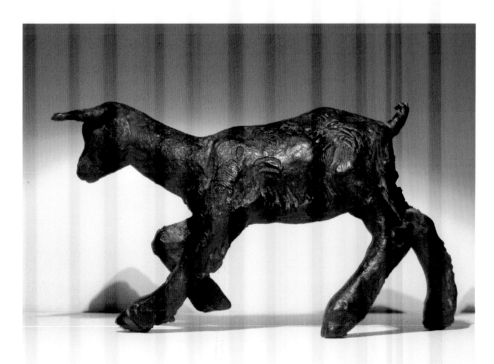

Untitled (Kid Goat), n.d., cast bronze sculpture, 3 × 5 × 1.5 in., signed underside. Courtesy of Betsee Seegert Talavera.

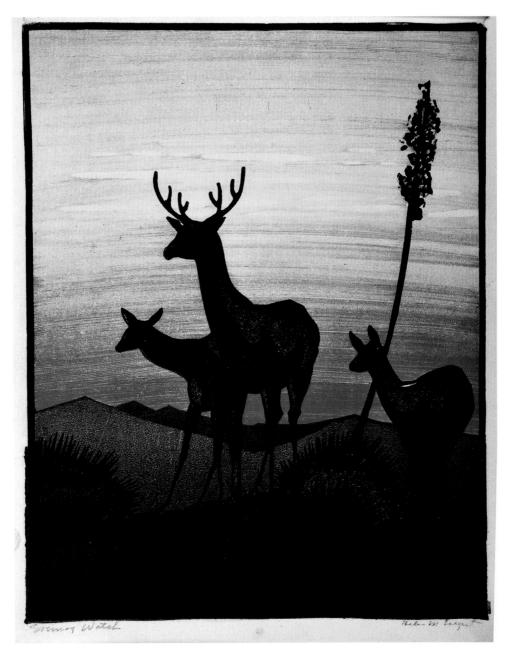

Evening Watch, 1936 (WPA), color woodblock on soft fibrous cream wove paper, 10 × 7.75 in.,
signed l/r. Courtesy of Roger Genser and The Prints and the Pauper. Photo: Martin A. Folb, PhD.

According to her husband's family, Helen was a woman of strong personality and was able to surpass her husband in her artistic output. According to memories recounted by her husband later in life, Helen stated that there would be only one artist in their family and that it would be her. He apparently capitulated, as he became the principal bronze caster for her works and the works of other sculptors in the Santa Barbara area. They were divorced on September 10, 1937.

In addition to her sculpture, Helen was one of a number of artists working in Santa Barbara in the late 1920s, 1930s and 1940s in color woodcut. During the Depression, Helen sought work with the WPA's Federal Art Project and produced at least two documented projects: a bas-relief sculpture at the La Purisima Mission and a mural/plaque at the Veterans Memorial Building both in Lompoc, Californian. She was listed as a sculptor in the New Deal Registry and did woodcuts for the Works Progress Administration in 1936.

After 1957, Helen spent eight years as an illustrator for Point Magu Naval Station. On August 9, 1958, she married William J.

Jansen, to whom she was still married at the time of her death.

She was a member of the Arts and Crafts League, Santa Barbara, and the Santa Barbara Associates, a group of artists who exhibited in the art gallery of the at the Chamber of Commerce on East Cabrillo Street in Santa Barbara. The members' work traveled throughout various locations in Southern California. Her exhibitions included San Diego Fine Arts Gallery, 1933; California Pacific International Exposition, San Diego, 1935; Palos Verdes Library, 1935; Southern California Festival of Allied Arts, 1936; and Golden Gate International Exposition, San Francisco, 1939. Her art work is incorporated in the Veterans Memorial Building and La Purisima National Park, both in Lompoc, California.

Helen Seegert Jensen passed away on September 26, 1975, in Carpenteria, California. She was cremated and buried at sea.

Biographical information courtesy of Betsee Seegert Talavera. Addition information: United States Census, 1910–1940; and *Los Angeles Times*, March 14, 1935, April 5, 1936.

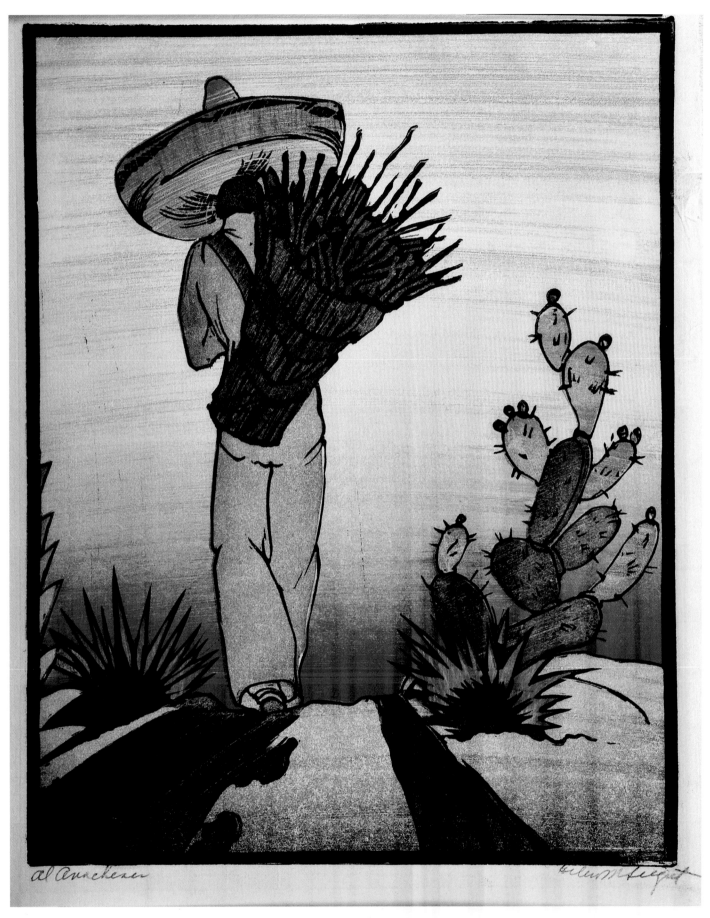

Al Anochec (At Dusk), 1936 (WPA), color woodblock on soft fibrous cream wove
paper, 10 × 8 in., signed l/r. Courtesy of Roger Genser and The Prints and the Pauper.
Photo: Martin A. Folb, PhD

Helen Inez Seibert
1914–1988

Helen Inez Seibert, known as Inez, was born on February 16, 1914, in Norfolk, Virginia. She spent the early years of her life living with her maternal aunt and uncle in Westchester County, New York. Known as an exemplary American modernist, Inez was initially tutored by the artist George Oberteuffer in New York in the early 1930s; in her early work, she was inspired by the rich canvas surfaces and compositions of French post-impressionist Paul Cézanne. In 1936, she married Charles Van Wyck Brooks, whose father was the distinguished literary lion of New England, Van Wyck Brooks, who in turn was the best friend of Duncan Phillips of the Phillips Collection in Washington, DC. After her marriage, Inez studied privately, around 1936–1937, with the artist Arthur Dove, also a friend of Inez's father-in-law. This began a lifelong relationship with Dove and his wife, Helen Torr.

Through social connections, and with ample funds, the attractive young couple traveled to Europe, where they explored the European social and artistic scene that existed prior to the outbreak of World War II. In France from 1938 to 1939, Helen encountered some of the most brilliant and important personalities of the day including Pablo Picasso, Georges Braque, Fernand Léger, and Gertrude Stein and her circle, including Ernest Hemingway, John Dos Passos, and Jean Cocteau. Upon their return to the United States, the couple made their home in Westport, Connecticut.

Inez Seibert, photographed by Arnold Genthe, c. 1935.
Courtesy of Denenberg Fine Arts, West Hollywood, California.

Sky and Land, n.d., watercolor on paper, 7 × 11 in., signed l/l. Collection of Catherine and Dan Gellert. Photo: Martin A. Folb, PhD.

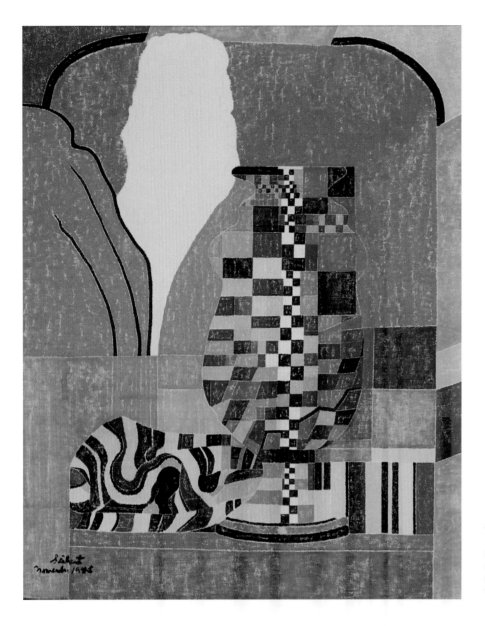

French Vase and Italian Scarf,
1945, oil on canvas, 20 × 16 in.,
signed and dated l/l and signed and
dated verso: "November 11, 1945."
Courtesy of Denenberg Fine Arts,
West Hollywood, California.

Inez became associated in New York with An American Place, Alfred Stieglitz's salon of American modernism. Her work from this period appears to respond to work being done at the time by internationally known artists Pablo Picasso and Piet Mondrian. In 1940, the Brookses left New York to move to California, staying for a time at Mabel Dodge's Taos, New Mexico, home (Dodge's home likewise was known for its salon atmosphere) prior to settling in Marin County in Northern California. The couple later divorced.

In California, Inez continued to paint, and created a body of modernist works. In 1946, two paintings by Inez, *Composition* (1944) and *French Vase and Italian Scarf* (1945), were shown at the California Palace of the Legion of Honor in San Francisco. However, the years of productivity in California and the promise of continued success were cut short by a diagnosis of schizophrenia in 1949, quite untreatable at the time; she was thirty-five years of age. Helen was institutionalized in a sanitarium on the East Coast where she remained until her death thirty-eight years later on March 18, 1988.

Biography courtesy of Stuart Denenberg, Denenberg Fine Arts, Los Angeles, California.

Marin County - California, 1941, oil on canvas, 25 × 27.5 in., estate stamped verso. Courtesy of Denenberg Fine Arts, West Hollywood, California.

Ethel Sharp
1913–1996

Ethel Sharp was born on August 2, 1913, in Chicago, Illinois, the daughter of Maurice J. and Marguerite (Fink) Sharp. Raised in Winnetka, Illinois, she studied at the Art Institute of Chicago, Illinois, prior to relocating to California with her parents in the late 1930s.

In July of 1941, she married Hans Katz in California. Ethel continued her studies at the Chouinard Art Institute in Los Angeles and in the early 1940s was introduced to a private study group by fellow artist Ann Lackey. The private group was lead by Stanton Macdonald-Wright and met weekly with him for instruction and critiques of their work. Wright was in his semi-abstract period and guided the group to explore the possibilities of abstraction in their works. He was also a part of the Los Angeles Art Association and was able to organize exhibitions for select members of his group, titled *Artists You Should Know.* Ethel was selected regularly. Her oeuvre included landscapes, still lifes, and nudes, many in a surrealist style.

In the words of her friend and fellow artist Pauline Khuri-Majoli: "There were always psychological aspects to Ethel's work; she added elements which made the art more personal. They had a surreal dreamlike quality. She was also a figurative artist and quite imaginative. Ethel was completely original and ahead of her time. She dyed her clothes exciting vibrant colors, smoked her cigarettes from a holder, wore cat-eye shaped eyeglasses, had her car custom-painted an unusual shade of salmon and decorated her interior of her home with Christmas lights year-round! She was well read, had an intellectual curiosity, open to diversity and was interested in all cultures. She was very bright, outgoing and witty, fun to be with!"

In the 1950s, Ethel worked as an artist for Ro Shep ceramic artware, a studio operated by Rose S. Shep in Seal Beach, California, and later in her life she operated her own gallery, Mosaic Arts and Crafts in Sherman Oaks, California.

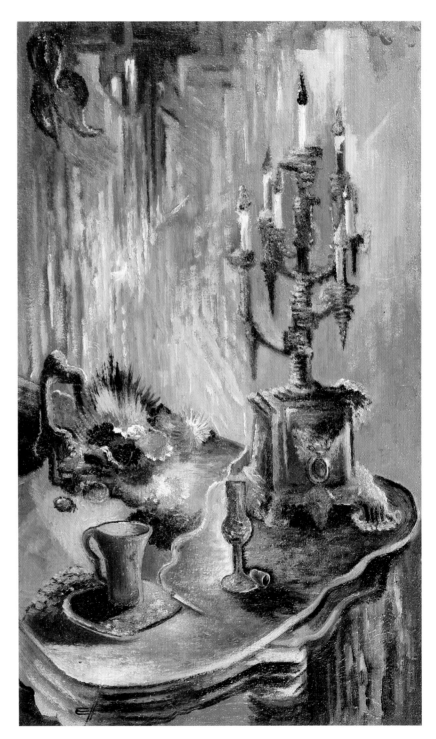

Untitled (Surreal Still Life with Candelabra), n.d., oil on canvas, 20 × 12 in., signed l/l. Private collection. Photo: Martin A. Folb, PhD.

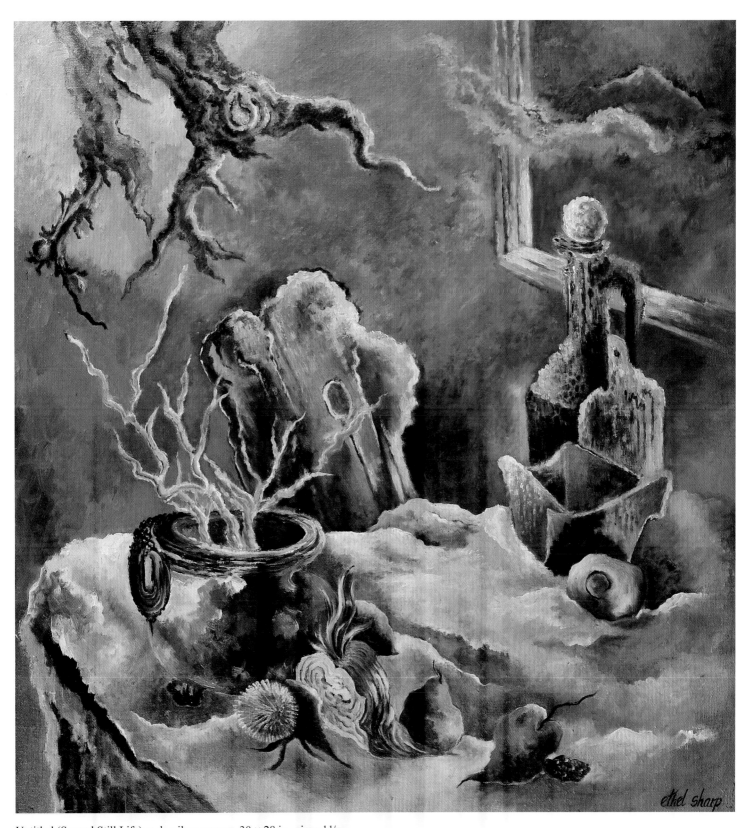

Untitled (Surreal Still Life), n.d., oil on canvas, 30 × 28 in., signed l/r.
Private collection. Photo: Martin A. Folb, PhD.

A complete history of her exhibitions is lacking, but she was a member of, and exhibited with, the Chicago Art Association and the Los Angeles Art Association. Examples of her work indicate that she used various signatures during her lifetime, including: "Ethel Sharp," "Ethel Sharp Katz," and a stylized version of "Ethel."

Ethel Sharp Katz passed away on January 8, 1996, in Los Angeles, California.

Biographical information compiled from: *Los Angeles Times*, July 4, 1941, October 12, 1947, April 17, 1958; United States Census, 1940; and California Death Index. Special thanks to the artist Pauline Khuri-Majoli.

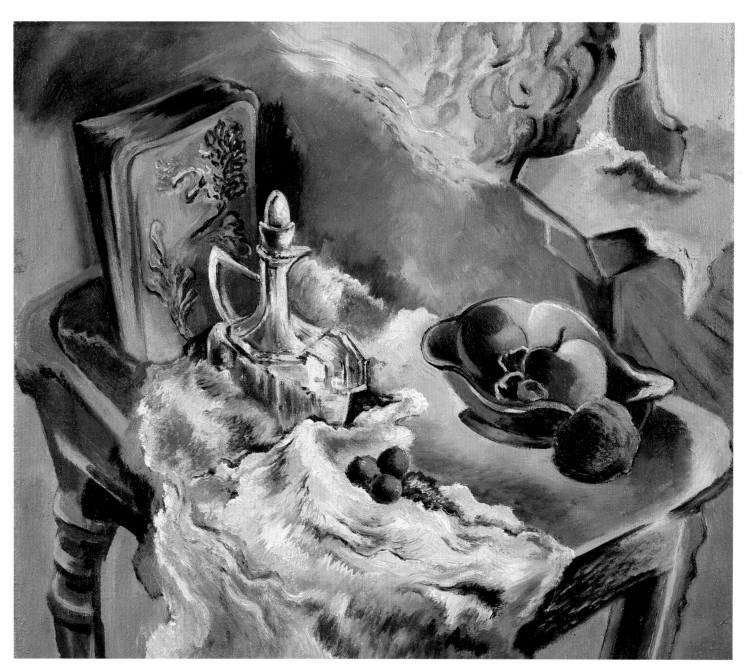

Untitled (Surreal Still Life), n.d., oil on canvas,
30 × 28 in., signed verso. Private collection.
Photo: Martin A. Folb, PhD.

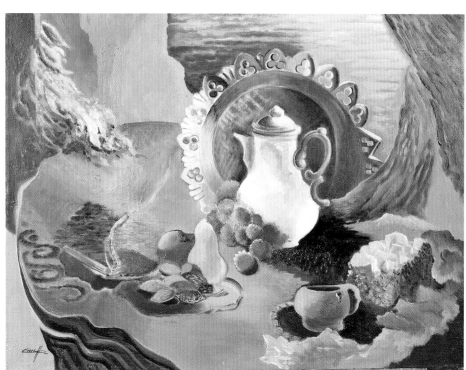

Untitled (Surreal Still Life with Coffee Pot and
Fruit), n.d., oil on canvas, 19 × 25 in., signed l/l.
Private collection. Photo: Martin A. Folb, PhD.

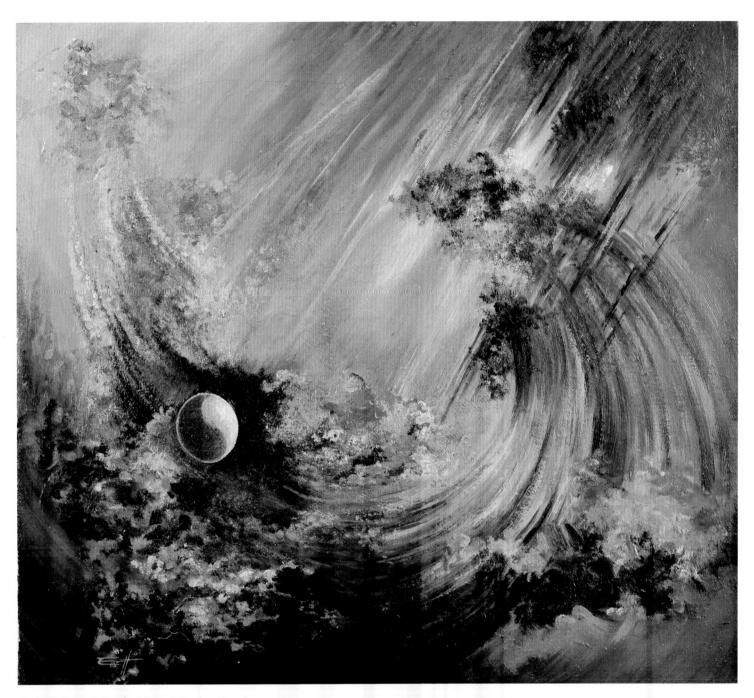

Untitled (Surreal Composition - "Yin Yang"), n.d.,
oil on canvas, 20 × 22 in., signed l/l. Private
collection. Photo: Martin A. Folb, PhD.

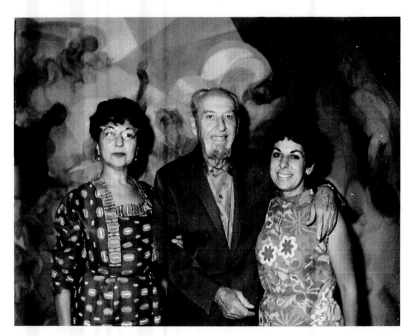

Photograph of the artists
(from left to right): Ethel Sharp,
Stanton Macdonald-Wright, and
Pauline Khure-Majoli, c. 1960.
Courtesy of Pauline Khure-Majoli.

Ada May Sharpless
1899–1988

Ada May Sharpless was born on August 16, 1899, in Hilo, Hawaii, the daughter of Benjamin H. Sharpless and Viola (Monroe) Sharpless. The Sharplesses left Hawaii and returned to the mainland when Ada May was a child, establishing a ranch in the Santa Ana/ Tustin area of Southern California. Her father established an orchard, planting avocado trees with fruit that became known as the Sharpless avocado. Ada May graduated from the local high school before attending the University of Southern California, from which she graduated in 1922. Between the years 1922 and 1925 she became involved with the California Art Club and the Los Angeles Art Association. Her activity with each of these groups continued throughout her career.

In 1925, Ada May, along with her sister, Mary Claire, traveled to France, where Ada May studied with the influential and prolific sculptor, painter, and teacher Émile-Antoine Bourdelle. During her four years in Paris, Ada May worked from a studio on the Rue Boissonnade and was a member of the Société des Artistes Indépendants, with whom she exhibited. She also had exhibitions in the galleries at the famed Tuileries. She returned to Los Angeles in 1929, the same year as Bourdelle's death. Upon her return to California, she resumed her activity with the California Art Club and the Los Angeles Art Association. She also continued her art studies, attending classes at the Otis Art Institute in Los Angeles.

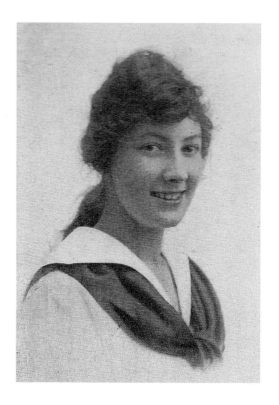

Ada May Sharpless, 1918.
The Marks family collection.

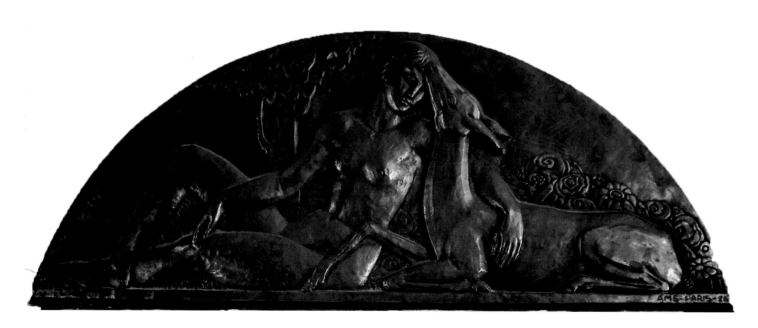

Untitled Bas-Relief, 1926, cast bronze, 10 × 28 in., initialed, annotated and dated l/r: "AMS - PARIS -'26." The Marks family collection.

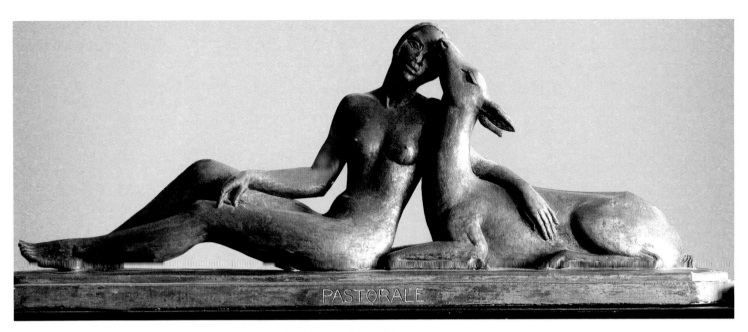

Pastorale, c. 1926, plaster cast sculpture with gold painted finish, 9.5 × 26 × 6.5 in., incised title center front and signature verso. The Marks family collection.

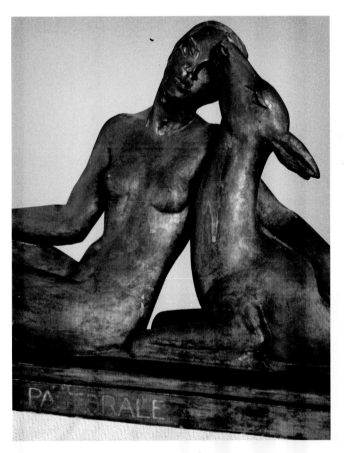

Detail: *Pastorale* (center of image - female and doe embrace).

Detail: *Pastorale* (signature verso sculpture).

At this point her reputation as a serious and talented sculptor was quickly becoming known. She established an art studio and soon began a series of private commissions and public works. She also became known as a successful teacher, instructing many noteworthy Hollywood personalities, including the actress Ginger Rogers. Her first exhibition upon her return to Los Angeles was with the California Art Club at the Los Angeles County Museum of History, Science, and Art in 1929 (first prize). Later exhibitions included the Painter and Sculptors, 1925, 1934, 1938; California Art Club, 1929–1935; Otis Art Institute, 1933; the Ebell Salon, 1933, 1934, 1941; Los Angeles County Fair, 1931–1933; San Diego Society of Fine Arts, 1934; Public Works of Art Project, 1934; and Riveria Gallery (Hollywood), 1936; and others.

Untitled (Reclining Nude), c. 1940, plaster cast with bronze finish, 15.5 × 33 × 10 in., signed underside. The Marks family collection.

In 1934, she received the first of her noteworthy public commissions to create the statue for the Juan Cabrillo Monument at the Santa Ana Historical Museum in Santa Ana (now the Bowers Museum). However, the work for which she is most often associated with is the iconic *Lady of the Lake* sculpture that was erected at Los Angeles's historic Echo Park Lake. Sculpted in the art deco style, the statue's original name was *La Reina de Los Angeles* (a.k.a. *Nuestra Reina de Los Angeles*); the work depicts a female figure representing the Queen of the Angels, patron saint of Los Angeles. Ada May was awarded this art commission by the federal Public Works of Art Project in Southern California in 1934, a Depression-era program that commissioned works of public art. Originally intended to be cast in bronze (in an edition of four), the eight-foot-high cast stone statue standing on a five-foot-high base was given as a gift to the City of Los Angeles by the federal government in 1935, the same year it was dedicated in Echo Park. Additional work by Ada May was commissioned for the New General Hospital (later Los Angeles County+USC Medical Center), the Sierra Vista School, the Malibar School, and the Los Angeles County Museum of History, Science, and Art.

In 1938, Ada May created a statue symbolizing *Dame Fashion* that was to be presented as an award at the Miss Dame Fashion pageant. In 1943, during World War II, when many artists's skill were put to use in helping the war effort, Ada May was among 220 artists from the Los Angeles area employed by Douglas Aircraft Company as part of their catalog illustration division. That same year, fifteen of these artists, including Ada May, were selected to display their art at the State Exposition Building in Exposition Park.

Untitled (Bust of a Man), c. 1935, wax polished terracotta, 12 × 7.5 × 8 in., signed on base. The Marks family collection.

Ada May was married three times. Her first husband, whom she married in 1926 in Paris, France, was Jean Lilliano (a.k.a. Jean Lilienfeld); he returned with Ada May to Los Angeles in 1929, and they divorced in 1932. Her second husband was Sheldon Bren (a.k.a. Sheldon Brennaaun), and her third was Norman Cornish; both of these marriages ended in divorce. In the 1950s Ada May returned to Hawaii to live. Although periodic world travels and adventures ensued, Hawaii continued to be her home for the remainder of her life.

Ada May Sharpless Cornish passed away on November 20, 1988, in Kailua Kona, Hawaii.

Biographical information compiled from: *American Art Annual, 1933*; *Who's Who in American Art, Volume II, 1938–1939* and *Volume III, 1940–1941*; *Los Angeles Times,* August 10, 1929, November 8, 1929, January 19, 1933, September 24, 1933, February 25, 1934, June 1, 1934, June 29, 1934, March 28, 1943 June 1, 1934, July 4, 1943; *Corona Daily Independent*, October 6, 1938; *Independent- Press-Telegram* (Long Beach), September 6, 1953; *Honolulu Advertiser*, November 26, 1988, and the Sharpless/Marks family archives.

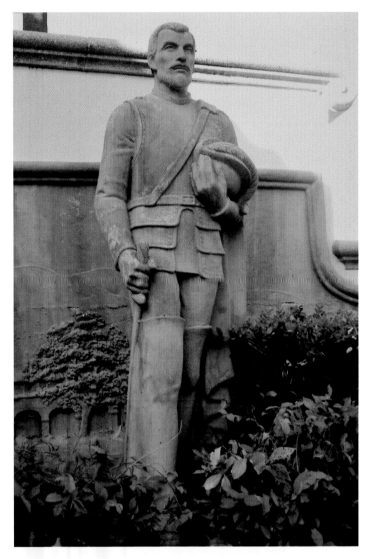

Below: Reprint: Vintage postcard of the Juan Rodriquez Cabrillo monument at the Santa Ana Historical Museum, circa 1940.
The statue of Juan Rodriquez Cabrillo was created in 1933 by Ada May Sharpless. Juan Rodriquez Cabrillo was a Portuguese navigator and shipbuilder who in 1542 led the first European expedition under the flag of Spain to explore what is now the West Coast of the United States. The likeness of Juan Rodriquez Cabrillo was created as the centerpiece of a patio fountain designed for the Santa Ana Historical Museum. The six-foot-six statue, originally sculpted in clay and then cast in artificial stone, is displayed with an ornate surround depicting historic imagery of the exploration and settlement of early California.

Statue of Juan Rodriquez Cabrillo, Santa Ana Historical Museum (later Bowers Museum), Santa Ana, California.

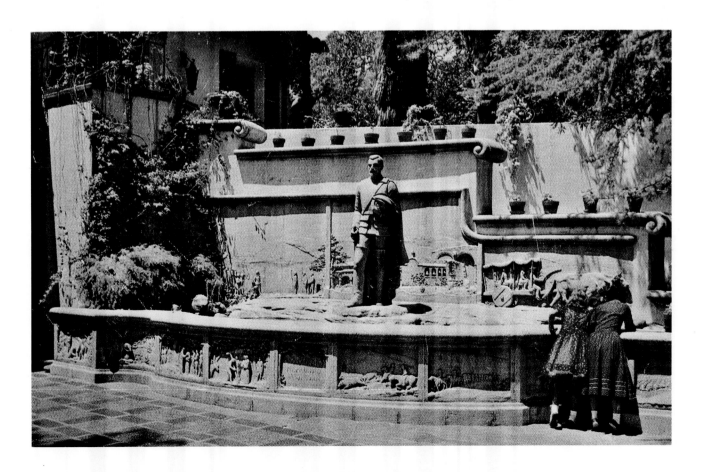

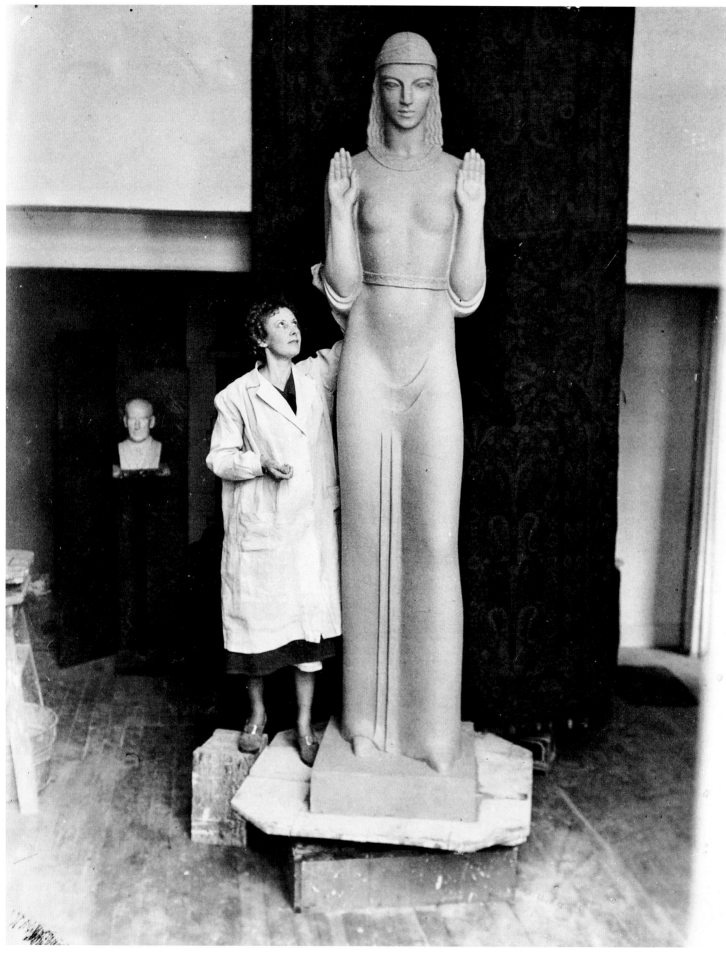

Reprint: News service photograph dated June 3, 1934. Image caption (annotated verso): A huge statue "Queen of Angels" recently completed under the auspices of the Public Works Art Project, has been offered to the City of Los Angeles with the suggestion that it be placed on the grounds of the Central Public Library there. The statue with its creator Ada May Sharpless is shown above. Private collection.

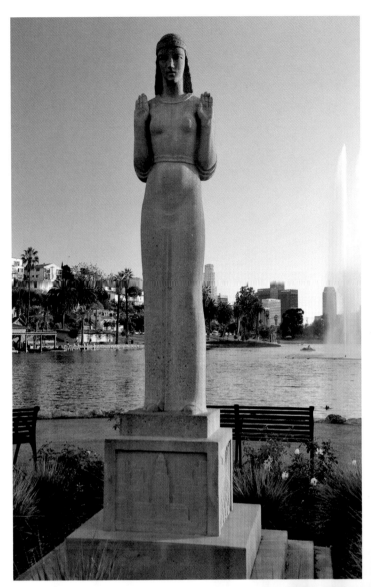

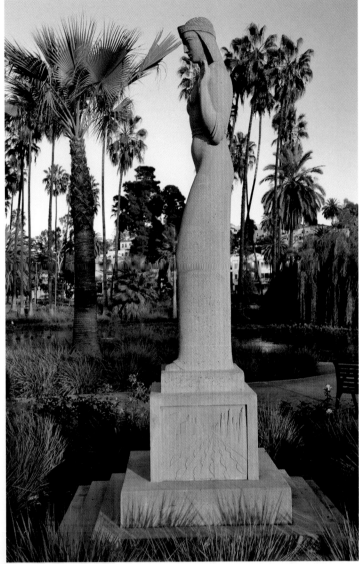

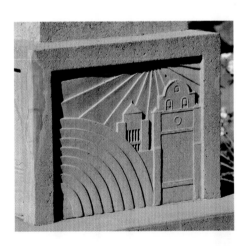

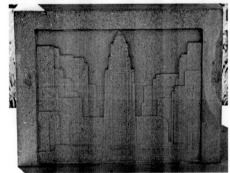

Nuestra Reina de Los Angeles or *Our Queen of the Angels* is her official name, but she is more commonly known as *La Reina de Los Angeles* or *The Lady of the Lake*. Designed and created in 1934 by Ada May Sharpless and dedicated in 1935 as a part of the federal Public Works of Art Project, this art deco stylized depiction of the female patron saint of Los Angeles stands atop a four-sided pedestal featuring bas-reliefs representing recognizable imagery from throughout Los Angeles County. One side of the pedestal has a relief of the iconic Los Angles City Hall, which was relatively new to the city skyline, with its completion in 1928; a second side depicts the city at work: agriculture, factories, a railroad line, oil derricks and ships in the Los Angeles harbor; a third depicts natural spaces: the ocean, hills and mountains; and the fourth shows off the Hollywood Bowl, the San Gabriel Mission, the Central Library and rays of sunshine. Originally, the artist had intended her fourteen-foot creation to be cast in bronze, but the monument was ultimately cast in artificial stone and erected on the grounds of the scenic Echo Park, with its landmark lake, in the City of Los Angeles. The Lady of the Lake remains a powerful example of one of the rare works created by women during the Federal Art Project.

Hazel M. Sheckler
1887–1981

Hazel M. Sheckler

Hazel Marguerite Finch was born on December 20, 1887, in Los Angeles, California, the daughter of Robert and Mary (Hall) Finch. She was raised in Los Angeles and later in South Pasadena. As a young girl she studied music and was as accomplished pianist; she also studied art while a student at South Pasadena High School (she graduated from there in 1907). It was Hazel's father, a carpenter, who initially led the family to San Diego, where he built homes and worked on the construction of the historic Hotel del Coronado. In San Diego, while attending a church social, Hazel met William Claude Sheckler, the son of early California pioneers who had established a cattle ranch in San Diego County in the 1870s. The couple courted by letter and on January 7, 1909, they were married in San Diego.

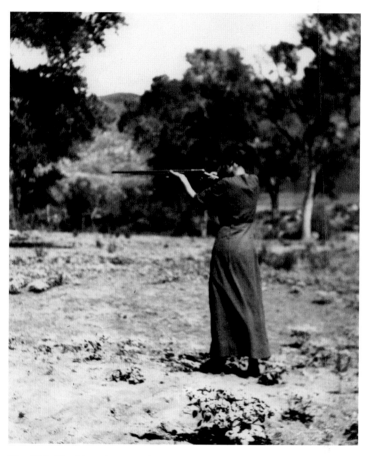

Hazel M. Sheckler, photographed at the Sheckler family ranch, c. 1914. Private collection.

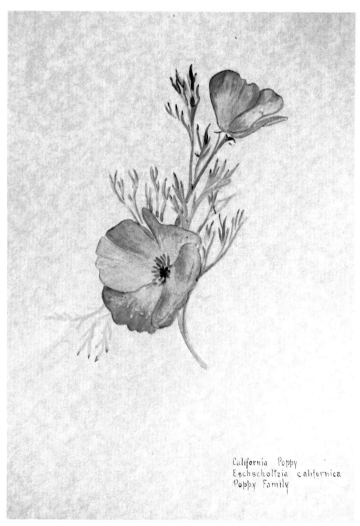

California Poppy
Eschscholtzia californica
Poppy Family

Botanical Study - California Poppy (Artist's Sketchbook), n.d., watercolor on paper, 14 × 11 in., unsigned. Private collection. Photo: Robin Brailsford.

After their marriage, the family ranch became their home. The ranch, along what is now Highway 94 and located ten miles from the Mexico/United States border, became an early way station for travelers in the days of horse and wagon transportation. The couple had two sons: Ben, who passed away at eighteen months, and Donald, born in 1915.

Although ranch life required work from sunrise to sundown, Hazel embraced her role as a "ranch wife." According to her daughter-in-law, Caroline Sheckler, "On the ranch, Hazel wove saddle blankets and rugs on a loom, sewed and knitted. She raised and sold chickens, eggs, and turkeys, baked bread, canned from her garden, and rode with the men rounding up cattle; and by all accounts she was considered a better shot than most of the men."

Even with the demands of daily ranch life, she continued to paint in oils and watercolor and to sketch, make ceramics, and do photography; she maintained a small shed behind the family home as her makeshift art studio, where she had a darkroom and a kiln.

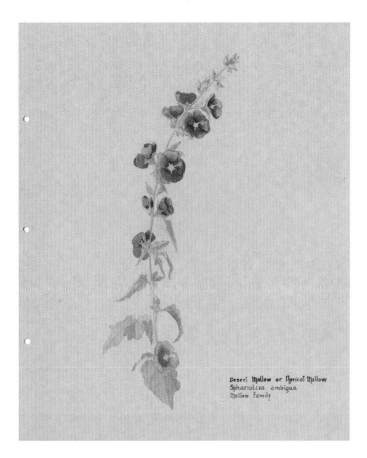

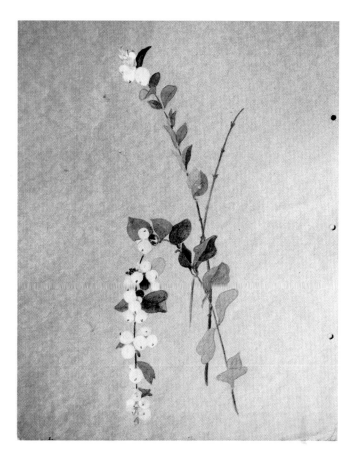

Botanical Study - Desert Mallow or Apricot Mallow
(Artist's Sketchbook), n.d., watercolor on paper, 14 × 11 in.,
unsigned. Private collection. Photo: Robin Brailsford.

Botanical Study - Common Snowberry (Artist's Sketchbook), n.d.,
watercolor on paper with gouache, 14 × 11 in., unsigned.
Private collection. Photo: Robin Brailsford.

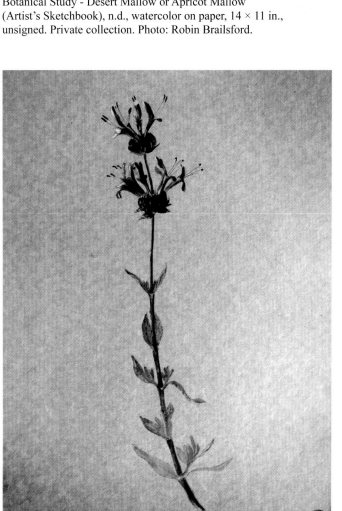

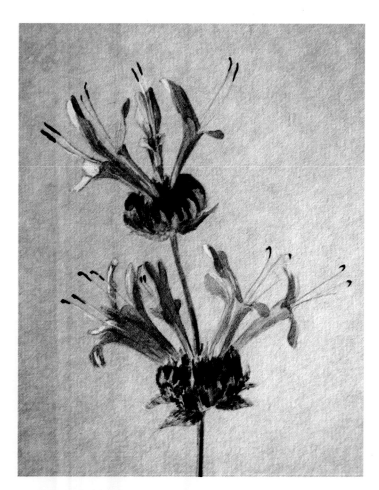

Botanical Study - Cleveland Sage (Artist's Sketchbook), n.d.,
watercolor on paper with gouache, 14 × 11 in., unsigned.
Private collection. Photo: Robin Brailsford.

Detail: Botanical Study - Cleveland Sage (Artist's Sketchbook).

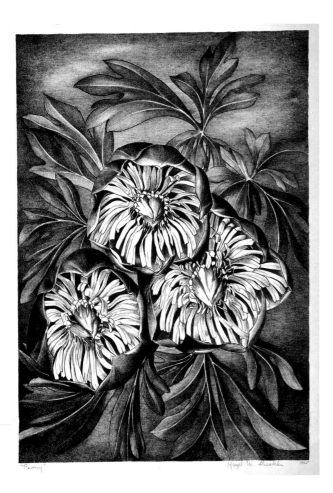

Peony, c. 1937, lithograph on paper, 16.5 × 11.5 in., ed. 19/25, signed l/r. Courtesy of Roger Genser and The Prints and the Pauper. Photo: Martin A. Folb, PhD.

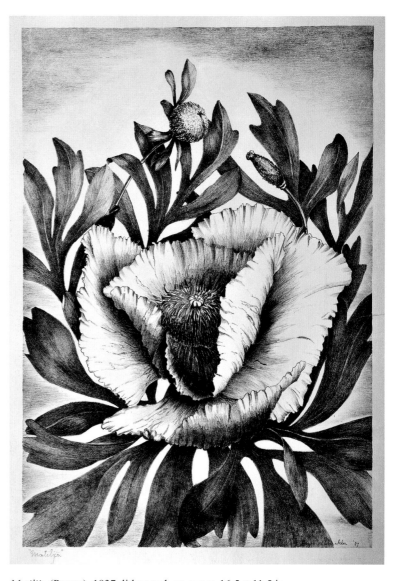

Matilija (Poppy), 1937, lithograph on paper, 16.5 × 11.5 in., signed l/r. Courtesy of Roger Genser and The Prints and the Pauper. Photo: Martin A. Folb, PhD.

From the mid-1930s through the early 1940s, Hazel produced a series of lithographs as part of the Works Progress Administration. However, her major public work for the WPA, which she executed in conjunction with the artists Jean Goodwin and Arthur Ames, consisted of a three-part mural completed in 1939 at the San Diego County Administration Center. Each mural stands about eighteen feet high and is painted in egg tempera on muslin over a gesso surface. Each panel represents an aspect of life in San Diego County.

Friendships with fellow San Diego artists Charles Fries, Anna Marie Valentien, Donal Hord, Bea Bradbury, and many others resulted in countless gatherings and many hours of painting at the Sheckler family ranch. Although a complete history of her art associations and exhibitions is lacking, she did exhibit with the San Diego Art Association in Balboa Park and at shows throughout San Diego County.

Hazel Sheckler passed away at the age of ninety-four on December 28, 1981, in San Diego, California.

Biographical information provided by and courtesy of Caroline Sheckler, daughter-in-law of the artist, and the Sheckler family. Additional information from: *Mountain Views*, September 15, 1999; United States Census, 1910–1940; and Los Angeles and Pasadena City Directories. Special thanks to Robin Braislford and Wick Alexander.

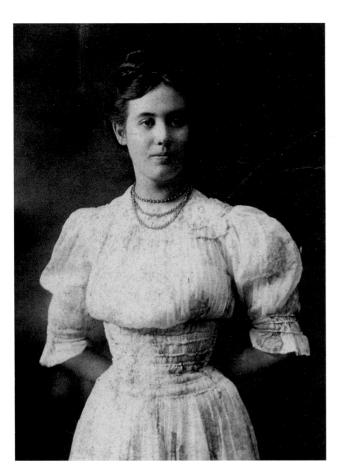

Hazel M. Finch (Sheckler), c. 1909. Private collection.

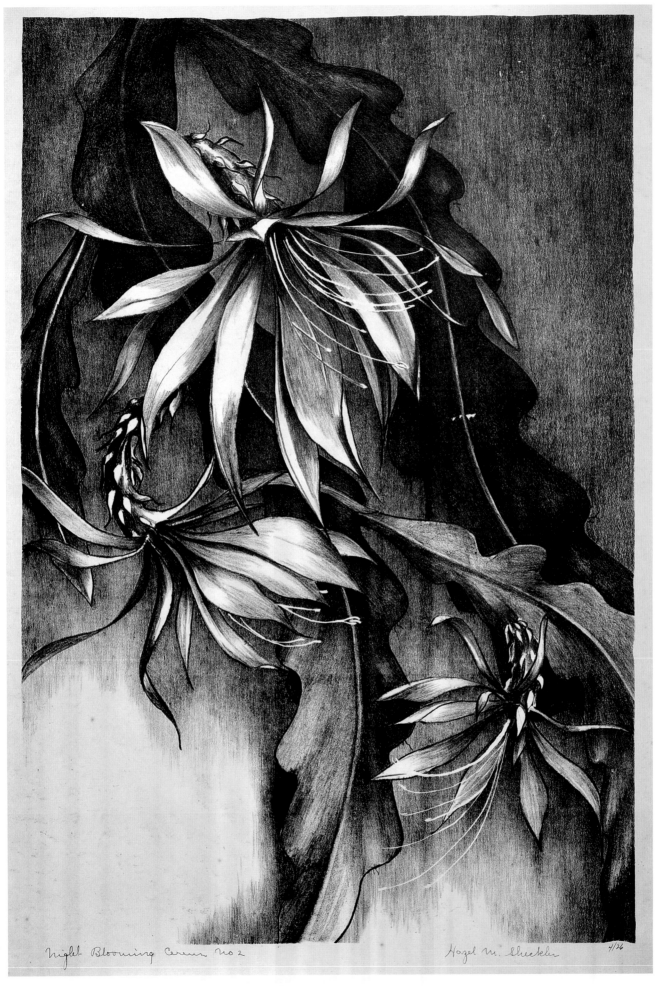

Night Blooming Cereus, No. 2, c. 1937, lithograph on paper, 16.5 × 11.5 in., ed. 4/26, signed l/r.
Courtesy of Roger Genser and The Prints and the Pauper. Photo: Martin A. Folb, PhD.

Marie O. Sheppard
1890-1984

Marie Osborne was born on January 5, 1890, in Garnett, Kansas, the first of five children of Harry Levi and Joanna Blanch (McCartney) Osborne. As a child, she loved the outdoors and hunting and fishing with her father. Her mother was an artist and taught art locally, giving Marie her early art training. While in Kansas, Marie attended Fairmount College in Wichita.

The family had an uncle who lived in Santa Barbara, California, and in 1908, when Marie was about eighteen, the family moved to join him. After settling in Santa Barbara she met and married James Sheppard in 1913. They had three sons; the third only lived a few days. The couple divorced in 1931. That same year, Marie, along with her sons, left California and traveled to Europe, where they spent the following year.

Marie Osborne, c. 1910.
Courtesy of the artist's granddaughter, Sally Joaquin.

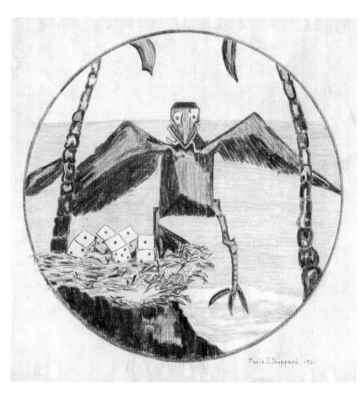

Bird - No. 1, Waldorf (Illustration - Waldorf Astoria Hotel Bar, New York, New York), 1921, graphite on paper, 11 × 11 in., signed l/r. Artist's hand-written note verso: "Sketched from wood carvings which were carved into the woodwork of the original bar in the old Waldorf Astoria Hotel on 5th Avenue in New York City, torn down in the early 1920s". Courtesy of the artist's granddaughter, Sally Joaquin.

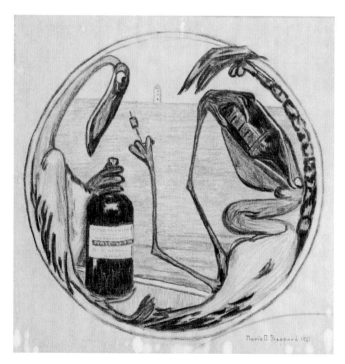

Bird - No. 2, Waldorf (Illustration - Waldorf Astoria Hotel Bar, New York, New York), 1921, graphite on paper, 11 × 11 in., signed l/r. Courtesy of the artist's granddaughter, Sally Joaquin.

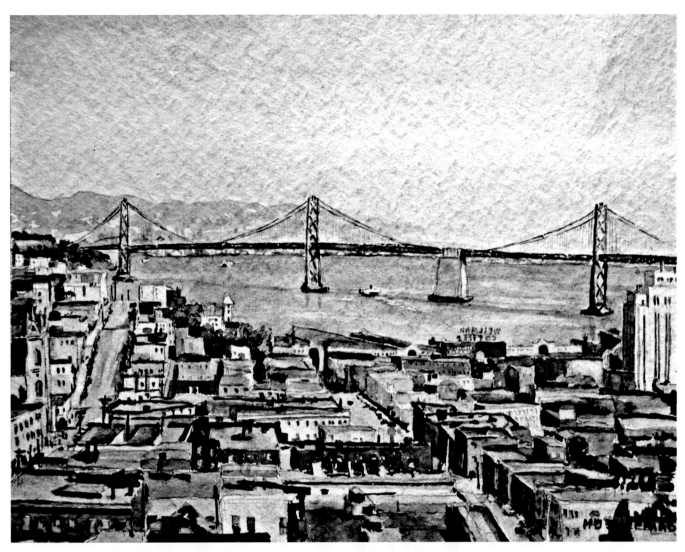

San Francisco (San Francisco Skyline and the Bay
Bridge from Russian Hill, California), 1945, watercolor
on paper, 10 × 12.5 in., signed l/r. Courtesy of the
artist's granddaughter, Sally Joaquin.

Marie O. Sheppard photographed sitting on the porch
railing at her parents' home in Santa Barbara, California.
Courtesy of the artist's granddaughter, Sally Joaquin.

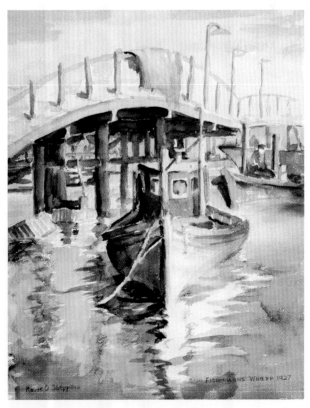

Fisherman's Wharf (San Francisco, California), 1927,
watercolor on paper, 12.5 × 16 in., signed and dated l/r.
Courtesy of the artist's granddaughter, Sally Joaquin.

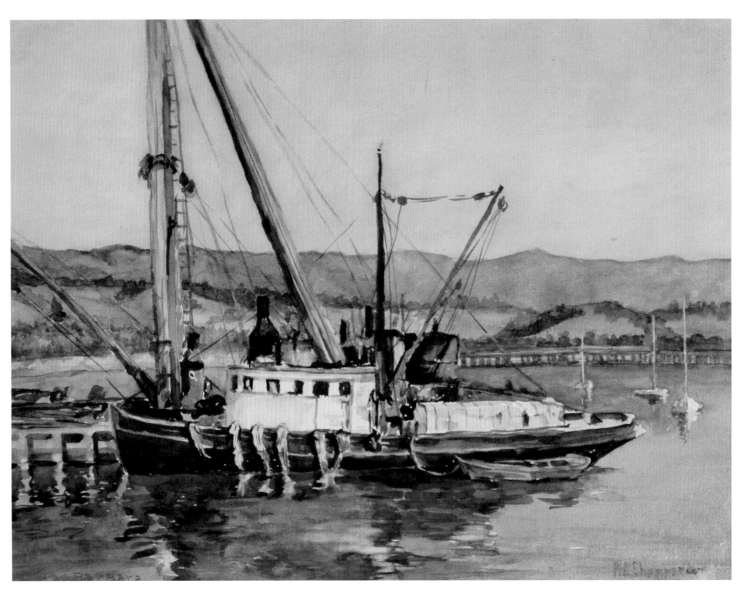

Santa Barbara (A boat docked in Santa Barbara Bay, California, before the breakwater was built in 1927), n.d., watercolor on paper, 12.5 × 16 in., signed l/r. Courtesy of the artist's granddaughter, Sally Joaquin.

In Geneva, Switzerland, with both boys attending a private boarding school, Marie lived on a very small pension and painted her way around Europe. In 1932, after the accidental death of her father, Marie returned home to Santa Barbara and she and her sons lived with her mother on Pedragosa Street. During the next twenty years she painted, etched, and operated the family book shop, the Osborne Book Store on State Street in Santa Barbara.

Marie continued to paint and was good friends with fellow artists Carl Oscar Borg and Ed Borein, who also lived in Santa Barbara at the time. Ed Borein taught etching for three years at the Santa Barbara School of Arts in 1926; Marie learned the art of etching from him. The majority of her paintings are of the outdoors: landscapes, buildings, barns and boats. She was active in the local art scene into the 1940s. Marie was asked to exhibit

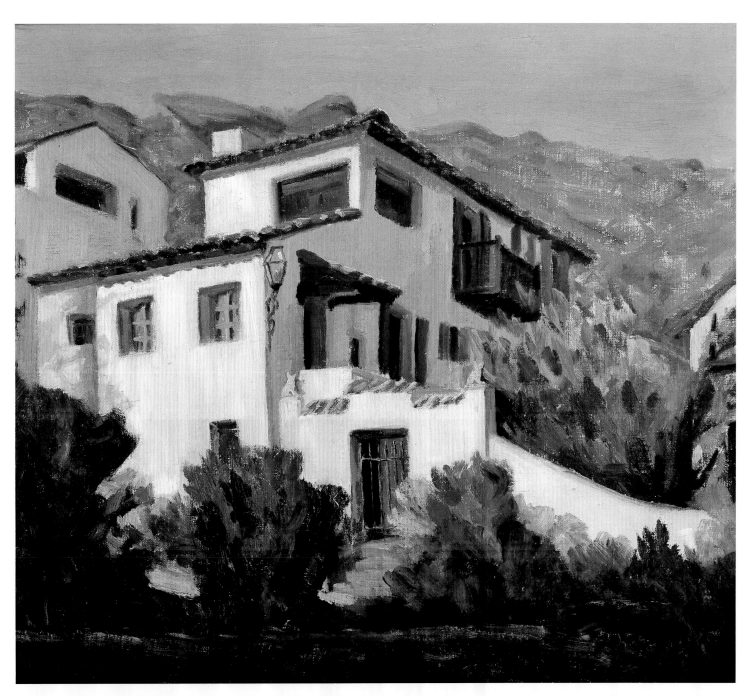

Palm Springs House (Atkinson Home,
JPalm Springs), 1943, oil on canvas on board,
16 × 18 in., signed and dated l/l.
Private collection. Photo: Martin A. Folb, PhD.
(This house belonged to the family of television
news personality Stan Atkinson; the Atkinsons
were friends with the artist and her family.)

The Atkinson Home - Palm Springs, 1936,
watercolor on paper, 9 x 12 in., signed and dated l/l.
Courtesy of the artist's granddaughter, Sally Joaquin.

Sorrento (Italy), 1931, watercolor on paper, 4 × 5 in., signed l/l and titled l/r. Courtesy of the artist's granddaughter, Sally Joaquin.

her artwork at the Santa Barbara Art League in 1929 but resisted as the works were required to be available for sale, which she opposed. It was suggested that she put a high price on them so they would not sell. Marie decided to enter the exhibition with that in mind. However, her high prices were not enough to deter buyers, and all of the paintings sold. From then on she was reluctant to show her works in exhibition if sales were a requirement. The majority of her artwork remains within her family, although throughout the course of her life, she often gifted and traded her art with her colleagues.

Marie was very competent in oils, water color, and etching. Her compositions are interesting and strong. Her color palette, draftsmanship and execution are, at the least, equal to her peers, many of whom were better known. All her life she was an avid outdoor person and continued to camp and fish into her eighties.

Marie O. Sheppard passed away in San Carlos, California, on October 16, 1984.

Biographical information provided by the Osborne/Sheppard family.

Marie O. Sheppard photographed sketching in Sorrento, Italy, May 1932. During 1931 and 1932 when the artist traveled around Europe, her art was done with mediums that could easily be packed (in her suitcase), either watercolor or graphite sketches. Courtesy of the artist's granddaughter, Sally Joaquin.

Untitled (Landscape, Santa Barbara, California), n.d., oil on board, 8 × 10 in., signed l/l. Private collection. Photo: Martin A. Folb, PhD.

Allied Arts Barn, Stanford (California), n.d., watercolor on paper, 9 × 12 in., signed l/l. Courtesy of the artist's granddaughter, Sally Joaquin.

Rock Creek Lodge (Smith River, Del Norte County, California), 1950, watercolor on paper, 12 × 14 in., signed and dated l/l. Courtesy of the artist's granddaughter, Sally Joaquin. (The lodge was owned by family friend E. S. Atkinson.)

Untitled (Harbor Scene with Boats), n.d., watercolor on paper, 12.5 × 16 in., signed l/l. Courtesy of the artist's granddaughter, Sally Joaquin.

Henrietta Shore
1880–1963

Henrietta Mary Shore was born on January 22, 1880, in Toronto, Canada, the daughter of Henry and Charlotte (Hull) Shore, and was reared and educated in Toronto. Encouraged by her mother, she decided at the age of thirteen to become an artist, and in 1893 she began to study art at St. Margaret's College, Toronto, under Laura Muntz Lyall. In 1900, she studied at the New York School of Art, first briefly with William Merritt Chase, then with Frank V. DuMond, and, in 1902, with Robert Henri. About 1905, she went to England, where she attended the Heatherly Art School in London and came to know John Singer Sargent, who influenced her work. She also traveled to Haarlem, Holland; Venice, Italy; and Madrid, Spain. By her mid-twenties, she was working as an art teacher in Toronto.

In 1913, Henrietta, who had visited the West Coast earlier, traveled to Los Angeles, California, and established herself as a permanent resident, becoming a citizen of the United States in 1921.

In Los Angeles she became involved in the art community and, in 1916, helped to found the Los Angeles Modern Art Society. She remained a resident of the city except for a return to New York (1920–1923) and trips to Newfoundland (1920), Maine (1921), and Mexico (1927–1928) until moving to San Francisco in 1928. In 1930, she established her last permanent home in Carmel, California.

The artist's subjects included portraits, many done on commission as a source of needed income, as well as stylized, somewhat surreal flowers, cacti, figural, genre, somewhat surreal trees, and land forms. Working in various mediums, in styles ranging from the literal to the imaginative, she devoted much of her attention to nature, creating works that represented the idea of a subject rather than the traditional view of it. During her Carmel period, she focused much of her attention on cypress trees but also found inspiration for her renderings in other natural forms in the region.

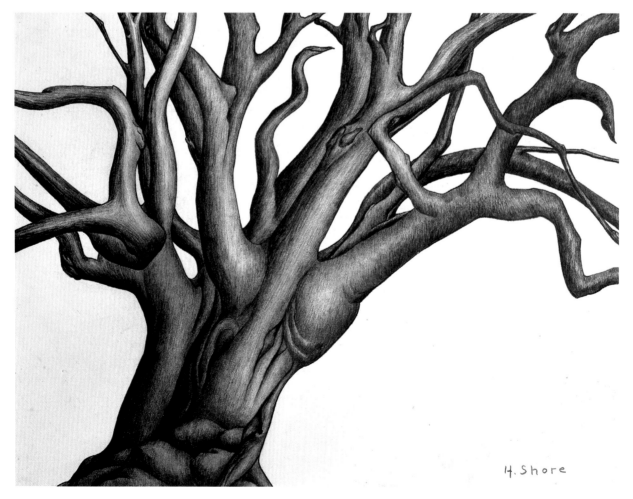

Untitled (Tree), n.d., graphite on paper, 12 × 16 in., signed l/r. Collection of Catherine and Dan Gellert. Photo: Martin A. Folb, PhD.

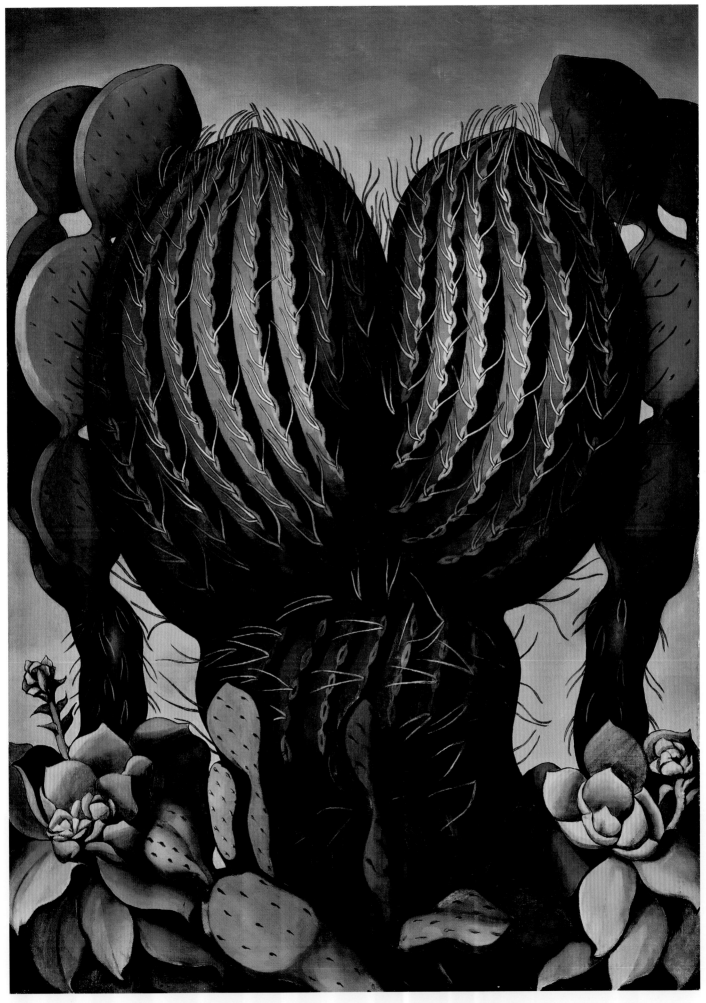

Cactus, c. 1926, oil on canvas, 38 × 28 in., signed l/l. Private collection. Courtesy of Traci McFarland Fieldsted.

Mexican Village, n.d., oil on canvas, 26 × 26 in., signed l/r. Collection of Diane and Sam Stewart. Courtesy of Traci McFarland Fieldsted.

Henrietta's oeuvre also included six murals executed in 1936–1937 on commission from the Treasury Relief Art Project. Four were done for the post office at Santa Cruz and dealt with the local industries of the coastal region. A fifth, *Artichoke Pickers*, was placed in the Old Customs House in Monterey, while the sixth, *Monterey Bay 1880–1910*, graced a wall in the post office on Hartnell Street in Monterey.

Highly regarded for her ability by such artists as Robert Henri and Jean Charlot, Henrietta exhibited from at least 1898 to the 1950s. Her solo exhibitions included those held at the Los Angeles County Museum of History, Science, and Art, 1914, 1917, 1927; Kraushaar Gallery, New York, 1920; Ehrich Galleries, New York, 1923, 1926; California Palace of the Legion of Honor, San Francisco, 1928, 1931; M. H. de Young Memorial Museum, San Francisco, 1933; Georgette Passedoit Gallery, New York, 1939; and Carmel Art Association Gallery, 1946, 1963. She also hung works at the Royal Canadian Academy, Toronto; Canadian National Exhibit;

Panama-California Exposition, San Diego; Britain Artists Association Invitational, London; Annual Exhibition of American Art, Detroit; New York Society of Women Artists, New York; Exposition d'Art Canadien, Paris; and in numerous shows of the Carmel Art Association. In 1986, the Monterey Museum of Art organized *Henrietta Shore: A Retrospective Exhibition, 1900–1963*.

Her works are held in the Los Angeles County Museum of Art; California Department of Parks and Recreation, Sacramento; Monterey Museum of Art Association; and the Oakland Museum of California, all in California. She spent her final years in a sanitarium and passed away on May 17, 1963, in San Jose, California.

Biography, with thanks, from: *An Encyclopedia of Women of Artists of the American West*, Phil Kovinick and Marian Yoshiki-Kovinick, Austin: University of Texas Press, 1998.

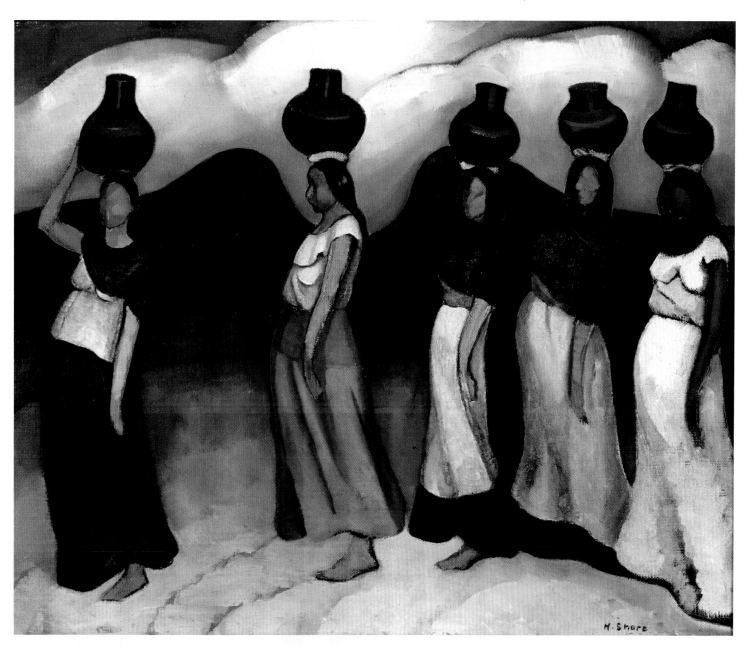

Women of Oaxaca, c. 1927,
oil on canvas, 16 × 20 in., signed l/r.
The Buck Collection, Laguna Beach,
California. Courtesy of Phil Kovinick
and Marian Yoshiki-Kovinick.

Women of Oaxaca, c. 1928,
lithograph on paper, 14.5 × 19 in.,
signed l/r and titled and numbered l/l:
"Women of Oaxaca, 119".
Private collection.
Photo: Martin A. Folb, PhD.

Mexican Mother, 1925–1930, lithograph on paper, 9 × 9 in., ed. 25, signed l/r. Courtesy of Tobey C. Moss Gallery, Los Angeles, California.

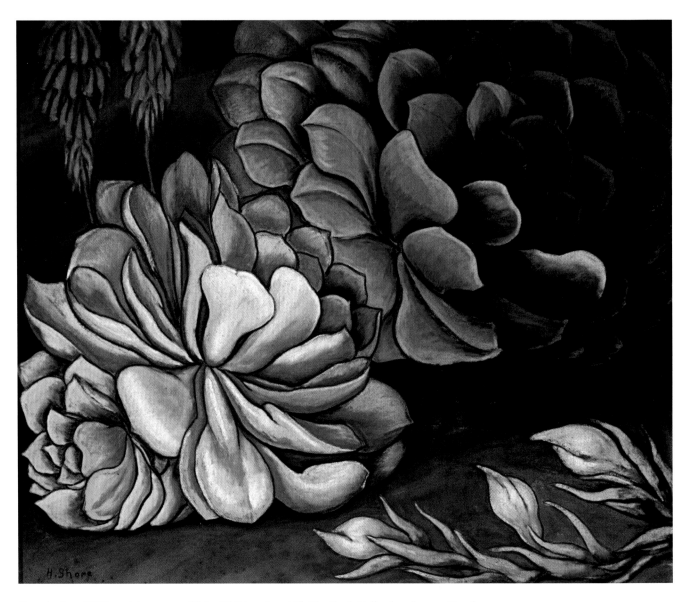

Succulents, c. 1930, pastel on paper, 19.5 × 23.5 in., signed l/l. The Buck Collection, Laguna Beach, California. Courtesy of Phil Kovinick and Marian Yoshiki-Kovinick.

Tulip Lady, n.d., oil on canvas, 30 × 25 in., signed verso.
Private collection, California. Courtesy of Catherine Gellert.

Hazel Brayton Shoven
1884–1969

Hazel Ella Brayton was born on July 1, 1884, in Jackson, Michigan, the daughter of John H. and Permelia "Pet" (Kettenger) Brayton. She spent her childhood and teenage years alternately between Illinois and Missouri. As a young woman she studied art under Anita Willets-Burnham and John Johanson at the Art Institute of Chicago, with additional study at the Chicago Academy of Fine Arts, both in Illinois. In 1911 she married Arthur Moses Shoven in Paris, Missouri, and they made their home in Kankakee, Illinois, where their son was born in 1912. In 1923, with her husband and son, she moved to San Diego, California.

Hazel continued her art studies in San Diego under Alfred Mitchell and at the San Diego Academy of Fine Arts under Eugene De Vol and his wife Pauline De Vol. She also studied briefly under the artists Eduard Buk Ulreich and his wife Nura Woodson Ulreich at the Fine Arts Gallery. She maintained active membership in the San Diego Art Guild, the San Diego Fine Arts Association, the La Jolla Art Association, the Los Sureños Art Center, the Laguna Beach Art Association, and the San Diego Women's Club. In 1937, she was one of the founding members of the Spanish Village artist colony in the heart of San Diego's Balboa Park, and she served for many years on the organization's board of directors.

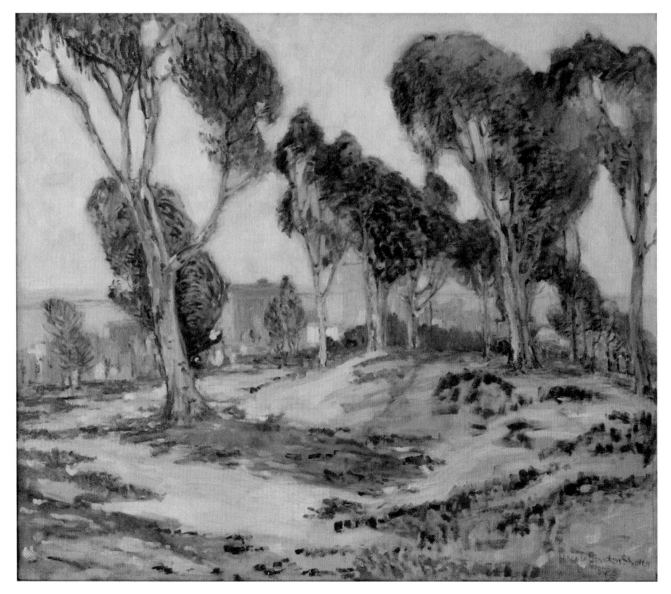

Marston Point, San Diego (California), 1930, oil on board, 30.5 × 35.25 in., signed l/r.
Private collection. Courtesy of Edenhurst Gallery.

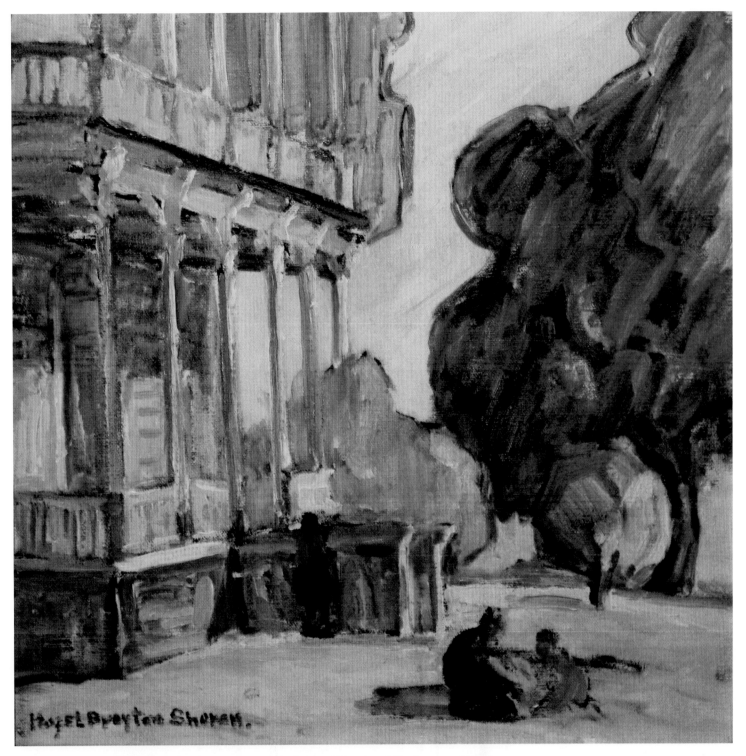

Old Hotel Laguna (California), 1928, oil on canvas on panel, 15 × 15 in., signed l/l. Courtesy of Edenhurst Gallery: Daniel Paul Nicodemo, Donald Allen Merrill, Thomas Gianetto.

Her oeuvre included primarily works in oils and watercolor of landscapes and still lifes. Her California exhibitions included La Jolla Library Gallery, 1926, 1928; Little Gallery, San Diego, 1927; Fine Arts Gallery, 1928; San Diego Academy of Fine Arts, 1929; California State Fair, 1930; Orange County Fair, 1930 (third prize); Theosophical Society, 1931; Los Angeles County Fair, 1931 (honorable mention); Pasadena Art Association, 1931, 1933; American Painters & Sculptors, Los Angeles County Museum of History, Science, and Art, 1931; California Statewide Art Exhibition, Santa Cruz, 1931; San Diego Women's Club, 1934 (solo) and 1935 (solo); California Pacific International Exposition, San Diego, 1935; Spanish Village Artists Fiesta, 1937; San Diego Art Center, 1942 (solo); Carlsbad Hotel Gallery, 1949; and the San Diego Art Guild, 1931–1953.

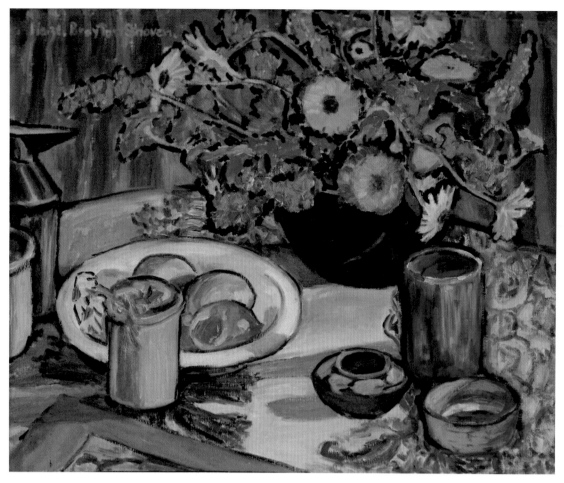

Untitled (Still Life), 1930, oil on canvas,
19 × 22 in., signed u/l. Private collection.
Courtesy of Edenhurst Gallery.

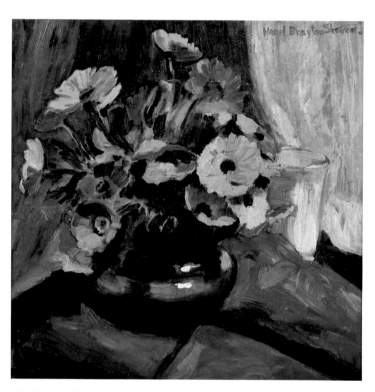

Untitled (Still Life), n.d., oil on canvas, 13.5 × 13.5 in., signed u/r.
Private collection. Photo: Martin A. Folb, PhD.

Untitled (Floral Still Life), n.d., oil on canvas, 13.5 × 13.5 in., signed
l/r. Collection of Carolyn Torrey Hannah.

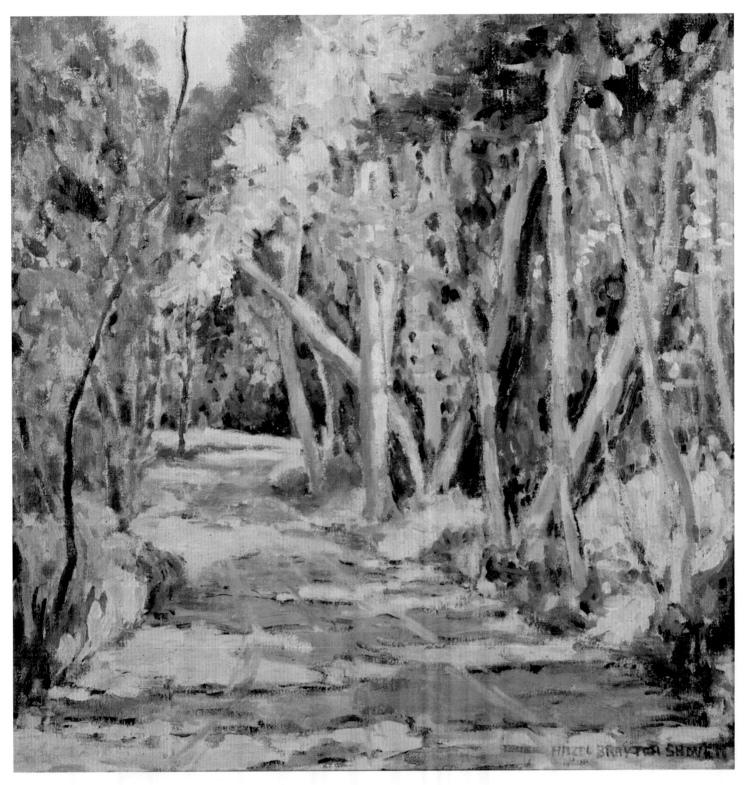

Untitled (Sunlight on Path, San Diego, California), n.d., oil on canvas, 20 × 20 in., signed l/r. Collection of Charles F. Redinger.

Throughout her career, Hazel was frequently included in print articles and exhibition reviews. In discussing the artist's work in a 1933 (San Diego) *Evening Tribune* newspaper article, the critic Octavia Page remarked that, " . . . she reveals a love of intense color and a strong sense of design, seeming at times to have almost the approach of the textile designer." She further remarked that "Her touch and feeling vary greatly . . . [and] her color schemes are not haphazard, but thoughtfully and effectively planned."

Hazel Brayton Shoven passed away on October 28, 1969, in San Diego, California.

Biographical information compiled from: *American Art Annual, 1933*; *Who's Who in American Art, 1936–1937*; *Evening Tribune* (San Diego), August 28, 1926, March 16, 1929, January 28, 1933; *San Diego Union*, August 26, 1945, October 30, 1969 (obituary); *San Diego Historical Society Quarterly*, Summer 1986, Vol. 32, No. 3, Thomas L. Sharf, ed.

Burr Singer
1912–1992

Bernice Lee Singer was born on November 20, 1912, in Saint Louis, Missouri, the daughter of noted physician Jacob J. Singer and Flora (Lowenstein) Singer. Raised in Saint Louis, she studied at the Saint Louis School of Fine Arts at Washington University. She continued her studies at the School of the Art Institute of Chicago, Illinois, and at the Art Students League in New York. She also studied privately with the artist Walter Ufer in Taos, New Mexico. She used the nickname Burr, which was short for Bernice, throughout her life.

In 1934, in Michigan, Burr married Harry I. Friedman. In the early years of their marriage the couple lived in Saint Louis, and then around 1939 they moved to Los Angeles, California, to be near her parents. From newspaper accounts, Burr first began exhibiting in Los Angeles as early as 1940; she was included in an exhibition with the American Artists' Congress (considered the leftist leaning art organization in Los Angeles). Her first solo exhibition in California was held the same year at the Vernon Branch (Public) Library.

In 1941, she was one of six women artists included in the exhibition *The Group of Six* at the Stendahl Gallery, Los Angeles. According to April Dammann's *The Exhibitionist: Earl Stendahl, Art Dealer as Impresario*, the "Group of Six," sometimes known as "Earl's Girls," a term coined by art critic Authur Millier, also included Eula Long, Dorr Bothwell, Martha Simpson, Marian Curtis, and Denny Winters. The group deliberately chose a name

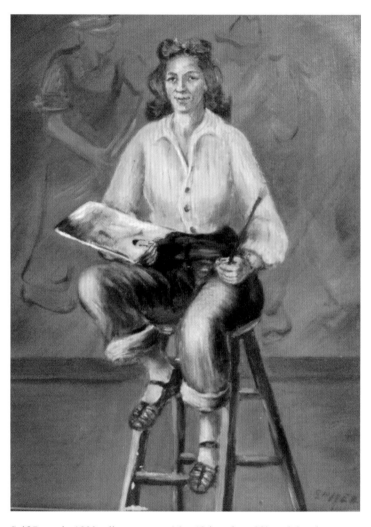

Self-Portrait, 1933, oil on canvas, 16 × 12 in., signed l/r and dated verso. The Singer Family Collection.

Untitled (Surreal Composition of Child's Dream), n.d., oil on board, 24 × 28 in., signed l/r. Courtesy of Roger Genser and The Prints and the Pauper. Photo: Martin A. Folb, PhD.

that had no suggestion of gender. Their work in watercolor, oil, and lithography won high praise and was deemed by critic Alma May Cook to be better than many showings of male artists at Stendhal's. Earl Stendahl was very supportive of female artists; he considered the world better for their bravery in dealing with the challenges of a career, marriage, and child rearing. He often featured them and did not charge less for works by female artists as was the custom of some dealers.

Known for her focus on the plight of workers, the lower classes, and minorities, during World War II Burr worked as a volunteer sketch artist for the Hollywood USO doing pastel and charcoal portraits of the servicemen. Her oeuvre also included oils, watercolor, and lithography, the last under noted lithographer Lynton Kistler. She was a member of the California Water Color

Society (vice-president, 1957 and 1958); the Los Angeles Art Association, and the Artists Equity Association, New York. Her numerous exhibitions included the New York World's Fair, 1939; Golden Gate International Exposition, 1939; Oakland Art Gallery, 1940, 1954; Los Angeles County Museum of History, Science, and Art, 1940–1955; San Francisco Art Association, 1942; the Metropolitan Museum of Art, 1944; Chabot Gallery, Los Angeles, 1949; California Water Color Society, 1951, 1953, 1954; Los Angeles County Fair, 1951, 1953 (prize); and the Library of Congress, 1983. Additional solo exhibitions are noted at the Esther Robles Gallery, 1957, the Landau and Kantor Galleries, 1957, the Comara Gallery, and the Kramer Gallery, all in Los Angeles, and the San Francisco Museum of Art. In 1972, Burr traveled to South America where she produced a series of paintings during a fourteen-month residency in Costa Rica.

Burr Singer Friedman passed away on November 18, 1992, in Los Angeles, California.

Biographical information compiled from: *Who's Who in American Art, 1940–1970*; *Who's Who of American Women*, 1958, 1961, 1964; *Los Angeles Times*. April 7, 1940, July 6, 1941, September 13, 1942, October 3, 1943, November 11, 1992 (obituary); *Northwest Leader*, May 18, 1972; *The Exhibitionist: Earl Stendahl, Art Dealer as Impresario*, April Dammann, Angel City Press, 2011.

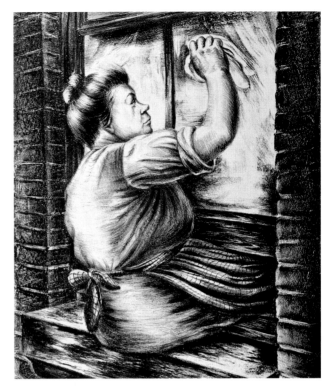

Window Washer, n.d., lithograph on paper, 13.75 × 11.75 in., ed. 4/15, signed l/r. Courtesy of Roger Genser and The Prints and the Pauper. Photo: Martin A. Folb, PhD.

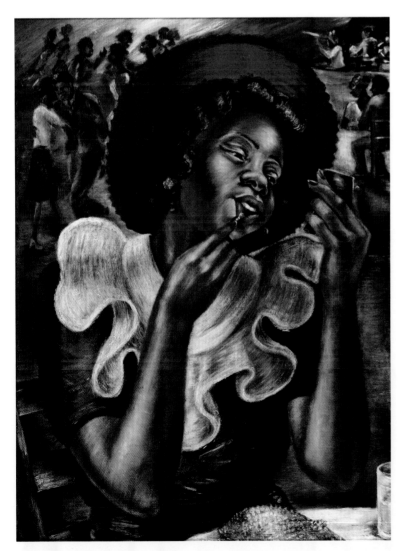

Touch Up, n.d., oil on canvas, 22.5 × 16.5 in., signed l/l. The Hilbert Collecton.

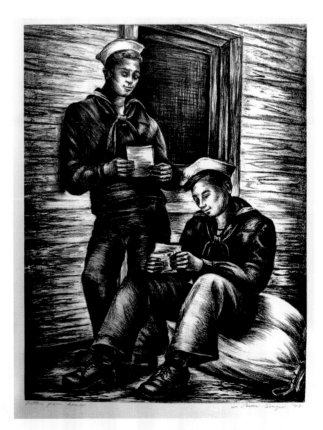

Letters from Home, 1943, stone lithograph on paper, 13 × 10 in., ed. 2/3, signed l/r. Courtesy of Steven Stoops, Stevens Fine Art.

Anna Katharine Skeele
1896–1963

Anna Katharine Skeele was born on July 2, 1896, in Wellington, Ohio, the daughter of Arthur S., a minister, and Alice (Bullard) Skeele and grew up in Ohio and Michigan. She first chose to be a pianist, but took art lessons privately and then in youth classes as a teenager at Olivet College, Michigan, from 1908 to 1912. Afterward, she moved to Monrovia, California, and studied at Pomona College from 1914 to 1917.

In 1922, she attended the California School of Fine Arts, San Francisco, and then became a pupil of Stanton Macdonald-Wright in Los Angeles. Anna Katharine continued her studies in Monterey, California, with Armin Hansen, 1923–1924; at the Art Students League in New York City with Charles W. Hawthorne in 1924, and with George Bridgman, 1924–1925; in Paris at L'Académie Julian and L'Académie de la Grande Chaumière, 1925–1926, and with André Lhôte, 1926; and at the Royal Academy of Fine Arts, Florence, Italy, with Felice Carena, 1926–1927.

Upon returning to Monrovia, Anna Katharine embarked on a serious career as a painter and also taught art for a time in the adult education department of the Monrovia-Arcadia- Duarte school district. Then, in 1946, firmly established as an artist, she married Frode Dann, also a painter. Five years later, they founded the Pasadena School of Fine Arts, with Dann as its director and one of its teachers. She also worked as an instructor at the school while continuing to devote much of her time to painting. In 1955, the couple moved to Pasadena.

Anna Katharine, who did portraiture, figure studies, and landscapes, first turned to the American Indians of the Southwest as subjects in 1928. Traveling to Taos, New Mexico, with a friend, she found the people's simplicity, honor, and humor appealing and returned often until 1957 to sketch them and New Mexico landscapes. She also sketched in Arizona. As a part of a Public Works of Art project, she executed a seven-by-thirty-three-and-a-half-foot mural depicting daily life in Taos for Torrance High School, California, in 1935.

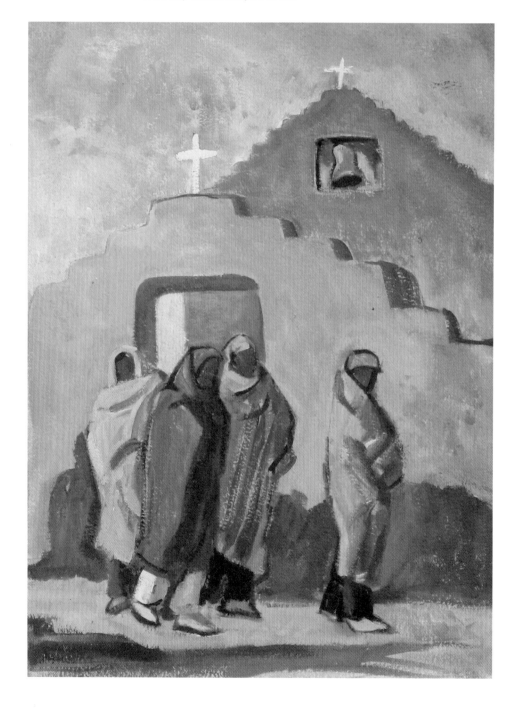

New Mexico Mission, n.d., gouache on paper, 24 × 18 in., signed l/r with initials. Courtesy of Steven Stoops, Stevens Fine Art.

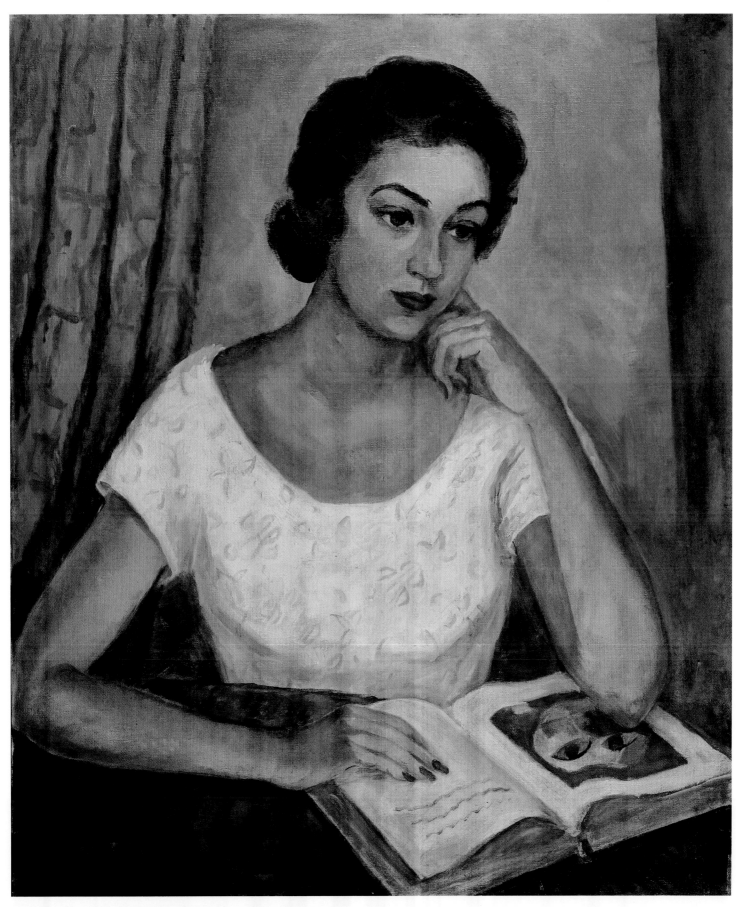

Self Portrait, c. 1920, oil on canvas, 30.5 × 25 in., signed l/r.
Private collection. Photo: Martin A. Folb, PhD.

Anna Katharine was an exhibiting artist for almost fifty years. She participated in major group shows in California from Sacramento to San Diego. Elsewhere, her work appeared at the Texas Centennial Exposition in Dallas and the New York World's Fair. Among her solo shows were those held at the Grace Nicholson Galleries, Pasadena, California, 1927, 1928; Dudensing Gallery, New York 1931; University of Southern California, Los Angeles, 1931, 1933; Faulkner Memorial Art Gallery, Santa Barbara, California, 1934; Pasadena Art Museum (memorial exhibition), 1964; and Jack Carr Gallery, Pasadena (retrospective with Dann), 1972.

Anna Katharine's works are in the collections of the Laguna Art Museum, Laguna Beach; Fine Arts Gallery, San Diego; and Long Beach Museum of Art, all in California. She received honors and awards from Los Angeles County Museum of History, Science, and Art; San Diego Museum; Sacramento State Fair; Los Angeles County Fair, Pomona, and the Women Painters of the West, among others.

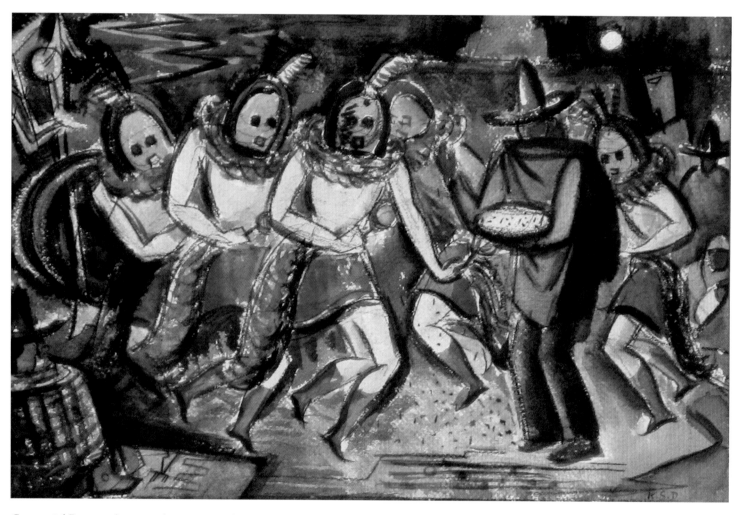

Ceremonial Dance, n.d., watercolor on paper, 12.5 × 18.5 in., signed l/r with initials. Courtesy of Steven Stoops, Stevens Fine Art.

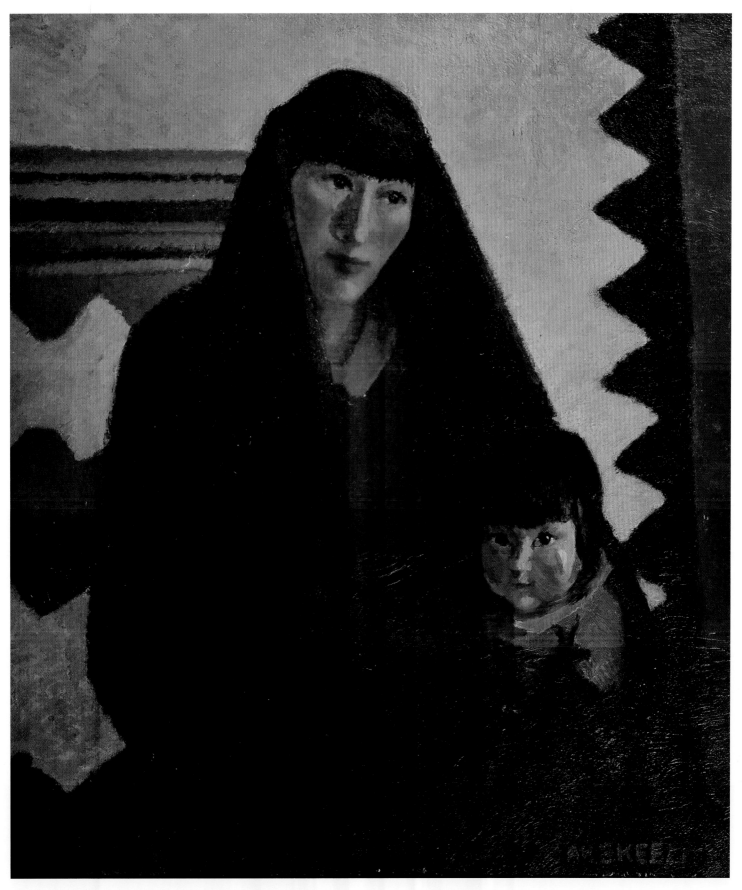

Mother and Child, n.d., oil on board, 29 × 25 in., signed l/r.
Private collection. Photo: Martin A. Folb, PhD.

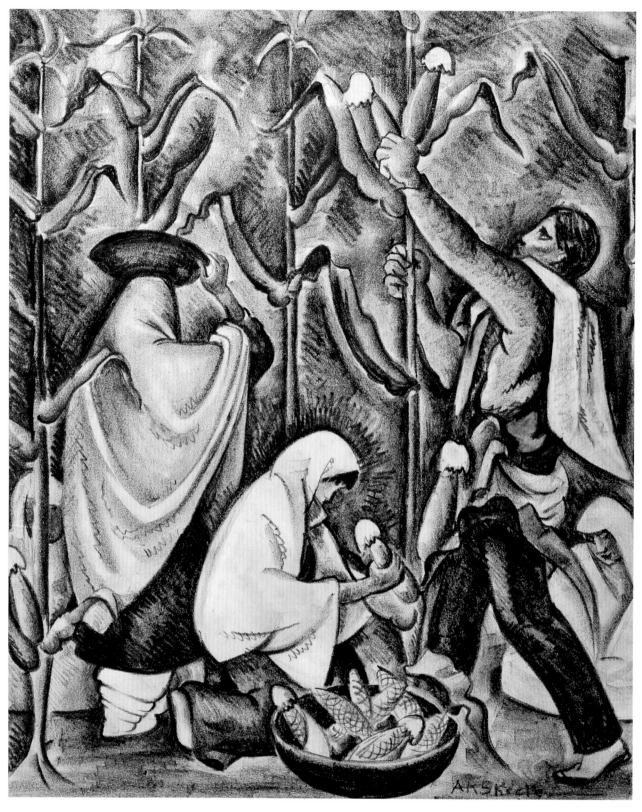

Corn Pickers, c. 1926, crayon lithograph on paper,
16.25 × 13.25 in., signed l/r. Private collection.
Photo: Martin A. Folb, PhD.

Detail: Exhibition label verso: *Corn Pickers*.
The San Francisco Art Association Exhibition of Drawings
and Prints, February 11 through March 1, 1927.

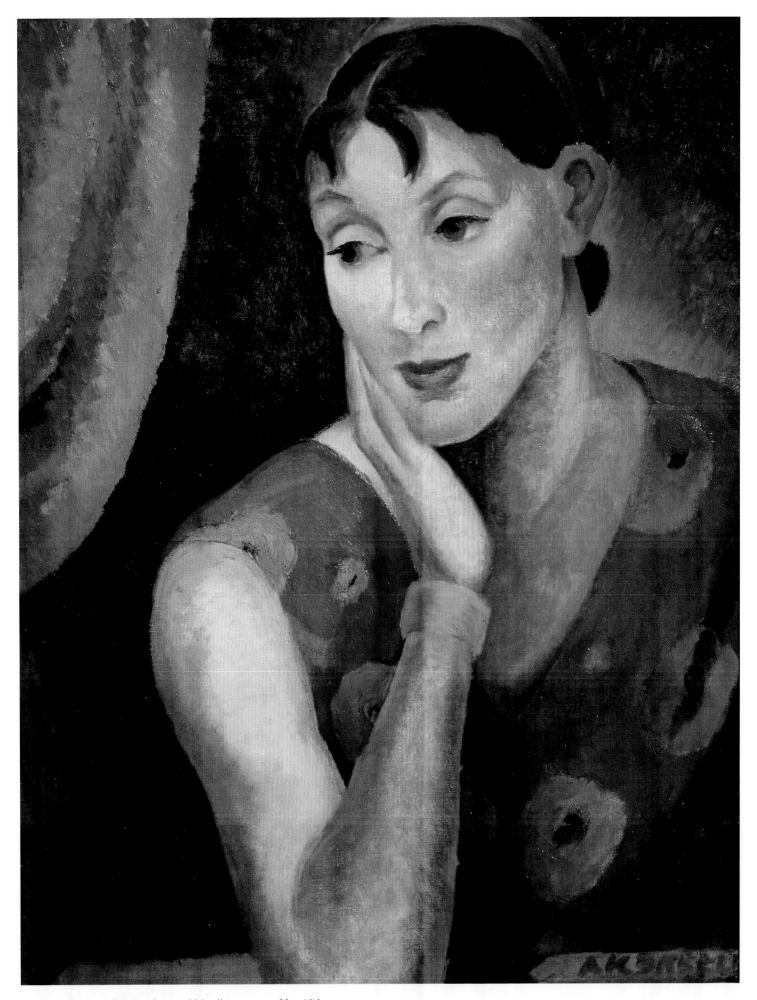

Portrait of Artist Edith Hamlin, c. 1935, oil on canvas, 23 × 18 in.
signed l/r. Courtesy of Steven Stoops, Stevens Fine Art.

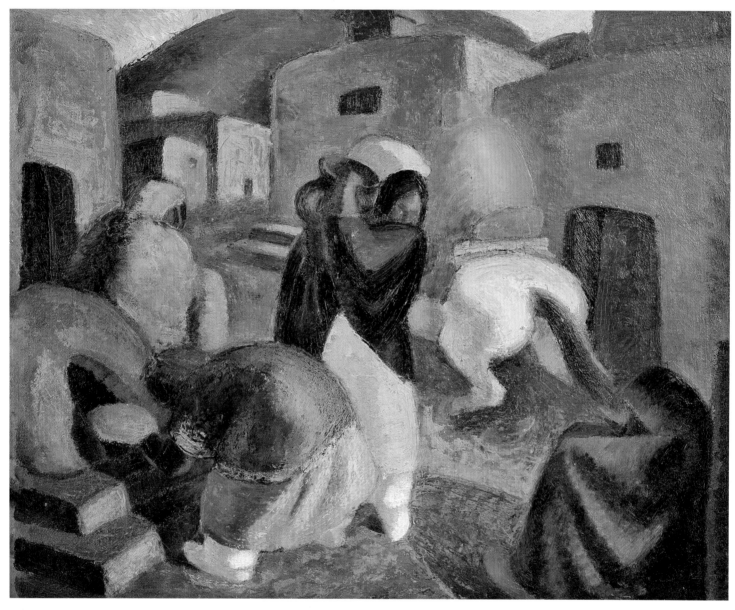

Untitled (New Mexico Pueblo Scene), n.d., oil on board, 18 × 22 in., unsigned. Private collection. Photo: Martin A. Folb, PhD. It should be noted that a similar painting by Katharine Skeele is in the WPA collection of the Roberts Art Gallery, Santa Monica High School, Santa Monica, California. This work is most likely a preliminary study for the painting in the Roberts Art Gallery collection.

The artist, who had made earlier trips to Europe, went abroad with her husband for the last time in late 1962. She spent most of her time in Morocco sketching the people, whose lifestyle reminded her of the American Indians of the Southwest. Her signature style varies; she often signed her work A. K. Skeele, A. K. S., A. Katharine Skeele, or K. S. D.

Anna Katharine Skeele Dann passed away ten days after returning home from her European trip, on June 28, 1963, in Pasadena, California.

Biography, with thanks, from: *An Encyclopedia of Women Artists of the American West*, Phil Kovinick and Marian Yoshiki-Kovinick, Austin: University of Texas Press, 1998.

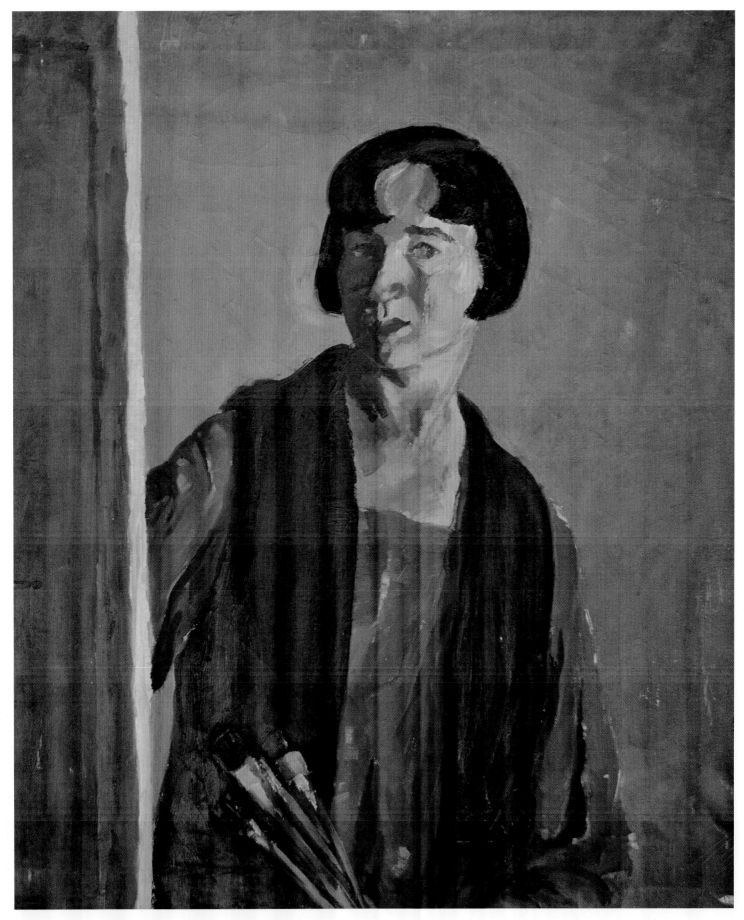

Self Portrait, c. 1948, oil on canvas, 25 × 30 in., signed l/r.
The Collection of Michael Frost. Courtesy of Robert Sommers.

Portrait of Frode Dann, n.d, oil on canvas,
40 × 34 in., signed l/l. The Collection of
Michael Frost. Courtesy of Robert Sommers.

Untitled (Landscape - New Mexico
Pueblo), n.d, mixed media on paper,
16 × 19 in., signed l/r. Courtesy of
Robert Sommers, Blue Heron Gallery.

Untitled (Female with Dove), n.d., oil on canvas, 30 × 24 in., signed l/r.
Courtesy of Jim Konoske. Photo: Martin A. Folb, PhD.

Dorothy Sklar
1906-1996

Dorothy Sklar was born on May 25, 1906, in New York, New York, the daughter of Nathan and Anna (Dolinsky) Sklar, Russian immigrants who came to the United States in 1904. Her family moved to Southern California when she was about four years of age and settled in the Los Angeles area, where she was raised. In 1927, she graduated from the University of California, Los Angeles, with a bachelor of education degree and was active in multiple art-related organizations, including the California Art Club and the Arthur Wesley Dow Association at the University of California, Los Angles. Later, she continued her studies at the Chouinard Art Institute in Los Angeles.

Beginning in the late 1920s, she worked as a teacher in the Los Angeles area public schools. While working as a teacher in Santa Monica, California, during the 1930s, she took instruction in watercolor painting from the artists Millard Sheets and Doug Kingman. By the 1940s, she stopped teaching to devote her energies full time to her art. Painting on location, her preferred studio, allowed her to capture whatever environs she found herself in, including at times working while sitting inside her parked car. Some of her favorite subjects were the old houses and street scenes of East Los Angeles during the 1940s.

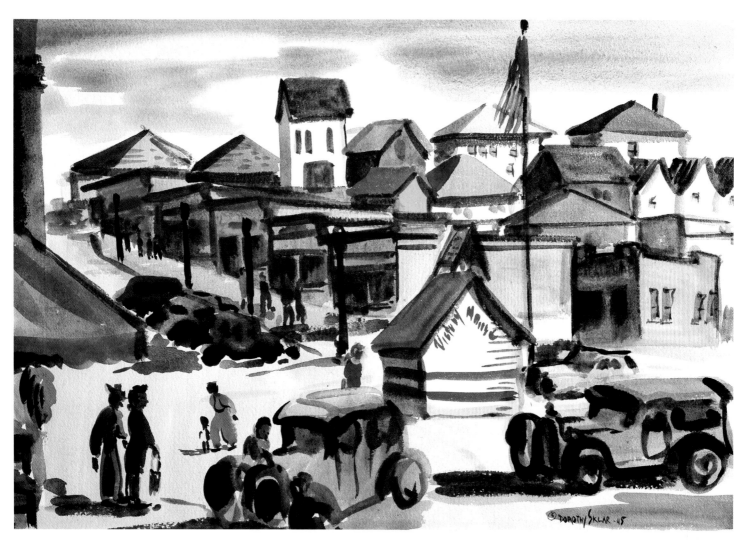

Pier Avenue, Hermosa Beach (California), 1945, watercolor on paper, 13.75 × 19.75 in., signed and dated l/r. Courtesy of Michael Kelley, Kelley Gallery, Pasadena. Photo: Martin A. Folb, PhD.

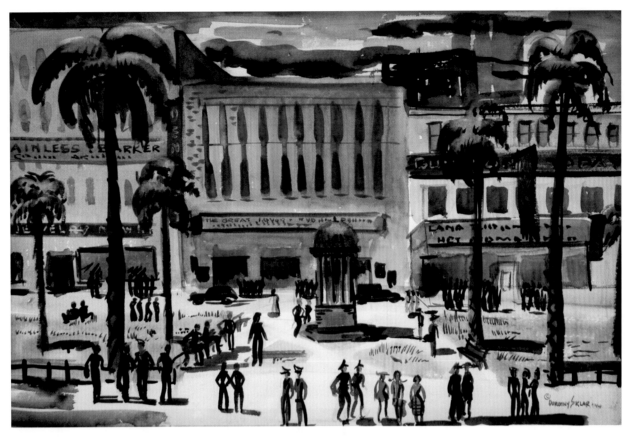

The Great Lover, 1944, watercolor on paper, 12 × 18 in., signed and dated l/r.
Courtesy of Sullivan Goss - An American Gallery.

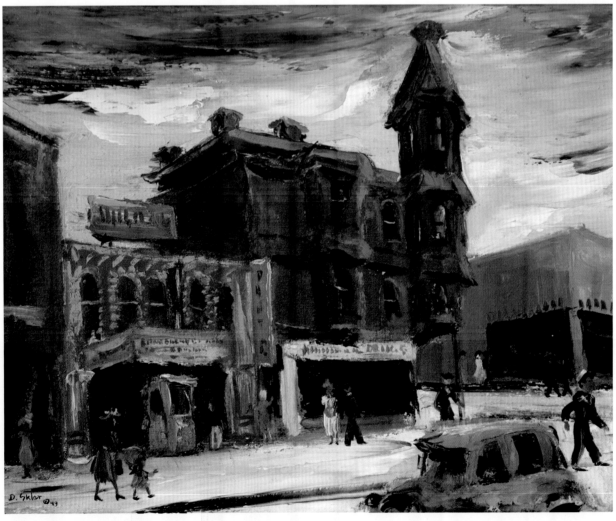

A Street in Los Angeles, 1949, oil on canvas, 16 × 20 in., signed l/l.
Courtesy of Sullivan Goss - An American Gallery.

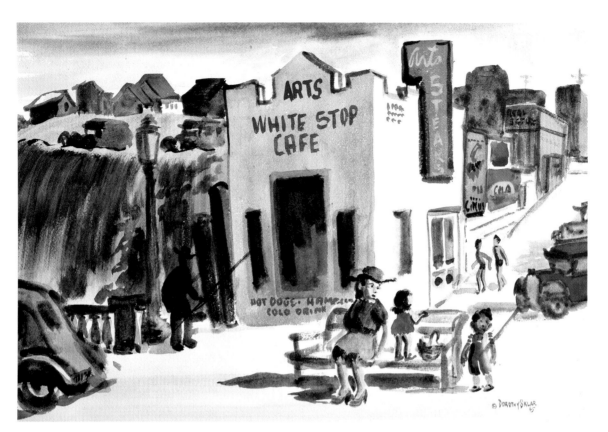

White Stop Cafe, 1945, watercolor on paper, 14 × 19.75 in., signed and dated l/r.
Courtesy of Michael Kelley, Kelley Gallery, Pasadena. Photo: Martin A. Folb, PhD.

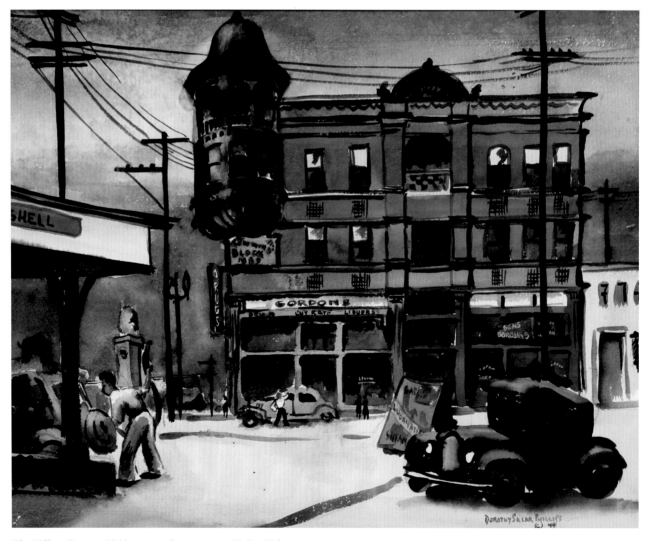

The Filling Station, 1944, watercolor on paper, 13.5 × 20 in.,
signed and dated l/r. The Hilbert Collection.

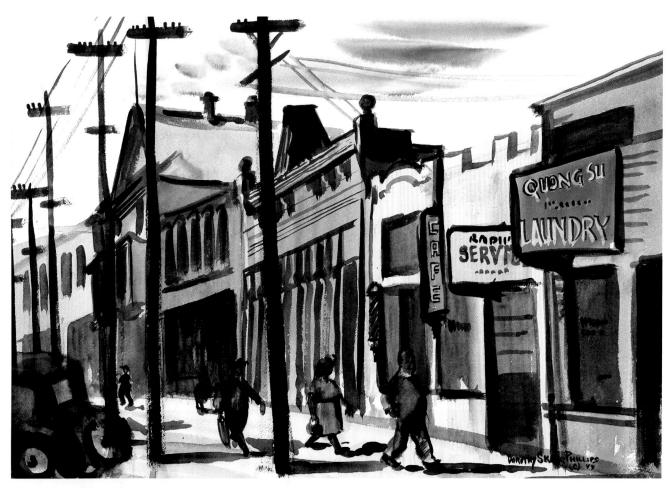

Quong Su Laundry, Los Angeles, 1944, watercolor on paper, 14 × 20 in., signed and dated l/r.
Courtesy of Michael Kelley, Kelley Gallery, Pasadena. Photo: Martin A. Folb, PhD.

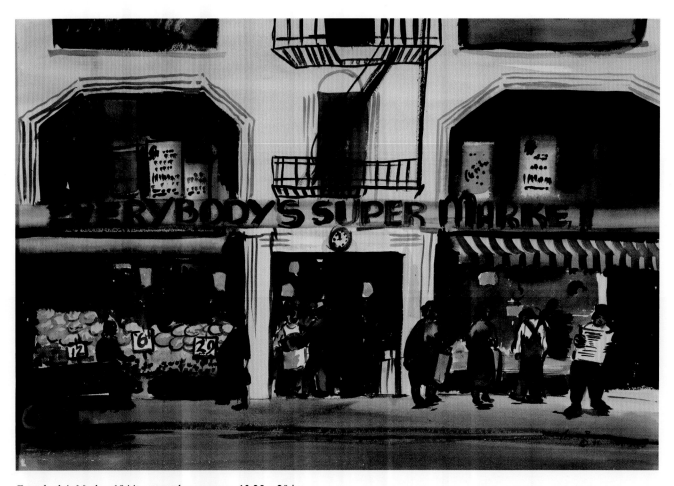

Everybody's Market, 1944, watercolor on paper, 13.25 × 20 in.,
signed and dated l/r. The Hilbert Collection.

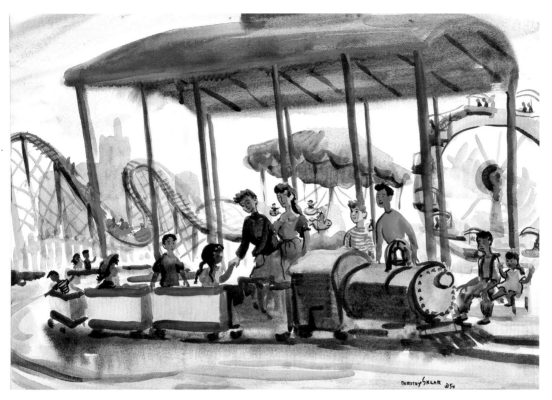

Choo Choo Play Time, 1954, watercolor on paper, 16 × 22 in., signed and dated l/r.
Courtesy of Michael Kelley, Kelley Gallery, Pasadena. Photo: Martin A. Folb, PhD.

Toonerville (Santa Monica Pier, California), c. 1944,
watercolor on paper, 21.5 × 27.5 in., signed l/r. The Hilbert Collection.

Dorothy was an active member of the National Association of Women Artists; New Orleans Art Association California Water Color Society; Laguna Beach Art Association; Art Educators of America; Alabama Water Color Society; Women Painters of the West; Westwood Art Association; and the National Society of Painters in Casein and Acrylic. Beginning in the early 1940s and continuing for the remainder of her life, she exhibited works in oils, casein, and watercolor in both local and national exhibitions and was the recipient of numerous awards for her work. Married twice, the surnames of Feldman and Phillips are found at various times added to her birth name.

Dorothy Sklar Phillips passed away on March 15, 1996, in Los Angeles, California.

Biographical information compiled from: *Who's Who in American Art, 1966*, Dorothy B. Gilbert, ed.; Gordon T. McClelland interview with the artist, 1983; *California Watercolors (1850-1970): An Illustrated History and Biographical Dictionary*, Gordon T. McClelland and Jay T. Last; United States Census, 1910–1940; and California Death Index.

Mexican Vendor Holding a Basket, n.d., oil on canvas, 36 × 24 in., signed l/r. Courtesy of Naim I. Farhat and the Farhat Art Collection.

Mexican Women and Child, n.d., oil on board, 30 × 36 in., signed l/r.
Courtesy of Naim I. Farhat and the Farhat Art Collection.

Eva Slater
1922–2011

Eva Caecilie Zeitz was born on June 17, 1922, in Berlin, Germany, the daughter of Paul E. and Else S. Zeitz. She studied design and illustration at the Lette-Verein Academy in Berlin from 1938 to 1942. In 1946, with her parents, she immigrated to the United States, where the family settled in New York. After working as an illustrator in Germany, she continued to do so in New York. In New York, she met John Slater, a scientist, whom she married in 1947 in El Paso, Texas. That same year the couple moved to California and she enrolled at the Art Center School of Design under artist/teacher Lorser Feitelson, who in the late 1950s was one of the leading proponents of the hard-edge style of painting. She remained at Art Center from 1947 until 1953.

Eva and John Slater, c. 1947.
From the collection of Harry and Miriam Carmean.

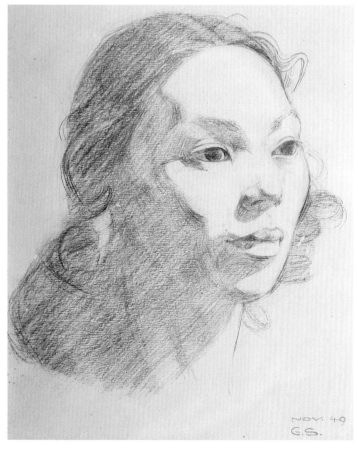

Untitled (Portrait Study - Female), Nov. 1949,
graphite on paper, 8 × 6.75 in., initialed and dated l/r.
From the collection of Harry and Miriam Carmean.
Photo: Martin A. Folb, PhD.

Eva's paintings stylistically follow the tenets of the hard-edge movement with her use of clean lines, broad areas of color, and simplified forms with well-defined edges. Her unique contribution to the hard-edge movement was the use of delicate triangles that flowed throughout the painting. She referred to them as "cells" that functioned much like the cells in our body, forming the underlying structure of a greater whole. The artist, Helen Lundeberg, said this about Eva Slater: "Eva Slater's art reveals an extraordinarily sensitive and poetic personality. Obeying the promptings of her creative personality, her exquisite craftsmanship explores the marvels of the hallucinatory world, attaining the unknown—the privileged moments of mystic ecstasy. She discovers the mystery itself, and makes communicable the inexplicable. Here is the autonomous world of pure lyricism."

Volcano, n.d., oil on Masonite, 60 × 20 in., signed verso.
From the collection of Harry and Miriam Carmean.
Photo: Martin A. Folb, PhD.

Tidal Wave, 1958, oil on panel, 50 × 18 in., signed verso.
From the collection of Harry and Miriam Carmean.
Photo: Martin A. Folb, PhD.

Her exhibitions included Los Angeles Art Association, *New Talent USA*, University of California Los Angeles Art Gallery, Los Angeles, 1958; Artists Invite Artists, Ester Robles Gallery, Los Angeles, 1958; The Littlest Gallery, Fullerton, California, 1958 (solo); *Fifty Paintings by Thirty Seven Painters* (curated by Henry T. Hopkins), University of California Los Angeles, 1959; Orange County Art Association, California, 1959 (first prize); Long Beach Museum of Art, Long Beach, California, 1961 (solo); *My Favorite*, Los Angeles Art Association, Los Angeles, California, 1961; *20th Century Painting*, Fullerton College, Fullerton, California, 1962; *Three*, Los Angeles Art Association, Los Angeles, California, 1964; *Group Show*, Carlson 20th Century Gallery, Carmel, California, 2005; *Driven to Abstraction: So. California and the Non Objective World, 1950–1980*, Riverside Art Museum, Riverside, California, 2006; and *Masters, Mentors, Metamorphosis*, Fullerton College, Fullerton, California, 2006. Her work is included in the collections of Fullerton College and Long Beach Museum of Art, and in numerous private collections.

In addition to her art, she became a scholar on American Indian basketry, publishing *Native American Basketry of Central California*, 1998, and *Panamint Shoshone Basketry: An American Art Form*, 2001, and she was a contributing writer to Riverside Museum Press's *Art in America* and more.

Eva Slater passed away on May 2, 2011, in Santa Barbara, California.

Biography courtesy of Miriam Slater and the Slater family.

Desert Rain, 1955, oil on Masonite, 8 × 10 in., signed verso. From the collection of Harry and Miriam Carmean. Photo: Martin A. Folb, PhD.

Nebula, n.d., oil on board, diameter (oval): 18.5 in., signed verso. From the collection of Harry and Miriam Carmean. Photo: Martin A. Folb, PhD.

Helen Edell Sloan
1902–1995

 Helen Edelman was born on June 13, 1902, in Chicago, Illinois, the daughter of Frank Edelman and Antoinette (Strauss) Edelman. She studied at the Chicago Art Institute and the Chicago Academy of Fine Arts, Illinois. In 1939, she married Frederick E. Sloan. It is not known when she began using the name Edell, or its origin. It may be derived from her maiden surname, but this is only conjecture. Helen was a commercial artist and designer in Chicago prior to her move to California where in the 1940s she began working at Walt Disney Studios. In 1948, her line drawings/illustrations were included in the book *Fashions in Furnishings: A Guidepost to Decorating*. She was a member of Laguna Beach Art Association. She lived in Laguna Beach for many years and exhibited her oils and watercolors locally and in national exhibitions.

 Helen Edell Sloan passed away on October 5, 1995, in Laguna Hills, California.

 Biographical information compiled from: *California Watercolors (1850-1970): An Illustrated History and Biographical Dictionary*, Gordon T. McClelland and Jay T. Last; United States Census, 1939; Cook County, Illinois, Marriage Index; and the artist's promotional materials.

Angels Flight, Los Angeles (California), 1950, watercolor on paper, 16.75 × 12.5 in., signed l/r. Private collection. Courtesy of California Watercolor Gallery.

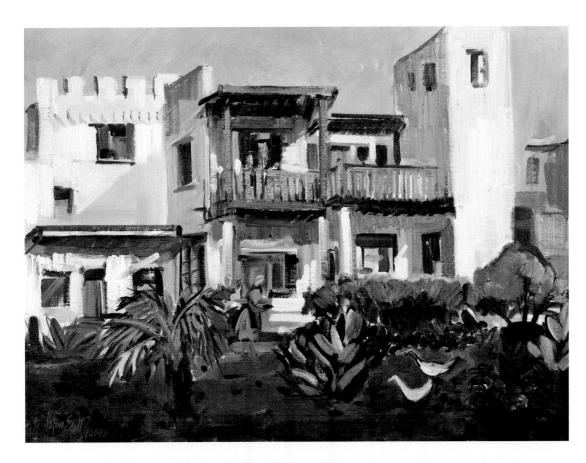

Untitled (Spanish-Style
Structure with Female Figure),
n.d., oil on canvas, 18 × 24 in.,
signed l/l. Private collection.
Photo: Martin A. Folb, PhD.

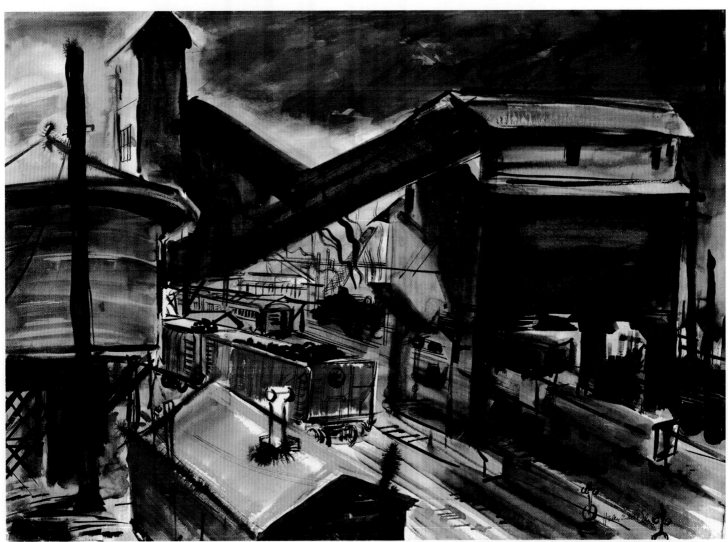

Tempo (Coal Loading Yard), n.d., watercolor on paper, 20 × 28 in., signed l/r.
Private collection. Courtesy of California Watercolor Gallery.

Helen M. Smith
1871–1954

Helen May Stafford was born on March 21, 1871, in St. Charles, Illinois, the daughter of William Lloyd Garrison Stafford and Jane (Miller) Stafford. Raised and educated in St. Charles, she received her early art education in Boston, Massachusetts. Helen then studied at the Milwaukee Art Institute, Wisconsin, under Friedrich Heine, who first introduced her to watercolor. In 1893, she married William "Will" A. Smith in Barre, Vermont, where the couple settled. In Barre, she continued her studies at Goddard Seminary, where she was a member of the faculty.

In 1900, soon after the birth of their son, the couple moved to the western United States, settling in Whittier, California. In Whittier, Will Smith established the *Whittier News*, the town's local newspaper. Years later, after the sale of the newspaper, he retained control of the print shop, turning the facility into a specialty printing business. In 1924, the family moved to Balboa Island, in Orange County, California, where they remained.

Helen's art took many forms. In the early days of her career, she created pen and ink sketches, then by the late teens and early 1920s she turned her attention to oils and finally watercolors. Her subjects were often centered around her life on Balboa Island, and her sketching trips took her throughout California, with considerable time spent in Northern California. Although she continued to use both mediums, watercolor (possibly due to shortages of oil paint during World War II) became her primary medium in the 1940s.

Helen M. Smith, c. 1939. Private collection.

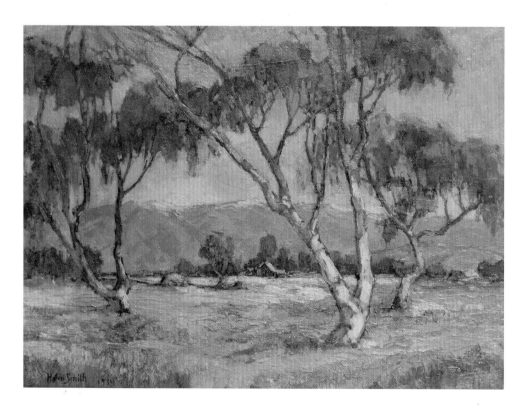

Windblown Trees and Snowy Mountain Beyond, c. 1930, oil on canvas, 18 × 24 in., signed l/l. Private collection.

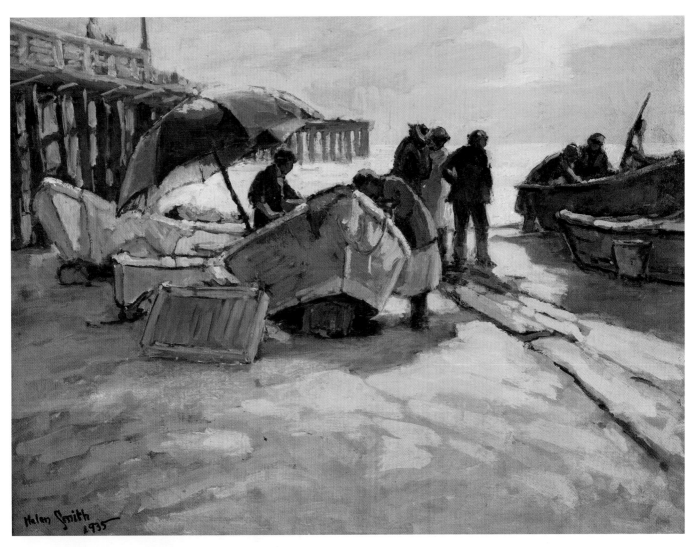

Fish Market at Laguna (Laguna Beach, California), 1935, oil on canvas, 18 × 20 in., signed and dated l/l. Springville Museum of Art. Courtesy of Traci McFarland Fieldsted.

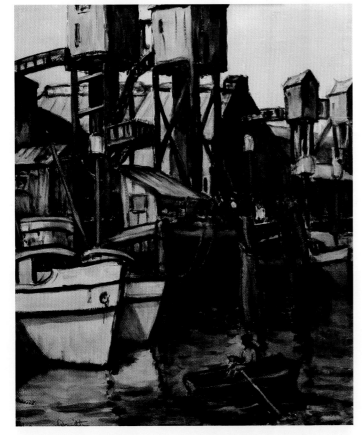

Terminal Island, Fish Harbor, Long Beach, California, c. 1934, watercolor on paper, 21 × 16.5 in., signed l/l. Private collection. Photo: Martin A. Folb, PhD.

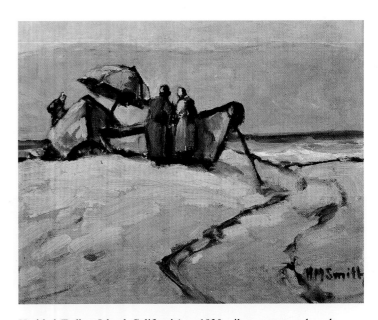

Untitled (Balboa Island, California), c. 1930, oil on canvas on board, 8 × 10 in., signed l/r. Courtesy of Michael Kelley, Kelley Gallery, Pasadena. Photo: Martin A. Folb, PhD.

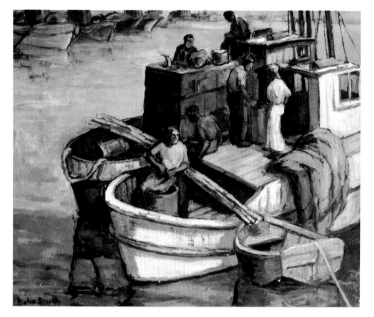

Two Fishing Boats Side-Tied, c. 1935, oil on canvas, 20 × 24 in., signed l/l. Private collection.

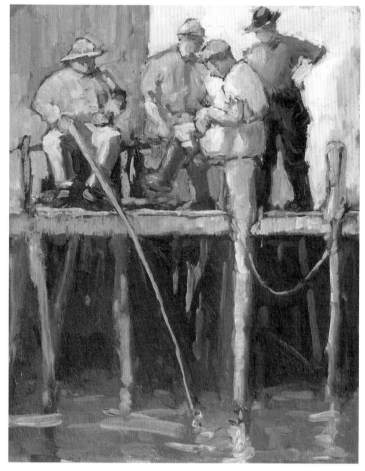

In Southern California, she continued her art studies under the artists Anna Althea Hill, Ruth Peabody, and George Brandriff, and studied watercolor under Arthur Beaumont. While in the northern part of the state, she worked under the artist William Gaw. In 1947, at the age of 76, her desire to earn her master of fine arts degree was thwarted when she was told that due to the fact that it had been fifty years since she earned her undergraduate degree, her transcripts no longer existed. Disappointed, to say the very least, she enrolled for further study at Scripps College in Claremont, California, under the artist Millard Sheets.

Fishermen on the Wharf, n.d., oil on canvas, 10 × 8 in., signed verso. Private collection.

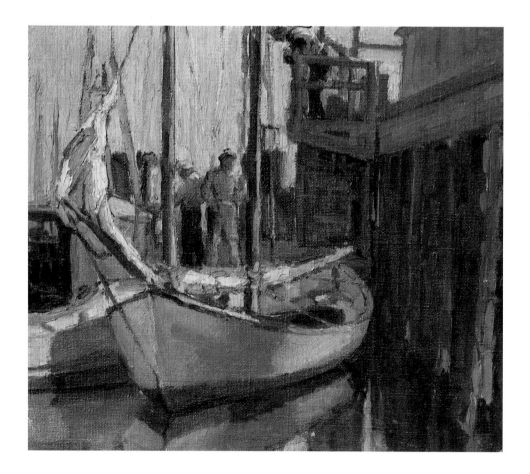

The Old Sailboat, n.d., oil on canvas, 13 × 15 in., signed verso. Private collection.

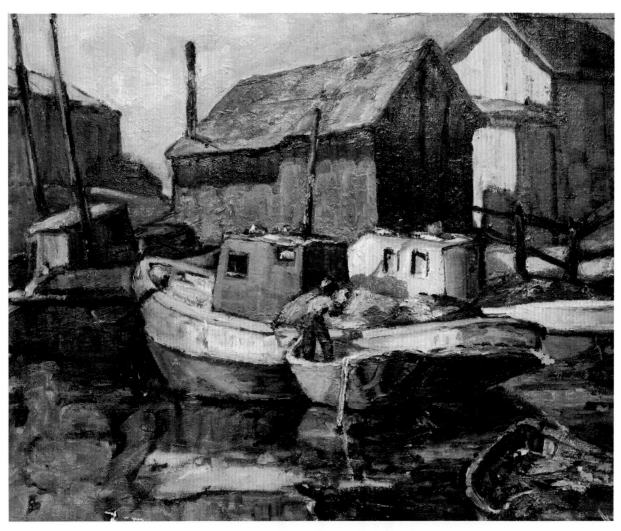

Blue Boat - Red and Green Shacks, c. 1932, oil on canvas, 15 × 18 in., signed verso. Private collection.

Four Sailboats and a Rowboat Being Launched, n.d., oil on canvas, 16 × 20 in., signed verso. Private collection.

Green Trees - Horses and Barn, c. 1935, watercolor and graphite on paper, 15 × 20 in., signed l/r. Private collection.

Fishing Shack and a Boat, c. 1932, oil on board, 20 × 24 in., signed l/l. Private collection.

Workers on the Pier with Boats Below, c. 1935,
oil on board, 15 × 20 in., signed verso. Private collection.

Untitled (Desert Scene Sand Painting), n.d, oil on sand
on Masonite, 4 × 6 in., signed l/r. From the collection of
Maureen R. Siegel Sprowles.

Throughout her career the artist used various signatures when signing her work, such as: Helen Smith, Helen M. Smith, or H. M. Smith. Truly a California painter, she maintained a studio in her home where she painted daily and took weekly on-site excursions in and around her Balboa Island home. Her subjects include harbor and marine scenes, seascapes, and landscapes of Yosemite and the Sierra Nevada. Although a complete list of her art association memberships and exhibitions is lacking, one of her earliest documented exhibitions was with the Whittier Association in 1930. She was a member of the Laguna Beach and Whittier Art Associations, as well as the Bay Region Art Association, in Northern California, with whom she exhibited at the Oakland Art Gallery in 1938. In the autumn of 1938, she was given a solo show at the Louis Terah Haggin Memorial Galleries in Stockton, which was followed by shows at the E. B. Crocker Art Gallery in Sacramento; the Whittier

Art Gallery; National Water Color Show at Balboa Park, San Diego; watercolors at the Laguna Art Gallery (later Laguna Art Museum) (solo); and Paramount High School, 1950–1952; all in California. Never eager to sell her work, she often gave her work away as gifts to family and friends.

Helen M. Smith passed away on March 20, 1954, in Balboa Island, California.

Biographical information from *The Western Woman* magazine, December 1939; *Sacramento Bee*, June 1, 1940; and *An Encyclopedia of Women Artists of the American West*, Phil Kovinick and Marian Yoshiki-Kovinick, University of Texas Press, Austin, 1998. Special thanks to Michael Smith, grandson of the artist, and the Smith family.

Salt Works and Workers (Newport Beach, California), c. 1942,
watercolor on paper, 15 × 20 in., signed verso. Private collection.

Curving Road with Trees and Houses, n.d., felt-tip pen on
tracing paper, 11 × 14 in., signed verso. Private collection.

River Mouth with Rocks, n.d., felt-tip pen on tracing paper,
10 × 13 in., signed verso. Private collection.

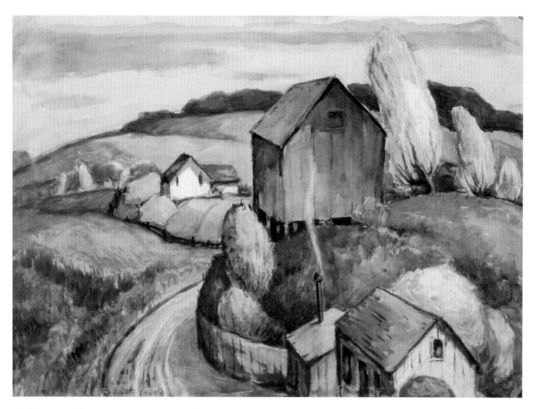

Red Barn - Yellow Trees, 1943, watercolor on paper,
19 × 26 in., signed and dated l/l. Private collection.

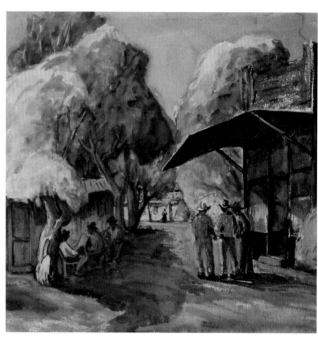

In Front of the Red Store, c. 1942, watercolor on paper,
21 × 21 in., signed l/c. Private collection.

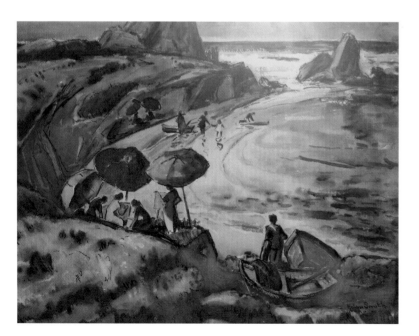

*Looking Down at the Artists Painting at Pirates Cove,
Corona del Mar, California*, c. 1944, watercolor on paper,
21 × 27 in., signed l/r. Private collection.

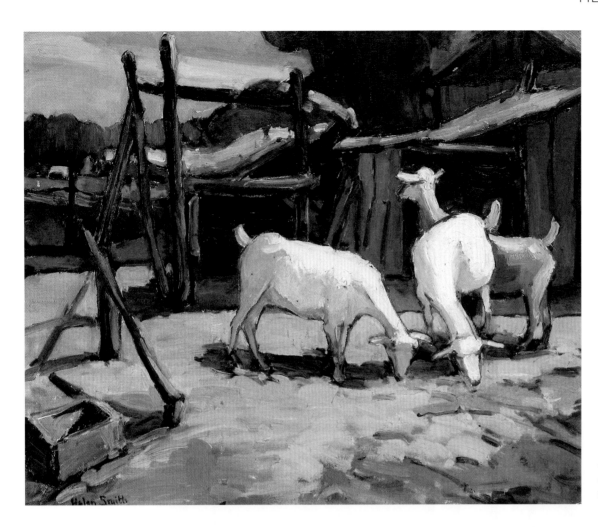

Goats in a Pen, c. 1938,
oil on canvas, 16 × 19 in.,
signed l/l. Private collection.

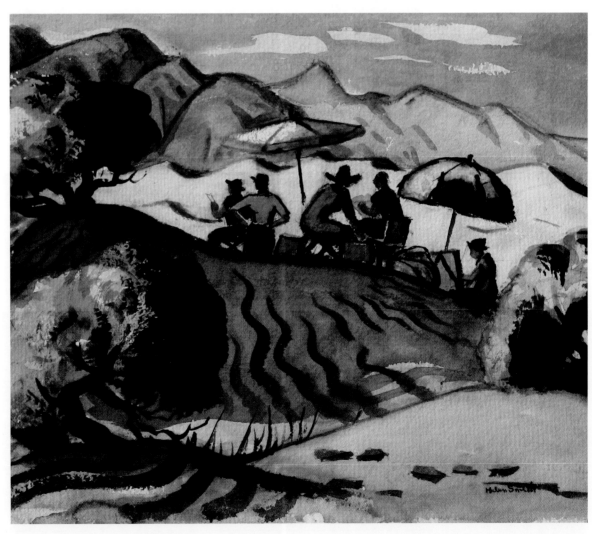

*Artists Painting at Death
Valley, California*, n.d.,
watercolor on paper,
15 × 17 in., signed l/r.
Private collection.

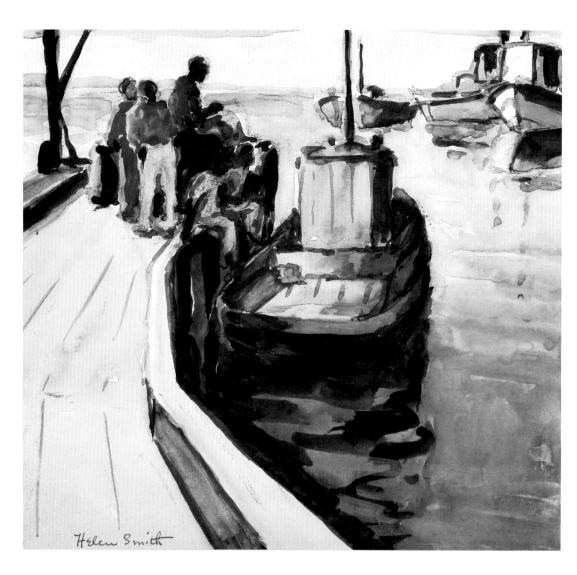

Untitled (On the Dock), n.d., watercolor on paper, 8.5 × 8.5 in., signed l/l. Courtesy of Michael Kelley, Kelley Gallery, Pasadena. Photo: Martin A. Folb, PhD.

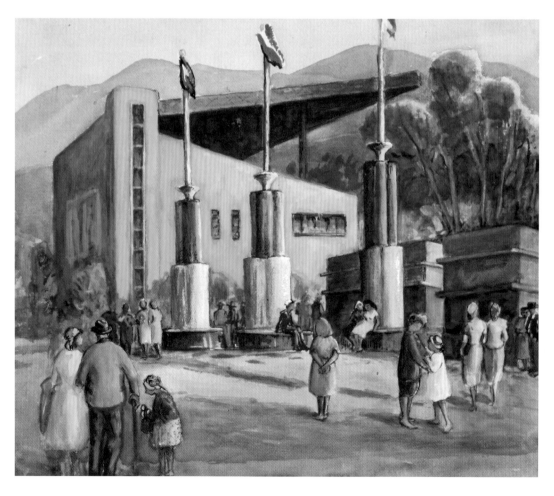

Outside the Del Mar Racetrack, c. 1948, watercolor on paper, 20 × 24 in., signed l/r. Private collection.

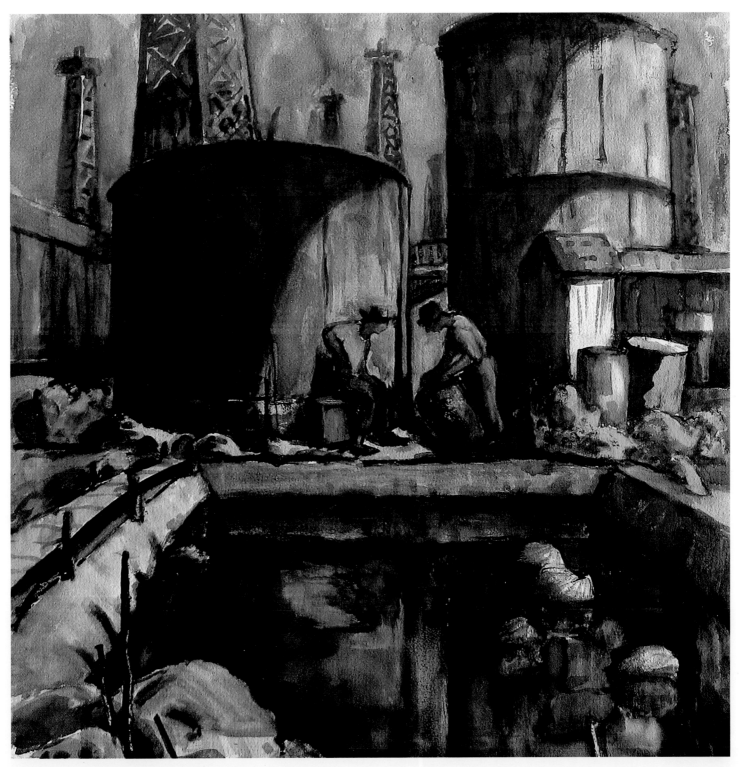

Red Oil Tanks, Huntington Beach, California, n.d.,
watercolor on paper, 19 × 17 in., signed verso. Private collection.

Ann Louise Snider
1899–1973

Ann Louise Snider was born on January 2, 1899, in Drummer, Illinois, the daughter of William C., a minister, and Patty (Sims) Snider. The family lived in Illinois and later North Dakota through the early 1930s. While in Illinois, she studied at the Art Institute of Chicago. By 1940, the family had moved to California, settling in Santa Barbara, where Snider maintained a private art studio and continued to paint and teach.

A complete list of exhibitions is lacking. Those documented include Southern California Federal Art Project, 1936; Golden Gate International Exposition, San Francisco, 1939, 1940; The Festival of Allied Arts (gold medal); The Faulkner Memorial Gallery; the Montecito Country Club, Montecito, California; Gardena High School, Gardena, California (concrete composition, later coated in a metallic bronze), 1945–1947, 1951, and 1953;

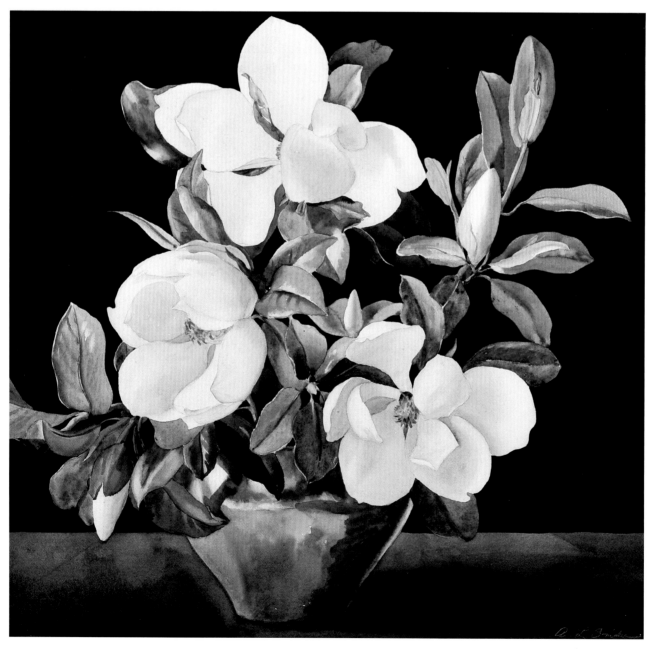

White Magnolias, n.d., watercolor on paper, 20.25 × 20.5 in., signed l/r.
Private collection. Photo: Martin A. Folb, PhD.

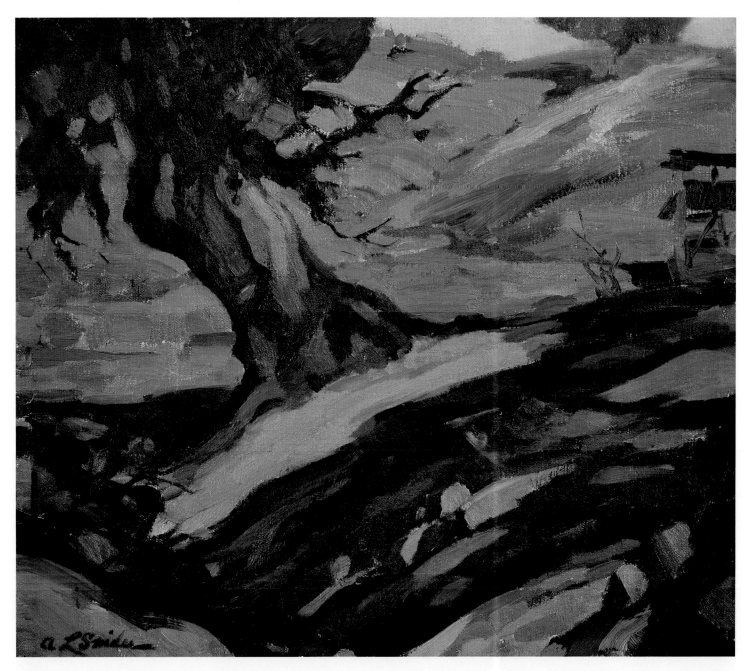

Untitled, n.d., oil on board, 16 × 14 in., signed l/l. Private collection.
Photo: Martin A. Folb, PhD.

and Oakland Art Gallery, 1947. Snider was awarded an honorable mention at the Oakland Art Gallery's 1939 Annual Exhibition (Oakland Art Gallery later became the Oakland Museum of California.)

In a 1938 *Bakersfield Californian* article, reporter Beth Dye stated: "Color seems to be completely at the command of Miss Ann Louise Snider of Santa Barbara, a portrait artist. It is this factor, plus an indefinable freshness and ability to combine accuracy with breadth, which have won her oil paintings an enviable series of awards."

Ann Louise Snider passed away May 23, 1973, in Santa Barbara, California.

Biographical information compiled from: *The Bakersfield Californian*, January 5, 1938, November 15, 1938, November 16, 1938; *Oakland Tribune*, April 9, 1939; *Oxnard Press-Courier*, December 7, 1949; *Hayward Daily Review*; and United States Census, 1910, 1920, 1930, 1940.

Edith Sowersby
1875–1959

Edith Lavina Sowersby was born on March 4, 1875, in either Bloomfield or Troy (Oakland County), Michigan, the daughter of Canadian parents John Russell Sowersby and Lavina (Butler) Sowersby. The youngest of the couple's three children, she was raised in Ithaca, Michigan, where she graduated from Ithaca High School in 1894. A history of any advanced education is lacking.

In the 1910s and into the 1920s, she was a resident of Watertown, New York, and is identified as a photographer and/or an employee in a photography shop. When she moved to Los Angeles around 1921 she once again identified herself as a photographer. She remained in California and spent the latter part of the 1920s as a resident of Oakland, California, and the San Francisco Bay Area, and at that time was identified as an artist. She returned to Southern California around 1931 and eventually settled in Huntington Park, where she remained.

Edith Sowersby, c. 1900. The Sowersby Family Collection.

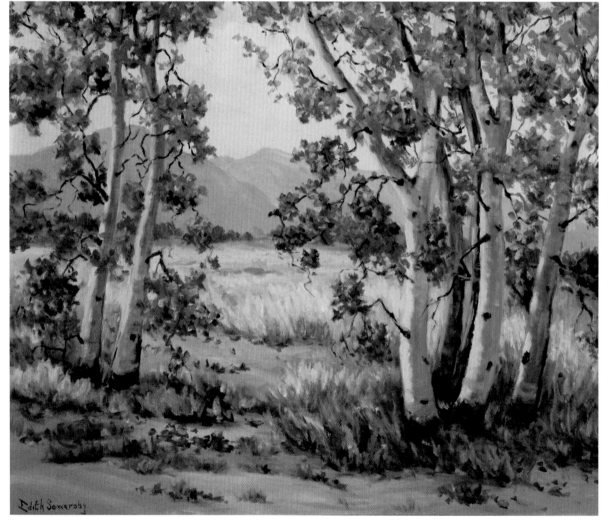

Sycamores, n.d., oil on canvas on board, 20 × 24 in., signed l/l. Courtesy of Michaan's Auctions.

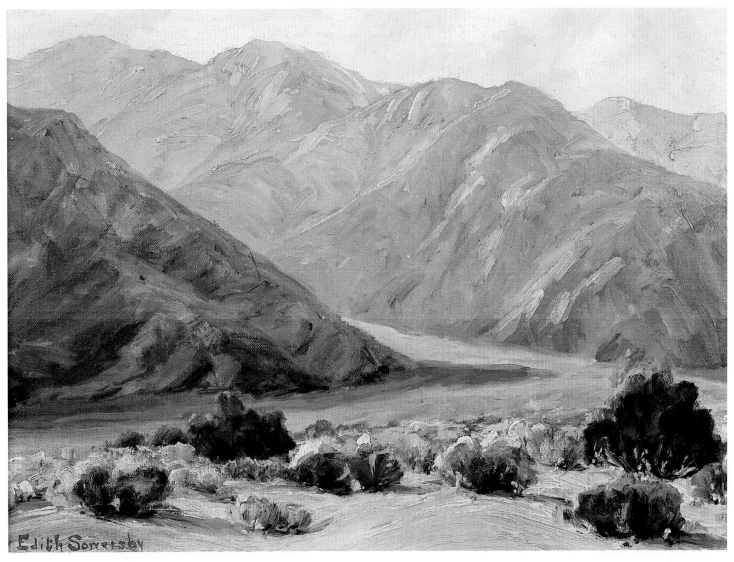

Untitled (California High-Desert Landscape), n.d., oil on board,
15 × 11.5 in., signed l/l. From the collection of Valerie Lardner.
Photo: Martin A. Folb, PhD.

Some sources suggest that in California she studied with the artists Jack Wilkinson Smith, Nell Walker Warner, and Hanson Puthuff. On her artist's business card she promoted herself as a painter of landscapes, marines, and still lifes. Edith was an active member of the Los Angeles Art Association and the Women Painters of the West, serving as the latter organization's assistant exhibition chair in 1936. Additional exhibitions included those with the Assistance League, 1934; the South Ebell Club, 1942; Southland Art Association, 1947; and the Long Beach Art Association, 1952; as well as at various venues throughout Southern California.

Edith Lavina Sowersby passed away on December 9, 1959, in Huntington Beach, California, and is buried in Forest Lawn Cemetery, Glendale, California.

Biographical information compiled from: *History of Gratiot County, Michigan: Historical, Biographical and Statistical*, Willard D. Tucker, 1913; United States Census, 1880, 1920, 1930, 1940; Watertown, New York, Directory, 1917–1921; Long Beach, California City Directory, 1926, 1931–1932; Oakland, California City Directory, 1928–1930; *Los Angeles Times*, July 22, 1934, February 21, 1936, March 8, 1936, February 6, 1937, February 22, 1942, June 22, 1947, December 11, 1959 (obituary); *Independent-Press-Telegram* (Long Beach), June 29, 1952; and California Death Index.

Anna Lee Stacey
1865–1943

Anna Lee Dey was born on September 10, 1865, in Glasgow, Missouri, to John and Eliza (Fisher) Dey. She spent her early years in Missouri and attended art school at the Pritchett Institute (later Pritchett College) in Kansas City, Missouri.

By the late 1880s, Anna had established a notable reputation as an artist under her maiden name, signing her work Anna Lee Dey. While attending the Prichett Institute, she met artist and teacher John F. Stacey of Boston, Massachusetts, who was a member of the faculty. They were married in Kansas City on October 15, 1891. From Missouri, the couple moved to Chicago, where she studied at the Art Institute of Chicago. During this period, the couple spent many of their winters in California, especially in Pasadena. The couple also made frequent trips to Europe not only to create but for further study. During these trips Anna studied at the L'Académie Delecluse in

Paris, France, as well as various locales throughout Europe. The couple, who had fallen in love with California during their winter visits, finally left Chicago and settled permanently in Pasadena.

Anna was a member of Chicago Painters and Sculptors, Illinois; Chicago Water Color Club, Illinois; California Society of Artists; Friday Morning Club, Los Angeles; Ebell Club, Los Angeles; California Art Club; and the Pasadena Society of Artists, California. Anna exhibited at the Art Institute of Chicago, Illinois, 1895–1933 (solo and prizes); Pennsylvania Academy of the Fine Arts Annual,

Untitled (Floral Still Life), n.d., oil on canvas, 30 × 24 in., signed l/r. Collection of Heather and Paul Haaga. Photo: Martin A. Folb, PhD.

Untitled (Woman Gazing across the Harbor), 1913,
oil on canvas, 16 × 20 in., signed and dated l/l. Private collection.
Photo: Martin A. Folb, PhD.

Philadelphia, 1908–1915, 1920–1925; Corcoran Gallery Biennial, 1910; Chicago Society of Artists, 1912 (prize); Panama-Pacific International Exposition, San Francisco, California, 1915; Chicago Gallery Association, Illinois,1927 (solo); California Art Club, 1938; Pasadena Society of Artists, California, 1938 (honorable mention); Golden Gate International Exposition, San Francisco, California, 1939; and Society for Sanity in Art, California Palace of the Legion of Honor, 1940. A large collection of her work is held by the Pasadena school system.

Anna Lee Stacey passed away on March 4, 1943, in Pasadena, California.

Biographical information compiled from: *Who Was Who in American Art, 1564–1975*, Peter Hastings Falk, ed.; *Who Was Who in American Art, 1940*; California Death Record; *Star-News* (Pasadena), April 4, 1942, March 5, 1943 (obituary).

The Moonlight, 1891, oil on board, 6.75 × 9 in., signed and dated l/l. Private collection. Photo: Martin A. Folb, PhD.

Untitled (New England Fishing Village), 1916, oil on board, 12 × 16 in., signed and dated l/l.
Collection of Catherine and Dan Gellert. Photo: Martin A. Folb, PhD.

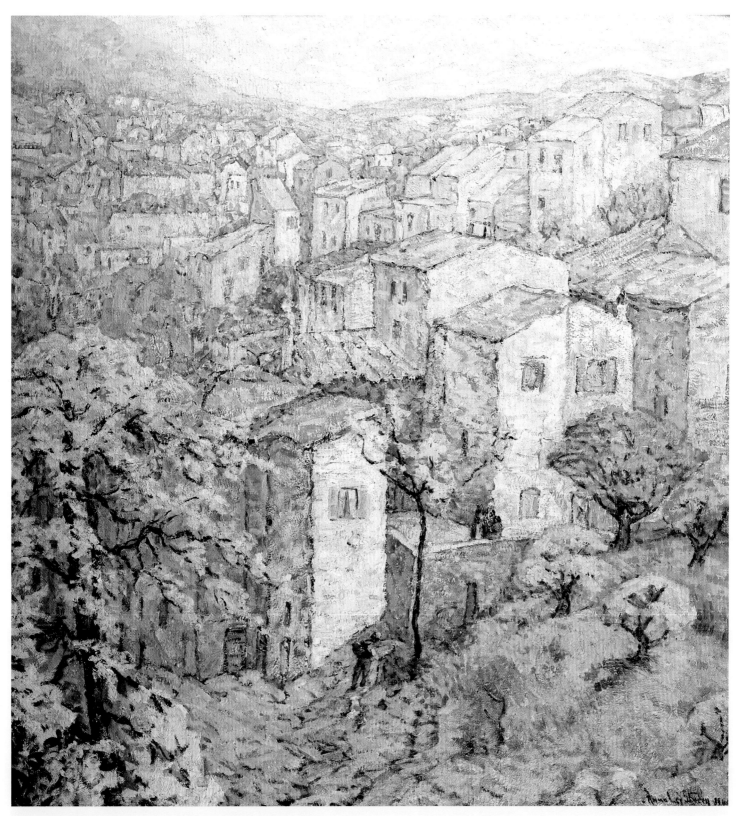

Grey Spring Morning in Cagnes (Cagnes-sur-Mer, France), 1940,
oil on Masonite, 36 × 32 in., signed l/r. Collection of Heather
and Paul Haaga. Photo: Martin A. Folb, PhD.

Vera C. M. Staples
1883–1954

Vera Clarice Milborough Bush was born on May 25, 1883, in Bath, England. She immigrated to the United States with her mother Evelyn in 1891. It is unclear when the family actually settled in California, although it is assumed that they were living on the West Coast soon after their arrival. By the mid-1890s, her mother was married to Henry G. A. Lovell, also a native of England, who had settled in Los Angeles, and both mother and daughter began using the Lovell surname. A complete history of Vera's education (scholastic and art) is lacking.

On June 14, 1904 in Los Angeles, Vera married Edward P. Carter and for the next twenty-five years, even after her husband's death in 1911, she was known as Vera Carter, Vera C. M. Carter, or Mrs. E. P. Carter. As early as 1913, she was listed as an artist and/or china decorator in the Los Angeles city directory under the Carter surname. On April 24, 1929, she married Robert Martin Staples, a noted music instructor and violinist who was a member of the Los Angeles Philharmonic from its inception in 1918. The Stapleses remained married until his death in 1939 and for the remainder of her life she was known as Vera C. M. Staples or Mrs. Robert Staples.

Early in her career, Vera maintained an artist studio on South Broadway Avenue in Los Angeles. A 1926 *Los Angeles Times*

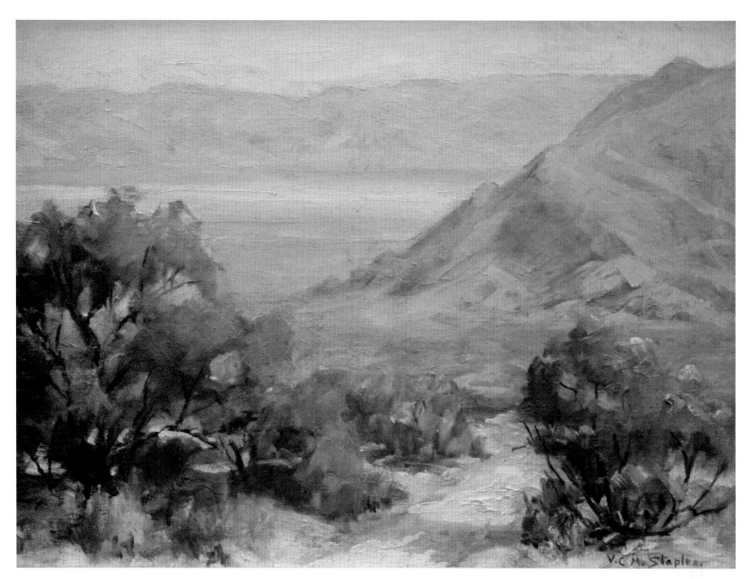

Desert Brush, n.d., oil on Masonite, 8.5 × 11.5 in., signed l/r. Courtesy of Clars Auction Gallery.

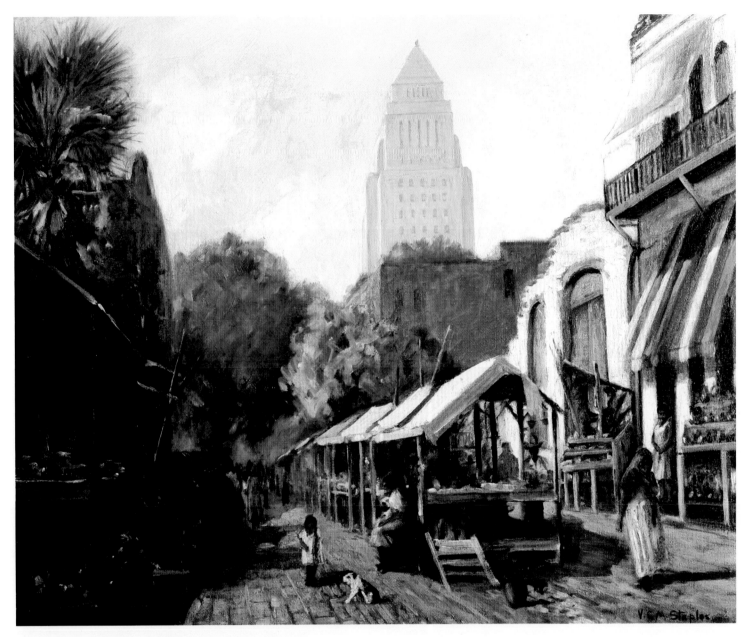

Olvera Street, El Pueblo de Los Angeles (with Los Angles City
Hall in the background), c. 1935, oil on canvas, 20 × 24 in.,
signed l/r. Courtesy of Michael Kelley, Kelley Gallery, Pasadena.
Photo: Martin A. Folb, PhD.

newspaper advertisement noted that from her studio she sold her prize-winning, hand-painted china as well as works of art executed in enamel and that she offered "lessons in all branches of china painting." An equally gifted landscape and genre painter (oils on canvas), she was a longtime member of and frequent exhibitor with the Women Painters of the West, the Long Beach Art Association, the Los Angeles Art League (past president), and the Southland Art Association. Her paintings were included in art exhibitions at the El Segundo Women's Club and the South Ebell Club and the Los Angeles County Fair.

Vera C. M. Staples passed away on June 17, 1954, in Los Angeles, California.

Biographical information compiled from: United States Federal Census, 1910,1920,1930,1940; Los Angeles City Directory, 1913; *Los Angeles Times*, June 15, 1904, October 24, 1926, January 1,1927, May 5, 1929, February 6, 1937, October 10, 1938, February 22, 1942, June 22, 1947, March 6, 1943; and California Death Index.

Juliette Steele
1909–1980

Julia Eleanor Wilm was born on July 21, 1909, in Union City, New Jersey, the daughter of Otto H. and Lily (Bracey) Wilm. Raised in New Jersey, she attended Dickenson High School in Jersey City and proceeded to study art and fashion design in New York at the Traphagen School of Design during the 1920s. In the late 1920s, she married her first husband, John Dodig, and they had one son, Mario Gerald Dodig; the couple later divorced. Her second marriage to Edward Steele took place in Reno, Nevada, in 1939. After their marriage, the couple settled in San Francisco, California. By this time, she had changed her given name and was known as "Juliette," which she continued to use for the rest of her life. In California, she enrolled at San Francisco State College, earning her bachelor of arts degree.

The 1940s were a highly productive period for the artist. She created a group of crayon lithographs representing San Francisco area landmarks, likely as part of the San Francisco unit of the Works Project Administration printmaking project under Ray

Julia Wilm Dodig, c. 1930. Courtesy of Gerald Dodig.

Below: *Chinatown*, c. 1945, lithograph on Warren's Oldestyle paper, 12 × 8.25 in., ed. 14/50, signed l/r. Courtesy of The Annex Galleries.

Julia Wilm Dodig, c. 1935. Courtesy of Gerald Dodig.

Night Scene (Coit Tower, San Francisco, California), c. 1940,
lithograph on buff wove Warren's Oldestyle paper, 12 × 8.25 in.,
ed. 4/50, signed l/r. Courtesy of The Annex Galleries.

Interlude (Abstract Expressionist Composition), 1948, color etching on paper, 7 × 5.75 in. (platemark), ed. 1/8, signed l/r. Courtesy of Gerald Dodig.

Juliette Steele, c. 1950.
Courtesy of Gerald Dodig.

Terra Firma, c. 1948, color intaglio on Warren's Oldestyle paper, 3.75 × 5 in. (platemark), signed l/r. From the collection of Gala Chamberlain. Courtesy of The Annex Galleries.

Island Universe, 1950, casein and tempera on board, 8 × 10 in.,
signed and dated l/r. Courtesy of Gerald Dodig.

Bertrand. In the mid-1940s, she received her master of fine arts degree from Stanford University and continued her studies at the more progressive California School of Fine Arts, both located in the San Francisco Bay area.

At the California School of Fine Arts, where she later served as a member of the faculty, she studied with notable artists such as Ray Bertrand, Clay Spohn, who was a proponent of the concepts and forms of Dada and surrealism, and with Stanley William Hayter. There she devoted considerable time to painting, working in a modernist style, which was a departure from her previous work, in addition to her printmaking.

David Action in Paths to the Press states that "Steele's prints of the mid-1940s are dreamlike abstractions, with organic forms and zoomorphic figures adrift in ambiguous space." She often found inspiration in literature an in nature, the latter evident in images inspired by the natural wonders of Yosemite National Park.

Juliette first exhibited her work in the early 1940s and continued to do so while teaching printmaking (lithography and intaglio) at the CSFA. Later she taught art at high schools in the San Francisco Bay area. In 1947, the first solo exhibition of the artist's work was held at the Artist's Guild Gallery in San Francisco. In 1948, the Weyhe Gallery in New York presented a show of her prints. She was president of the San Francisco Society of Women Artists in 1949–50 and later served as a juror for many Bay Area exhibitions.

By the mid-1950s, she was a resident of San Rafael, California, where she lived with her husband and for many years operated Steele's Patio Shop. Her oeuvre includes oils, watercolors, printmaking, and ceramics. She continued to exhibit her paintings and prints, but her artistic output waned in later years. She was a member of the San Francisco Art Guild, San Francisco Art Association, and San Francisco Women Artists. Her other exhibitions included Palace of the Legion of Honor, 1946; San Francisco Art Association, 1944–1946; Oakland Art Gallery, 1944; Laguna Beach Art Association, 1944; San Francisco Women Artists, 1945; Walnut Creek Festival Art Show, 1949 (prize); and many others.

Juliette Steele passed away on March 4, 1980, in San Rafael, California.

Biographical information compiled from: *Who's Who in American Art,* Dorothy B. Gilbert, ed.; *Paths to the Press: Printmaking and American Women Artists, 1910–1960,* Elizabeth G. Seaton, ed.; United States Census, 1910–1940; and California Death Index. Special thanks to the artist's son, Gerald Dodig.

Mary L. Stevens
1833–1920

Mary A. Lord was born on July 24, 1833, in Batavia, New York, the daughter of Israel S. P. Lord, a physician, and Mary G. (Wilson) Lord. When she was six months old her parents left New York and traveled west by horse and wagon, first to Michigan and then to Illinois, living in settlements near what was then the recently established city of Chicago. It was Mary's maternal grandfather, Isaac Wilson, who suggested the name of Batavia for their new home in honor of the home they had left in New York, and so the community of Batavia, Kane County, Illinois, was established.

Although a complete history of the first decades of her life is lacking, it is assumed that the majority was spent in Batavia, Illinois, where on June 14, 1853, she married Sylvester S. Stevens. They had two daughters: the eldest, Neally Stevens, went to Europe to study under acclaimed composer Franz Liszt and became an accomplished and well-known international pianist.

Because of Mary's husband's employment with the railroad, it appears that the family lived in several locales from Illinois to Council Bluffs, Iowa, to Salt Lake City, Utah, and finally to Southern California. There they joined Mary's father and her brother, Isaac Wilson Lord, who was a California pioneer and had settled earlier in Los Angeles. By the late 1880s, the Stevenses had established their residency in Pasadena, California. Although a history of where and with whom she studied art is lacking, it appears that she was a practicing artist prior to her arrival in California.

According to newspaper accounts, Mary began exhibiting her work locally soon after her arrival in Pasadena. Because the Lord family had already established a home in Southern California, Mary may have visited California prior to actually settling in the state. This is evidenced by a painting that is recorded as being submitted by a Mrs. M. Stevens in the 1886 California State Agricultural Society (Fair). Known as a landscape artist, she was included in various group exhibitions in the galleries at the Los Angeles Chamber of Commerce. Her activity is further evidenced by her involvement in the planning committee for Pasadena's entries (art) at the 1893 Chicago World's Fair. Notably, she was a founding member of the Society of Fine Arts of Southern California, which was established in 1895, and she was included in the group's initial autumn exhibition in November of 1895. Although frequently referred to in the press as Mrs. Sylvester S. Stevens or Mrs. M.L. Stevens, she signed her work either Mary L. Stevens or M. L. Stevens.

After her husband's death in 1895, Mary divided her time between Los Angeles and the San Francisco Bay Area, eventually settling in Alameda County. She continued to paint and identify herself as an artist throughout the final decades of her life and is known for her oils of the California landscape and images of the historic missions found throughout the state. A series of California mission paintings done by Mary L. Stevens was given by her heirs to the Washington Township Historical Society, Alameda County, California, and they are on display at Mission San Jose (California Mission No. 14), located in Fremont, California.

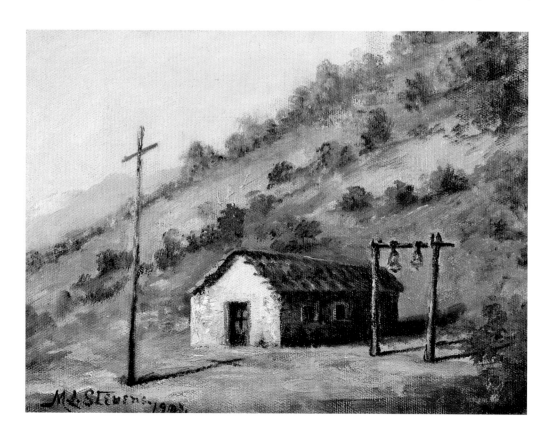

Santa Ysabel Mission, San Diego 1907 (California Mission Building with Two Bells Hanging in a Wooden Timber Frame), oil on board, 10 × 13.5 in., signed and dated l/l. Courtesy of Eric Berg, Early California Antiques.

Mary Lord Stevens passed away on June 24, 1920, and is buried in the Lord family plot in Evergreen Cemetery in Los Angeles, California.

Biographical information compiled from: *The National Cyclopaedia of American Biography,* James Terry White, 1898; *American Biography and Genealogy, California Edition*, Volume 1, D. D. Robert J. Burdette, 1912; United States Census, 1870, 1900, 1910, 1920; California State Agricultural Society Exhibition Record, 1856–1902; Los Angeles City Directory, 1897, 1902, 1907; Richmond City Directory, 1911–1912; Oakland, Berkeley, Alameda City Directory, 1918; *Los Angeles Times,* October 9, 1888, July 7, 1892, December 18, 1894, April 8, 1895, August 15, 1895, October 25, 1895, and November 24, 1895.

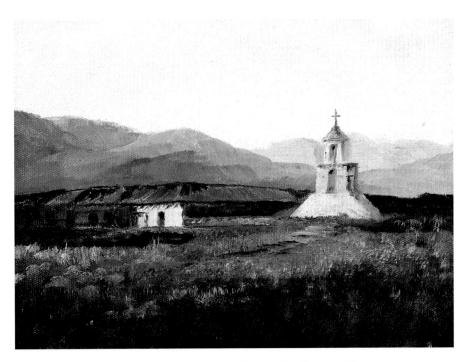

Chapel and Bell Tower of San Antonio de Pala Mission, San Diego 1907 (California Mission), oil on board, 10 × 13.5 in., signed and dated l/l. Courtesy of Eric Berg, Early California Antiques.

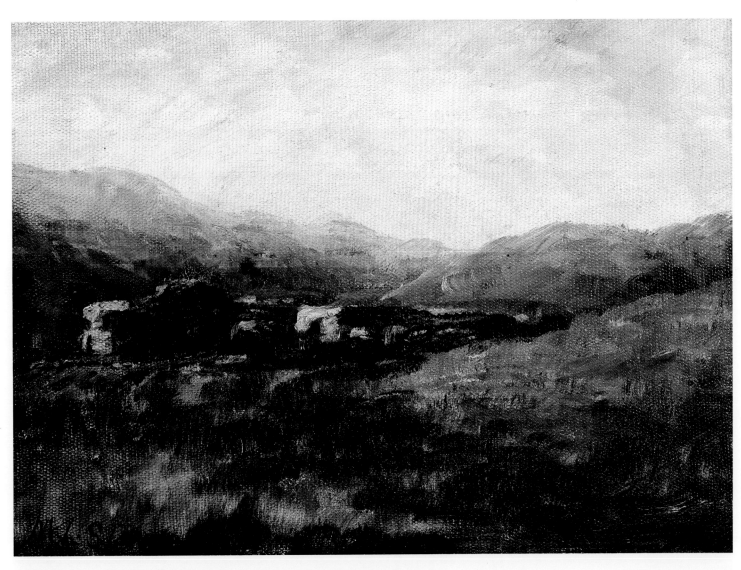

Jalama Canyon and Mission of Saint Margarita, San Luis Obispo 1907 (Jalama Canyon was home to the Paleo and Chumash American Indians), oil on board, 10 × 13.5 in., signed and dated l/l. Courtesy of Eric Berg, Early California Antiques.

Edna Stoddart
1888–1966

Edna Anita Lehnhardt was born in Oakland, California, on January 9, 1888, the daughter of Emil and Henrietta "Hattie" (Marcus) Lehnhardt. Her father, a successful early merchant in Oakland, established Lehnhardt's, the once-famed confectionery and ice cream emporium and candy manufacturer. Her mother was the sister of Josephine Sara (Marcus) Earp, a notable character in her own right and the (common-law) wife of famed western sheriff Wyatt Earp, a relationship that connected Edna to one of the most legendary figures of the Old West.

Raised in a life of privilege in Oakland, at the age of seventeen in 1908, Edna married Estes Joseph Cowing, the son of another socially prominent Oakland family. The marriage produced two children, a daughter and a son, but ended in divorce. Edna was a student in 1920 at the time of her second marriage, to Herbert Allen Stoddart. She began using the Stoddart surname and continued to do so even after her husband's death in 1929.

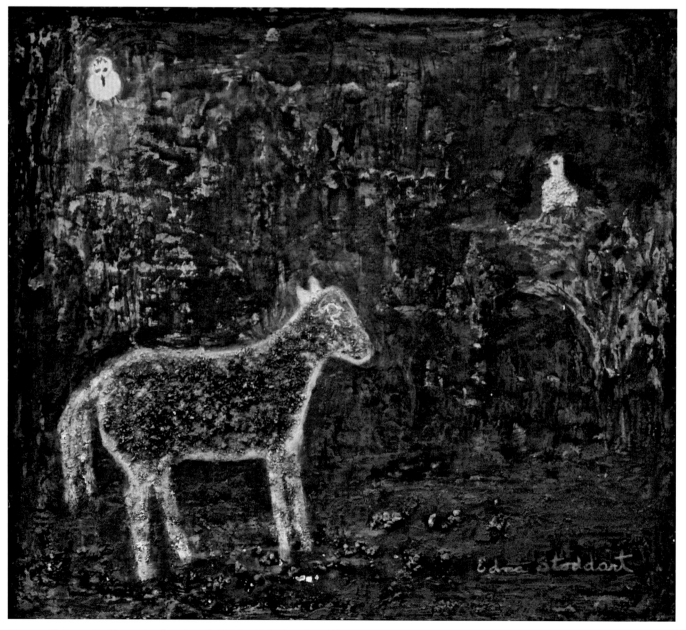

Horse with Lavender Eye, n.d., oil on board, 10.25 × 11.25 in., signed l/r. Courtesy of Calabi Gallery. Photo: Camille M. Palmer.

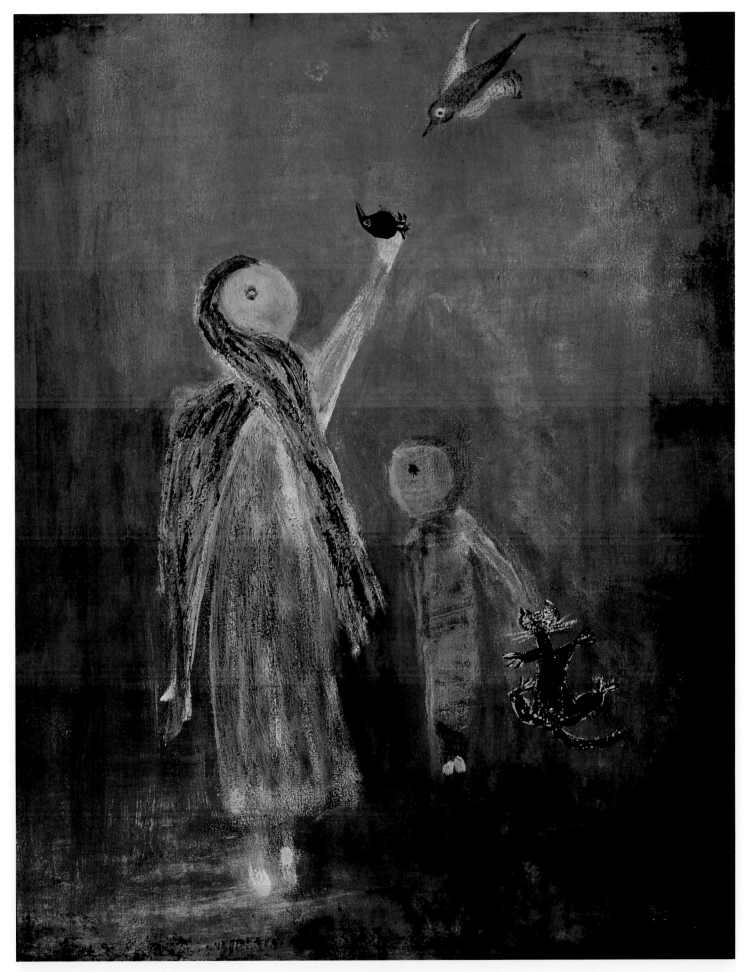

The Witch Bewitching, n.d., oil on board, 18 × 14 in., signed l/r and annotated verso.
Private collection. Photo: Martin A. Folb, PhD.

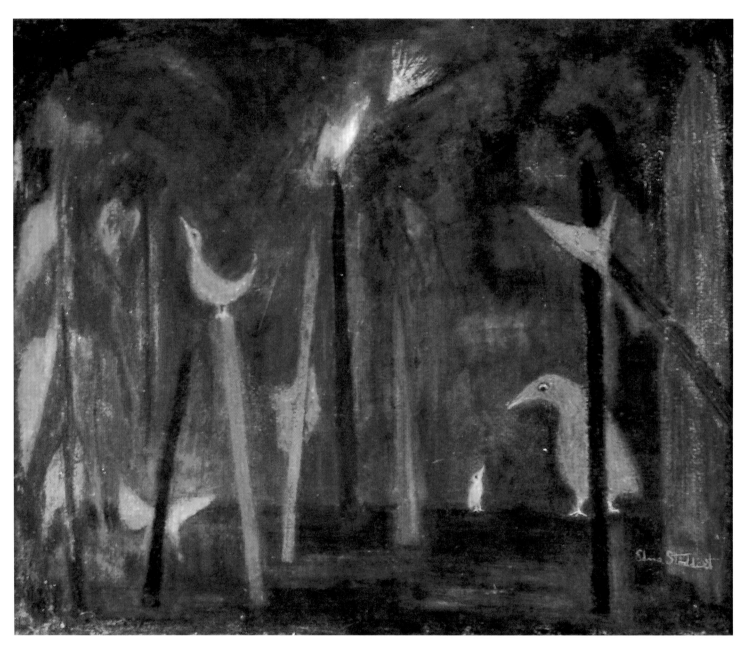

Forest Near Chatham, n.d., oil on panel, 19.5 × 23.5 in., signed l/r and annotated verso. Courtesy of Le Trianon Fine Art & Antiques.

Edna studied at the University of California, Berkeley, Mills College in Oakland, California School of Fine Arts in San Francisco, California College of Arts and Crafts in Oakland and under noted artists Glenn Wessels, Felix Ruvolo, Mark Rothko, Jean Varda, and Fernand Leger, and others. Edna was a painter and ceramist; she worked in oils, gouache, watercolor, and lithography. Although she studied with some of the finest artists/teachers of the day, her style was uniquely her own. She painted cubist-like landscapes, structures, and magical fairytale settings teeming with brightly colored, exotic, surreal creatures, birds, witches, and cats. Birds were one of her favorite subjects and frequently appeared in her compositions. Some elements in her small-format paintings seemed influenced by Mexican folk art.

Garden in Oaxaca, n.d., oil on board, 12 × 12 in., signed l/m and
annotated verso. Courtesy of Calabi Gallery. Photo: Camille M. Palmer.

In the early 1950s, through their mutual friend the photographer Johan Hagemeyer, Edna met Louis Siegriest, who was one of the group of artists known as the Oakland Society of Six. After their marriage on January 8, 1958, their Oakland home became a gathering place for the young artists of the East Bay Area. Edna and Louis were very supportive of each other's work; she set up a studio in their home and frequently exhibited with Siegriest and with his artist son, Lundy, which gained them the reputation as Oakland's first family of the arts.

Edna was a member of the San Francisco Art Association; San Francisco Women Artists; Artists Equity Association, New York; California Watercolor Society; and the Mills College Ceramic Guild. Her awards and exhibitions included United States Government, 1941 (prize); California Watercolor Society, 1942–1955; Fenner Fuller's Gallery, 1947; San Francisco Art Association, 1947 (prize); San Francisco Women Artists, 1952 (President's Purchase Prize); Area Arts, San Francisco, 1952 and 1953; City of Paris Rotunda Gallery, 1954; Gump's, San Francisco; California

I Remember That Day, 1947, gouache on panel, 16 × 21 in., signed l/l and
annotated verso. Courtesy of Calabi Gallery. Photo: Camille M. Palmer.

Untitled (Church), n.d., pastel on paper, 18 × 24 in., signed l/r.
Private collection. Photo: Martin A. Folb, PhD.

Witches Meeting, c. 1960, oil on panel, 11 × 14 in., signed l/r
and annotated verso. Collection of the Lockard Family.
Courtesy of Calabi Gallery. Photo: Camille M. Palmer.

State Fairs; and the Riverside Art Museum, New York. Additional venues in California included Oakland Art Gallery (later, the Oakland Museum of California); Walnut Creek California Art Festival; Richmond Art Center; Gallery de Silva, Santa Barbara, 1963; Santa Barbara Museum of Art; and the Pasadena Art Institute. Her works are held in the San Francisco Museum of Art, California, and Fort Stanton Hospital, New Mexico. In the 1960s, she was represented by the Triangle Gallery in San Francisco.

Edna Stoddard Siegriest passed away from heart failure on December 23, 1966, in Mexico. After travelling earlier in the year to the Soviet Union, she and her husband had taken a painting holiday to Mexico. She is buried in San Luis Potosi, Mexico. The art critic Miriam Dungan Cross, in eulogizing Edna in the *Oakland Tribune* wrote: "Her idiom and her imagery were her very own.

She and her art had an ageless quality. She had never lost the wide wonder of a child. She painted an enchanted place where a pink and white 'pussy-cat angel' floats on gossamer wings, a glittering green 'bewildering frog' blinks his beautiful eyes and a flaming orange bird sings amid jewel-like flowers or maybe flower-like jewels."

Biography compiled from: *Who's Who in American Art, 1953*, Dorothy B. Gilbert, ed.; *Society of Six*, Nancy Boas, Bedford Arts Publication, San Francisco, 1988; *Past and Present of Alameda County*, vol. II, S.J. Publishing Company, 1914; *Berkeley Daily Gazette*, April 29, 1920; *Art Forum*, September 1963; and *Oakland Tribune,* December 23, 1966, January 1, 1967.

Dorothy Stratton
1908–2007

Dorothy E. Stratton was a painter and printmaker. She was born on December 21, 1908, in Worchester, Massachusetts, and grew up in Sharon, Massachusetts. Dorothy showed a talent for art as a young child.

She married Michael Hicks-Beach in 1928, and the couple moved to Brooklyn, New York, where she studied figure drawing and painting at the Pratt Art Institute and took classes at the Brooklyn Museum School in drawing and painting with artist Alexander Brook. In 1942, she moved back to her parents' house in Connecticut, helping her father deliver telegrams to the families of soldiers killed in World War II. After her divorce in 1944, she moved to Los Angeles, California, where her first job was at Warner Bros. Studios painting *Tom and Jerry* cartoon film cells. She continued at Paramount Pictures as a costume and set designer.

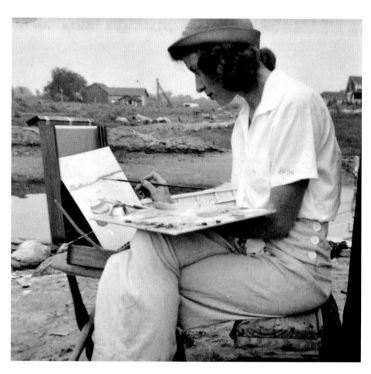

Dorothy Stratton, c. 1945. Private collection.

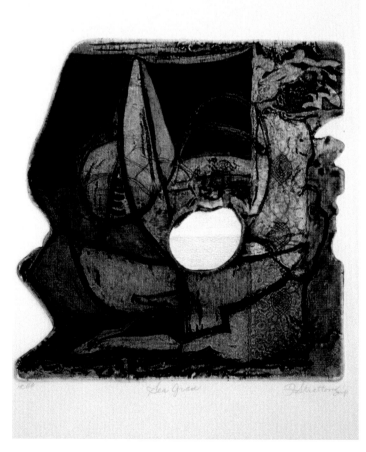

Sea Grave (Abstract Composition), n.d., lithograph on paper, 12 × 10 in., signed l/r. Private collection.

While in Hollywood, she met director of animation William Asbury King. The couple married in 1948 and spent their first eighteen months in Paris, France, where Dorothy studied painting with André Lhote at L'Académie de la Grande Chaumière. Upon their return to Los Angeles, she continued her studies at the University of California, Los Angeles under Rico Lebrun and began gaining attention for her abstract impressionist paintings. Dorothy had her first major solo show at the Pasadena Museum of Art in 1959.

By the mid 1960s, she was registrar for the La Jolla Museum School, in La Jolla, California. She also studied printmaking with Paul Lindgren at the University of California, San Diego. She had many exhibitions of her abstract expressionist works during the 1950s, 1960s, and 1970s. In the early 1980s, Dorothy and her husband moved to McLean, Virginia, where she helped found the Washington Printmakers Gallery in 1985 and became a founding member of the Columbia Pike Artist Studios in Arlington. She also was a member of the Washington Print Club and the Artists Equity Association.

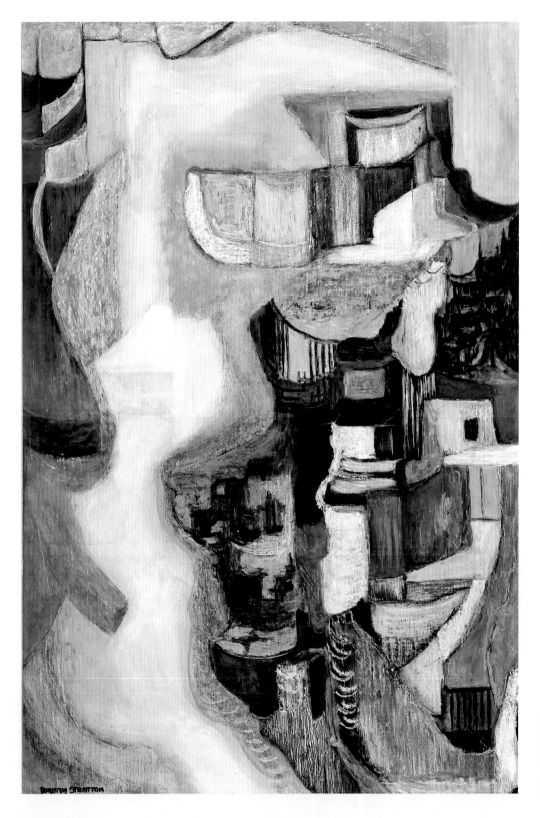

Of Hills and Shore
(Abstract Landscape), c. 1948,
oil on Masonite, 30 × 20 in.,
signed l/l and annotated verso.
Private collection.
Photo: Martin A. Folb, PhD.

Dorothy Stratton King said her style stemmed from nature and living forces in our environment; the works ranged from representational to abstract, with a personal idiom. Her intaglio prints and paintings have been exhibited in the World Bank, the Tunisian Ministry of Culture, the Pushkin Museum of Fine Arts in Russia, the Long Beach Museum of Art, the La Jolla Art Gallery, Pasadena Art Museum in California, and US embassies through the Arts in Embassies program. Her works are in the collections of the Georgetown University Fine Print Collection, the Corcoran Gallery of Art, the National Museum of Women in the Arts in Washington, the Long Beach Museum of Art, California, and many others.

Dorothy returned to San Diego, California, after her husband's passing in 1990, and in 1994, a retrospective of her work was held at the University of San Diego's Founders Gallery. She moved back to Virginia in 1996.

Dorothy Stratton King passed away at the age of 98, on June 14, 2007, in Arlington. Virginia.

Biography compiled from information provided by Heather Peck, the artist's granddaughter; *Who's Who in American Art*, 1973, 1978; and the *Washington Post*, June 28, 2007 (obituary).

Phyllis Strickland
1915–1993

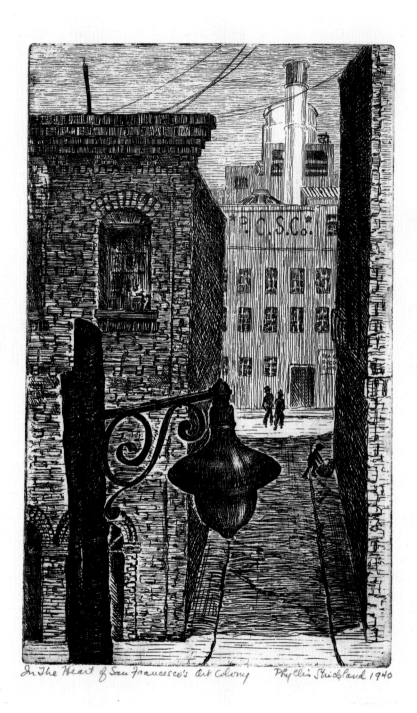

Phyllis Alba Strickland was born on July 27, 1915, the daughter of artist Frederick Strickland and Alberta L. (Harrison) Strickland, in Portland, Oregon, where she and her sister Gladys were raised. Presumably this is where she received her earliest art instruction, from her father, a respected artist and teacher.

Later she studied with the artist Sidney Bell in Portland. In the 1930s, she moved to California and studied in Los Angeles at the Chouinard Art Institute and at the Art Center School under Richard Munsell. By 1940, she was a resident of San Francisco, California. She married Harley Henry Melzian and by 1945, the couple were residents of Detroit, Michigan, where her husband was a designer with the General Motors Corporation. The couple remained residents of Michigan.

A painter and printmaker, she was a member of the Laguna Beach Art Association and exhibited in California and Oregon, including with Painters and Sculptors Annual, Portland Museum of Art, Oregon, 1939; Society for Sanity in Art, California Palace of the Legion of Honor, 1940; and Residence Club, San Francisco, 1940.

Phyllis Strickland Melzian passed away on July 27, 1993, in Northport, Michigan.

Biographical information compiled from: *Who's Who in American Art*, Volume III, 1940; United States Census, 1920, 1930, 1940; City Directory, Michigan, 1945. Special thanks to The Annex Galleries, Santa Rosa, California.

In the Heart of San Francisco's Art Colony, 1940, etching on antique-white textured wove paper, 8 × 5 in. (platemark), signed and dated l/r. Courtesy of The Annex Galleries.

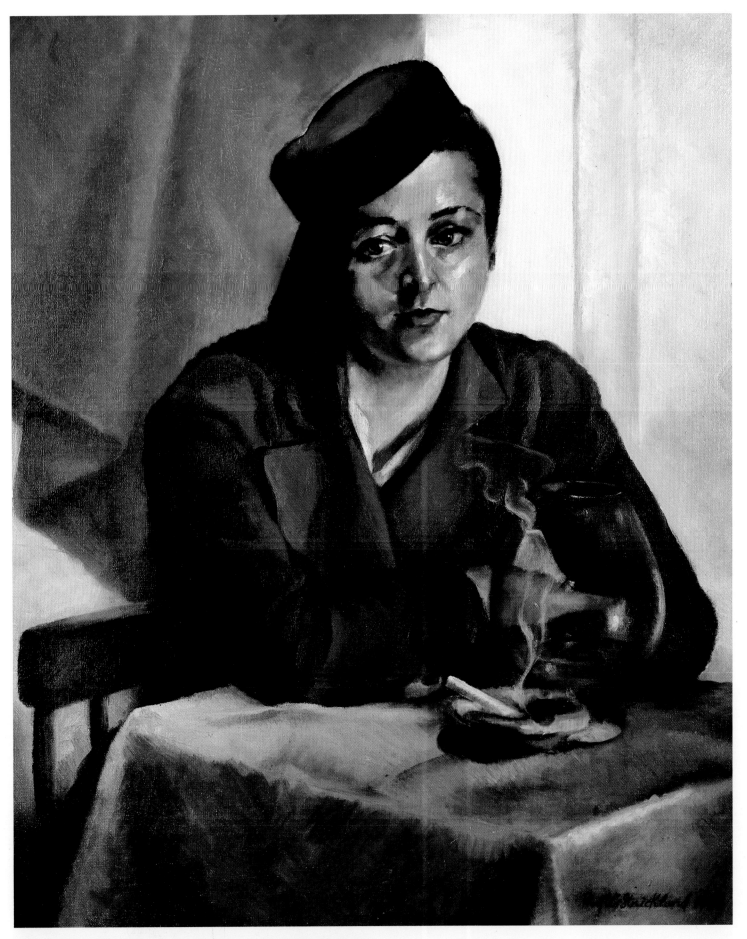

Portrait of Stella Ratto, 1940, oil on canvas, 30 × 25 in., signed and dated l/r.
Courtesy of Martin Durante. Photo: Martin A. Folb, PhD. The subject of this painting,
Stella Ratto, in addition to being a close friend of the artist, led an exciting and
adventuresome life as a member of the Central Intelligence Agency, a world traveler,
and a part of the Taos (New Mexico) artist's colony of the 1930s and 1940s.

Vivian F. Stringfield
1881–1933

Vivian F. Stringfield was born on November 6, 1881, in the area around San Luis Obispo, California, to J.W. and Lydea Stringfield. Her parents were early settlers of San Luis Obispo and later Pomona. She and her family moved to Los Angeles while she was a child. She had an older sister Vera, who died of illness at a young age, and a younger brother Raymond, who became a successful chemist. Her father was a teacher and Vivian lived her entire life, besides travel and education, with her parents.

She graduated from Los Angeles High School in 1899 and then the University of California, Berkeley. She continued her studies at the Mark Hopkins Institute of Art (now the San Francisco Art Institute) and the Pratt Institute in Brooklyn, New York, with Ralph H. Johonnot. From 1908 to 1910, she attended the University of Southern California. Her early works are very much in the style of the California arts and crafts Movement. A fantastic colorist, her landscapes contain flat, muted, Fauvist-like colors; with an influence of Japanese block prints. Her early work seems to have been inspired by Ralph Johonnot, with a bit of Arthur Wesley Dow. Her subjects reflect California; she painted seascapes, native trees, fanciful plants, rolling hills, the Sierras, and other locales. Vivian continued to study art throughout her career and also studied and worked with Douglas Donaldson at the Batchelder School of Design and Manual Arts high school in Los Angeles, a vocational school founded in 1910.

Vivian F. Stringfield, c. 1900.
Courtesy of the Stringfield family.

In 1910, she returned to Los Angeles and began her teaching career with the Los Angeles city schools. In March 1917, she was awarded a teaching diploma from the state of California. From 1917 to 1919, she taught at John Muir High School, Pasadena, later returning to Los Angeles High School. Vivian continued to be a teacher of drawing and art appreciation in the Los Angeles schools for twenty years. She was also an active member of the First United Methodist Church of Los Angeles.

Untitled (Rocky Coast), 1915, watercolor on paper, 9 × 13 in., initialed l/r.
Courtesy of the Stringfield family.
Photo: Martin A. Folb, PhD.

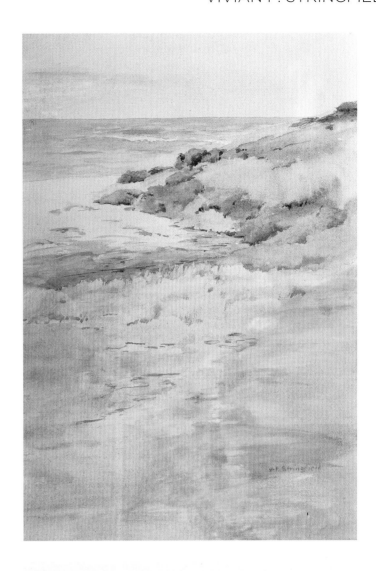

Untitled (Coastal Wetlands),
c. 1895, watercolor on paper,
17 × 11.75 in., signed l/r.
Courtesy of the Stringfield family.
Photo: Martin A. Folb, PhD.

Untitled (Still Life with Carrots), c. 1900, watercolor on paper, 8 × 9.75 in.,
unsigned. Courtesy of the Stringfield family. Photo: Martin A. Folb, PhD.

The Family House in Pomona (From the Artist's Sketchbook), c. 1900,
graphite on paper, 9 × 8.25 in., annotated (Oct. 29) and unsigned.
Courtesy of the Stringfield family. Photo: Martin A. Folb, PhD.

Vivian was awarded a bronze medal at the Panama-California Exhibition, San Diego, California, in 1915. And in 1918, Vivian F Stringfield, Fannie M. Kerns, and Marjorie Hodges exhibited at The Los Angeles County Museum of History, Science, and Art in Exposition Park, Los Angeles. In a *Los Angeles Times* article dated June 2, 1918, "The Realm of Art," Antony Anderson gave the exhibition a very positive review and wrote that three public school instructors of art, two of them teaching in Pasadena, one in Los Angeles, had been holding a joint exhibition of decorative studies in the main gallery at Exposition Park. The exhibition closed May 31, but due to its popularity had been transferred, in its entirety, to the Battey Gallery, No. 294 Colorado Street, Pasadena, where it reopened and continued for about three weeks. All the proceeds of sales in the Battey Gallery were donated to the Red Cross fund. Anderson concluded that: "the beauty of the collections, of small decorative canvases, was the perfusion of color, the excellent drawing and simplicity of line combined with the economy of composition, such that every student of art should take time to make a close study of it."

Colorado Street Bridge, Pasadena (From the Artist's Sketchbook), c. 1914 ,
graphite on paper, 4.5 × 8.5 in., unsigned. Courtesy of the Stringfield family.
Photo: Martin A. Folb, PhD.

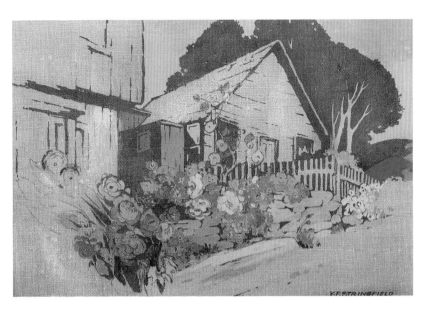

Vivian F. Stringfield photographed in a playful pose, c. 1897. Courtesy of the Stringfield family.

Untitled (House and Garden), c. 1914, oil on canvas on board, 12 × 10 in., signed l/r. Courtesy of the Stringfield family. Photo: Martin A. Folb, PhD.

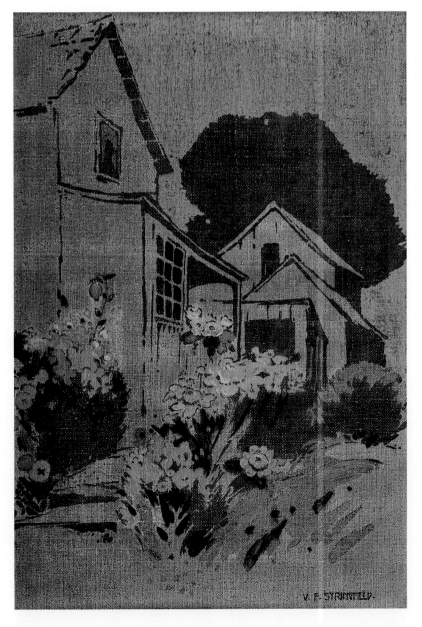

Garden Walk No. 4, c. 1914, oil on canvas on board, 13 × 9 in., signed l/r. Courtesy of the Stringfield family. Photo: Martin A. Folb, PhD.

Untitled (Structures in Colorful Landscape), c. 1914, oil on canvas
on board, 8.5 × 9.5 in., unsigned. Courtesy of the Stringfield family.
Photo: Martin A. Folb, PhD.

Vivian F. Stringfield (seated lower left)
photographed with two unidentified women,
c. 1910. Courtesy of the Stringfield family.

Untitled (Beach Cottages), c. 1914, oil on canvas on board, 10.75 × 10.5 in., unsigned.
Courtesy of the Stringfield family. Photo: Martin A. Folb, PhD.

Untitled (possibly an image of the old Mt. Washington School, Pasadena), c. 1919, oil on canvas
on board, 12.75 × 28 in., signed l/r. Courtesy of the Stringfield family. Photo: Dr. Martin A. Folb.

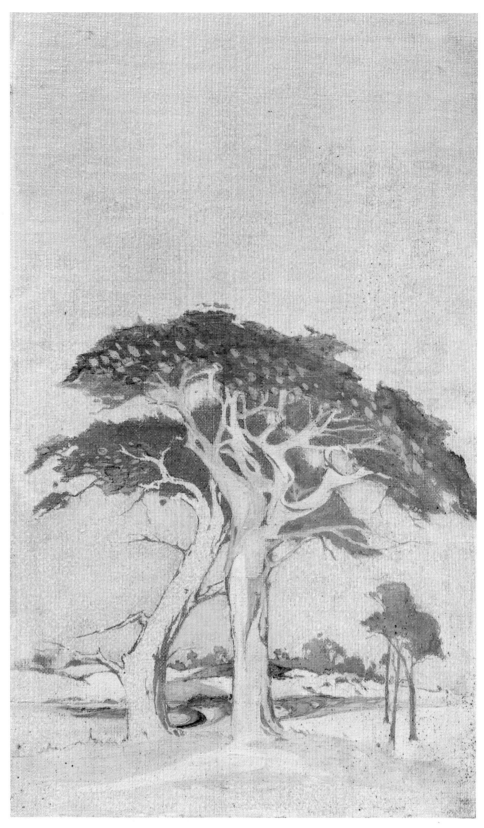

Cypress Trees, (Monterey, California) c. 1918, oil on canvas applied to board, 13 × 8 in., unsigned, annotated verso. Private collection. Photo: Martin A. Folb, PhD.

In addition, Vivian exhibited at the Painters and Sculptors of Los Angeles, 1920 and 1926; the International Printmakers Society; the Art Teachers Association of Southern California; and a California art club exhibition, *All Modern Art Show* at Barnsdall Park, 1929. Also in 1929, she participated in a five-person exhibition of the Art Students League with James Redmond, Albert King, Phyllis Shields, and Stanton Macdonald-Wright at Zeitlin's Bookstore (Zeitlin's was a famous gallery/bookstore in a converted barn on La Cienega Boulevard in Los Angeles that exhibited all manner of avant-garde works in a magical environment with paintings hanging all the way to the ceiling surrounded by books. Owner Jake Zeitlin was an American bookseller, publisher, collector, poet, and intellectual in Los Angeles in the mid-twentieth century.)

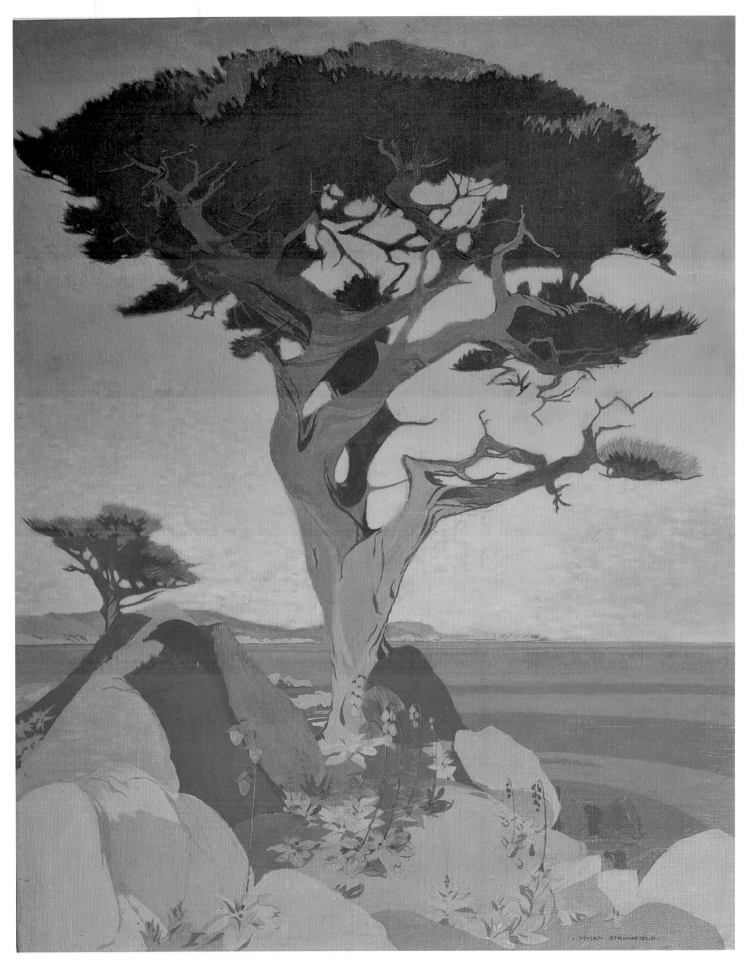

Monterey Cypress, c. 1925, oil on canvas applied to artist board, 30 × 24 in., signed l/r.
Courtesy of the Stringfield family. Photo: Martin A. Folb, PhD. Exhibited: Painters
and Sculptors of Los Angeles Exhibition, 1926.

Untitled (Cottage), n.d., colored woodblock
on paper, 6 × 4 in., unsigned. Courtesy of the
Stringfield family. Photo: Martin A. Folb, PhD.

Artist's Hand-carved Wood Block (and an example of its impression),
n.d., carved wood, 5 × 11 in. Courtesy of the Stringfield family.
Photo: Martin A. Folb, PhD.

Artist's Hand-carved Wood Block (and an
example of its impression), n.d., carved wood,
5 × 11 in. Courtesy of the Stringfield family.
Photo: Martin A. Folb, PhD.

Easter Greeting (Holiday Card), c. 1918, colored woodblock on
tissue paper, 4 × 4 in., House of KHS monogram verso. Courtesy of
the Stringfield family. Photo: Martin A. Folb, PhD.

A Joyful Christmas to You (Holiday Card), c. 1918, colored woodblock on paper, 6 × 5 in., artist's monogram l/l. Courtesy of the Stringfield family. Photo: Martin A. Folb, PhD.

Vivian Stringfield, Fannie Kerns, and Marjorie Hodge became business partners in their greeting card business, House of KHS (the greeting cards were of limited production, each one was a work of art, either a print or illustration designed and then hand-painted by the artists). They had exhibitions, which included the cards, titled *Decorative Landscapes and Textiles* at The Museum of History, Science, and Art, Exposition Park, Los Angeles.

Wishing You A Joyful Christmas (Holiday Card), c. 1918, colored woodblock on paper, 9 × 6.5 in., artist's monogram l/r. Courtesy of the Stringfield family. Photo: Martin A. Folb, PhD.

Merry Christmas (Holiday Card), c. 1918, colored woodblock on paper, 9 × 6.5 in., artist's script l/l. Courtesy of the Stringfield family. Photo: Martin A. Folb, PhD.

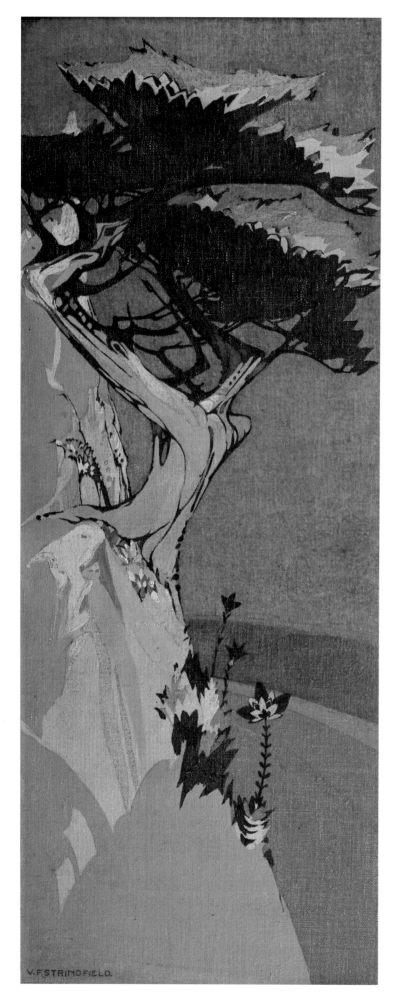

Vivian F. Stringfield (left) and an unidentified woman photographed in a playful pose, dressed in men's clothing and each holding a tobacco pipe, c. 1906. Courtesy of the Stringfield family.

Tree Panel for George, c. 1919, oil on canvas on board, 22 × 9 in., signed l/l. Courtesy of the Stringfield family. Photo: Martin A. Folb, PhD.

San Juan Capistrano (Female Figure in Period Dress by Mission Ruins), c. 1920, 14 × 14 in., signed l/r. Courtesy of the Stringfield family. Photo: Martin A. Folb, PhD.

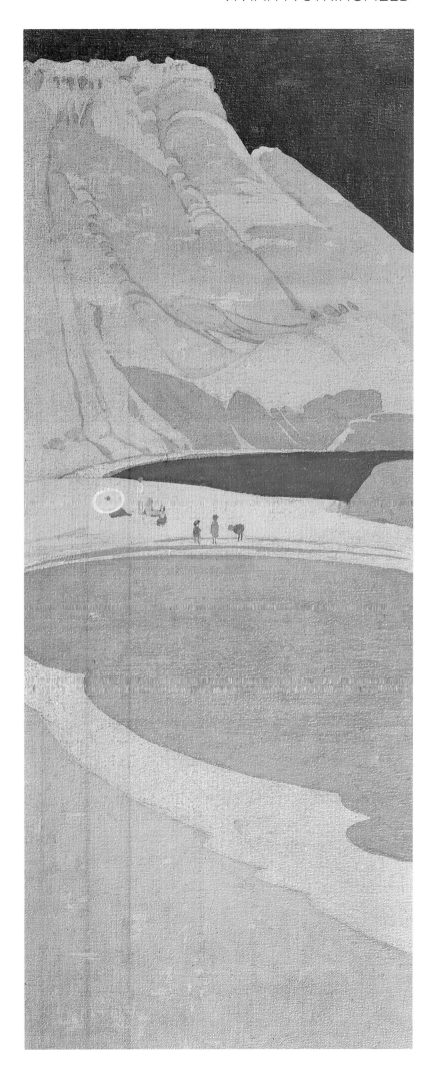

Vivian attended the Art Students League, Los Angeles, while Stanton Macdonald-Wright was the director. Founded in 1906 as a school for modern painting in defiance of the academic tradition, the Art Students League of Los Angeles was a crucial institution in the development of Southern California art. Its early instructors taught in the realist style of the Ashcan School until Stanton Macdonald-Wright assumed the directorship in 1923 and gave the school a new vitality. During his nine-year tenure, the League became a diverse center, stressing the art of the Middle and Far East as well as western Europe. Vivian embraced Macdonald-Wright's techniques and synchronistic color theories. Her works from this period are noted by the use of bright, rich, highly saturated complex colors and abstract geometrical forms of nature. She collected numerous works by Stanton Macdonald-Wright and donated many of them to museums upon her death.

It bears mentioning that Vivian did her work as an artist in a time when women artists were frequently denied access to education and studio time that male artists were afforded. Yet, she was a very independent single woman. She was an early member of the Sierra Club, drove her own car, succeeded in her educational pursuits on the east and west coasts, traveled to Europe at least twice with female companions, exhibited publicly, and was involved in the Los Angeles art scene.

Untitled (California Beach Scene), c. 1920, oil on canvas on board, 22 × 9 in., signed l/r. Courtesy of the Stringfield family. Photo: Martin A. Folb, PhD.

Vivian F. Stringfield photographed sitting on a horse, c. 1911. Courtesy of the Stringfield family.

Untitled (Japanese-Style Structures on Rocky Island), c. 1920, oil on canvas
on board, 15.75 × 15.5 in., unsigned. Courtesy of the Stringfield Family.
Photo: Martin A. Folb, PhD.

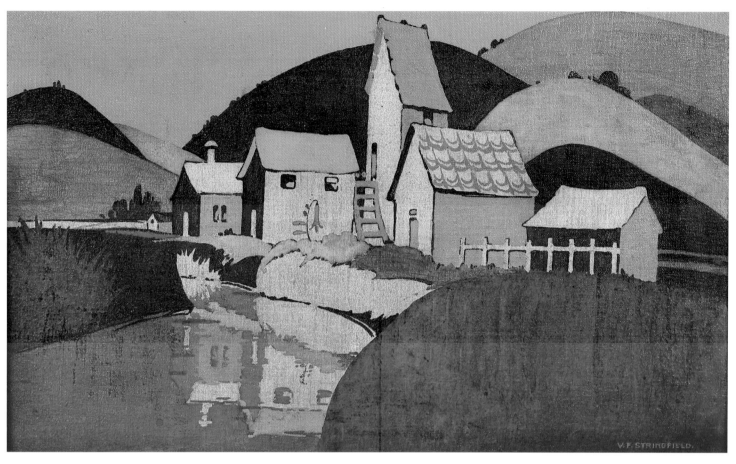

Lagoon # 16, c. 1918, oil on canvas on board, 11 × 18 in., signed l/r.
Courtesy of the Stringfield family. Photo: Martin A. Folb, PhD.

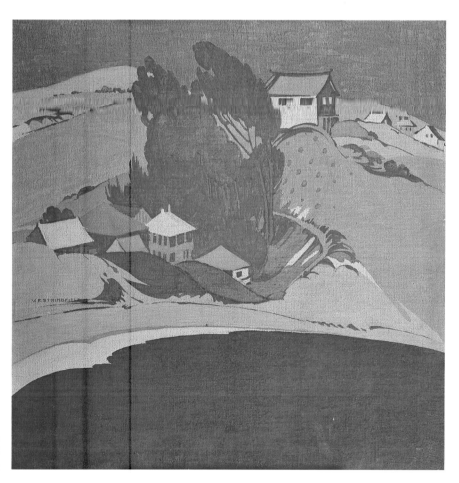

Untitled (Structures/Village by Water) n.d.
16.5 × 16.5 in., Signed l/m. Courtesy of the
Stringfield family. Photo: Martin A. Folb, PhD.

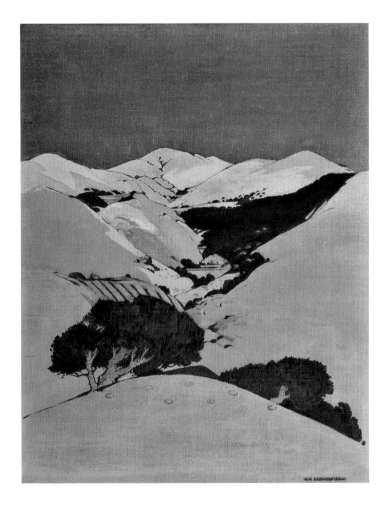

The Valley, n.d., 20 × 16 in., signed l/r,
titled verso. Courtesy of the Stringfield family.
Photo: Martin A. Folb, PhD.

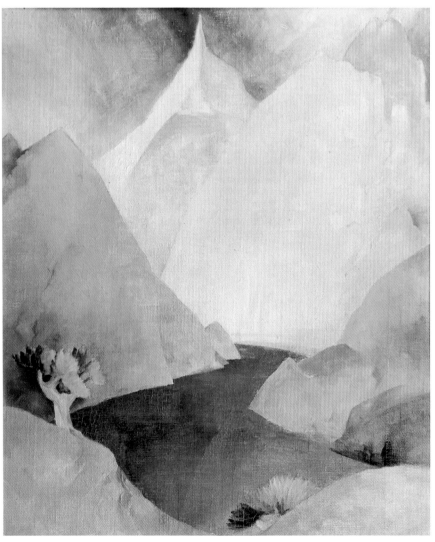

Untitled (Landscape with Lake and
Mountains), c. 1925, oil on canvas
on board, 23 × 19.5 in., unsigned.
Courtesy of the Stringfield family.
Photo: Martin A. Folb, PhD.

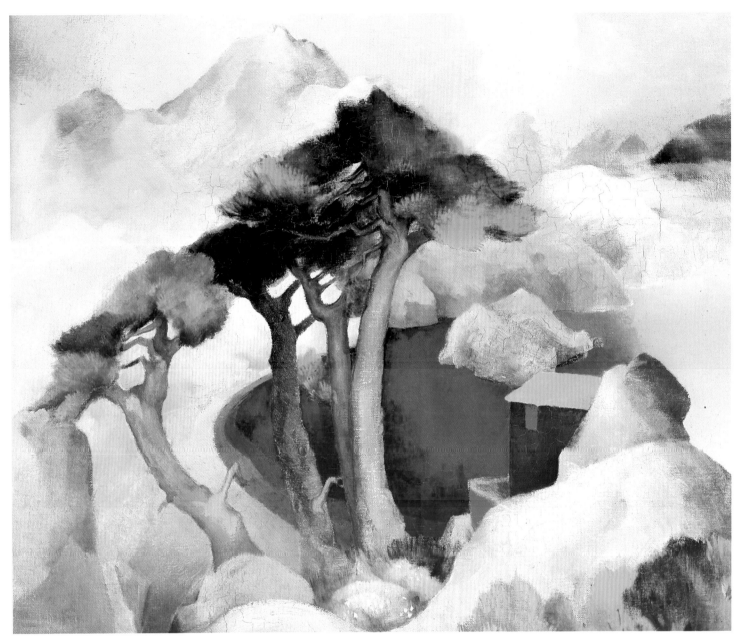

Landscape (Magical and Colorful Landscape with Lake, Trees and Structure), c. 1924, oil on canvas on board, 20 × 24 in., unsigned. Courtesy of the Stringfield family. Photo: Martin A. Folb, PhD.

Vivian Stringfield passed away in Pasadena, California, on October 25, 1933.

In 1934, a year after Vivian's death, her work was posthumously included in an exhibition with Macdonald-Wright, Nick Brigante, Conrad Buff, Thomas Craig, Charles H. Davis, Barse Miller, James Redmond, Donald R. Smith, and Phyllis Shields at the Carl Fisher Art Gallery in New York City titled *Ten Pacific Coast Painters*.

Biographical information provided by Alicia Vanden Heuvel, great-grand-niece of the artist; *American Art Annual*, 1919–33; *Dictionary of American Painters, Sculptors & Engravers*, Mantle Felding; *Publications in Southern California Art*, Nancy Dustin Wall Moure; *California Arts & Architecture artist directory*, December 1932; *Who Was Who in American Art*, Peter Hastings Falk, ed.; *A Seed of Modernism: The Art Students League of Los Angeles, 1906–1953*, exhibition publication, Will South, Marian Yoshiki-Kovinick, and Julia Armstrong-Totten; *Women Artists in America, Eighteenth Century to the Present*, J.L. Collins, MFA, University of Tennessee at Chattanooga; and *Los Angeles Times*, September 8, 1929, October 13, 1929, October 27, 1929.

Beatrice Stuart
1918–2003

Beatrice Harriet Goldberg was born on October 10, 1918, in Chicago, Illinois, the daughter of Meyer and Fannie (Plotkin) Goldberg. Known as Bea, she first studied art as a scholarship student at the American Academy of Art in Chicago with an emphasis on fashion illustration and design. After continuing her education at Northwestern University in Evanston, Illinois, also with a focus on fashion illustration and design, she moved to Los Angeles, California, with her husband David Stuart in the late 1930s. She attended classes at the University of California, Los Angeles; the Chouinard Art Institute, as a scholarship student; and at the Otis Art Institute, all in Los Angeles.

A signature member of both the California Art Club and the National Watercolor Society (twice as an elected officer/board member) and a member of Women Painters of the West, her oil, watercolor, and mixed media artworks have been exhibited at the

Beatrice Stuart, c. 1942, at her studio at 5416 West Franklin Avenue, Los Angeles, California. Courtesy of Tirage Fine Art Gallery.

National Academy of Design in New York; the Frye Art Museum in Seattle, Washington; the Academy of Arts, Honolulu, Hawaii; and, in California, at the Municipal Art Gallery, Los Angeles; the Wilshire Ebell Club; the Luckman Gallery at California State University, Los Angeles; the Pasadena Museum of History; Brand Art Library; and Los Angeles County Fair, and more.

Her numerous awards received during her career included many blue ribbons, first prizes, and two gold medals from the California Art Club's annual *Gold Medal Exhibitions*. She continued to create artworks until the last days of her life, from her Hollywood studio of over fifty years.

Beatrice Stuart passed away on December 25, 2003, in Los Angeles, California.

Biography courtesy of Tirage Gallery, Pasadena, California.

Poppies, c. 1942, oil on panel, 20 × 16 in., signed l/r.
Courtesy of Tirage Fine Art Gallery. Photo: Martin A. Folb, PhD.

Tea at Midnight (From the Teapot Series),
n.d., oil on Masonite, 20 × 24 in., signed m/l.
Collection of Kevin J. Casey.
Courtesy of Tirage Fine Art Gallery.
Photo: Martin A. Folb, PhD.

Exhibition Label affixed verso:
Still Life. Van de Kamp's Wilshire Art
Gallery, Los Angeles.

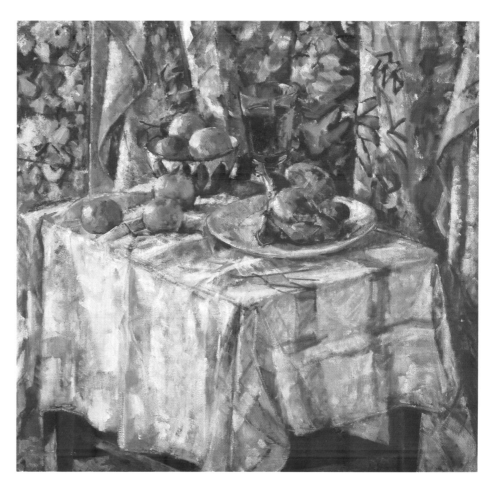

Still Life (Turkey Dinner), n.d., oil on canvas, 28 × 30 in., signed verso.
Courtesy of Tirage Fine Art Gallery. Photo: Martin A. Folb, PhD.

Beatrice Stuart photographed pulling a silkscreen print, c. 1950.
Courtesy of Tirage Fine Art Gallery.

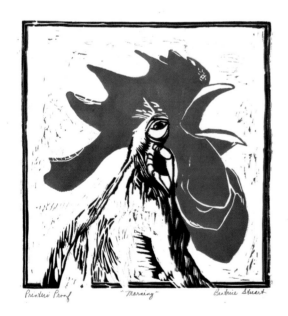

Morning, n.d., colored silkscreen print, 11.5 × 11 in.
(image), annotated: "printer's proof", signed l/r.
Collection of Kevin J. Casey. Courtesy of Tirage Fine
Art Gallery. Photo: Martin A. Folb, PhD.

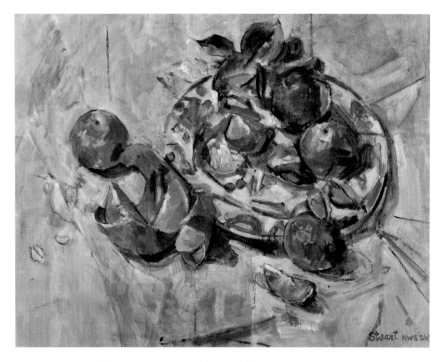

Tangerines, n.d., oil on canvas, 16 × 20 in., signed l/r.
Collection of Karen and Paul Hackett. Courtesy of Tirage Fine Art Gallery.
Photo: Martin A. Folb, PhD.

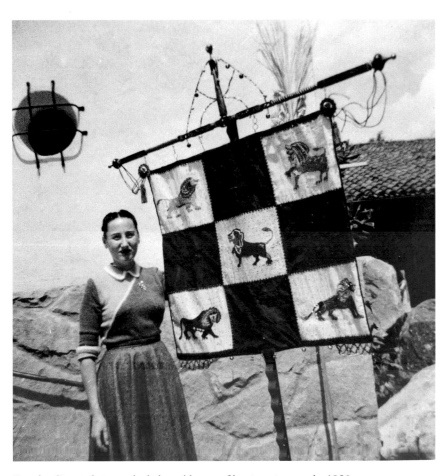

Beatrice Stuart photographed alongside one of her tapestry panels, 1956. Courtesy of Tirage Fine Art Gallery.

Detail of one panel section from Untitled (Lions - Tapestry Panel).

Untitled (Lions - Tapestry Panel), circa 1955, cotton fabric, hand embroidery, beads, pearls and sequins, 36 × 17 in., unsigned. Collection of Kevin J. Casey. Courtesy of Tirage Fine Art Gallery. Photo: Martin A. Folb, PhD. This series of tapestries was created by Beatrice Stuart in collaboration with the artist (and Catholic nun) Sister Mary Corita Kent.

Mabel Sumerlin
1879–1956

Mabel Ernestine Journeay was born on May 4, 1879, in San Diego, California, the daughter of George and Ernestine (Thomas) Journeay. She was a lifelong resident of San Diego and was educated locally. In 1900, at the age of twenty-one, she married Howard Leon Sumerlin. Her early art training came under local artist Charles Fries and later under Charles Reiffel. She was active in San Diego's art community and exhibited locally from the mid-teens forward. Her home at 4011 Ingalls Street included a converted attic with a large skylight that served as her primary studio, although for several years she maintained a studio in the Spanish Village complex in San Diego's Balboa Park.

Her oeuvre included landscapes and seascapes of San Diego County, studio still lifes, and portraits. She worked primarily in oils, often painting in a colorful style reminiscent of the Fauvists. In 1932, she was included in the *California Arts & Architecture* magazine's list of working artists in California. In 1934, more than twenty of her works were exhibited at the San Diego Women's Club. Although a complete list of her exhibitions is lacking, she was included in shows at the San Diego Art Guild, of which she was also a member, the San Diego Fine Art Gallery, and the 1935 California Pacific International Exposition in San Diego.

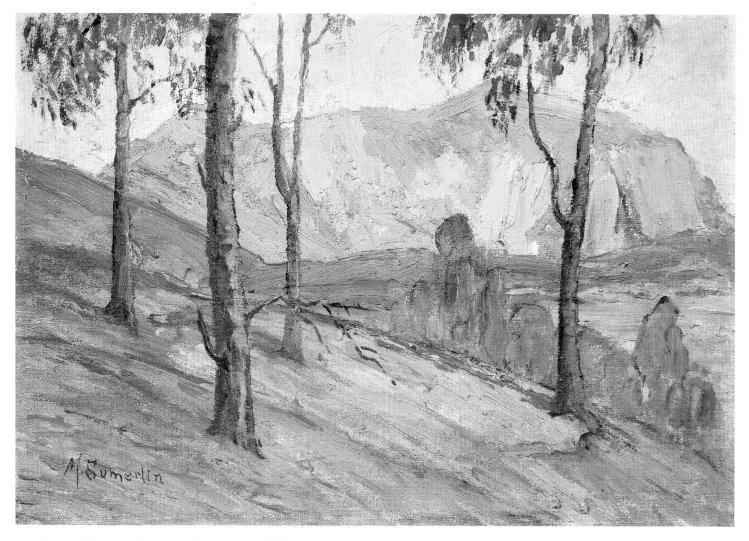

Untitled (Red Mountain with Trees), n.d., oil on board, 10.5 × 15 in., signed l/l. Collection of Gary M. Lang. Photo: Martin A. Folb, PhD.

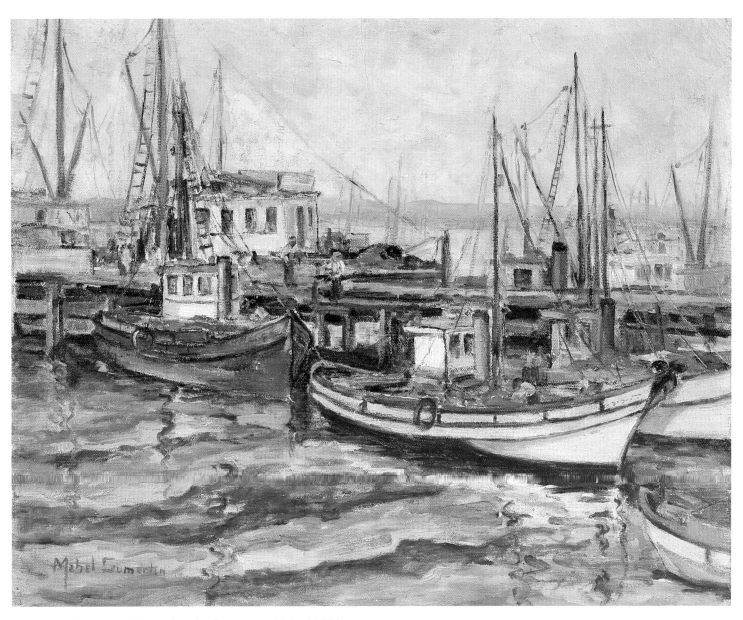

Untitled (Harbor Scene with Boats), n.d., oil on canvas, 15.5 × 18.75 in., signed l/l. Collection of Gary M. Lang. Photo: Martin A. Folb, PhD.

Mabel Journeay Sumerlin passed away on July 8, 1956, in San Diego, California.

Biographical information courtesy of the Sumerlin family, with special thanks to Robert Monson, nephew of the artist. Additional information compiled from *California Arts & Architecture* artist directory, December 1932; San Diego History Center, California; United States Census, 1880, 1900, 1920, 1940; and California Death Index.

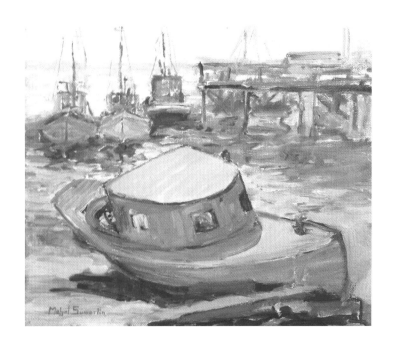

Untitled (Beached Boat), n.d., 10 × 12 in., oil on canvas, signed l/l. Courtesy of the Sumerlin family.

Untitled (Mexican Garden Wall and Doorway), n.d., oil on canvas, 8 × 10 in., signed l/l.
Courtesy of the Sumerlin family. Photo: Martin A. Folb, PhD.

Untitled (Coastal Landscape with
Orange Cliffs), n.d., oil on canvas
on board, 9 × 12 in., signed l/r.
Collection of Gary M. Lang.
Photo: Martin A. Folb, PhD.

Untitled (Fauvist - Mountain Landscape), n.d., oil on canvas, 10 × 13.5 in., signed l/r.
From the collection of Valerie Lardner. Photo: Martin A. Folb, PhD.

The Sumerlin Family, c. 1928. Mabel
Sumerlin is seated in the back row on the
left. Courtesy of the Sumerlin family.

Emily E. Syminton
1916-2002

Emily Elinor Syminton was born in Los Angeles, California, on April 18, 1916, the daughter of Gilbert J. and Inez Louise (Hallett) Syminton. Her father was a co-founder of the Richfield Oil Company.

Emily enrolled at the Chouinard Art Institute upon her high school graduation. She remained at Chouinard for three years before enrolling in the Accademia di Belle Arti di Firenze (Academy of Fine Arts of Florence), Italy. This was at a time when Italian Prime Minister Benito Mussolini was allowing foreigners into the country to attend the Accademia free of charge. The practice proved to be an annoyance to many of the teachers, especially because many of the foreign students, including Emily, did not speak Italian, making instruction difficult.

She returned to California and enrolled at Scripps College, Claremont. Studying under Millard Sheets, who proved to be an influence on her own work, she received her master of fine arts degree from Scripps. After graduation, she worked as a teacher in Pasadena at the private Westridge School for Girls, followed by a move to New York and a job teaching children's art classes at the Metropolitan Museum of Art. After her time in New York, she was employed by several of the large casinos in Las Vegas, designing and painting murals for the Sahara, Dunes, and Riviera casinos.

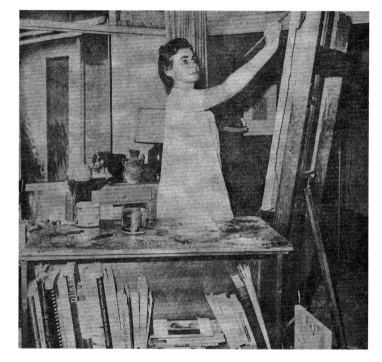

Reprint: *Pasadena Star-News*, July 18, 1965: Emily Syminton photographed in her new studio located in Pasadena. The newspaper caption states: "She will be painting full-time after years of teaching art."

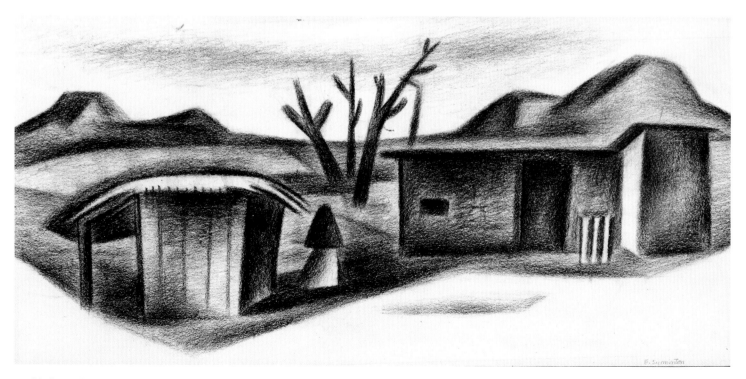

Untitled (Mexican genre scene), n.d., charcoal on heavy paper, 7 × 14.5 in., signed l/r.
Private collection. Photo: Dr. Martin A. Folb.

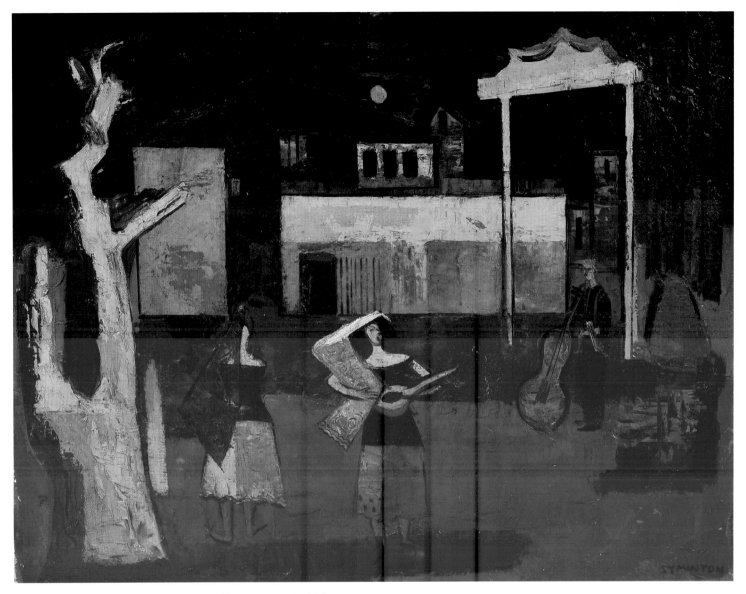

Untitled (Musicians in a Courtyard), 1947, oil on canvas, 16 × 20 in.,
signed l/r. Private collection. Photo: Dr. Martin A. Folb.

From Nevada, she returned to California where she resumed her teaching career, while continuing to paint and exhibit locally. She continued to paint, exhibit, and teach for the remainder of her life.

On January 20, 1967, she married fellow artist George H. Degroat. The couple lived in Pasadena and during her marriage she added the Degroat surname to her signature and signed her work accordingly. In 1973, the couple divorced and she returned to solely using the "Syminton" surname.

A painter, muralist, and teacher, her oeuvre included Mexican and California architectural scenes, figurative, abstracts, and genre. She was a member of the Laguna Beach Art Association. She exhibited at the Oakland Art Gallery, 1939; All-California Exhibition, Painting, Sculpture, 1939; Laguna Beach Art Gallery, 1940; Los Angeles County Fair, 1940, 1941; Scripps College Annual, 1944; California Watercolor Society, 1944–1948; *Artists of Los Angeles*, Los Angeles County Museum of History, Science, and Art, 1948; Los Angeles Art Association, 1949; and more.

Emily Syminton passed away on June 9, 2002, in Pasadena, California.

Biographical information compiled from: *Los Angeles Times*, March 26, 1944, March 27, 1949; *Star-News* (Pasadena), November 8, 1964; United States Census, 1920, 1930, 1940; California Death Index.

Alice Blair Thomas
1857–1945

Alice Mary Blair Pollard was born on October 1, 1857, in Collingwood, Ontario, Canada, the daughter of William Darley Pollard, a lawyer, and Mary Stuart (Strang) Pollard. She grew up in Ontario and received her early education under a governess. She later attended the Bishop Strachan School for girls, Wykeham Hall, Ontario. She married Adolphus Richard Thomas, an English-born gentleman of Canada, in 1887, and had a daughter. Later in life, following a long residency in Toronto and then Vancouver, she joined her daughter and granddaughter in Los Angeles in 1917, where she remained until her death.

A self-taught artist who helped found both the Woman's Art Association, Toronto, and the British Columbia Society of Artists, Alice had a special affinity for outdoor subjects. Her earliest known paintings, done in the late 1890s, consisted of landscapes in the environs of Toronto. During her Canadian years, she also sketched in other parts of the country, as well as in England, Scotland, Europe, and India.

Even before settling in Los Angeles, she sketched among the mountains of western Washington and throughout the American West and exhibited her work. After moving to Los Angeles, she focused largely on California subjects, producing studies of Southern California landscapes; Monterey Peninsula scenes; the High Sierra; Laguna Beach views; and other sights. One of her canvases of the Rocky Mountains hung in a museum in Berlin, Germany, in 1928.

Alice also exhibited in shows, in Toronto, of the Toronto Industrial Exhibition, Royal Canadian Academy of Arts, Ontario Society of Artists, and Women's Art Association. Other exhibitions included Montreal Art Association; British Columbia Society of Artists; Dore Gallery and Grosvenor Gallery, London; Pasadena Art Institute,

California; and Grace Nicholson Galleries, Pasadena, California. In Los Angeles, she exhibited at Kanst Gallery; West Coast Arts, Inc.; MacDowell Club; Gardena High School; California Art Club; and Southwest Museum,

Alice Blair Thomas passed away on April 19, 1945, in Los Angeles, California.

Biographical information compiled from: *An Encyclopedia of Women Artists of the American West*, Phil Kovinick and Maria Yoshiki-Kovinick, Austin: University of Texas Press,1998; *Los Angeles Times*, October 3, 1920, January 21, 1923, January 8, 1928; *Who Was Who in American Art*, Peter Hastings Falk, ed.; *Dictionary of Women Artists: An International Dictionary of Women Artists Born Before 1900*, Chris Petteys; *Artists of the American West: A Biographical Dictionary*, Doris Dawdy; *Dictionary of Art and Artists in Southern California before 1940*, Volume 1, 2, 3, Nancy Dustin Wall Moure; *Los Angeles Times*, April 22, 1945 (obituary); California Death Index.

Untitled (Cottage), n.d., oil on board, 4 × 4 in., signed l/l. Private collection. Photo: Martin A. Folb, PhD.

Untitled (Landscape), n.d., oil on canvas on board, 12 × 9 in., signed l/l.
Private collection. Photo: Martin A. Folb, PhD.

Flowering Trees, 1942, oil on canvas on board, 16 × 11.25 in., signed and dated l/l. Private collection. Photo: Martin A. Folb, PhD.

Untitled (European River Scene), n.d., oil on canvas, 20 × 16 in., signed l/l.
Courtesy of Eric Berg, Early California Antiques. Photo: Martin A. Folb, PhD.

Jane McDuffie Thurston
1887–1967

Jennie Lee Duffie was born in Ripon, Wisconsin, on January 9, 1887, the daughter of newspaper publisher, college professor and business executive George Carlton and Mary Emma (Harwood) Duffie. Prior to 1918, the family used "Duffie" as their surname. After 1918, upon their move from Wisconsin to California, they resumed the use of their original surname "McDuffie."

She studied at the National Park Seminary, Forest Glen, Maryland, a private girls finishing school that emphasized education in the arts, from 1903 to 1906. Later, she studied at the Art Institute of Chicago, 1910 to 1912, and then in Los Angeles with Richard E. Miller, Jean Mannheim, and C. P. Townsley.

When she moved to California, she assumed the name "Jane McDuffie" which she used throughout her life. The family settled in Pasadena by 1918; some city records indicate they may have arrived as early as 1916. Jane worked first as an instructor at the Stickney Memorial Art School, Pasadena, created in 1912 by artist Jean Mannheim, and later at the Pasadena Art Institute. In 1923, she married Carl Hammond Philander Thurston in Washington, DC. Thurston, whom she had met in Pasadena, became a noted author on art, as well as an art critic and one of the founders of the Pasadena Art Institute. For many years the couple lived in the family home at 550 West California Street, Pasadena, although

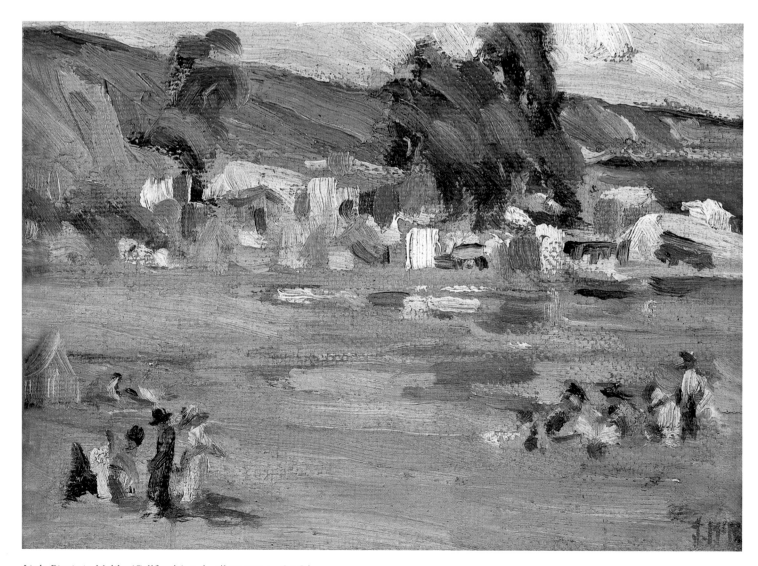

Little Picnic in Malibu (California), n.d., oil on canvas, 6 × 8 in., initialed l/r: J McD. Courtesy of Rudy and Jo Ann Summers. Photo: Martin A. Folb, PhD.

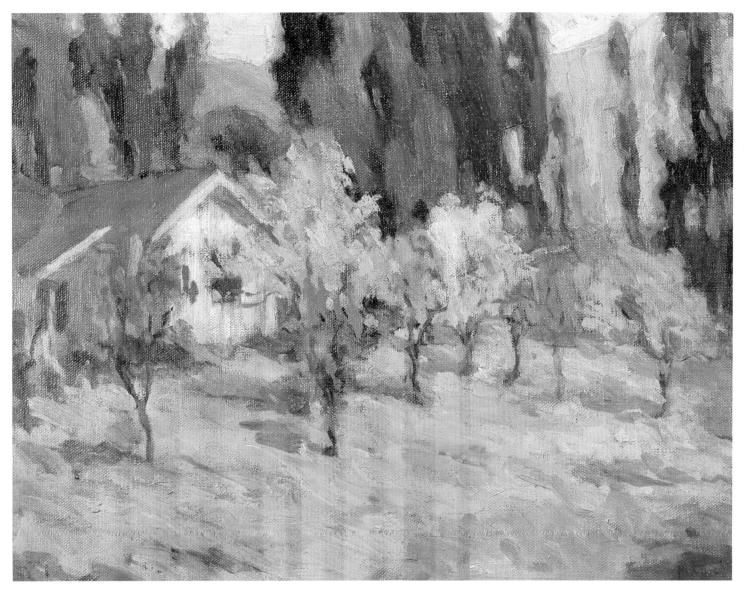

Untitled (Altadena House and Orchard), n.d., oil on canvas, 14 × 18 in.,
signed l/r: "McDuffie". Private collection. Photo: Martin A. Folb, PhD.

they spent several years as residents of San Francisco and Tujunga,
California. After her husband's death in 1946, she lived in a home
adjacent to Jean Mannheim's studio/residence on the Arroyo Seco
in Pasadena.

A painter, etcher, author, and producer of art-related films,
Jane was active primarily in Southern California. Her subjects
included landscapes, figures, and genre. In the 1950s, she began
making art films with artists Richard Taggart, Jean Mannheim,
Alson Clark, and others.

Her exhibitions included Women Painters of the West, 1922
(prize); California Art Club, 1921–1928; West Coast Arts, 1923;
Pasadena Art Institute, 1925,1926, 1927; Laguna Beach Art
Association; California Watercolor Society, 1930, 1946, 1960;
Pasadena Society of Artists, 1946, 1955; Los Angeles County
Museum of History, Science, and Art, 1945, 1946; and more. She
was a member of the: American Art Association, 1923–24,
1925–1933; and Western Women Art Association, 1936–1962

Jane McDuffie Thurston passed away on May 6, 1967, in
Los Angeles, California

Biographical information based on Maurine St. Gaudens's
interview with artist Richard Taggart, 1985; *Artists of the American
West: A Biographical Dictionary*, Doris Dawdy; *Who Was Who
in American Art, 1564–1975*, Peter Hastings Falk, ed.; United
States Census, 1900, 1910, 1920, 1930, 1940, and California
Biographical Index Cards, 1781–1990, California State Library.

Florence H. Tompkins
1883–1963

Florence H. Johnson was born in Washington, DC (although, various records indicate Newark, New Jersey), on September 3, 1883, the daughter of Joseph R. and Charlotte (Holbrook) Johnson. She grew up in Washington, where she began her formal studies at the Corcoran Gallery School of Art.

In 1905, in Washington, she married Harry James Tompkins, a ranger with the United States Forest Service. Soon after their marriage the couple moved to California, taking up residence in the state's High Sierras and later in Berkeley, where she studied with the artist Armin Hansen. By 1920, they were residents of

Pasadena, California, where they remained. While in Pasadena, she studied with the artists Ejnar Hansen and Conrad Buff. After her husband's death in 1949, she married DeWitt Clinton Lusk; the marriage was brief as he passed away in 1951.

Primarily a watercolorist, her oeuvre includes landscapes of American and European scenes. A teacher as well, she was active in numerous civic and art associations and was a member of the California Watercolor Society; California Art Club; Women Painters of the West; Artists of the South West; National Society of Arts & Letters, Pasadena Chapter (President,1953); Laguna Beach

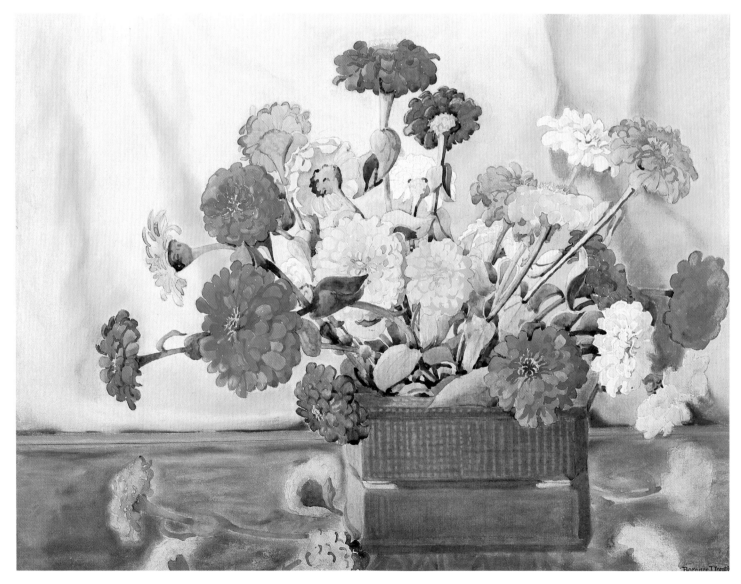

Untitled (Still Life with Zinnas), n.d., watercolor on paper, 20 × 26 in., signed l/r.
Collection of Muriel Saint-Gaudens Gee. Photo: Martin A. Folb, PhD.

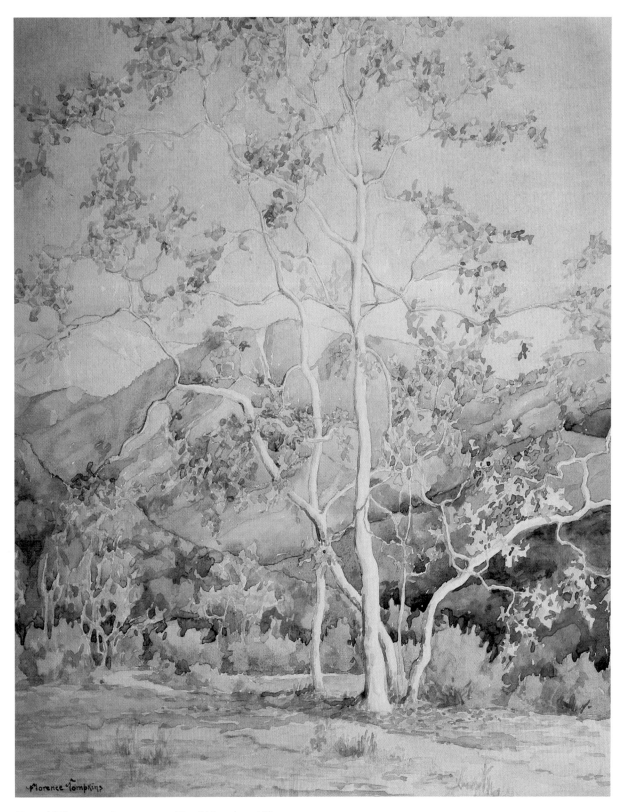

Trees, 1919, watercolor on paper, 17 × 14 in., signed l/l.
Collection of Muriel Saint-Gaudens Gee. Photo: Martin A. Folb, PhD.

Artist Association; Valley Artists Guild; Glendale Art Association; and Pasadena Art Association. Her exhibitions included California State Fair, 1935; California Art Club, 1941; Friday Morning Club, Los Angeles, 1941–52; Ebell Club, Los Angeles, 1942–1944; Laguna Beach Art Festival; Glendale Art Association, 1947; Bowers Museum, 1947; Greek Theatre, Los Angeles, 1948,1949; and more.

Florence Tompkins Lusk passed away on May 8, 1963, in Pasadena, California.

Biographical information compiled from: *Who's Who In American Art, 1953*, Dorothy B. Gilbert, ed.; *Women Artists in America*, Jim L. Collins, 1973; *Dictionary of Women Artists: An International Dictionary of Women Artists Born Before 1900*, Chris Petteys; *Star-News* (Pasadena), May 16, 1941, May 9, 1963 (obituary); *Independent Star-News* (Pasadena), February 9, 1964; California Death Index; California State Library, Biographical Index Cards, 1781–1990; and United States Census, 1910, 1920, 1930.

Mary Travis
1893–1976

Mary Harriet Simpson was born on August 28, 1893, in Van Buren, Michigan. She was the daughter of Frank G. and Leona (Johnson) Simpson. Raised in Michigan, Mary graduated in 1915 from Western State Normal School in Kalamazoo, Michigan, where she earned her teaching certificate with advanced credits in art. Additional information concerning further education or art studies is lacking. On June 24, 1921, in Flint, Michigan, she married Hiram Wayne Travis. The couple moved to West Frankfort, Illinois, and later to Greenup, Illinois, where their son, Wayne, was born in 1925. The family later returned to Flint, where they remained from the late 1920s through the early 1930s. In Flint, Mary first began showing her work in local exhibitions. By 1935, the family had relocated to California, living at 2715 Channing Way, Berkeley. Beginning in the late 1930s and through the early 1950s, her work was included in numerous exhibitions in the San Francisco Bay Area. By the mid-1950s, the family were residents of Fresno, California, where they remained.

Mary Travis, c. 1920. Courtesy of the Travis family.

Mary's oeuvre includes watercolors and woodblock prints. Her father was a master woodcarver and his instruction undoubtedly contributed to and influenced her skill in creating the woodblocks she used for her prints. Although a complete list of her exhibitions is lacking, they included Flint Institute of Arts, Michigan, 1935; and, in California, Golden Gate International Exposition, *Exhibition of Works By California Artists*, San Francisco, 1940; Bay Region Art Association, 1940; Oakland Art Gallery, 1940; and San Francisco Art Association 5th Annual Watercolor Exhibition, 1941. Throughout the 1940s, her work was sold through the S. & G. Gump Company, San Francisco.

Mary H. Travis passed away on June 10, 1976, in Fresno, California.

Biographical information compiled from various exhibition labels (verso art); United States Census, 1910–1940; Flint (Michigan) City Directory, 1930; Berkeley and Fresno, California, City Directories; and California Death Index. Special thanks to Michael Travis, grandson of the artist.

Untitled (The artist's son and his dog dockside), n.d., colored woodblock print on paper, 5.4 × 6.5 in. (image), signed verso. Courtesy of the Travis family.

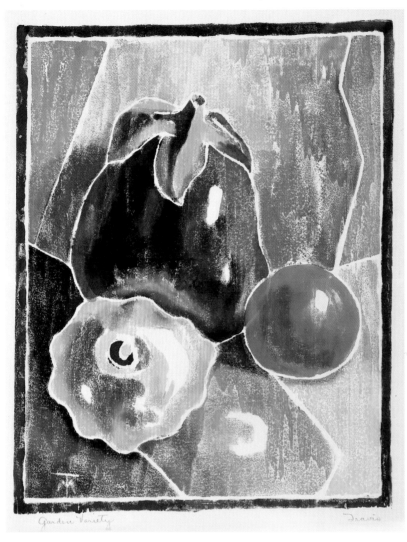

Garden Variety, n.d., colored woodblock print on paper, 10 × 8 in. (image), monograph in print l/l, signed l/r. Courtesy of Roger Genser and The Prints and the Pauper. Photo: Martin A. Folb, PhD.

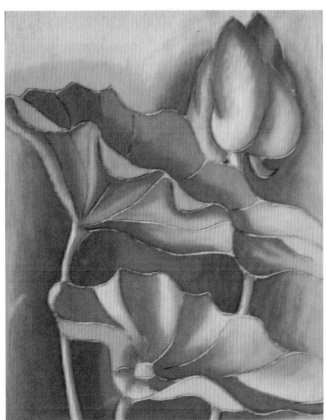

Printer's Block (for *Lotus Flower*), n.d., hand-carved wood. Courtesy of the Travis family. Photo: Martin A. Folb, PhD.

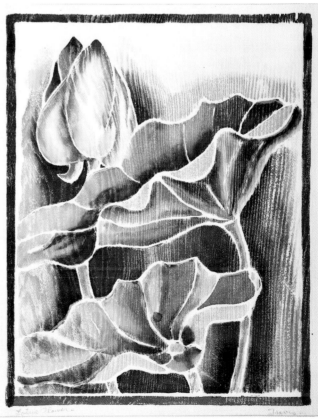

Lotus Flower, n.d., colored woodblock print on paper, 10 × 8 in. (image), signed l/r. Courtesy of Roger Genser and The Prints and the Pauper. Photo: Martin A. Folb, PhD.

Unidentified Planes, n.d., watercolor on paper, 12 × 19 in., signed l/r. Courtesy of the Travis family.
Photo: Martin A. Folb, PhD. Exhibited at the Oakland Art Gallery, Oakland, California.

Circus Siesta, n.d., watercolor on paper, 14 × 19 in., signed l/l and annotated verso.
Courtesy of the Travis family. Photo: Martin A. Folb, PhD. Exhibited at the Twelfth
Annual State-wide Exhibition, California.

Untitled (Mexico Plaza Scene),
watercolor on paper, 15 × 18 in.,
signed l/r and annotated verso.
Courtesy of the Travis family.
Photo: Martin A. Folb, PhD.

Untitled (Hoover Tower - Stanford
University, California), n.d., watercolor
on paper, 17 × 14 in., signed l/r and
annotated verso. Courtesy of the Travis
family. Photo: Martin A. Folb, PhD.

Janet Turner
1914–1988

Janet Elizabeth Turner was born on April 7, 1914, in Kansas City, Missouri, the daughter of James Ernest and Hortense (Taylor) Turner. She grew up in Kansas City and showed an early interest in nature, aspiring to become a biologist. However, after enrolling at Stanford University in California, she dropped the biology program in her junior year; she changed her major to Far Eastern history, in which she earned her bachelor of arts degree. During her junior year at Stanford, she became interested in art and took some drawing classes and first worked in linocuts.

After graduating in 1936, she visited the Far East, where she was exposed to Eastern printmaking methods. Upon her return, she attended the Kansas City Art Institute from 1937 to 1941, studying painting with Thomas Hart Benton and graphic arts mainly

with John De Martelly. Upon receiving her diploma, in 1941 she returned to California and began teaching the Girl's Collegiate School in Claremont. Additional painting study followed under Millard Sheets and Henry McFee at Claremont Graduate University, where she received her master of fine arts degree in 1947. The same year she accepted a position teaching art at Stephen F. Austin State College in Nacogdoches, Texas.

During this period she began to experiment with printmaking and exhibited her work extensively. Subsequently, she studied the art of serigraphs with Edward Landon and attended Columbia University Teachers College in the summer of 1952 and from 1956 to 1958, completing her doctorate in education at Columbia in 1960. In 1952, she was awarded a Guggenheim fellowship that

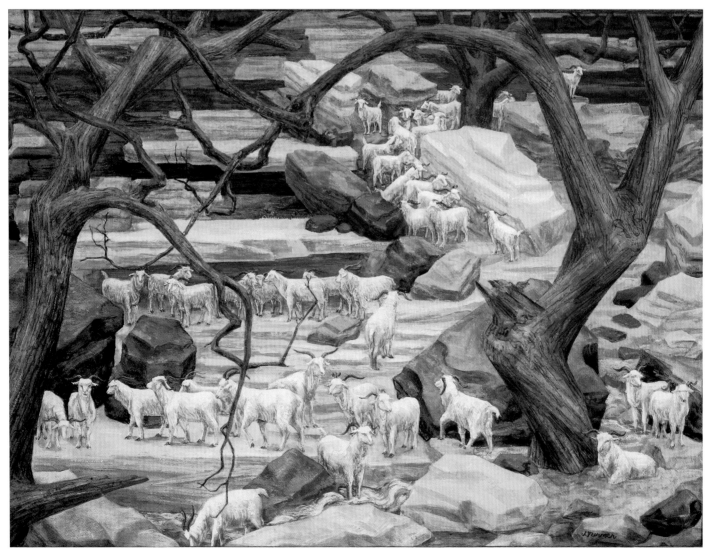

Mountain Goats in Pinyon Canyon, 1941, watercolor on paper, 21.75 × 30 in., signed l/r.
Collection of Jim and Virginia Moffett. Courtesy *American Art Review*.

enabled her to experiment in combining serigraph and linoleum techniques; it was this combination of print methods that became the technique for which she is best known. In 1959, she began her association with California State University at Chico, becoming a full professor of art in 1968 and remaining there until her retirement in 1983.

The West remained a dominant source for Janet's art subjects throughout her life. Working in a variety of mediums but primarily as a graphic artist, she depicted small town and rural scenes, wildlife, and the California landscape, which continued to provide a source of inspiration in her art.

Janet first displayed her work in Kansas City around 1937 while a student at the art institute. In the following five decades, she exhibited at shows in every state and in fifty countries on six continents. Among major group exhibitions in the United States, she had works included at the Metropolitan Museum of Art's *American Painting Today,* 1950, and *Watercolors and Prints*, 1952; at the New York World's Fair, 1964–1965; and in important print annuals or biennials of the National Academy of Design, New York; the American Color Print Society; the Brooklyn Museum; the Print Club of Philadelphia; and the Society of American Graphic Artists. Her solo exhibitions of paintings and prints were held in the United States, Israel, and Japan. In 1981, in connection with California State University at Chico, when Janet was a professor emeritus at the school, the Janet Turner Print Museum was opened.

Janet Turner passed away on June 27, 1988, in Chico, California.

Biography, with thanks, from: *An Encyclopedia of Women Artists of the American West*, Phil Kovinick and Marian Yoshiki-Kovinick, Austin: University of Texas Press, 1998.

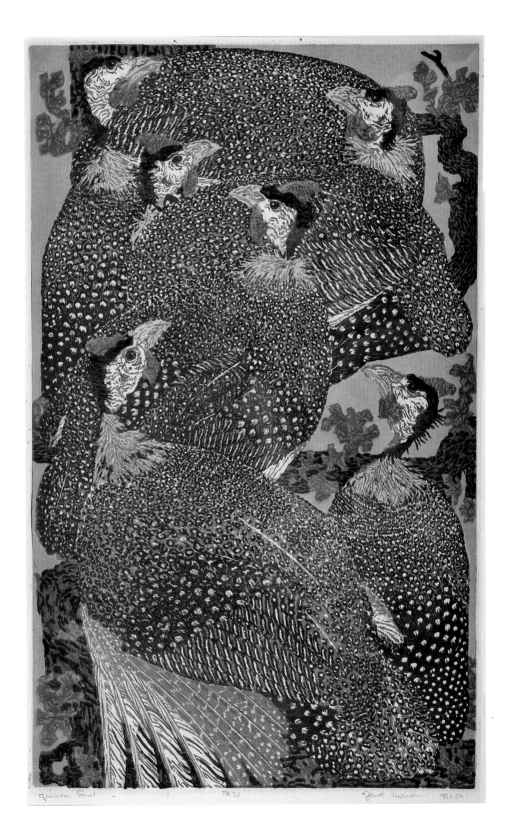

Guinea Fowl, 1952, color linocut on paper, 16.5 × 10.5 in., signed l/r, ed. 75.
Courtesy of Roger Genser and The Prints and the Pauper. Photo: Martin A. Folb, PhD.

Muriel Tyler
1892–1977

Muriel Leone Dexter was born on January 15, 1892, in Los Angeles, California, the daughter of William W. and Ida A. (Gutterson) Dexter, and according to family genealogy a direct descendent of several of the original signers of the Mayflower Compact. Muriel was raised and educated in Los Angeles. In 1913, she married Arthur Wisner Tyler, who became a successful land developer and commercial builder in Los Angeles. After his death in 1934, Muriel assumed the role of managing the family real estate interests.

In the 1940s, Muriel enrolled at the Chouinard Art Institute in Los Angeles. One of her instructors at Chouinard was the artist Myron Chester Nutting. The couple married in 1948.

One of the earliest public showings of her art was in the Los Angeles Art Association's *Painters You Should Know* exhibition in 1946. The *Los Angeles Times* art critic Arthur Millier noted in his review of the exhibit that "Muriel Tyler paints a beautifully colored and textured world of her own imagining in some of the most sensitive 'abstractions' ever made here."

The Stone, c. 1948, color lithograph on paper, 8.25 × 9 in., ed. 15, signed l/r. Courtesy of Tobey C. Moss Gallery, Los Angeles, California.

Surrealist Landscape, c. 1948, color lithograph on paper, 10 × 11.75 in., signed l/r. Courtesy of Tobey C. Moss Gallery, Los Angeles, California.

Epithalamium, c. 1947, color lithograph on paper, 10.25 × 11.75 in.,
signed l/r. Courtesy of Tobey C. Moss Gallery, Los Angeles, California.

In 1947, she participated in group shows of nonobjective art, first at the Art Institute of Chicago, Illinois, where she exhibited the lithograph *Fantasy Abstraction*, and then at the Coronado Gallery, Los Angeles, California. Beginning in the late 1940s, in Los Angeles, she exhibited with the Royar Gallery. Also in the late 1940s and early 1950s, she produced work at Lynton Kistler's Lithography Studio. Kistler, known as a master lithography printer, worked with many Los Angeles artists during this period. The three images presented here all bear the Kistler blind stamp (a colorless impression that is embossed without ink onto a print as a distinguishing mark for the artist or owner), which was used between 1948 and 1951.

The Nuttings' involvement in the Southern California arts community was well known and together they maintained a studio in their home where they taught art for many years. Their joint archive papers are included in the Smithsonian Institution's Achieves of American Art in Washington, DC. Muriel Nutting continued to paint into the 1970s.

Muriel Tyler Nutting passed away on September 14, 1977, in North Hollywood, California.

Biographical information compiled from: *The Annual Exhibition Record of the Art Institute of Chicago, 1888–1950*, Sound View Press, Peter Hastings Falk, 1990; *Who Was Who In American Art, 1564–1975*, Peter Hastings Falk, ed.; and *Los Angeles Times*, February 10, 1946, June 11, 1950. Special thanks to Terri Tyler O'Conner and the Tyler family.

Althea Ulber
1897–1991

Althea Ulber was born on July 27, 1897, in Los Angeles, California, the daughter of the artist Julius E. Ulber and Anna Marguarita (Keusthardt) Ulber. She first studied with her father and later at the Chouinard Art Institute, as well as in Munich, Germany, and Vienna, Austria, with Hans Hofmann and Joseph Binder, and with A. D. Roziare, Frank Tolles Chamberlin, and Stanton MacDonald-Wright in California. She taught in the children's department at Chouinard Art Institute in Los Angeles from 1921 to 1941 and again in the early 1950s. During the 1930s, she was active with the Federal Art Project of the Works Projects Administration and many of her murals and lithographs were completed under this program. In the 1940s, she worked as a fabric designer with Johnson & Faulkner and Arthur H. Lee in New York. Although she remained a resident of California for the better part of her life, she later moved to Hawaii, where she remained until her death.

Althea Ulber photographed c. 1935 in her studio at 1053 South New Hampshire Avenue in Los Angeles, California. Courtesy of Althea Harper, niece of the artist.

Navajos, 1937, lithograph on paper, 7 × 8 in., signed l/r. Courtesy of the Roberts Art Gallery, Santa Monica High School, California. Photo: Martin Ledford.

In addition to her many years as a teacher, her oeuvre includes her work as a painter, printmaker, sculptor, muralist, and designer. She was a member of the National Society of Mural Painters; California Art Club; and Art Teachers Association of Southern California. Her exhibitions included California Art Club, 1925–28; Painters & Sculptors of Los Angeles, 1924–35; Pasadena Art Institute, 1928; California State Fair, 1930; American Painters & Sculptors, Los Angeles County Museum of History, Science, and Art, 1931; Pottinger Gallery, Los Angeles, 1938; and, in California, Gardena High School, 1949–1951, and Paramount High School, 1955 (prize). Her works are found, in California, in the collections of the Los Angeles County Museum of Art; Long Beach Board of Education; Roberts Art Gallery, Santa Monica High School; John Marshall High School; Jordan High School; and Gardena High School.

Althea Ulber passed away on September 26, 1991, in Maui, Hawaii.

Biographical information compiled from: *Who's Who in American Art, 1953*, Dorothy B. Gilbert, ed.; *Publications in Southern California Art*, Nancy Dustin Wall Moure; United States Census, 1910, 1920, 1930; Social Security Death Index; and *California Arts & Architecture* artist directory, December 1932. Special thanks to Althea Harper, niece of the artist.

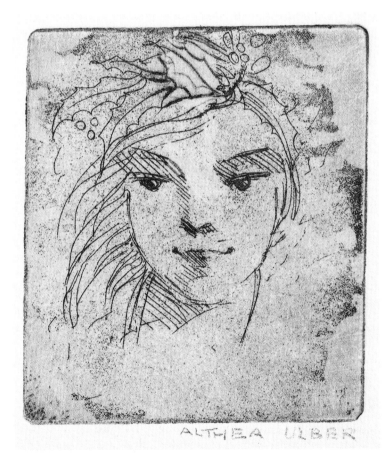

Untitled (Portrait of a Young Woman), c. 1945, etching on cream-colored paper, 3.25 x 3.25 in., signed l/r. Courtesy of Althea Harper, niece of the artist.

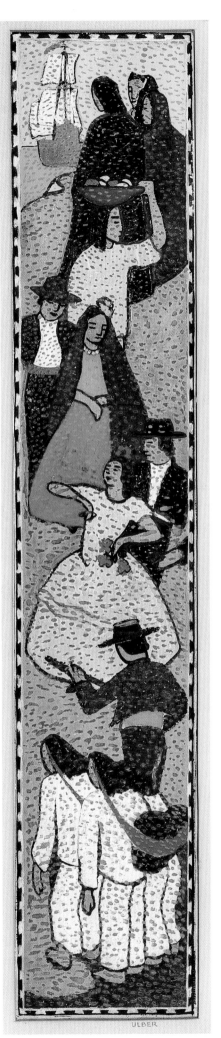

Arrival of the Explorers, n.d., oil on canvas, 23 × 4.5 in., signed l/r. Collection of Maxine and Clifton Graves. Photo: Martin A. Folb, PhD.

Nina Ullberg
1901–1993

Nina Grigorian was born on August 2, 1901, in the Baku region of Russia near the Caspian Sea in what is now Azerbaijan, the eldest child of Michail and Agolina "Lena" (Svestenov) Grigorian. At the age of three, she contracted polio and was severely crippled by the illness. In an effort to minimize the ravages of the illness, she was sent to a polio treatment center in the country's Caucasus Mountains region. Throughout her recovery, to keep her hands and feet from stiffening, she was encouraged to play a pump organ and was taught to crochet by her grandmother, a skill she would continue throughout her life. With the success of the treatment and the unrelenting motivation of her father, she regained the use of her hands and the ability to walk unaided.

The family first immigrated to the United States in 1906. However, in 1910, they returned to Russia. During this return stay in Russia, Nina's lifelong interest in art began. The impact of being exposed to lithographs depicting the Tatars, ethnic warriors in Eastern Europe and Northern Asia, and the intensity and strength she found in the work, often warriors on horseback, left a lasting impression on her, and later served as an influence in her own work.

In 1914, the family returned permanently to the United States and settled in California, where Nina began to take a serious interest in being an artist, copying Nell Brinkley's Brinkley Girl images that appeared in national newspapers. These illustrations would influence her early style. In 1918, she graduated from Lincoln High School in Los Angeles. Her father felt that because of her polio-related physical limitations she needed to have a career; hence, he encouraged her to become a teacher. This led her to enroll at the University of California at Los Angeles (UCLA).

At UCLA, she enrolled in her first formal art classes, and although she did not graduate, she continued to learn primarily through her association with a large circle of artist friends and contemporaries. In Los Angeles, on March 8, 1924, she married Axel Ullberg, a radio/electronics technician. Except for one year during the 1920s when the couple lived in El Paso, Texas, they remained California residents. In Texas, the first of their three children, daughter Michaelena, was born in 1925. In 1926, they returned to California where sons Thomas and Sven were born in 1927 and 1930, respectively. In 1938, Nina became a naturalized citizen; her friend and fellow artist Olinka Hrdy served as the witness on her naturalization application.

Nina's career as an artist began in earnest with the creation of the Works Progress Administration. During the 1930s and 1940s, she was employed by the WPA and was engaged in various forms of work, including the creation of a series of lithographs based upon the Greek mythological tale of Jason and the Golden Fleece. Throughout most of her adult life, she maintained a studio in her home, although it was not until the early 1960s when she settled in Thousand Oaks, California, that she actively began to exhibit her work. During this same time period, she altered the spelling of her given name to "Nena." During her career, her mediums included lithography, graphic art, watercolor, and oils. In 1971, at the age of seventy, she enrolled at Moorpark College and embraced the freer and more expressive styles and techniques that were then being taught. Also, in the mid-1970s, she began the first of three collaborations with the writer Jewell R. Coburn, contributing illustrations for a series of books on Southeast Asian history and folktales, including: *Beyond the East Wind: Legends and Folktales of Vietnam*, 1976; *Khmers, Tigers and Talisman: From the History and Legend of Mysterious Cambodia*, 1978; and *Encircled Kingdom: Legends and Folktales of Laos*, 1979. These award-winning publications were among Nena's proudest accomplishments.

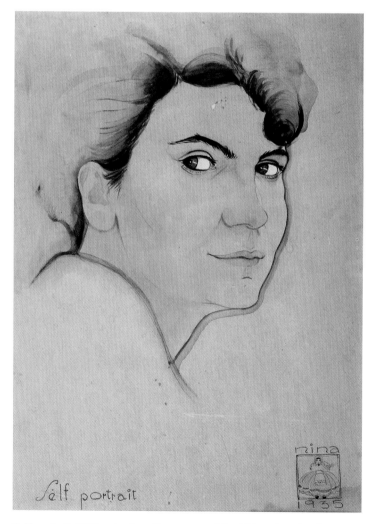

Self-portrait, 1935, mixed media on paper, 16 × 12 in., signed and dated l/r. Courtesy of the Ullberg Family. Photo: Martin A. Folb, PhD.

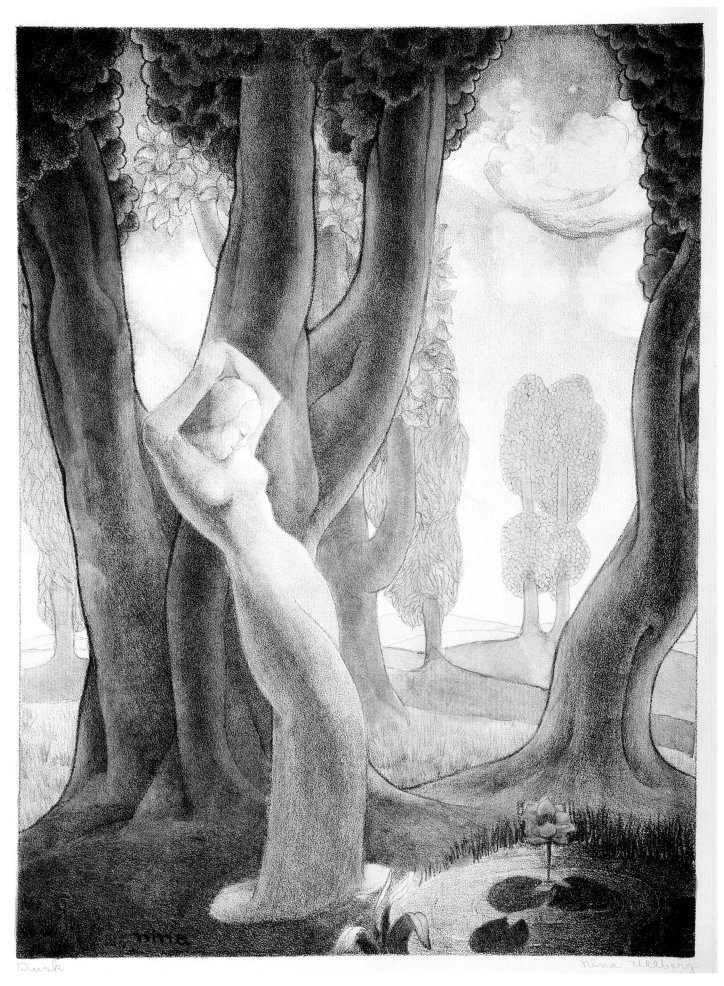

Dusk, c. 1940, colored etching on paper, 12 × 9 in., signed l/r. Courtesy of
Roger Genser and The Prints and the Pauper. Photo: Martin A. Folb, PhD.

Nena was a member of the Thousand Oaks Art Association and was a frequent exhibitor with the group as well as in exhibitions throughout Southern California. Her WPA-era work is in the permanent collection of the Roberts Art Gallery, Santa Monica High School, California; the Wexner Center for the Arts, Ohio State University, Columbus, Ohio; and the Spencer Museum of Art, The University of Kansas, Lawrence, Kansas. Nena continued to paint, draw, and exhibit her work until the end of her life.

Nena Ullberg passed away on January 5, 1993, in Thousand Oaks, California.

Biographical information from 2012 interview with Sven Ullberg, son of the artist. Additional information compiled from: United States Census, 1910, 1920, 1930, 1940; El Paso (Texas) City Directory; and California Death Index. Special thanks to Kerstin O'Mara and the Ullberg family.

The Boat of Fire (Illustration for *Encircled Kingdom: Legends and Folktales of Laos*), c. 1978, graphite on paper, 18 × 16 in., unsigned. Courtesy of the Ullberg Family. Photo: Martin A. Folb, PhD.

Untitled (Abstract Composition), c. 1970, oil on canvas, 24 × 20 in., signed l/r: "Nena". Courtesy of the Ullberg Family. Photo: Martin A. Folb, PhD.

Water Carrier, c. 1937, etching on paper, 10 × 8 in., signed l/r.
Courtesy of Roger Genser and The Prints and the Pauper. Photo: Martin A. Folb, PhD.

Kathleen Taylor Upper
1905–1955

Kathleen E. Taylor was born on February 10, 1905, in England, the daughter of Franklin T. and Ada (Holmes) Taylor. Her family immigrated to the United States and settled in Los Angeles, California, around 1913. Little is known of her education and career, however by the early 1930s, she is listed as a working artist in Los Angeles. She married Foster Blatchford Upper, also an artist, and the couple lived in Venice, California.

In 1936, the first public exhibition of work created by artists working under the Federal Art Project was held at the Los Angeles County Museum of History, Science, and Art located in Exposition Park. FAP was the visual arts arm of the Great Depression-era New Deal Works Progress Administration Federal Project Number One program in the United States. Of the three hundred and fifty artists employed in Los Angeles at the time by FAP, only seventy-five artists were represented in this first exhibition, one of whom was Kathleen Taylor Upper. In a *Los Angeles Times* review of the exhibition, the art critic Arthur Millier signaled out Kathleen's work in the exhibition and noted that "Unusual effects are gained from dissolving colored chalks in cleaning fluid by Kathleen Taylor Upper, who painted two imaginative pictures of wild horses and an island with this medium."

A lithographer, painter, and art teacher, during the 1930s, she was an employee of the Works Projects Administration. Her work is included in the Museum of Art, University of Oregon, Eugene, and the Roberts Art Gallery Collection, Santa Monica High School, California. Her exhibition history, other than the Federal Art Project Exhibition, Los Angeles County Museum of History, Science, and Art, 1936, is undocumented. She is listed in the December 1932 *California Arts & Architecture* state-wide directory of working artists living in California.

Kathleen Taylor Upper passed away on November 30, 1955, in Los Angeles, California. She is buried under the Taylor family name at Forest Lawn Cemetery, Glendale, California.

Biographical information from: *WPA Federal Art Project: Printmaking in California 1935–1943*, Elizabeth Seaton, 2005; *California Arts & Architecture*, December 1932; *Los Angeles Times*, June 4, 1936; United States Census, 1920, 1930, 1940; California Death Index; and United States City Directories.

Abstraction No. 6, n.d., lithograph on paper, 8 × 12 in., ed. 25, signed l/r.
Courtesy of Roger Genser and
The Prints and the Pauper.
Photo: Martin A. Folb, PhD.

Untitled (Surreal Composition of a Figure Seated on a Stag with Giant Bugs), n.d.,
lithograph on paper, 17 × 12 in., ed. 25, signed verso. Courtesy of Roger Genser and
The Prints and the Pauper. Photo: Martin A. Folb, PhD.

Untitled (Surreal Priestess), n.d., lithograph on paper,
17.25 × 17.25 in., ed. 25, signed verso. Courtesy of Roger Genser
and The Prints and the Pauper. Photo: Martin A. Folb, PhD.

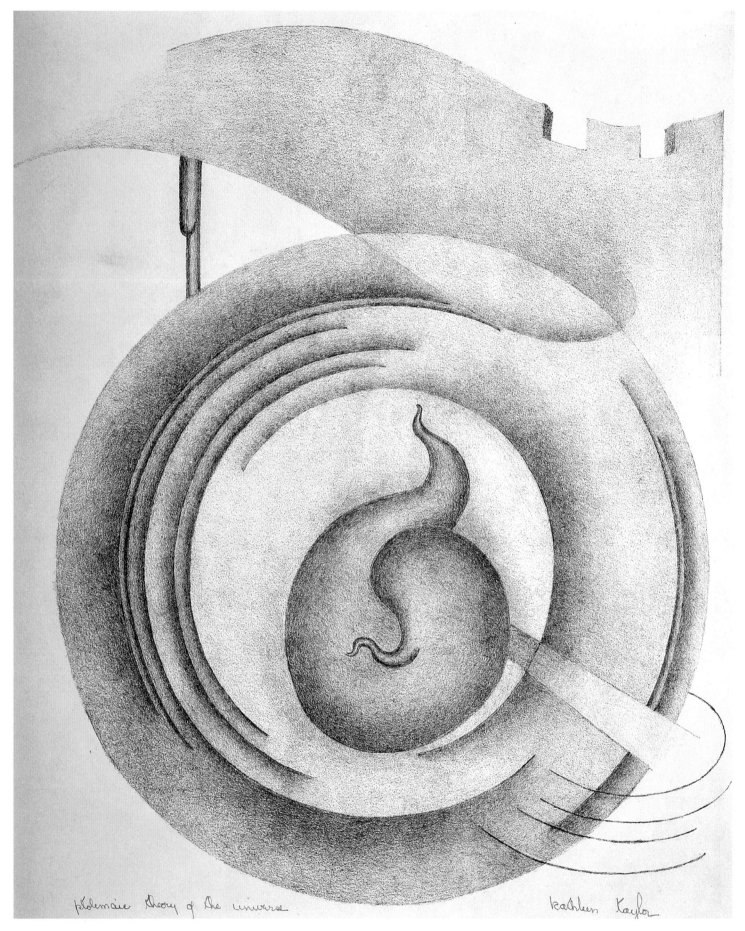

Ptolemaic Theory of the Universe, n.d., lithograph on paper, 12 × 10 in.,
signed l/r. Courtesy of Roger Genser and The Prints and the Pauper.
Photo: Martin A. Folb, PhD.

Cora A. Van Epps
1858–1947

Cora Adelaide Van Epps was born on April 2, 1858, to Henry Roosevelt and Elizabeth L. (Buck) Van Epps. Her parents moved to Peoria, Illinois, the year she was born. The Van Eppses had two daughters, and Cora was the eldest. Cora and sister Myra were raised and educated in Peoria, where their father, an inventor and manufacturer of wire and iron goods, established the Peoria Novelty Wire Works Company. Confusion exists as to the correct spelling of the family surname. The inaccuracies include: Van Eps, Vaneps, Vanepps, and VanEppe. Based on our research, and the manner in which she actually signed her artwork, it is believed that Van Epps is correct.

A complete record of Cora's education is lacking. As a young woman, she likely participated in art classes conducted by the Peoria Ladies Art Society. As with many of the young women of Peoria who wanted to study art, she may have traveled to nearby Chicago for advanced study. It is known that once the Peoria Art

League was established in 1894, she received instruction under the artist Frank Peyraud and possibly the artist Hardesty Maratta, both of whom were teachers in the early days of the Art League. At the time, there were several other notable art instructors in Peoria including the White sisters, Nona and Emily, both of whom are also included in *Emerging from the Shadows*.

An artist and teacher during her time in Illinois, Cora was active in the local art community. She exhibited frequently while maintaining charter membership in the Peoria Society of Allied Arts and the Peoria Art League, where she served as the group's assistant secretary under Emily White. Early in her career, possibly under the guidance of the White sisters, she and Myra (also an artist) produced and exhibited painted china. Cora changed her focus and proceeded to become a fine arts painter of landscapes, marines, and still lifes in both oils and watercolor.

Mr. Frank Peyrand and his art class at Shady Beach, Illinois, c. 1898. Cora Van Epps is seated (semi-reclining) on the far left of the bench. Courtesy of the Local History and Genealogy Collection, Peoria Public Library, Peoria, Illinois.

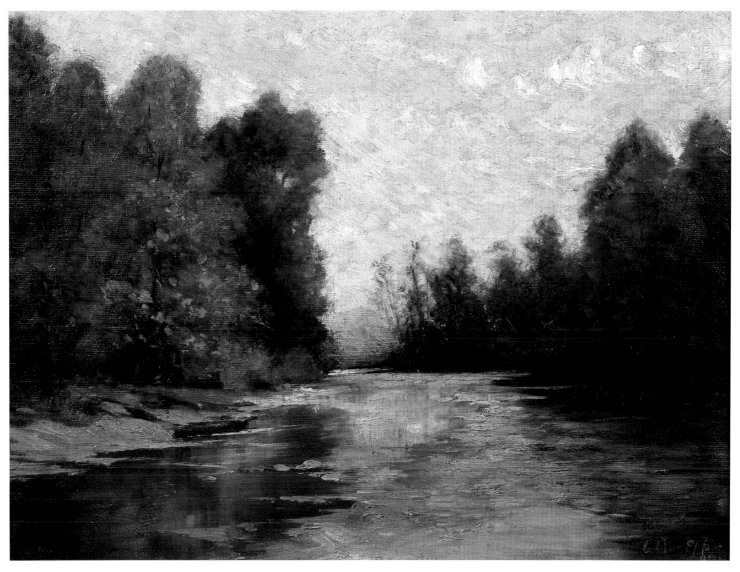

Untitled (Russian River, Sonoma County, California), 1903,
oil on canvas, 18 × 24 in., signed and dated l/r. Collection of
Maurine St. Gaudens. Photo: Martin A. Folb, PhD.

Beginning in the late 1890s, Cora began traveling throughout the United States, including extended periods of time in California. In 1908, Cora purchased property in La Jolla (Park), California. After the death of her father in 1915, seeking a milder climate, much like the White sisters had done a few years earlier, Cora and Myra moved permanently to California, dividing their time between La Jolla and Los Angeles. As a resident of California, she continued to identify herself as an artist, and was listed as such in local directories and publications, including the *California Arts & Architecture* 1932 artists directory. During her lifetime, she donated her painting *A Sunset View of the Pacific Ocean along the California Coast* to the permanent collection of the Peoria Art League. In a 1942 Peoria newspaper article, her work was described as noteworthy for "her exquisite delicate coloring in both mediums (oils and watercolor)." Although she made occasional trips back to Illinois to exhibit her work, Cora remained a resident of Los Angeles for more than thirty years until her death.

Cora Adelaide Van Epps passed away on May 19, 1947, in Los Angeles, California.

Biographical information compiled from: *Historical Encyclopedia of Illinois (History of Peoria County)*, Volume II, Newton Bateman and Paul Selby, 1902; *Women of Peoria,* Channy Lyons, 2003; *California Arts & Architecture* artist directory, December 1932; United States Census, 1880, 1910–1940; *Oakland Tribune*, Oakland, California, March 19, 1908; *San Diego Union*, January 3, 1908, January 26, 1908, February 28, 1908, March 3, 1908; *Peoria Journal-Transcript*, March 29, 1942. Special thanks to Channy Lyons for her assistance and biographical data.

Lucretia Le Bourgeois Van Horn
1882–1970

Lucretia Blow Le Bourgeois was born on June 30, 1882, in Saint Louis, Missouri, the daughter of Elizabeth Charless and Louis Le Bourgeois. When she was one year old the family moved to a sugar plantation called "Belmont" in Louisiana, where she spent most of her childhood. Her early years were marred by tragedy. Her mother died when Lucretia was three, and the family's plantation on the Mississippi River was destroyed by a breach in the river when Lucretia was ten.

At age fourteen, she went to live with her maternal aunt and uncle, Martha Blow Wadsworth and Herbert Wadsworth, a socially and politically prominent couple. The Wadsworths, who were known for their grand lifestyle, divided their time between two homes; a stately mansion in Washington, DC, where they frequently entertained during the social season, and a secondary residence, a lodge called Ashantee, in Avon, New York, where they lived during the summer months.

THE PEACOCK

The Peacock (Illustration for Helen Hay Whitney's book of poetry *Herbs and Apples)*, c. 1910, ink on paper, 5.25 × 3.5 in., signed in plate l/r. Private collection.

CARTE D'INVITATION POUR UNE EXPOSITION DE CHRYSANTHÈMES
Illustration de Mlle L. B. LE BOURGEOIS

Reprint: Cover Illustration for *Carte D'Invitation Pour Une Exposition de Crysanthemes*. Illustration by Lucretia Blow Le Bourgeois, c. 1904. Private collection.

L'Académie Julian Concours Julian-Smith prize (front and back) presented to Lucretia Le Bourgeois in 1904. Double-sided cast bronze. Private collection.

Untitled (Young Woman in Bed Surrounded by Surreal Flora), c. 1907,
ink drawing on paper, 11 × 9 in., initialed. Private collection.

When she was eighteen, Lucretia enrolled in the Art Students League of New York, where she took classes with, among others, Bryson Burroughs and Benjamin West Clinedinst. Burroughs encouraged her to continue her studies at L'Académie Julian in Paris and her aunt and uncle provided her with the financial support. A year after arriving, she won the school's premier prize, the Concours Julian-Smith, in 1904. She was the first woman in the school's history to do so. Her early works of this time period show the influence of Aubrey Beardsley.

On her return to the United States and her life in Washington, she aspired to become an illustrator and continued to create art, exhibiting but selling little. During this time, in 1907, she met Douglas MacArthur, who was serving as a military aide to President Theodore Roosevelt. MacArthur later became famous during World War II. The two fell in love. Lucretia resisted marriage, however, fearing that MacArthur was too dependent on his mother.

A year later she met Robert Van Horn who replaced MacArthur as both Roosevelt's military aide and as her lover. They married in 1908 at Ashantee. Shortly after their marriage, Robert Van Horn was assigned to Cuba for military service. It was the only occasion that Lucretia accompanied him abroad. She and her husband had two daughters: Margaret, born in 1909, and Lucretia, born in 1916. In the First World War, Van Horn was awarded the Distinguished Service Medal for leading his regiment through the German lines in November 1918.

During her marriage, her work as an artist continued. She earned occasional commissions for her meticulous illustrations in magazines and books, such as those she drew for Helen Hay Whitney's book of poems, *Herbs and Apples* (1910). In Texas, she helped form the San Antonio Conversation Society in 1924, which preserved the city's river and saved many of its historic buildings.

Untitled (Women and Children - Mexico), c. 1926, ink and charcoal on paper, 8 × 10 in., unsigned. Private collection.

Untitled (Corn Gatherers - Mexico), c. 1926, watercolor and ink
on paper, 6.5 × 4.5 in., unsigned. Private collection.

Tehuanas Bathing, (Mexico), c. 1926, ink, charcoal and graphite
on paper, 8 × 11.5 in., signed l/r and titled bottom margin.
Annotated: Property of Diego Rivera. Private collection.

In 1926, she traveled to Mexico and met Diego Rivera, who was working on a major mural project at the Ministry of Education in Mexico City. They became friends, and he invited her to join him in the completion of the work. Rivera included her portrait in one of the murals on the third floor of the education building. Rivera's friendship energized Lucretia and gave new direction to her work. She simplified her figures, flattened the perspective and mainly chose native peasant women, in outdoor activity, as her subjects. She returned to Mexico in the summer of 1927 before moving to California, where she became a major advocate for Rivera and helped prepare his visit to San Francisco.

From 1927 through 1933 she lived in Berkeley, California. She made friends with prominent artists in the Bay Area, including John Emmett Gerrity, David Park, Galka Scheyer, W. H. Clapp, Marian Simpson, and Bernard Zakheim, and also with critics and art supporters, like Jehanne Salinger, Florence Wieben Lehre, and Albert Bender. Lucretia became a member of the San Francisco Art Association and the Society of Women Artists and won several notable awards.

In 1932, her daughter Margaret contracted tuberculosis and died. Lucretia was devastated by the loss, and it appears she created very few works for a number of years. However, in May 1933, her work was included in a major international retrospective at the Legion of Honor in San Francisco; she was one of only thirty-five American artists chosen. In 1943, she participated in the San Francisco Art Association exhibition at the San Francisco Art Museum. During her married years, the Van Horns lived in many places: Cuba, Georgia, Kansas, Texas, and California. She and her husband made many friends, including the sculptor Gutzon Borglum and his family. Borglum sculpted a head of Lucretia in clay (now at Brenau University in Gainesville, Georgia).

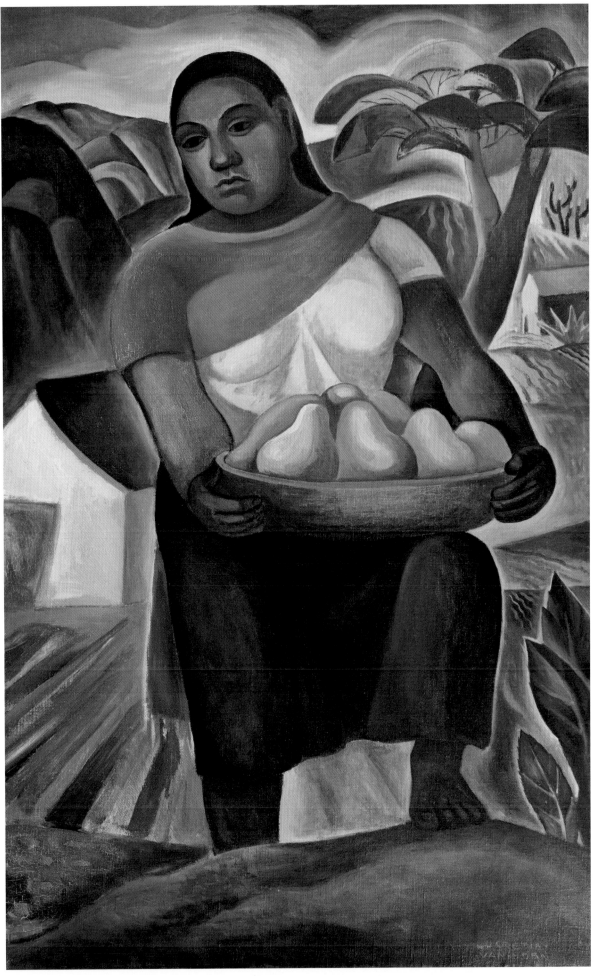

The Gatherer, c. 1926, oil on canvas, 36 × 22.25 in., signed l/r. Private collection.
Courtesy of Peyton Wright Gallery, Santa Fe, New Mexico. Provenance: Albert Bender Collection.
Photo: Dr. Martin A. Folb.

Man and Woman (Abstract), c. 1945, ink, charcoal and
graphite on paper, 19 × 12 in., signed l/r. Private collection.

Lucretia Van Horn photographed in Mexico,
c. 1926. Private collection.

Woman with Purse, c. 1930, watercolor on paper, 22 × 15 in.,
signed l/l. De-accessioned from the Estate of Marjorie Eaton.
Private collection. Photo: Martin A. Folb, PhD.

Untitled (Abstract Landscape), c. 1940, watercolor and ink on paper,
11 × 11.5 in., signed verso. Private collection.

In 1941, after her husband had retired in 1940 as brigadier general and commandant of Fort McPherson, near Atlanta, Georgia, the Van Horns returned to California. When her husband died a year later, Lucretia decided to live in Palo Alto on the Juana Briones Ranch, the home of her friend and fellow artist Marjorie Lee Eaton. There she spent the last twenty-nine years of her life. She continued to paint but appears to have stopped exhibiting after World War II. Toward the end of her life, she became friends with the artist Morris Graves and exchanged some drawings with him. Graves introduced Lucretia to marijuana, which she found a very satisfying smoke.

Her artistic evolution went through at least four distinctive phases. Her earliest works are in the manner of Aubrey Beardsley. Her illustrations reflect her attraction to the work of Maxfield Parrish. Her work of the late 1920s and 1930s were deeply influenced by Diego Rivera, and in her later years, she was drawn to the European abstractionists, especially the work of Paul Klee. However, she always maintained her own creative style. While Lucretia was primarily an illustrator through her early years, after her encounter with Diego Rivera she began to paint more frequently in oils and watercolors.

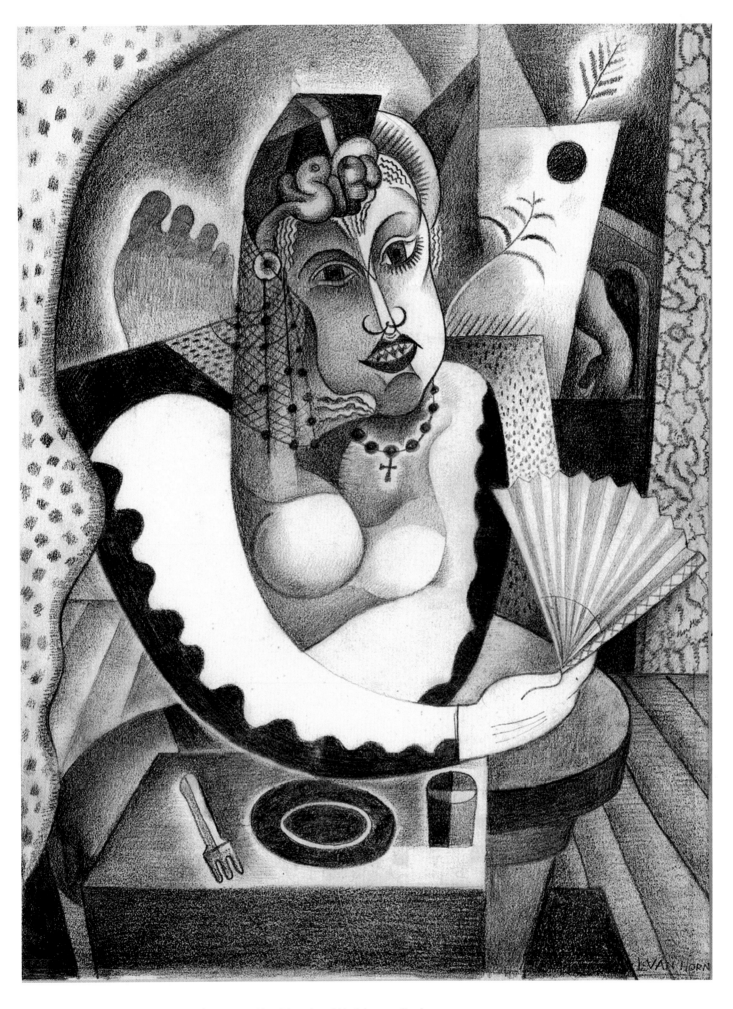

Woman with Fan, c. 1940, ink and charcoal on paper, 12 × 9 in., signed l/r. Private collection.

Untitled Male (Portrait), c. 1927, graphite pencil on paper, 16 × 12 in., unsigned. Collection of Leonard Hill.

Holy Head, n.d., ink drawing on paper, 11 × 9 in., signed l/r. Collection of Leonard Hill.

Lucretia was included in the 1932 *California Artists and Architecture* magazine's artist directory. Over the years, she exhibited at the East West Gallery, San Francisco, 1928; Oakland Art Gallery, California, 1928–1933; University of California, Berkeley, 1930; San Francisco Art Association, 1930–1946; the International Exhibition at the Legion of Honor, San Francisco, 1933; San Francisco Museum of Art, 1936; and the San Francisco Art Association exhibition at the San Francisco Art Museum, 1943.

Her works are held, in California, at Oakland Museum of California; M.H. de Young Memorial Museum; and Norton Simon Museum; and also the Minneapolis Institute of Art, Minnesota.

Lucretia Blow Le Bourgeois Van Horn passed away on July 30, 1970, in Palo Alto, California.

Biography by John Le Bourgeois and courtesy of the Le Bourgeois and Van Horn families, with additional information provided by Tom Hunt.

Untitled (Abstract Figures), n.d., watercolor on paper, 19 × 15 in., signed. Collection of Robert Van Horn Adams.

Walking Woman, n.d., graphite pencil on paper, 13 × 9 in., unsigned. Collection of Leonard Hill.

Untitled (Abstract Sunbathers), n.d., watercolor on paper, 15 × 18 in., signed l/r. Private collection. Photo: Martin A. Folb, PhD.

Hilda Van Zandt
1892–1965

Hilda C. Mutton was born in Henry, Illinois, on June 18, 1892, the daughter of Richard and Effie (Stapp) Mutton. Raised in Canton, Illinois, she moved to California where she attended the University of California, Los Angeles, graduating from the school in 1915. Employed as a teacher, she married Jerome Van Zandt in 1922. After settling in San Pedro, at 3740 Bluff Place, she taught at Fremont High School in Los Angeles. Early in her career, she studied with artists Douglas Donaldson and Stanton McDonald-Wright and in private studios in Los Angeles.

Hilda traveled widely and frequently. In 1928, she exhibited her paintings from South America in Los Angeles and she also served as a delegate to the International Federation of Arts Convention in Prague, Czechoslovakia. She lectured on the event when she returned to California. In 1929, she traveled to southern Spain and North Africa to sketch. Many of her works reflect her travels to areas that were considered exotic places at the time. Hilda was a member of the California Art Club, the California Water Color Society, The Printmakers Club, Laguna Beach Art Association, San Diego Fine Arts Society, and the Women Painters of the West. Her exhibitions included the San Francisco Art Association, 1916; California Print Makers Society, 1916–19; Women Painters of the West; California Art Club, 1919; Painters & Sculptors of Los Angeles, 1920; California Watercolor Society, 1926–36; Los Angeles County Museum of History, Science, and Art, 1928 (solo); Oakland Art Gallery, 1934; and Gardena High School, Gardena, 1940. Her work is held in the Baldwin Park Women's Club, California.

Hilda Van Zandt passed away in Long Beach, California, on July 31, 1965.

Biography compiled from: Biographical Index Card, California State Library; *Publications in Southern California Art*, Nancy Dustin Wall Moure, and *Who's Who in American Art, 1938–1941*, Alice Coe McGlauflin, ed.

Loading Bananas - Brazil, n.d., watercolor on paper, 9 × 12 in., signed l/r. Collection of Bill Stern. Photo: Martin A. Folb, PhD.

Untitled (Landscape with Rustic Cabin in Tree Grove), n.d., watercolor on paper, 12 × 18 in.,
signed l/r. Collection of Bill Stern. Photo: Martin A. Folb, PhD.

Untitled (Landscape with Rock Outcropping), n.d., watercolor on paper, 12 × 18 in.,
signed l/r. Collection of Bill Stern. Photo: Martin A. Folb, PhD.

Calthea Vivian
1857–1943

Calthea Campbell Vivian was born on March 2, 1857, in Layette, Missouri, the daughter of Harry Jackson and Nancy Boon (Cooper) Vivian. She grew up in Fayette, and, from the early 1870s, in Sacramento, California. With aspirations of becoming an artist, she first studied at the Sacramento School of Design, winning a gold medal in 1886. Following attendance at the University of California, Berkeley, 1891, and the California School of Design, San Francisco, where she studied with Arthur F. Mathews, Amadee Joullin, and Douglas Tilden, she went abroad in 1897. After attending L'Académie Colarossi and L'Académie de la Grande Chaumière, Paris, and studying with Charles Lazar in England, she lived briefly in Los Angeles in 1900, then moved to Northern California and embarked on a dual career as an artist and art teacher.

Morning Fog, 1915, oil on canvas, 21 × 15 in., signed l/l.
The Buck Collection, Laguna Beach, California.
Courtesy of Phil Kovinick and Marian Yoshiki-Kovinick.

Untitled (Hollyhocks and House), n.d., oil on canvas, 20 × 16 in., signed l/l. The Buck Collection, Laguna Beach, California.
Courtesy of Phil Kovinick and Marian Yoshiki-Kovinick.

Vivian was head of the art department at San Jose State College (now University) for most of the years between 1900 and 1916 and taught at the California School of Arts and Crafts (now California College of Arts and Crafts, Oakland), Berkeley, between 1917 and 1923. Afterward, while continuing to teach privately, she lived in Berkeley until settling in Southern California in 1938.

Vivian exhibited at the Paris Salon. Her other exhibitions included those of the San Francisco Art Association; Mark Hopkins Institute of Art, San Francisco; San Francisco Society of Women Artists; Panama-Pacific International Exposition, San Francisco; California State Fair, Sacramento; Hotel Del Monte, Monterey;

Richardson Bay, San Francisco (California), n.d., oil on artist board, 5 × 7 in., signed l/r. Courtesy of Rick and Anne Petteford. Photo: Martin A. Folb, PhD.

Stanford Art Gallery, Palo Alto; California Art Club: Painters and Sculptors of Southern California, Los Angeles Berkeley Art League; Springville Museum of Art, Utah; and Santa Cruz Art League, Santa Cruz, California. She had solo shows at the Hotel Claremont, Berkeley (1923, 1929), and the City of Paris Gallery, San Francisco (1926).

The artist, who also executed several murals, is represented in the collections of the California Historical Society and the Society of California Pioneers, both in San Francisco; Bancroft Library, University of California, Berkeley; Fine Arts Gallery of San Diego; Tweed Museum of Art, University of Minnesota, Duluth; Vassar College, Poughkeepsie, New York; Massachusetts Historical Society, Boston; and Worcester Art Museum, Massachusetts.

Calthea Vivian passed away on December 24, 1943, in Norwalk, California.

Biography, with thanks, from: *An Encyclopedia of Women Artists of the American West*, Phil Kovinick and Marian Yoshiki-Kovinick, Austin: University of Texas Press, 1998.

Grace Libby Vollmer
1884–1977

Grace Libby was born on September 12, 1884 in Hopkinton, Massachusetts, and grew up in Chelsea, just north of Boston. Her parents were both of old New England stock dating back to the seventeenth century. Her mother was a direct descendant of two of the original Mayflower Pilgrims. Grace's father, Edgar Howard Libby, was a native of Maine, and a graduate of the Massachusetts Agricultural College, Amherst (now, the University of Massachusetts, Amherst). He briefly edited an agricultural journal before achieving financial success in the 1890s by irrigating a tract of barren land in Washington state directly across the Clearwater River from Lewiston, Idaho. This eventually led to the establishment of the town of Clarkston, Washington.

Grace was educated at Quincy Mansion School for Girls in Wollaston Park, Massachusetts, a finishing school that offered courses in the arts. A number of surviving early sketches demonstrate that she had drawn from an early age. E. H. Libby moved his family to Clarkston, Washington, in 1901. There, in 1906, Grace married Ralston Vollmer, the son of John Philip Vollmer, Lewiston's leading banker and reputedly Idaho's first millionaire. A son, J.P. Vollmer II, was born in 1907 and a daughter, Anne, in 1911. Little is known of the family's activities for the next several years, although they visited Berkeley, California, as early as 1909 and lived in Los Angeles between 1910 and 1914, returning there permanently in June 1917.

Grace Libby (Vollmer), c. 1900. Collection of Peter K. Danner.

Still Life, n.d., oil on canvas, 22 × 30 in., signed l/l. Springville Museum of Art. Courtesy of Traci McFarland Fieldsted.

Portrait of Anne Vollmer (the artist's daughter), c. 1927, oil on canvas, 18 × 16 in.,
signed l/r. Collection of Peter K. Danner. Photo: Eric M. Danner.

Stone Barn (Santa Barbara, California), c. 1940, oil on canvas, 24 × 24 in., signed l/l. Collection of Peter K. Danner. Photo: Eric M. Danner.

In 1925, Grace resumed her career by enrolling in the Otis Art Institute in Los Angeles for two years, studying principally with Edward Vysekal, Roscoe Shrader, and Alfred Ramos Martinez. While there she also established lifelong associations with fellow artists Clarence Hinkle, Jean Mannheim, George Brandriff, and Millard Sheets. Grace's first solo exhibition, which included 142 of her paintings, took place in 1926 at Cannell & Chaffin gallery, a major interior design firm in Los Angeles. The same year she won an honorable mention at the Orange County Fair. Throughout this period in their lives the Vollmer family lived in a home on Avenue 64 in the community of Eagle Rock, near Pasadena. They rarely left Los Angeles, although they did make an extended trip to New Mexico, where Grace was captivated by the light and ambience of the region. By 1928, she was a member of the Pasadena Art Association and was exhibiting with the group locally.

Fisherman's Cove (Laguna Beach, California), c. 1936, 34 × 36 in.,
signed l/l. Collection of Peter K. Danner. Photo: Eric M. Danner.

By 1929, Grace and Ralston Vollmer moved to Laguna Beach, California, where they remained until 1939. During this time she joined the Laguna Beach Art Association. Ralston was employed at the time as an agent of a fire insurance company and Grace opened her studio to students. Fortunately, Ralston's inheritance protected them from any dire effects of the Great Depression. Grace studied briefly with Hans Hoffman in 1930 when Hoffman was affiliated with the Chouinard Art Institute in Los Angeles.

Hoffman's influence can be seen in a bolder, more expressionistic style in Grace's subsequent work. A second period of study with Hoffman occurred in Berkeley later in the decade.

A final relocation occurred in 1939 when the Vollmers moved to Santa Barbara, into a house they had built on Middle Road in the adjoining community of Montecito on the grounds of the old Santa Barbara Polo Club. The house included a large studio for Grace with a skylight facing north.

Untitled Still Life (Poppies), n.d., oil on canvas, 20 × 16 in., signed l/r. Courtesy of California Art Company, LLC. Photo: Martin A. Folb, PhD.

Untitled (Harbor Scene), n.d., oil on canvas, 6 × 7 in., signed l/l. Courtesy of the Oltman Family Trust. Photo: Martin A. Folb, PhD.

Grace continued to paint and exhibit her work, although with the death of her son in 1940 and the subsequent passing of her father, daughter, and finally her husband in 1946, she eventually curtailed her artistic activities. During the 1950s, her work was included in exhibitions throughout California, culminating in her final solo exhibition in 1958 at the Santa Barbara Frame Shop & Gallery. A review of the exhibition in the *Santa Barbara News-Press*, which would be the last during her lifetime, sums up Grace Vollmer's accomplishments as a painter: "The current exhibit reveals the sober intensity of a mature artist. A dozen still-lifes and landscapes show a firm mastery of technique and point of view. Mrs. Vollmer's work has a sureness that commands respect."

Grace Vollmer passed away on November 24, 1977, in Santa Barbara, California.

Biographical information compiled from: Peter Kolb Danner and the Danner-Vollmer family (Peter Danner is the husband of Grace Vollmer's granddaughter Zuriel Elizabeth Lelande); Sullivan Goss - An American Gallery, Santa Barbara, California; Springville Museum of Art, Springville, Utah; *Who's Who in American Art, 1940*; *Los Angeles Times*, July 22, 1928, August 2, 1931, January 1, 1933; *Santa Barbara News-Press*, September 7, 1958; and California Death Index.

Untitled (Jazz Musician), c. 1938, oil on canvas, 22 × 28 in., signed l/l.
Collection of Moe Parniani. Provenance Orr's Gallery, San Diego.

Inez Johnson von Hake
1905-1993

Inez Garnet Johnson was born on May 21, 1905, in Missouri Valley, Iowa, the daughter of Emil and Eva (Rydman) Johnson. She was one of eight children, all of whom had the name of a precious stone as their first or middle name.

The family moved to Omaha, Nebraska, when Inez was six months old and then in 1913, when she was eight years old, to California. Inez attended Glendale Academy high school in Glendale, California, where she showed an early artistic talent and studied mechanical drawing. She graduated in 1924 and a few years later she was hired as an artist at Malibu Potteries, which was in operation from 1926 to 1932. It was one of several Los Angeles area manufacturers of decorative clay tiles and custom furnishings. Joining Malibu in 1927, she worked as an illustrator and designer, one of the few women employed in this field, until the business closed in 1932. In 1928, she married Carl August von Hake and the couple lived in Venice, California. In the 1940s and 1950s, she took additional art courses at Santa Monica Junior College.

Of her work with Malibu, she recalled that most of her creations consisted of watercolor illustrations. In conjunction with designer Don Prouty, she produced colorful designs and small-scale drawings for small catalogs used as salesmen's sample books. Additionally, she varnished the designs for preservation and appearance and made watercolor sketches for special orders for storefronts and wainscots. A complete list of the artist's designs for the company is incomplete. Inez is credited for an original Persian-type design in a two-by-four-foot table top made especially for the Adamson House entry hall. She also created two additional table tops, one round and one a curved console, both of which are in the permanent collection of the Malibu Lagoon Museum.

Inez further recalled that her last and most challenging assignment was to design a fifty-nine-by-thirteen-foot Persian rug for the loggia of the Rindge mansion on Laudamus Hill in Malibu. Created completely out of tiles, the pattern motif and color schemes were selected and designed by Inez. The mansion was later sold to the Franciscan Order of the Catholic Church for use as a monastery, which after 1942 became known as the Serra Retreat. Inez selected and designed the pattern motif and color schemes. While the original building was destroyed in 1970 by a wildfire, a few of the original tiles were salvaged from the rubble and were later incorporated into the design of a fountain and planter boxes on the grounds of the rebuilt complex.

Upon leaving Malibu Potteries she continued to paint and draw. She later gained additional instruction under the artist/teacher

Inez Garnet Johnson (von Hake), c. 1922.
Courtesy of Margaret von Hake.

Margaret Dobson. Her later work consisted of oils, pastels, pencil drawings, and ceramics

Inez Johnson von Hake passed away on March 7, 1993, in Camarillo, California.

Biographical information courtesy Cristi Walden, William Clark, and The Adamson House, with additional data from United States Census, 1920, 1930, 1940, and California Death Index. Special thanks to Margaret von Hake, daughter of the artist, as well as Kathy Foley, Julie Jenssen, and Kirubel Kebede.

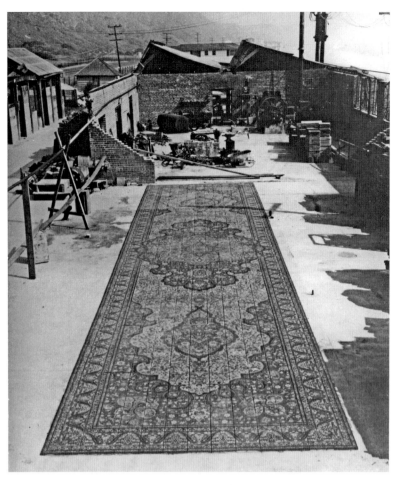

The famous Persian-style rug designed by Inez von Hake and created at Malibu Potteries for the May Rindge mansion in Malibu, California. This photograph of the assembled rug, one of the few known photographs believed to exist, was taken at the Malibu Potteries factory in 1932 and shows the entire rug, (tiles) laid out (minus fringe tiles) but not grouted down, prior to it being transported and installed at the mansion. Sadly, no photographs exist of the rug after its installation at the mansion, which was destroyed by a wildfire in 1970. Courtesy of the Malibu Lagoon Museum.

A Malibu Potteries tile (12 × 12 in.) used in the design and execution of the Persian-style rug at the May Rindge mansion. This tile with its vibrant colors and pattern is one of the few remaining intact tiles salvaged from the original design. Courtesy of Julie Jensen. Photo: Kathy A. Foley.

One of the numerous designs created by Inez von Hake during her tenure at Malibu Potteries. This sketch for a tile panel consists of watercolor heightened with gouache on lined onionskin paper. Courtesy of the Malibu Lagoon Museum.

Kanab Ranch (Utah), n.d., oil on canvas, 7 × 14 in., signed l/l.
Courtesy of Margaret von Hake. Photo: Kirubel Kebede.

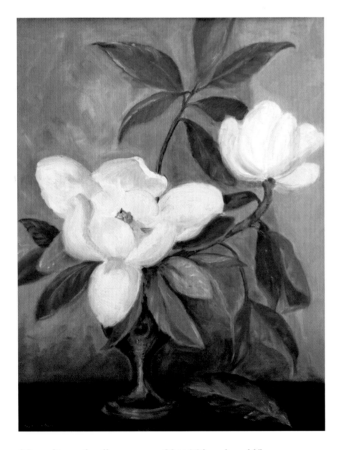

Magnolias, n.d., oil on canvas, 20 × 16 in., signed l/l.
Courtesy of Kathy A. Foley.

One of the numerous designs created
by Inez von Hake during her tenure at
Malibu Potteries. This preparatory
sketch design is for a three-tile wall
mural, shown right. The sketch
consists of watercolor heightened with
gouache on onionskin paper. Courtesy
of the Malibu Lagoon Museum.

A three-tile wall mural (based upon
the preparatory sketch also shown)
designed by Inez von Hake during
her tenure at Malibu Potteries.
Courtesy of the Malibu Lagoon
Museum.

Malibu Potteries workers photographed on the beach adjacent to the pottery factory; swimming was a lunch time activity at the factory, c. 1930. Left to right: Inez von Hake, Margaret Curtis Smith, Lillian Ball, and head ceramist Rufus Keeler. Courtesy of the Malibu Lagoon Museum.

One of the numerous designs created by Inez von Hake during her tenure at Malibu Potteries. This design for *Fountain No. 12* is a fully realized and annotated watercolor sketch (heightened with gouache) on paper. Lists are the measurements for the full-scale design. Courtesy of the Malibu Lagoon Museum.

Luvena Buchanan Vysekal
1873–1954

Luvena Buchanan was born in Le Mars, Iowa, on December 23, 1873, the daughter of John C. Buchanan, the editor of the *La Mars Sentinel*. From 1886 to 1889, the family resided in Illinois, and then they moved to Pittsburg, Kansas, where her father held a similar position with the *Pittsburg Kansan*. In 1897, she attended the Art Institute of Chicago. There she studied with John H. Vanderpoel, Ralph E. Clarkson and Harry M. Walcott. She returned to the Art Institute of Chicago in 1910 after teaching in the Pittsburg public schools.

During this period, at the Art Institute of Chicago, she met fellow artist and future husband Edouard Vysekal (1890–1939), who was an instructor there. In 1914, Harold Bell Wright, a former Kansas pastor and one of America's best-known fiction writers, commissioned Luvena to paint murals for the new Barbara Worth

Hotel in El Centro, in the Imperial Valley of California. Wright's book *The Winning of Barbara Worth* inspired local land developers to build a hotel to perpetuate the mysterious romance of the desert and to attract people to settle in the valley. Inviting Edouard to assist her, she accepted the assignment, which consisted of covering the walls of the lobby with a circular progression of murals closely following the story line of the book. The murals were ready to install in March of 1915. In May, that same year, five hundred guests attended the Barbara Worth Hotel's grand opening banquet. After the completion of the commission and a short visit to the Panama-California Exposition in San Diego, Edouard and Luvena settled in Los Angeles, where they married on January 1, 1917. There they sketched, painted, exhibited, and enjoyed life.

Illustrations for the Vysekals Christmas cards. Private collection.
Photo: Martin A. Folb, PhD.

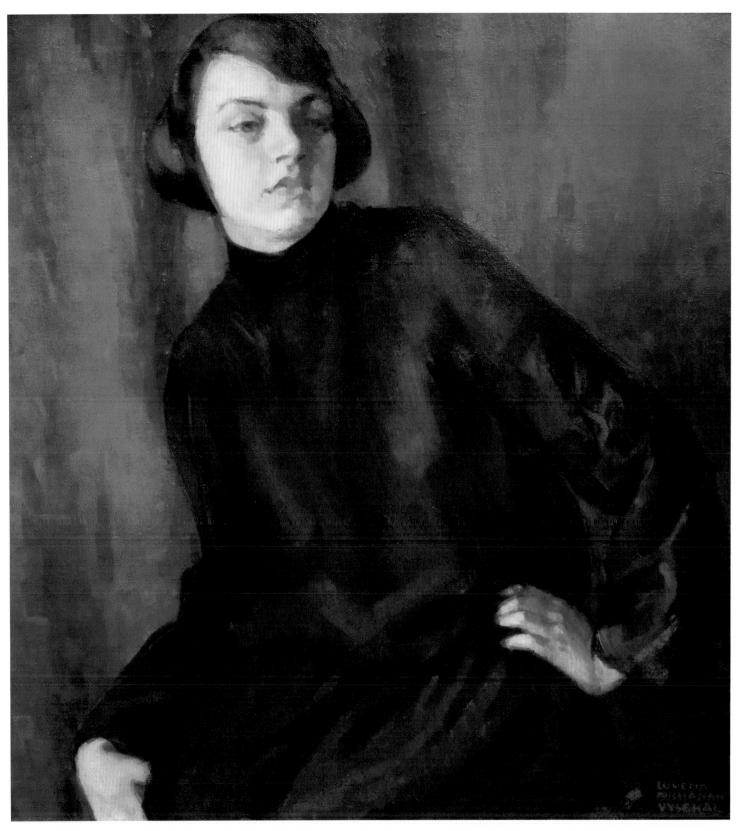

Sonia, Russian Model, c. 1930, oil on canvas, 29 × 27.25 in.,
signed l/r. The John and Susan Horseman Collection.
Courtesy of Thom Pegg and Tyler Fine Art.

Luvena's artwork, consisting of portraits, figures, landscapes, florals, and still lifes, were almost exclusively executed in oil. She considered herself an uncompromising realist.

In the early 1920s, while Edouard began his career teaching at the Otis Art Institute (1922–1939), Luvena showed another of her talents, the ability to write well and to wield a very sharp pen.

Beginning in mid-1922, writing under the nom de plume Benjamin Blue, thirty-four "Little Portraits" and "Counterfeit Presentments" appeared in Antony Anderson's *Los Angeles Times* "Art and Artists" column. All were written with the subject's identity a mystery; Anderson described them as clever pen-portraits of well-known artists, critics, and dealers.

Ranunculus Floral Still Life, n.d., oil on canvas, 22.25 × 20.5 in., signed l/l. Courtesy of George Stern Fine Arts.

Luvena and Edouard were active in conservative and progressive art associations. Among the former were the California Art Club and the Laguna Beach Art Association. They were also influential in the organization of the earliest progressive groups: the California Progressive Group, 1919, the Group of Eight, 1921, and The Modern Art Workers, 1925, with the intention of introducing the community at large to post-impressionism, synchronism, futurism, Fauvism, and abstract art.

After Edouard suddenly passed away on December 2, 1939, a saddened Luvena found herself financially devastated, but with help from many friends, she opened the Vysekal Studio Gallery on Sunset Boulevard in 1942. The gallery held exhibitions of the Vysekals and, later, showed work by their contemporaries. The gallery floundered in 1950, and subsequently closed, but in less than a quarter of a century after they arrived in Los Angeles, they had established themselves as vital components and left their imprint on the early development of modernism in the city.

Luvena Buchanan Vysekal passed away on January 11, 1954.

Biography courtesy Marian Yoshiki-Kovinick.

Ruth and Baby Nell, n.d., oil on canvas board, 14 × 10 in., annotated verso.
Courtesy of George Stern Fine Arts.

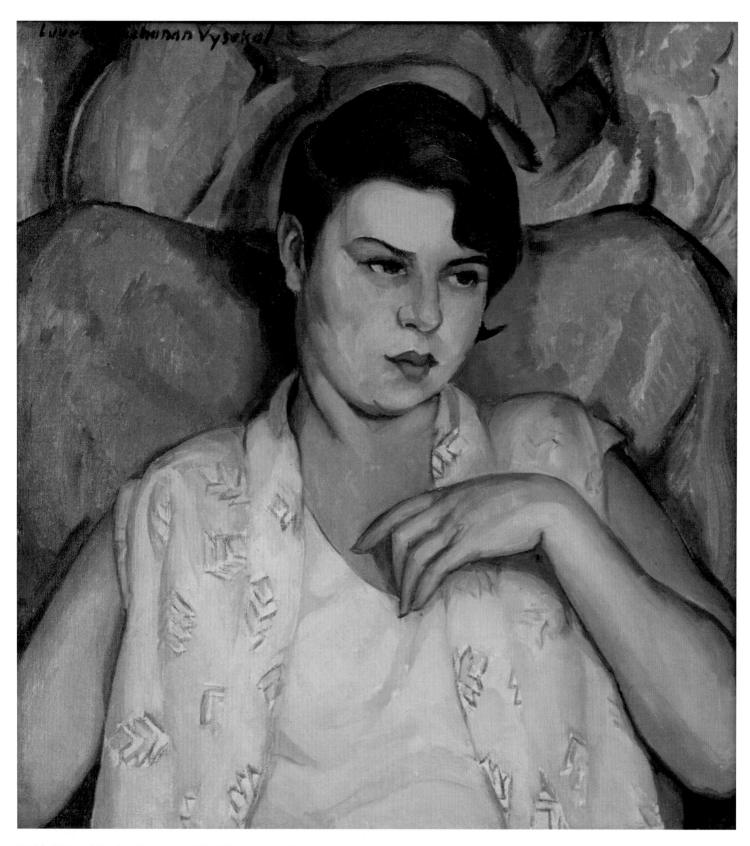

Untitled (Portrait), n.d., oil on canvas, 24 × 22 in., signed u/l.
Collection of Leonard Hill.

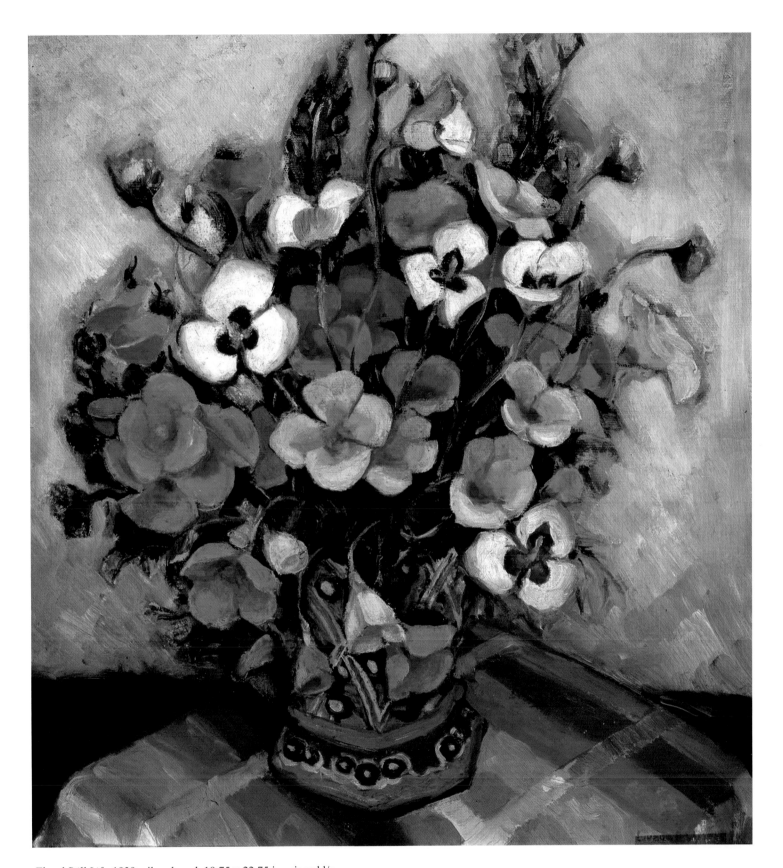

Floral Still Life, 1939, oil on board, 19.75 × 22.75 in., signed l/r.
Courtesy of George Stern Fine Arts.

Marion Kavanaugh Wachtel
1870–1954

Born in Milwaukee, Wisconsin, on June 10, 1870, Marion Ida Kavanaugh, the daughter of James T. and artist Jean (Johnston) Kavanaugh, grew up in Milwaukee. Early in her life she studied with her mother, a leading Milwaukee painter and teacher, then later with Henry Spread in Chicago until his death in 1890. Afterward, she spent many years at the Art Institute of Chicago, under John H. Vanderpoel, Pauline Doane, and Frederick Freer. She also was a pupil of Richard Lorenz in Milwaukee and William M. Chase in New York.

Marion was a teacher in Chicago while pursuing a career as a portrait painter; she also created landscape sketches and paintings. One, a scene in the mountains of North Carolina, was seen by a Santa Fe Railway vice president, who offered her free passage to California in exchange for future paintings of western scenes. Unhappy in the classroom, she quickly accepted the proposition.

Although Marion had visited California earlier, the 1903 trip proved to be significant to her future life and career. She spent several months in Santa Barbara making sketches of the coastal range. Then, in October, before returning to Southern California, she exhibited the results of her efforts at the home of Oscar K. Cushmans in San Francisco. During the exhibition she met Elmer Wachtel, a gifted violinist and painter. A whirlwind courtship ensued, followed by marriage in Highland, a suburb of Chicago, in July of 1904. They returned to California and settled in Los Angeles.

The Los Angeles area, specifically Pasadena from 1922, remained her home, but much of the West and Mexico became her studio. During the twenty-five years with her artist husband, who died in Mexico in 1929, she traveled first on horseback and later by car to remote areas in search of subject matter. Influenced by the scenery, she became primarily a painter of landscapes, although she featured figures in many of her views of Mexico and the Southwest. Her works, mostly watercolors produced during her marriage (with the exception of at least two solo exhibitions in oils, most notably one at the Kanst Art Galleries, Los Angeles, in 1928) included scenes of California and the Southwest. She switched to oil paints later in life.

Untitled (Portrait of a Young Woman), c. 1895,
water color on paper, 10 × 7 in., signed l/r:
Marion Kavanaugh. Private collection.
Photo: Dr. Martin A. Folb.

Hopi Woman, n.d., watercolor on paper, 15 × 12.5 in., initialed l/m.
Private collection. Photo: Dr. Martin A. Folb.

Hopi Sheep Herder, Walpi, Arizona, c. 1903, watercolor on paper,
18 × 24 in., signed and dated l/r. Courtesy of George Stern Fine Arts.

The artist was an exhibitor from the early 1900s until her death. Outside of California, she had works in shows with the New York Watercolor Society; City Art Museum, St. Louis, Missouri; Herron Art Institute, Indianapolis, Indiana; Detroit Museum of Art, Michigan; Art Institute of Chicago, Illinois; Arizona State Fair, Phoenix; Rhode Island School of Design, Providence; Brooklyn Art Museum, New York; and American Watercolor Society, New York, which used her *Sierra Madre* as the frontispiece for its 1911 catalogue. In California, she took part in countless exhibitions from San Francisco to San Diego. She had solo showings at the Los Angeles County Museum of History, Science, and Art, 1915, 1917; Milwaukee Art Institute, 1917; Stanford University, Palo Alto, California, 1935; and University of Southern California, Los Angeles, 1936.

Marion continued to paint in her later years and, for a time, taught privately. She is represented in the collections of the Laguna Art Museum, California; Gardena High School, Los Angeles; Los Angeles County Museum of Natural History, Los Angeles; Irvine Museum, California; Hubbell Trading Post National Historic Site, Ganado, Arizona; Syracuse University, New York; John H. Vanderpoel Art Association, Chicago; and Santa Fe Railway Company, Chicago.

Marion Kavanaugh Wachtel passed away on May 22, 1954, in Pasadena, California.

Biography, with thanks, from: *An Encyclopedia of Women Artists of the American West*, Phil Kovinick and Marian Yoshiki-Kovinick, Austin: University of Texas Press,1998.

Untitled (Walpic, Hopi Mesa), n.d, watercolor on paper, 16 × 20 in., signed and dated l/r. Private collection, courtesy of Edenhurst Gallery.

California Ranch, n.d., oil on canvas, 13 × 17.5 in., signed l/l. Collection of Diane and Sam Stewart. Courtesy of Traci McFarland Fieldsted.

Lillias Waddell
1881–1947

Lillias Jaquins was born on December 18, 1881, in Clymer, New York, the daughter of Edward and Luella (Hanks) Jaquins. She and her twin sister were two of ten children born to the couple. Her early years were spent at the family home in the rural community of French Creek, New York, where her father served in local politics. By her teen years, the family was living in Kansas, in the community of Winfield. As early as 1902, the family was spending the winter months in Riverside, California.

Her first husband was Philip K. Franklin, and by 1908 the couple had settled in Riverside, where their son, Philip Jaquins Franklin, was born. Her first husband passed away in 1921. In 1924, she married Charles Wilkin Waddell in Santa Barbara, California, and the couple settled in the Westwood section of Los Angeles, where her husband was a professor at the University of California, Los Angeles.

Although a history of her education is lacking, her images have been compared to those of the artist Marion Kavanagh Wachtel, whom she may have studied under.

Lillias J. Waddell passed away on March 30, 1947, in Los Angeles, California, and is buried in Evergreen Memorial Park and Mausoleum, Riverside, California.

Biographical information compiled from: United States Census, 1900–1940, 1895 Kansas State Census Collection, 1855–1925; Wilken Family Genealogy; *Los Angeles Times*, September 21, 1902; and California Death Index.

Untitled (Old Bridge Over Foothill Creek, Southern California), n.d., oil on canvas on board, 16 × 12 in., signed l/l. Courtesy of Maureen Long.

Near Victorville (California), 1940, oil on canvas, 16 × 20 in., signed l/l. Courtesy of Maureen Long.

Untitled (California House and Garden), n.d., oil on canvas on board, 12 × 16 in.,
signed l/l. Private collection. Photo: Martin A. Folb, PhD.

Carmel Coast, n.d., oil on canvas, 30 × 36 in.,
signed faintly l/l. Courtesy of Maureen Long.

Phebe Ray Wadsworth
1882–1962

Phebe Ray Wadsworth was born on January 5, 1882, in Ishpeming, Michigan, the daughter of Daniel F. and Martha (Ray) Wadsworth, the youngest of four children. Her early years were spent in Ishpeming, where her father served as the city's mayor and was a respected member of the business community. A graduate of the Thomas Normal Training School, Detroit, Michigan, she began her teaching career in art and music shortly after graduation. A history of additional art studies, if any, is lacking. After seven years as an instructor at various schools in Michigan and Hibbing, Minnesota, she came to the western United States in 1909 and settled in Centralia, Washington, where she served as supervisor of art and music for the local school system.

In 1916, she moved to California, joining her family who had moved there several years earlier, and settled in South Pasadena. She taught music and art in the local elementary school and introduced the concept of the Kinderband, an early childhood musical program, to the school curriculum. In 1925, she began teaching art at Washington Junior High School in Pasadena.

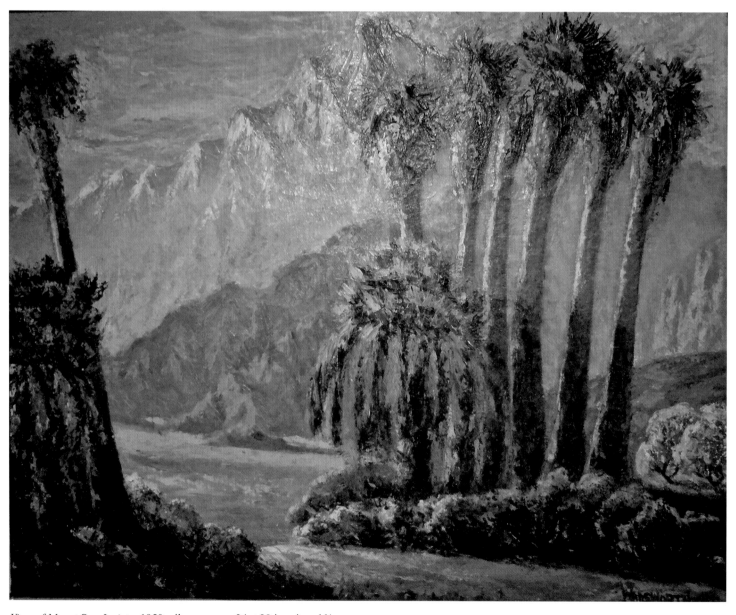

View of Mount San Jacinto, 1950, oil on canvas, 24 × 29 in., signed l/r.
Courtesy of Stewart Galleries, Palm Springs, California.

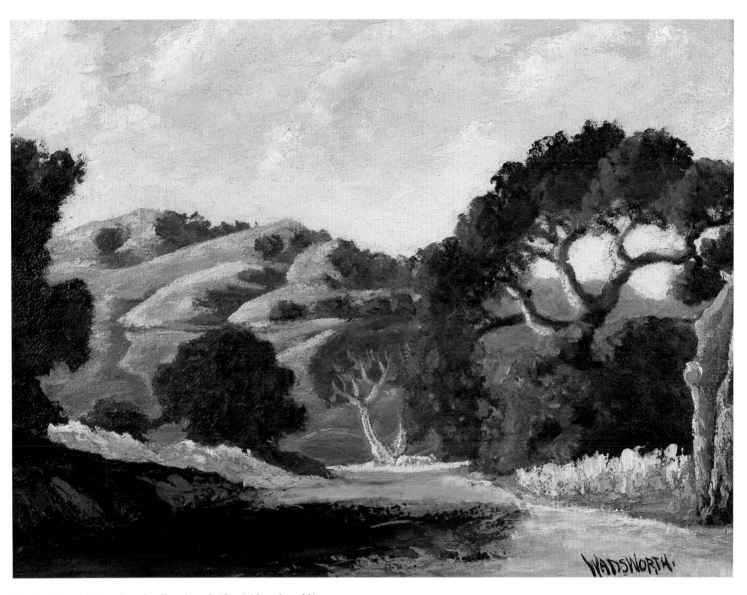

Untitled (Foothill Road), n.d., oil on board, 12 × 16 in., signed l/r.
Courtesy of Rudy and Jo Ann Summers. Photo: Martin A. Folb, PhD.

She retired from teaching in 1945. An exhibition history for the artist is lacking, although with her inclusion in the December 1932 *California Arts & Architecture* directory of working California artists, one could infer that she was also exhibiting her work locally. Phebe remained a resident of California for forty-six years.

Phebe Ray Wadsworth passed away on August 7, 1962, in Pasadena, California.

Biographical information compiled from Michigan Births and Christenings Index, 1867–1911; United States Census, 1900–1940; *California Arts & Architecture* artist directory, December 1932; *Centralia News-Examiner*, September 22, 1909; *Los Angeles Times*, August 10,1962; *Pasadena Independent*, August, 11, 1962.

Elizabeth F. Waggoner
1874–1966

Elizabeth F. Waggoner was born on May 28, 1874, in Gilman, Iowa, the eldest daughter of Christopher W. and Maria (Hughes) Waggoner. By 1880, the family was living in Minneapolis, Minnesota, with later moves to Bismarck, North Dakota and Chicago, Illinois, where Elizabeth attended and graduated from the Chicago Art Institute. Later she served as a member of the school's faculty for four years and was active with the Art Students League in Chicago.

In 1908, accompanied by her mother and sister, Elizabeth moved to Los Angeles, California, to direct the arts and crafts department at the College of Fine Arts at the University of Southern California, Garvanza, under William Judson. An article published in the *Los Angeles Herald* announced her appointment to the school. The article reported on an exhibition of her work presented to the public, stating: "The large reception room and picture gallery (at the school) were devoted yesterday to an exhibit of many of Miss Waggoner's creations. Her metal work is perhaps the most interesting at first sight for the rich tones of copper and brass are always alluring to the eye. She has designed some most unique pieces and finds a comprehensive field for her labors. Her exhibits in metal work alone include candlesticks, book racks, and nut and fruit bowls, spoons and ladles and trays of various sizes and design. Another interesting field of the arts and crafts work in which Miss Waggoner is successful is that of pottery . . . woodblock engravings, stenciled work and leather work were also represented in the group of artistic and useful objects with which the tables and shelves of the gallery and in each department Miss Waggoner has introduced an individual note that gives her work distinction."

In 1909, her metalwork was shown at the Alaska-Yukon Pacific Exhibition (silver medal) in Seattle, Washington. By 1910, she was associated with the art department of Hollywood Polytechnic High School and Hollywood High School, where she continued to teach arts and crafts. Also, in addition to her art and teaching, she was a frequent contributor to the *Los Angeles Herald*, writing the "Art Notes" column. In 1910, she wrote an article, "The Art of Julia Bracken Wendt," about another artist, and friend, who had made the journey from Chicago to Los Angeles, Julia Bracken Wendt. Around this time Elizabeth became a member of the California Art Club and was included in the CAC's Second Annual Exhibition as an honorary member in 1911. Over the ensuing decades she continued to have a prominent presence in both art and social organizations in Los Angeles. Likewise, she continued her relationship with the Chicago Art Institute even after her move to Los Angeles, periodically returning to Chicago for work and to participate in various art exhibitions.

She was a frequent traveler to Europe, initially going for study in 1922. In 1939, Elizabeth moved to England, to study sculpture in London. Within three months of her arrival, England entered into World War II. She remained in England for three years during the war and worked tirelessly as a volunteer in war relief, serving with the American Committee for the Evacuation of Children and later with the American Outpost, gaining recognition for her service. A painter, sculptor, teacher, craftswoman, and occasional journalist, she returned in 1942 to her home and studio of many years at 2041 Pinehurst Road in Hollywood.

She was a member of the California Art Club, the Friday Morning Club, and the Fine Arts League, and her work was included in exhibitions throughout California.

Elizabeth Waggoner passed away on February 21, 1966, in Los Angeles, California, and is buried in Forest Lawn Memorial Park Cemetery, Hollywood Hills, California.

Biographical information compiled from: "Hollywood Art History, 1911–1936," *Publications in California Art,* Vol. 8, Page XXXVII, Nancy Dustin Wall Moure; *American Art Annual*, 1925; *Los Angeles Herald*, October 17, 1908, November 30, 1908, March 28, 1909, March 27, 1910; *Daily Register-Gazette* (Rockford, Illinois), September 17, 1915; *Los Angeles Times*, November 19, 1911, June 30, 1912, May 31, 1942; *California Arts & Architecture* artist directory, December 1932; United States Census, 1880, 1900, 1910, 1920; and California Death Index.

Moonlit Street, (Los Angeles, California), n.d., pastel on paper, 9.5 × 14 in.,
signed l/r. Private collection. Photo: Martin A. Folb, PhD.

Mildred Kizzie Walker
1915–1995

Mildred Kizzie Walker was born on August 26, 1915, in Hamilton County, Ohio, the daughter of Charles Townsley Walker, a Baptist minister, and Kizzie J. (Smiley) Walker. Raised primarily in Indiana, she received her bachelor of arts degree in fine art and English from Indiana Central College. She continued her studies at the John Herron Art Institute (now Herron School of Art and Design) and Purdue University, both in Indiana, at Columbia University and the Art Students League, both in New York and at the Chicago Art Institute, Illinois. In the early 1940s, she earned her master of fine arts degree at University of Southern California, studying under Glen Lukens and Francis de Erdely. A desire to remain in Southern California led her to El Camino College. There, in 1947, she founded the school's art department, serving as teacher and department head for thirty-three years until her retirement in 1980.

Mildred Kizzie Walker, c. 1940.
Courtesy of Janet Napolitano and the Mildred Walker Estate.

Factory Town, Stockton (California), 1941, oil on canvas, 18 × 16 in., signed l/l. Courtesy of Michael Kelley, Kelley Gallery, Pasadena.

A lifelong world traveler, she drew inspiration for her work from the places she visited, including an early expedition to the Galapagos Islands, New Guinea, the South Seas, and throughout Europe, Mexico, and Central and South America. Mildred commented, "As both artist and teacher I believe that strong, fluid, dynamic figure drawings are achieved when the artist's command of technical demands is so sound as to become an intuitive process. Although the 'grand' classical themes are profound, I am far more attracted to a Daumier sort of world with its whimsy, pathos, absurdity, and humor. I do not regard drawing as reportage and am therefore inclined to avoid depicting actual occurrences. My subjects exist in the world I create for them whether it is symbolic, surreal, or amusing."

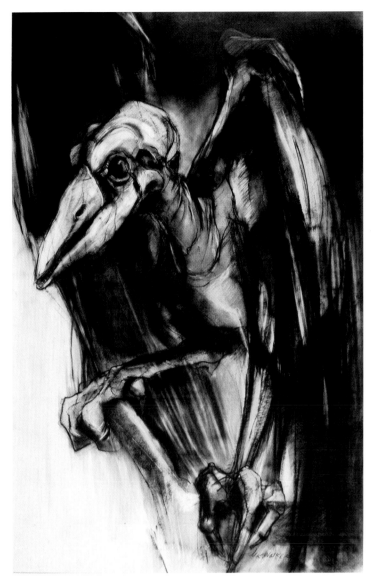

Prehistoric Bird, n.d., black chalk on paper, 40 × 26 in., signed l/r. Collection of El Camino College, California. Photo: Robert Wedemeyer.

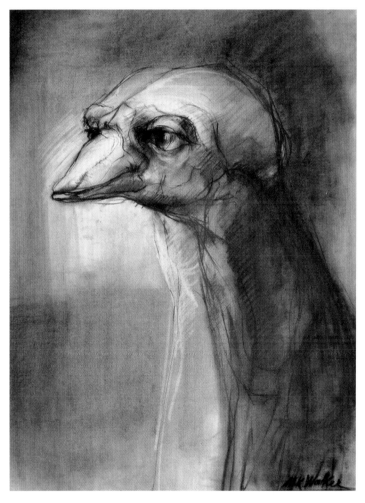

Pensive Bird, n.d., brown and black chalk on paper, 8.25 × 10.75 in., signed l/r. Collection of El Camino College, California. Photo: Robert Wedemeyer.

She first began exhibiting at the Annual Indiana Artists' Show, Indianapolis, and continued exhibiting nationally throughout her life, including shows with California State Fair, Long Beach Museum Annual, Palos Verde Art Center, and more. An artist, educator, and writer, upon her retirement from El Camino College Mildred continued teaching life drawing and art history at the Palos Verdes Art Center and privately for many years. In her own words, she said it best: "I make art because I have to, because I cannot imagine life any other way."

Mildred Walker passed away on September 22, 1995, in Palos Verdes Estates, California.

Biographical information compiled from: *Drawing From Life: A Retrospective of Figurative Drawings by Mildred K. Walker*, Palos Verdes Art Center, Anne Morris, 1993; *Daily Breeze* (Los Angeles County South Bay region), December 2, 1992; United States Census, 1930, 1940; and Mildred Walker's own writings. With special thanks to El Camino College and to Jan Napolitan, on behalf of the Walker Estate.

Florence Walsh
Dates Unknown

Biographical information for this artist is incomplete. During our research it was discovered that there were several artists by the same name working within the state of California as early as 1912. Also, a California artist of the same name was exhibiting at the Art Institute of Chicago, Illinois, in 1937. Further attempts to confirm the artist's actual identity, including information concerning her early life, education, and career as an artist has been inconclusive.

From our research, we believe the identity of the artist presented here in *Emerging from the Shadows* to be an individual who was active in San Diego, California, and the surrounding area. While reviewing local San Diego area newspapers, several articles written during the 1950s, with additional articles in the 1960s and 1970s, led us to believe that the artist in question was indeed a resident of San Diego and was active there as an artist, possibly as early as the 1930s. The most informative article about the artist is from the May 2, 1954, *San Diego Union*. This is the article in its entirety: "Florence Walsh's Paintings Shown: Oil paintings featuring landscapes and marines of the San Diego-La Jolla area are on display at the La Jolla Art Association's gallery on Girard St. The show will continue through May 15 1954. The artist Florence Walsh is a long-time California resident and is known for the ethereal quality of mist and sunlight that identifies her work. Originally from Ohio, Mrs. Walsh won a four-year scholarship to the Philadelphia School of Design for Women. After her arrival in San Diego she studied with Roland McNary and Dorothy King and has emphasized local scenery in her paintings."

The same artist is mentioned in newspaper articles as being included in the San Diego Art Institute's *All Member Theme Show* at the San Diego Art Institute Gallery, House of Charm, Balboa Park, in 1956, and in exhibitions with the La Jolla Art Association throughout the 1950s,1960s, and early 1970s.

Biographical material compiled from: *San Diego Union*, May 2, 1954; *The Annual Exhibition Records of the Art Institute of Chicago, 1888–1950*, Peter Hastings Falk, ed., Sound View Press, 1990; *Who Was Who In American Art*, Peter Hastings Falk, ed.; *Publications in Southern California Art*, Nancy Dustin Wall Moure; *Dictionary of Women Artists: An International Dictionary of Women Artists Born Before 1900*, Chris Petteys.

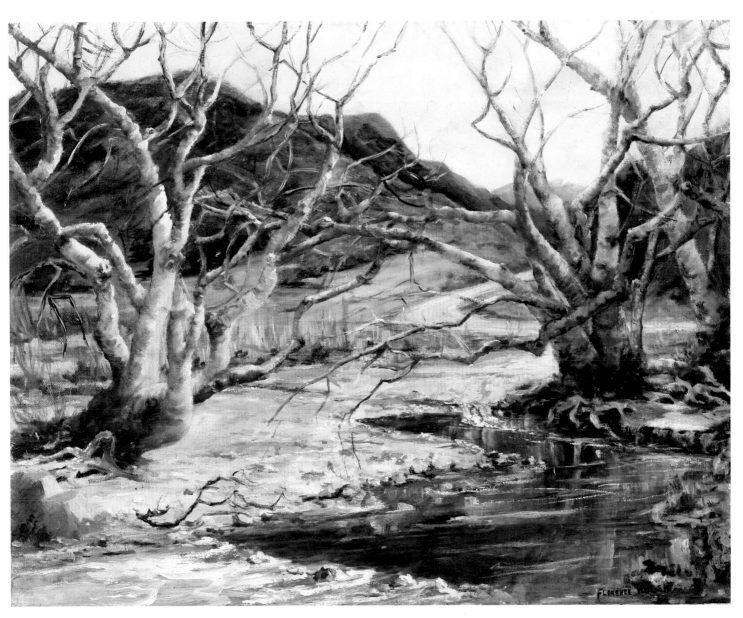

Untitled (Landscape with Creek), n.d., oil on canvas, 12 × 16 in.,
signed l/r. Private collection. Photo: Martin A. Folb, PhD.

Louisa Cooke Ward
1888-1966

Louisa Mary Cooke was born on February 13, 1888, in Harwinton, Connecticut, the daughter of Benjamin Augustus and Nellie Elizabeth "May" (Cables) Cooke. She grew up in Connecticut, where she obtained her earliest education. From 1904 to 1907 she was a student at Yale University, School of the Fine Arts, in New Haven. As early as 1910, Louisa identified herself as an artist and teacher. In the early 1910s, she married Harry F. Ward, and the couple lived in Connecticut. By 1930, with their children, they moved to Southern California, where Louisa continued to live throughout the remainder of her life.

Louisa Ward was a painter of landscapes, portraits, and still lifes. She worked primarily in oils. She was a member of Yale Women of Southern California; California Art Club; Brush & Palette Guild; Southland Art Association; California Federation Women's Club; Los Angeles County Federation Women's Club (art chairman, 1946–1948, 1950–1952); and Las Artistas (president, 1950–1951). She exhibited at the Bridgeport Women's Art Club; Los Angeles City Hall; Los Angeles Library, 1945 (prize); Las Artistas Exhibition, Los Angeles, 1946 (prize), 1948 (prize); Los Angeles City Hall, 1953 (prize); Santa Monica Public Library (prize); Los Angeles Museum of Art; Carlsbad, California; and the Greek Theatre, Los Angeles.

Louisa Cooke Ward passed away on October 16, 1966, in Los Angeles, California.

Biographical material compiled from: *Who's Who in American Art, 1959*, Dorothy B. Gilbert, ed.; *Who Was Who in American Art, 1564–1975*, Peter Hastings Falk, ed.; and United States Census, 1910, 1920, 1930, 1940.

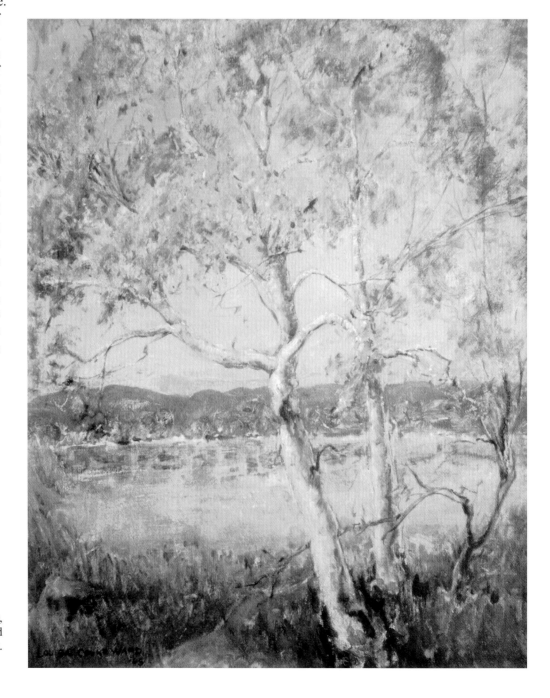

Untitled (Landscape with River), 1945, oil on board, 20 × 16 in., signed and dated l/l. Collection of Kurt Kasten.

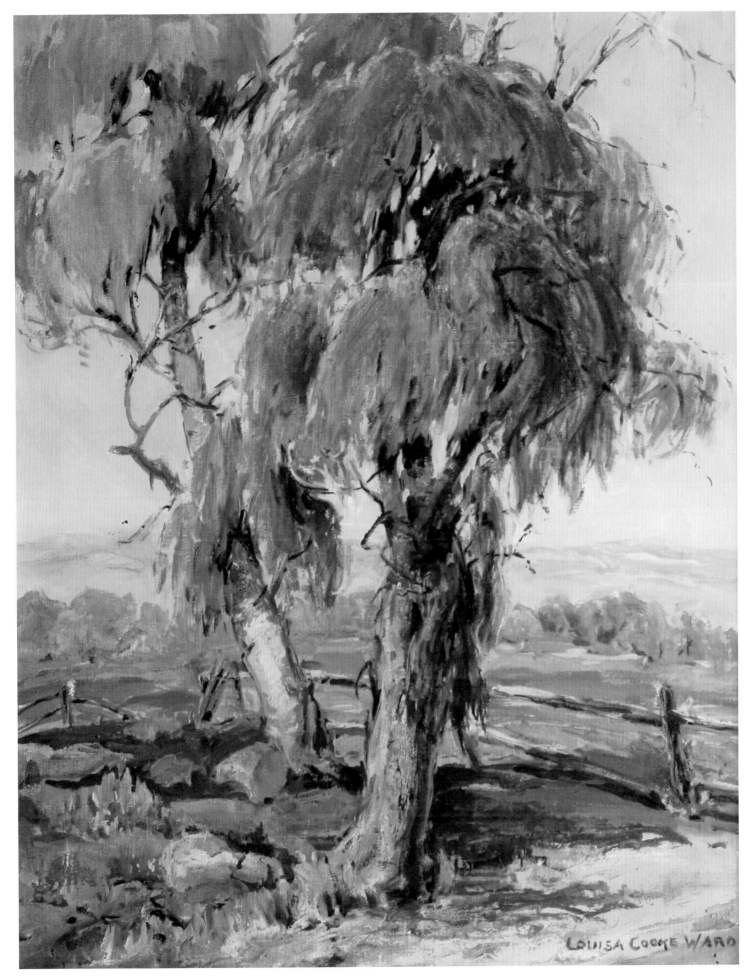

Eucalyptus, c. 1925, oil on canvas, 22 × 28 in., signed l/r. Private collection.
Courtesy of Edenhurst Gallery.

Nell Walker Warner
1891–1970

Nellie Gertrude Walker was born on April 1, 1891, near Palls City, Nebraska, the daughter of William Thomas and Ida Katherine (Zoeller) Walker. She grew up in Nebraska, Kansas, and, after about 1902, in Colorado Springs, Colorado. At the age of eleven, she began studying art and, after completing public school, graduated from Lexington College for Young Women in Missouri in 1910. Following a brief teaching assignment in Colorado Springs, she moved to Los Angeles and studied at the Los Angeles School of Art and Design, receiving a diploma in 1916. She then taught art classes at the Hollywood School for Girls and the Westlake School for Girls, 1916 to 1918, and later did backgrounds for titles of silent motion pictures.

In 1920, Nell married Bion Smith Warner, an osteopathic physician and surgeon, and soon moved to Glendale, California, where she lived until the late 1920s. During this period, from 1923 to 1925, she studied art with Fritz Werner and Nicholai Fechin. Afterward, she continued to live in the foothills of Los Angeles, first in La Crescenta, then in La Cañada, with intervals in Hollywood, while continuing with her painting and teaching. Although divorced from her first husband, she continued to use his name professionally even after she married Emil Shostrom in 1945. In 1952, she settled in Carmel, where she had been a frequent visitor for years.

Creek in the Woods, n.d., oil on canvas, 20 × 24 in., signed l/l.
Private collection. Photo: Martin A. Folb, PhD.

Coastal Eucalyptus (California), c. 1940, oil on canvas, 13.5 × 17.5 in.,
signed l/r. Christiansen California Art, Courtesy of Kevin Stewart.

Nell elicited praise from many critics as one of the foremost flower painters in the West and received favorable comments for her foreign studies; her landscape paintings of Rockport and Gloucester, Massachusetts; and her western landscapes, particularly of California. The artist exhibited in shows of the Laguna Beach Art Association; Pasadena Art Institute; Santa Cruz Art League; Artists of Southern California, San Diego; California State Fair, Sacramento; Arizona State Fair, Phoenix; Pasadena Society of Artists; Springville Museum of Art, Utah; Golden Gate International Exposition; Carmel Art Association; Academy of Western Painters; and, in Los Angeles, with California Art Club, California Watercolor

Society, Gardena High School, Women Painters of the West (of which she was president, 1946–1948), Ebell Club, Artists Fiesta, and Artists of the Southwest. She had solo exhibitions at the Desert Sun Gallery, Palm Springs, 1937, and the Artists Guild of America Galleries, Carmel, 1953, 1960, and 1963.

Nell Walker Warner passed away on November 30, 1970, in Carmel, California.

Biography, with thanks, from: *An Encyclopedia of Women Artists of the American West*, Phil Kovinick and Marian Yoshiki-Kovinick, University of Texas Press, Austin, 1998.

Kaye Waters
1906–1955

Information concerning the artist Kaye Waters is incomplete. Based on existing biographical reference material, it is believed that she was born on August 28, 1906 (location unknown), and passed away in Los Angeles, California, on February 11, 1955. According to a 1964 Archives of American Art interview with the artist Buckley MacGurrin, he remarked that he knew Kaye Waters while they were both in Paris during his days as a student and for a time thereafter in the 1920s and early 1930s and then again years later in California while both were employed under the Works Progress Administration's Federal Art Project in Los Angeles. Presumably, she too was in Paris as a student, although this is pure conjecture.

She is known as a painter and lithographer and it appears that she was especially active during the 1930s with the Federal Art Project. In 1936, the FAP employed 350 artists in Southern California. It was in this same year that the FAP presented its first exhibition of work done by artists under their employ. The exhibition presented at the Los Angeles County Museum of History, Science, and Art, which opened on June 5, 1936, was comprised of the work of seventy-five FAP artists, including Kaye Waters.

From the work that has been documented, the general theme of her oeuvre consists of female nudes, portraits, religious-themed images (Madonna and child) and Southeast Asian figuratives. She is often mentioned as one of the early Los Angeles abstractionists, along with the artists Helen Klokke and Olinka Hrdy, both of whom are included in *Emerging from the Shadows*.

Kaye's WPA-era lithographs are included in the permanent collections of the Baltimore Museum of Art, Maryland; Newark

Untitled, 1937, lithograph on paper, 10 × 14 in., initialed and dated l/l. Courtesy of Roger Genser and The Prints and the Pauper. Photo: Martin A. Folb, PhD.

Cameo, 1937, lithograph on paper, 14 × 10 in., unsigned. Courtesy of Roger Genser and
The Prints and the Pauper. Photo: Martin A. Folb, PhD.

Museum, New Jersey; Weisman Art Museum, University of
Minnesota; Museum of Art, University of Oregon; The Washington
County Museum of Fine Arts, Hagerstown, Maryland; Wexner
Center for the Arts, The Ohio State University; and Spencer
Museum of Art, University of Kansas. A WPA-era oil painting by
Kaye Waters is in the collection of the Roberts Art Gallery at Santa
Monica High School, California. Further research is needed
concerning this artist and her career.

Biographical information compiled from an interview with
Buckley MacGurrin, June 20, 1964, Archives of American Art,
Smithsonian Institution; *WPA Artwork in Non-Federal Repositories*,
Edition II, December 1999, United States General Services
Administration; *Los Angeles Times*, June 4, 1936; and California
Death Index.

Adele Watson
1873-1947

Fanny Adele Watson was born in Toledo, Ohio, on April 30, 1873, the daughter of Pliney Henry and Clara (Sears) Watson. After the death of her father in 1880, the family moved to Pasadena, California. After some time in California, she relocated to New York City, where in 1905 she entered the Art Students League. Later she studied with Raphael Collin in Paris and traveled throughout Europe.

She became a good friend of philosopher, author, and artist Kahlil Gibran and was influenced by his writings. She was further influenced by the dreamy, idyllic paintings of Arthur B. Davies. From exposure to their work came Adele's unique style of symbolism. Her symbolic works fall basically into two categories.

From about 1916 to the mid-1920s, her formula was generally a deep-bluish landscape backdrop peopled with luminous nude figures in movement of celebration. Most of the paintings from this period are set amongst the towering cypress trees on the coast around Monterey, California. In a 1918 review, art critic Antony Anderson wrote of Watson in the *Los Angeles Times*, "There is something here akin to William Blake. Miss Watson is a mysticWe are transported to that mysterious region between waking and sleeping, where perhaps the most important part of our lives transpires . . . lose yourself in this unusual atmosphere, and you will find yourself at home in this new and seldom visualized country of the soul."

Around 1925, her viewpoint expanded, and Adele began to see man and nature as one. Her palette lightened overall, moving from the twilight to the daylight in her color choice. Landscapes and people actually began to merge into one another, appearing as one unified creation. Human figures "sprouted" from gargantuan rock formations, symbolizing for her the immensity of the human spirit.

Untitled (Landscape with Figures), n.d., oil on canvas, 24 × 30 in., signed l/l. Courtesy of Naim I. Farhat and the Farhat Art Collection.

Untitled (Drifting Figures over Coast), n.d., mixed medium on paper, 9 × 12 in., signed l/l. Private collection. Photo: Martin A. Folb, PhD.

Untitled (Rock Formation with the Hint of Hidden Figures),
n.d., oil on canvas, 40 × 30 in., signed l/l.
Private collection. Photo: Martin A. Folb, PhD.

She exhibited at the California Liberty Fair, 1918; Painters and Sculptors of Los Angeles, California, 1925; American Artists Professional League, New York City; National Academy of Design, New York City; Society of Independent Artists, New York; and Pasadena Art Institute, Pasadena, California, 1953 (retrospective).

Adele Watson passed away on March 23, 1947, in Pasadena, California.

Biography complied from: *An Encyclopedia of Women Artists of the American West*, Phil Kovinick and Marian Yoshiki-Kovinick, Austin: University of Texas Press, 1998; *Star-News* (Pasadena), March 3, 1947 (obituary); *Dreams, Visions and Imagination; an exhibition of Symbolic and Imaginative Paintings by California Artists, 1910-1930,* presented by Maureen Murphy and Michael Kelley, September 16–October 14, 1990, Maureen Murphy Fine Arts, Montecito, California.

June Wayne
1918–2011

Janie Claire Lavine was born in Chicago, Illinois, on March 7, 1918, the daughter of Abe and Dorothy (Kline) Lavine. After her parents' divorce, when Janie was still an infant, her name was changed and she was raised as June Claire Kline by her mother. As a teenager, she had aspirations to be an artist and dropped out of high school at the age of fifteen to pursue that goal; she also took the entrance exams to attend the University of Chicago, but she decided against enrolling.

In 1935, she was given her first solo painting exhibition. *Watercolors by June Claire,* at Max Lippitt's Boulevard Book Shop and Gallery in Chicago. The following year, she was invited to Mexico to paint by the Mexican Department of Public Education, culminating in a solo exhibition, *Cuadros de June Claire*, at El Palacio de Bellas Artes in Mexico City. Upon her return to the United States in 1937, she worked in Chicago, at Marshall Field & Company, in their modern art picture galleries. Simultaneously, she applied for and was accepted in the Easel Project, a division of the Works Progress Administration's Federal Arts Project in Chicago in 1938. Her work led her to join the Artists' Union and subsequently testify before a congressional committee in Washington, DC, in an effort to preserve the WPA projects as permanent government agencies and reverse the government policy of discharging the participating artists every thirteen weeks.

In 1939, she moved to New York, supporting herself as a costume jewelry designer by day, while continuing to paint and exhibit. In 1941, she married United States Air Force flight surgeon George Wayne; although the couple divorced in 1960, she continued to use the Wayne surname both personally and professionally for the rest of her life. With her husband serving overseas during World War II, she relocated to Los Angeles, California. Unfortunately, because of a temporary illness she was unable to paint. In order to compensate, she taught herself to write copy for radio programs while pursuing her certification in aircraft production illustration, converting blueprints to drawings at the Art Center School in a program in conjunction with the California Institute of Technology, a skill that would come into play later on in her art. After several years, she returned to Chicago, taking a job as a scriptwriter at WGN, a local AM radio station. In 1945, her husband home from military service and after the birth of their daughter, the family moved to Los Angeles, establishing an art studio for June in the garage of their home.

In Los Angeles, once again able to paint, she became an integral part of the local art community, while intensifying her own creative output. In her work, she began exploring aspects of optics, including focal and peripheral vision, where the rules of perspective become aberrant. Further, she was fascinated by the molecular nature of matter and the interchange of time and space. In 1948, she entered the lithography workshop of noted master printer Lynton Kistler, beginning a lifelong relationship with lithography. As with her painting, she explored her work in optical illusion and allegorical images relating to the writings of Franz Kafka and scientific themes of fission and the atom bomb. In Los Angeles, beginning in the mid-1940s, she exhibited in local group exhibitions, including at the Los Angeles County Museum of History, Science, and Art. In 1950 she was awarded that museum's first place purchase prize award; in the same year, she had her first solo West Coast exhibition, *June Wayne – Paintings, Drawings, Space Constructions, Lithographs*, at the Santa Barbara Museum of Art. During the remainder of the 1950s, she continued to exhibit on a local and national level, and was the recipient of numerous awards, including the Los Angeles Times Woman of the Year Award for Meritorious Achievement in Modern Art in 1952.

The 1950s were a time creativity not only in her personal art, but also in the role she played in the overall advancement of the ideology of modern art. In 1953, with the art critic Jules Langsner, she established a discussion series, using the guidelines of the Fund for Adult Education of the Ford Foundation. The Fund for Adult Education was a subsidiary foundation established and supported by the Ford Foundation. Founded in 1951, its purposes were to aid and encourage liberal adult education in political, economic, and international affairs and in humanities, with an emphasis on study-discussion. It became instrumental in the establishment of an educational broadcasting system (ETV) in the United States. (The Fund officially ended its activities in 1961.) The series *You and Modern Art* was a tool to look at modern art as a political counterweight to McCarthyism and to the unjustified proclamation and attitude that modern artists and their art "are unwitting tools of the Kremlin." June remained involved with this project until 1960.

The Advocate, 1952, oil on canvas, 60.25 × 28 in., signed verso. From the Park Collection.

Waiting for Newspapers, 1936, oil on canvas, 25 × 22 in., signed l/l:
June Claire. Courtesy of the June Wayne Collection.

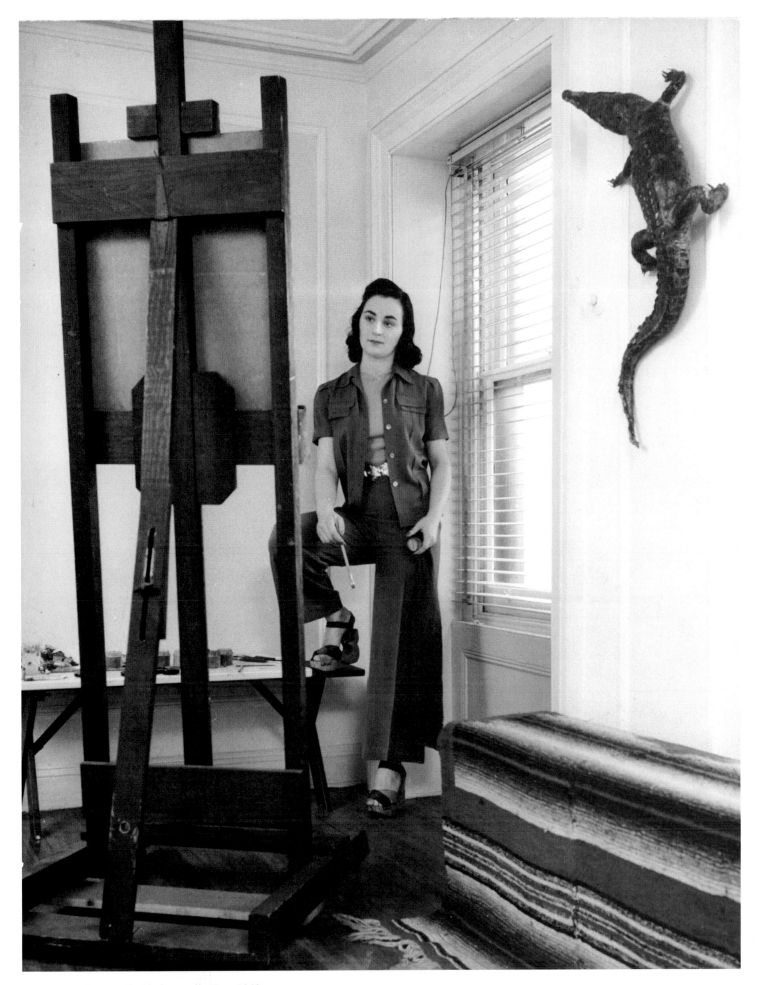

June Wayne photographed in her studio, June 1940.
Courtesy of the June Wayne Collection.

The Witness II, Aug. 1952, color embossed lithograph on paper, 23 x 28.75 in.,
signed and dated l/r. Courtesy of the June Wayne Collection.

The Sanctified, 1950, lithograph on paper, 13.75 × 17.75 in., signed l/r. Courtesy of the June Wayne Collection.

The Cavern (From the Kafka Series), 1948, oil on canvas, 36 × 54 in., signed l/r. Courtesy of the June Wayne Collection.

...look with one eye, parts of the image appear to move into 3-D. The reason you have to close one eye is that I have already taken binocular vision into account with the variations or breakdowns in form moving out from the focal area to the peripheral.

—June Wayne, 2006
June Wayne: The Art of Everything
Robert P. Conway

In 1957, she began making annual trips to France, collaborating in Paris with the French master printer Marcel Durassier, with whom she created the *livres de peintres* for *Songs and Sonnets* by John Donne in 1958, becoming one of the first American artists to illustrate a great poet. The book was included in the influential 1961 exhibition *The Artist and the Book, 1860-1960* at Boston's Museum of Fine Arts. By 1959, fully engrossed in the art of lithography and keenly aware of its moribund condition as an art form in the United States, June presented a plan to W. MacNeil Lowry, the director of the Ford Foundation's program in humanities and the arts, to resurrect lithography as a well-respected art form.

This plan was a blueprint for how the art of lithography could be restored through the systematic re-creation of master-printers including both national and international artists. The result was the Tamarind Lithography Workshop, which opened in 1960 with June as its director and funded by the Ford Foundation. By the late 1960s, Tamarind had become an international force in the printmaking arts and further established Los Angeles as a leading center for printmaking in the United States. In 1970, Tamarind would leave Los Angeles and be transformed into the Tamarind Institute of the University of New Mexico, where it continues to this day.

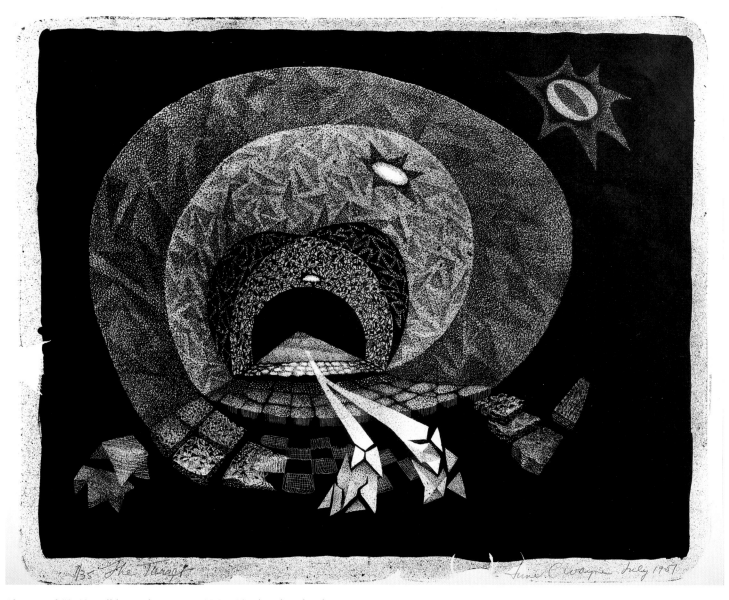

The Tunnel #2, 1951, lithograph on paper, 15.5 × 19.5 in., signed and dated l/r, ed. 35. Courtesy of Roger Genser and The Prints and the Pauper. Photo: Martin A. Folb, PhD.

In 1964, she entered into her second marriage to Arthur Henry "Hank" Plone. In 1972, June, a lifelong advocate for women and the feminist movement, developed a series of professional training seminars for and about the problems faced by women artists. Called the Joan of Art Seminar, the program encouraged each participant to mentor and encourage other women in their individual pursuits. June continued to work as a writer, speaker, and host of lectures, television programs, and documentaries on the subject of artists and their art. She was a founding member of the Los Angeles Council of Women in the Arts, which sought the equal representation of women artists in museum exhibitions. She also served on the selection committee for the 1977 Los Angeles exhibition *Contemporary Issues: Works on Paper by Women*, sponsored by the Woman's Building in Los Angeles and the National Caucus for Art, which featured the work of 200 women artists from across the United States.

The recipient of numerous awards for her art and activism, her work was exhibited at venues across the United States and internationally, and her work is included in museum collections, including the National Museum of Women in the Arts, Washington, DC; the Museum of Modern Art, New York; the Norton Simon Museum, Pasadena; and the Los Angeles County Museum of Art. She was awarded honorary doctorates from the International College, Los Angeles and London, 1976; The Atlanta College of Fine Arts, Georgia, 1988; California College of Arts and Crafts, San Francisco, 1988; Moore College of Art and Design, Philadelphia, 1991; Rhode Island School of Design, Providence, 1994, and Rutgers University, New Brunswick, New Jersey, 2005. In 2002,

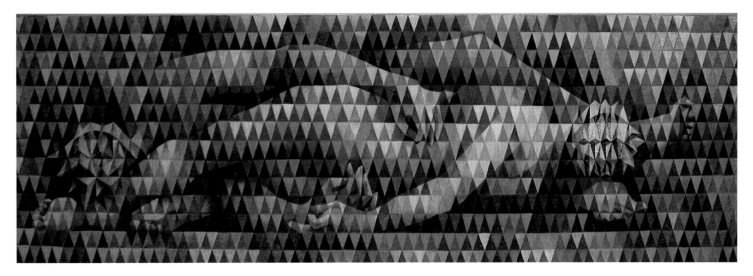

The Dreamers, 1952, oil on canvas, 21 × 63 in., signed l/r.
Courtesy of Tobey C. Moss Gallery, Los Angeles, California.

This is the painting when I discovered my glasses were a wrong
prescription. I had to back off of it to find out if it was working
but the painting looked fuzzy. An eye doctor prescribed new
glasses . . . saved the painting.

June Wayne, 2006
June Wayne: The Art of Everything
Robert P. Conway

Rutgers University established the June Wayne Archive and Study
Center as part of the Rutgers Center for Innovative Print and Paper
(renamed The Brodsky Center for Innovative Editions in 2008)
when she donated a large collection of both her work and the work
of other artists from her collection of graphic works. In 2007,
Rutgers published *June Wayne: A Catalogue Raisonné, 1936–2006:
The Art of Everything*.

June Wayne passed away on August 23, 2011, in Hollywood,
California.

Biographical information courtesy of the artist's daughter,
Robin Wayne Park, and the June Wayne Collection. Additional
information from the Cook County, Illinois, Birth Certificates
Index, 1871–1922 and the California Death Index.

June Wayne photographed in her studio, 1952.
Courtesy of the June Wayne Collection.

Emilie Sievert Weinberg
1882–1958

Emilie Sievert was born in Chicago, Illinois, on November 27, 1882, the daughter of wealthy clothing manufacturer Frederick J. Sievert and Wilhemina (Langlass) Sievert. While in her teens, Emilie began her art studies at and graduated from the School of the Art Institute of Chicago. In October of 1905, she married Isadore Weinberg in Chicago, where they lived until moving to California in 1912, first settling in Oakland and then in San Francisco, where she established a studio in her home at 1801 California Street; her husband passed away in 1920. In 1916, she studied privately with William Merritt Chase at his New York studio. She would carry the distinction of being one of his last students before his death that same year. Returning to California, she moved across the San Francisco Bay to Berkeley and eventually continued her studies with Hans Hofmann at the University of California, Berkeley. Her final move was to the nearby community of Piedmont, where she remained.

Her early works were done in watercolor, a medium she later discarded in favor of oils. Her subjects include figures, landscapes, floral, and abstractions, in addition to murals and frescos. Emilie painted landscapes and portraits in New Mexico during the summer of 1918, a location she returned to regularly for many years.

Her exhibitions included Art Institute of Chicago, 1905, 1915–18; San Francisco Art Association, 1916–40; Oakland Art Gallery, 1917, 1928, 1929; California Liberty Fair, 1918; California Art Club, 1919; Academy of Western Painters, Los Angeles, 1922; San Francisco Society of Women Artists, 1918–33; Bohemian Club, 1928; California State Fair, 1933 (prize); Bay Region Art Association, 1937 (solo); San Francisco Museum of Art, 1937, 1939 (solo), 1941, 1942 (solo), 1947; Golden Gate International Exposition, 1939; Montalvo Foundation, Los Gatos, 1941 (solo), M. H. de Young Memorial Museum, San Francisco, 1959, all in California, and career retrospectives at the Salem Art Association, Oregon, 1984, and Western Oregon College, 1985.

She was a member of Art Institute of Chicago Alumni Association; Oakland Art Association; California Art Club; San Francisco Art Association; San Francisco Society of Women Artists; and the Mural Society of California.

Flight of the Bumble Bee, n.d., oil on canvas, 10 × 8 in., initialed l/r. Exhibited Oakland Art Gallery (later the Oakland Art Museum), tag verso. Private collection. Photo: Martin A. Folb, PhD.

The Golden Cloak, 1919, oil on canvas, 30 × 32 in., signed and date l/r. Collection of Leonard Hill.

Her works are held in the Shasta State Historical Monument; University Elementary School, Berkeley (fresco); and Mills College, Oakland, all in California; and the Vanderpoel Art Association, Chicago, Illinois.

Emilie Weinberg passed away on January 15, 1958, in Piedmont, California.

Biography compiled from: *American Art Annual*, Volume XVI, 1919; *Who's Who in American Art, 1938–39*, Alice Coe McGlauflin, ed.; *Who's Who in American Art, 1940–1941*, Charlotte Ball, ed.; *Artists of the American West: A Biographical Dictionary*, volume II, Doris Dawdy; California State Library, Biographical Index Card, 1781–1990; *San Francisco Chronicle*, January 19, 1958 (obituary).

View From My Studio, (San Francisco, California), 1921, oil on canvas, 20 × 24 in., signed u/l. Collection of Leonard Hill.

Ludmilla Welch
1867–1925

Ludmilla Pilat was born on April 1, 1867, in Ossining, New York, the daughter of Charles F. and Anna (Enzinger) Pilat, and she grew up in Ossining. Her Austrian-born father escaped during the Austrian revolutions of 1848 and the subsequent students' rebellion and immigrated to Savannah, Georgia, in 1848, where he met his future wife, and eventually owned a peach orchard in Dalton, Georgia. Following the Civil War, her parents moved to Ossining, New York, where Ludmilla was born. When she was fourteen, Ludmilla met the artist Thaddeus Welch when he was sketching in the woods near the family home. Two years later, in 1883, with her parents' consent, she married the thirty-nine-year-old artist, moving with him and pursuing art studies with him in New York, Boston, and Chicago between 1884 and 1888. Thaddeus encouraged Ludmilla's talent for drawing from the early days of their relationship. When Thaddeus received a commission to paint a cyclorama in Australia in 1888, she returned to her parents' home in Ossining. During this period, she accompanied her family on visits to Georgia; paintings depicting Georgia scenes date from 1890, 1892, and 1893. Ludmilla remained in Ossining with her family until the couple reunited in 1893, the same year they moved to California.

Initially the couple settled in Southern California, although after some difficult times in Los Angeles, Ludmilla and her husband traveled to San Francisco in 1894, then across the bay to Mill Valley, finally settling in Marin Hills. There, in a place they called "Steep Ravine," the couple lived in a relatively primitive state for a number of years. During this time, they made a trip to Oregon in 1897 and spent a summer in Yosemite. In 1902, they resettled in nearby San Geronimo Valley, staying until 1905, except for a winter in San Francisco, 1902 to 1903. Afterward, seeking a milder climate and because of his poor health, they established their final home in Santa Barbara; Thaddeus passed away in Santa Barbara in 1919.

Springtime, Lion Hill, Millwood, 1903, oil on canvas, 10.5 × 18.5 in., signed l/l. Courtesy of The North Point Gallery, San Francisco, California.

At the Easel, Marin Hills, n.d., oil on board, 9 × 11 in., signed l/l.
Courtesy of Josh Hardy Galleries.

Cabin at Steep Ravine, c. 1900, oil on canvas, 13.5 × 8.5 in., signed l/r.
Bolinas Museum, Bolinas, California. Courtesy of The North Point Gallery,
San Francisco, California. Ludmilla and Thaddeus Welch moved to Marin
County, California, in 1894 and set up house in a rustic cabin at Steep Ravine on
the western slope of Mount Tamalpais, where they lived and painted until 1902.

Farallon Islands (In the Gulf of the Farallones, off the coast of
San Francisco, California), n.d., oil on canvas on board, 10.5 × 18.5 in.,
signed l/r. Collection of Courtney S. Clarkson.
Courtesy of The North Point Gallery, San Francisco, California.

Ludmilla was a pupil of her husband; the two often painted side by side, and she made her greatest progress as an artist during their Marin years. While living in a rustic cabin that she and her husband had built and subsisting much of the time on wild greens, fruit, bread, and the like, she not only refined her artistic skills, but also learned to improvise. She painted in oil and watercolor on whatever material was at hand, frequently using pieces of cardboard and cigar-box lids. Her subjects included Marin County landscapes, Yosemite scenes, Oregon views, and animal studies. Later she added glimpses of the Santa Ynez Mountains east of Santa Barbara, renderings of the Channel Islands, and studies of the adobes.

Ludmilla's paintings of the historic structures in the Santa Barbara area are among her best-known works. Over the years, she produced such titles as *A Montecito Adobe*, *The Carrillo Adobe*, and *An*

Adobe in Santa Barbara, all of which were displayed in public exhibitions. A number of her adobes also appeared in color in Edward S. Spaulding's publication *Adobe Days along the Channel.*

Ludmilla, who passed away on a train while traveling en route to New York, is represented in the collections of the Oakland Museum of California, Santa Barbara Historical Society; and Historical Museum Foundation of Sonoma County, California, and her work has been included in numerous posthumous exhibitions.

Ludmilla Pilat Welch passed away on May 17, 1925, near Tallahassee, Florida.

Biography, with thanks, from: *An Encyclopedia of Women Artists of the American West*, Phil Kovinick and Marian Yoshiki-Kovinick, Austin: University of Texas Press,1998. Additional source material: *Sunset* magazine, vol. 13, May 1904.

Julia Bracken Wendt
1868–1942

Julia M. Bracken was born on June 10, 1868, in Apple River, Illinois, the daughter of Andrew and Mary (MacNamera) Bracken. She was the second youngest of thirteen children. In 1876, the family moved to Galena, Illinois. Due to financial difficulties, Julie was forced into domestic service at the age of seventeen. This decision would prove to be beneficial in more than one way. Her employer, Alice Stahl, recognizing Julia's artistic talent, encouraged her to pursue studies in art, and sponsored her education at the Art Institute of Chicago. Julia enrolled at the Institute, where she remained from 1887 to 1892.

While at the Art Institute of Chicago, she was a student under, and later an assistant to, the sculptor Lorado Taft. Taft, who was working on sculpture commissions for the 1893 World's Columbian Exposition, which was being held in Chicago, employed a group of female students who became known as the "White Rabbits" to assist in the completion of the sculpture for the exposition. Julia showed great promise and many considered her the most talented of this group.

Julia, who had taken up wood carving and had become skilled in the medium early in life, used this art form to help support herself during and after college. She was employed as a teacher at the Ephatha Deaf Mute School on the West Side of Chicago, where she taught the art form.

During the last year of work with Taft, she established a studio of her own in the Tree Studio Building on the North Side of Chicago. She would maintain the studio for roughly the next twelve years, continuing to receive public and private commissions for her sculpture.

In 1906, she married the artist William Wendt and, within a few months of their marriage, the couple moved to Los Angeles, California, where they bought the former studio/cottage of Marion and Elmer Wachtel

at 2814 N. Sichel Street. In 1912, the Wendts built a home/studio in Laguna Beach, California; however, Julia still maintained her studio in Los Angeles where she did most of her sculpting, continuing to receive commissions for her work.

In 1913, she created the very first piece of public art funded by Los Angeles County, a Beaux-Arts statue titled *Three Muses*, which represented the disciplines of history, science, and art, and was housed in the rotunda of the Los Angeles County Museum of History, Science, and Art.

From 1906 to 1913, she was on the faculty at the Otis Art Institute. Equally skilled in bronze, wood, and marble, her specialties were bas-relief portrait medallions and fountain figures. For the remainder of her life she continued to receive commissions on both a local and national level. She achieved a reputation as one of America's finest sculptors, and her works continued to enrich the cultural landscape.

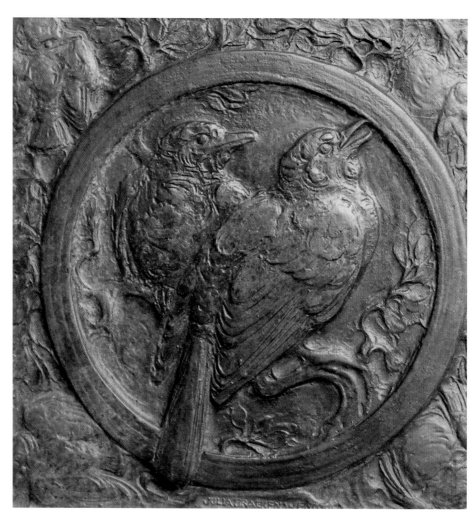

Spring Song (Bas-relief Plaque), c. 1915, cast bronze, 7.25 × 7.25 in., signed l/m. Courtesy of Christopher Queen Galleries.

Photograph (with handwritten annotation) of Julia Bracken Wendt's studio workshop, c. 1915. Photographer unknown. Courtesy of the Braun Research Library Collection, Autry National Center of the American West, P.32643.

The photograph of Julia Bracken Wendt's studio workshop shows a number of her sculptural works, including the bas-relief work titled *Spring Song* and a work titled *San Lucas, Patron of the Arts* (both pictured in the lower center of the photograph). Examples of these two works are being presented here in *Emerging from the Shadows*.
A handwritten annotation on the photograph (l/r) reads: "Christmas Greeting from the Workshop of Julia Bracken Wendt to Chas. F. Lummis".

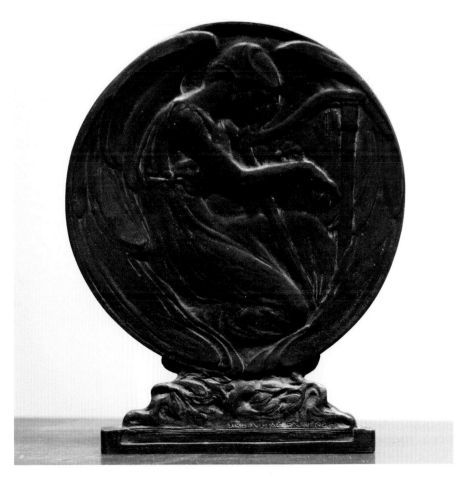

Music (Sculpture), 1915, cast bronze, 9 × 7.25 in., signed on base. Private collection. Courtesy of Edenhurst Gallery.

Reprint: *The Western Woman*, Volume IX - Number 6, January, February, March, 1938.

She was a member of Chicago Society of Artists; Chicago Municipal Art League; California Art Club; Three Arts Club Los Angeles; Society of Western Artists; American Federation of Arts; National Arts Club, New York City; Los Angeles Municipal Art Commission; and Laguna Beach Art Association. She had exhibitions at the World's Columbian Exposition, Chicago, Illinois, 1893; Annual Exhibition of Works by Chicago Artists, Art Institute of chicago, 1898 (sculpture prize); Pennsylvania Academy of the Fine Arts, 1899; Chicago Municipal Art League, 1905 (prize); Art Institution of Chicago, 1899–1908, 1909 (with William Wendt), 1910, 1921; St, Louis Exposition, 1904; Panama-Pacific International Exposition, San Francisco, 1915 (gold medal); California Art Club, 1918 (gold medal); Los Angeles County Museum of Art, 1918, 1939 (solo); California Pacific International Exposition, San Diego, 1935 (gold medal); Golden Gate International Exposition, San Francisco, 1939; and more. Her works are in the rotunda of the Natural History Museum of Los Angeles County (formerly Los Angeles County Museum of History, Science, and Art), Exposition Park, Los Angeles; Lincoln Park, Los Angeles; New Ebell Club of Los Angeles; Hollywood High School; and Illinois State Capitol, Springfield, Illinois.

Julia Bracken Wendt passed away on June 22, 1942, in Laguna Beach, California.

Biographical information compiled from: *Who Was Who in American Art, 1564–1975*, Peter Hastings Falk. ed.; *Oxford Dictionary of American Art and Artists*, Ann Lee Morgan, Oxford University Press; *The Art of Julia Bracken Wendt*, Everett Carroll Maxwell, 1910; *Exhibition of Painting by William Wendt and Sculptures by Julia Bracken Wendt*, the Art Institute of Chicago, January 5 to January 24, 1909 (pamphlet); *The Daily Northwestern* (Oshkosh, Wisconsin), October 8, 1892; *Chicago Times-Herald,* December 1898, as reprinted in *The Times Democrat (*Lima, Ohio), December, 27, 1898; California Biographical Index Cards,1781–1990, California State Library; and United States Census, 1870, 1880,1900, 1910, 1920, 1930.

San Lucas, Patron of the Arts (Sculpture), c. 1915, cast bronze, 20 × 13 in.,
signed on base l/r. Private collection. Courtesy of Edenhurst Gallery.

Carol Caskey Weston
1894–1975

Carol Caskey was born on April 13, 1894, in Salt Lake City, Utah Territory, the daughter of Robert J. and Helen (Wishard) Caskey. Carol, along with her three sisters, spent her early years in Salt Lake City until 1905, when the Caskey family moved to Highland Park, California.

Carol showed an early interest and aptitude in art, a talent that was encouraged by her family. She graduated from South Pasadena High School in 1912 and from California State Normal School, Los Angeles (later renamed University of California, Los Angeles) in 1914 with a bachelor of arts degree in art education. After graduation, Carol started teaching art in Los Angeles area schools; it was important for her to help with the family's meager income. By 1916, an opportunity presented itself for Carol to move to Skagway, Alaska, to work. Although Carol's time in Alaska was brief, it gave her a year's experience outside of California and allowed her the time to sketch and paint in an entirely new surrounding.

Carol Caskey Weston. Private collection.

Unique Hand-Illustrated Note Card, 1917, mixed medium on heavy stock paper, 4.5 × 3.5 in. Private collection. Photo: Martin A. Folb, PhD. An early example of her art and emerging style, this illustrated note card was created by Carol Caskey in 1917 and sent to Joseph Weston, prior to their marriage.

Untitled (Rural Structure), c. 1920, gouache on paper, 12.75 × 11.75 in. (image), signed l/l. Private collection. Photo: Martin A. Folb, PhD.

Untitled (From the Artist's French Countryside Series), c. 1925, tempera on board, 9.75 × 8 in., signed l/l. Private collection. Photo: Martin A. Folb, PhD.

La Rocha - Posay, September 25 (From the Artist's French Countryside Series), 1925, tempera on board, 9.75 × 8 in., signed and titled l/r. Private collection. Photo: Martin A. Folb, PhD.

Isle St. Marguerite, Cannes
(From the Artist's French
Countryside Series), c. 1925,
ink, casein, and tempera on
paper, 12 × 15.25 in., signed
l/r. Private collection.
Photo: Martin A. Folb, PhD.

Untitled (Landscape with Structures), c. 1930, graphite on paper, 12.25 × 19 in.,
unsigned. Private collection. Photo: Martin A. Folb, PhD.

Untitled (Back Bay Harbor - Newport, California), c. 1938,
watercolor and casein on paper, 11.5 × 12 in., unsigned. Private
collection. Photo: Martin A. Folb, PhD.

After returning to Los Angeles in 1917, she met and married architect Joseph Weston on July 28, 1919. The couple rented a small house in a courtyard complex in Hollywood just off Hollywood Boulevard, where Carol would have a small studio of her own. Carol did not return to teaching but concentrated on creating her own art.

By 1925, the always-thrifty couple, who were by now parents, had saved enough for their first major family excursion abroad. Joe took a sabbatical from his successful architectural practice and the family departed Los Angeles for a six-month sketching and painting bicycle tour of France.

When the Westons returned to Southern California, they each continued their individual architectural and artistic pursuits. By this time Carol was doing linoleum block prints that she printed on a small press in her home; many of the images were based on sketches she had done while in France. For larger print runs, she had the blocks printed on a commercial job press to achieve a good, solid black line on various types of colored paper. By hand, she added watercolor to each of the prints, making each a monoprint; thus no two hand-painted prints were exactly the same. She sold these prints through Southern California area galleries and department stores.

In addition to printmaking and painting with watercolor, Carol explored the use of oil paints in her work. In the 1930s she took private instruction in oils from the artist Mabel Alvarez and although she enjoyed the experience, she preferred working with watercolors, gouache, and tempera, and continued to do so for the rest of her life.

In 1931, the family moved to rural El Monte, California, and built a simple wooden house with a brick floor on a half-acre in a walnut grove. Carol and Joe became, with much study and hard work, successful subsistence farmers.

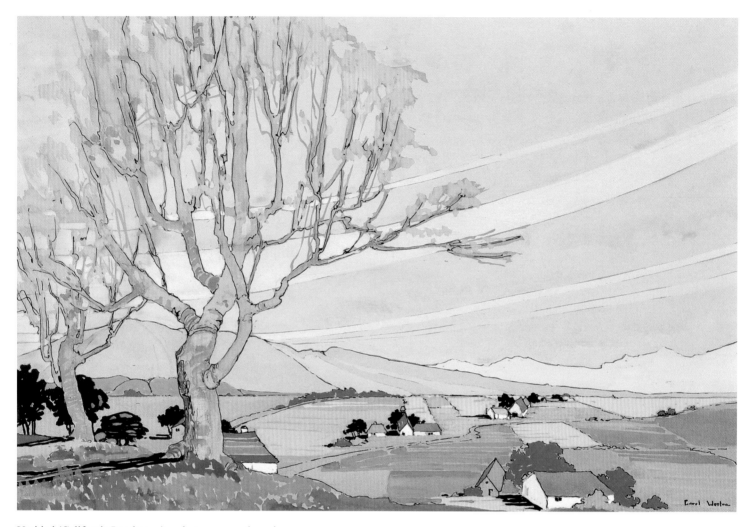

Untitled (California Landscape), n.d., tempera and casein on paper,
10 × 14 in., signed l/r. Private collection. Photo: Martin A. Folb, PhD.

Joe's employment with the US Department of the Interior's Rural Resettlement Administration meant the family needed to move to Berkeley, California, in 1935 and then to Washington, DC, in 1936. Wherever the family went, Carol took along her sketchbooks, pencils, charcoal, pens and ink, paints, brushes, drawing board, and block cutting tools.

When the family returned to El Monte at the end of 1936, Carol became interested in silk-screen printmaking and applied her concentration to mastering the medium. She continued to paint, re-print old blocks at the job press at the *El Monte Herald* newspaper, and create new blocks, a practice she continued for many years.

Her work in watercolor intensified and during this period she began producing larger works using this medium. Her use of color was always simultaneously subtle and daring, which enriched the quality of the individual work. She could transform a shingle or tile roof into a complex multihued abstract of color. Often she would make a detailed charcoal drawing and paint directly onto the charcoal image so the watercolor and charcoal would combine to give the overall effect she wanted to create. Most of these paintings were scenes of rural Southern California, many including her two favorite images: truck farms and cabbage fields.

In early 1942, as part of the war effort, the family moved to Washington, DC. Carol continued to sketch in DC and later that year she continued her sketching on a walking trek in Connecticut and Massachusetts.

The Westons returned to California in late summer of 1942. In the fall and winter of 1943, she made a weekly drive to Hollywood to take an advanced color theory class with the artist Hilaire Hiler. Carol continued her artistic output during the mid -1940s despite serious health problems. Through the war years she made weekly trips to Los Angeles to tie bandages for the Red Cross.

In 1947, the family again relocated, this time to Tacoma, Washington. Carol embraced the topography of the region, capturing the landscape of the northwest coast in her art. In 1955, Carol traveled to Europe, where she visited nine countries and completed fifty watercolor drawings during her tour.

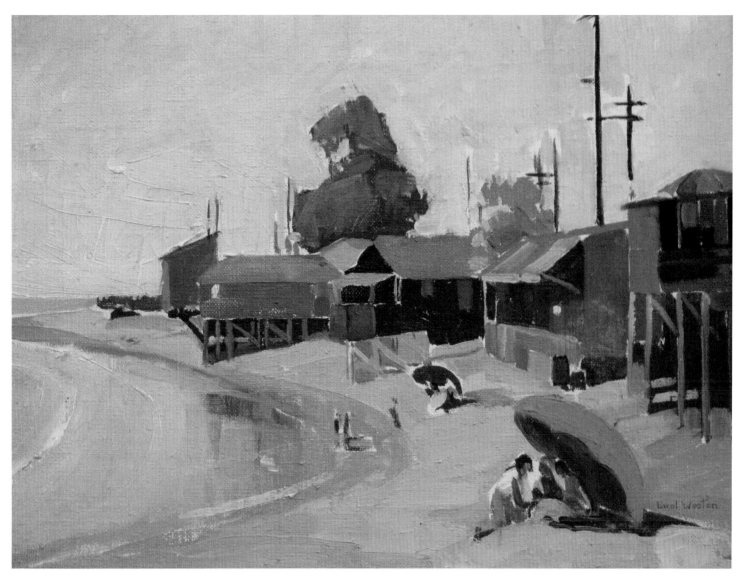

Untitled (Southern California Beach Scene), c. 1935,
oil on canvas, 11.5 × 15.75 in., signed l/r. Private collection.
Photo: Martin A. Folb, PhD.

In 1957, upon her husband's retirement, the couple moved to Carmel, California, and together they designed and built a home. The house was featured in the August 1960 issue of *Sunset* magazine. Together the couple learned the art of weaving. They created a studio in the lower level of the home and proceeded to study weaving, winning many awards for their work. In addition, throughout her adult life, Carol practiced her other artistic passion, music, in which she excelled as a singer and pianist.

Carol was a member of various art organizations including the California Watercolor Society, in which she served in a governing position for several years. Through these affiliations she met the artists Conrad Buff, Barse Miller, Paul Sample, and the *Los Angeles Times* art critic Arthur Millier, all of whom became lifelong friends of the Westons. She loved the California countryside and coastline and created many paintings and block prints central to these subjects. Beginning in the early 1920s, she exhibited throughout Southern California including with the California Water Color Society, 1921–1944; the Los Angeles County Museum of History,

Science, and Art, 1927; The California Art Club inaugural exhibition held at the Hollyhock House, Barnsdall Park, Los Angeles, 1927; the California Art Club, 1927–1930; and Bullocks Wilshire gallery, Los Angeles, California.

After her husband's death in 1963, Carol did extensive traveling around the western United States and the world, including the South Pacific, Scandinavia, the British Isles, and Canada, completing over 180 watercolor drawings during her travels. In 1975, once again on a drawing excursion, Carol traveled to Africa. It was upon her return to California from her African excursion that she passed away unexpectedly after a brief illness.

Carol Caskey Weston passed away at the age of 81 on May 29, 1975.

Biography courtesy of the Weston Family.

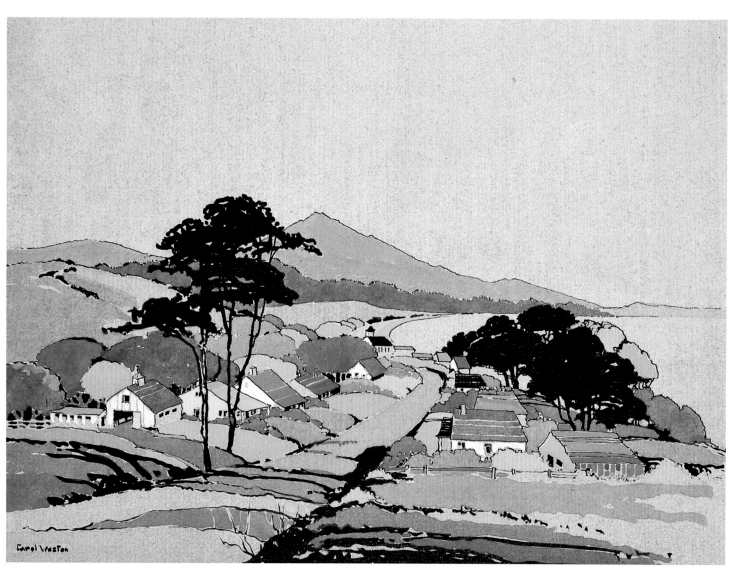

Untitled (Coastal Village Landscape), n.d.,
tempera and casein on paper,
11 × 8 in., signed l/l. Private collection.
Photo: Martin A. Folb, PhD.

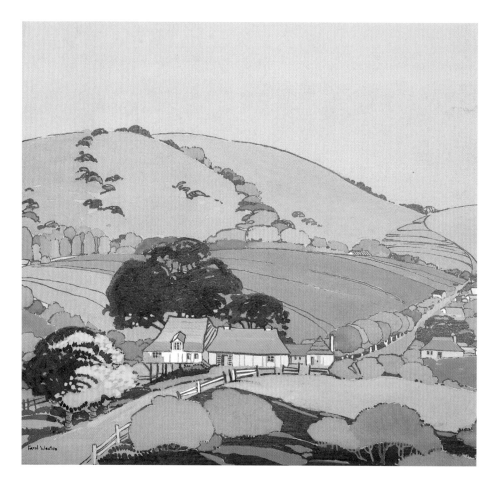

Untitled (Village Landscape), n.d.,
tempera and casein on paper,
12.25 × 14 in., signed l/l.
Private collection.
Photo: Martin A. Folb, PhD.

Untitled (Village Street Scene), n.d., tempera and casein on paper, 11 × 8 in.,
signed l/r. Private collection. Photo: Martin A. Folb, PhD.

Untitled (Washington State - Landscape), c. 1950, linoleum block print on colored paper, 8.25 × 9.5 in., unsigned. Private collection. Photo: Martin A. Folb, PhD.

Alaskan Village, 1949, linoleum block print with casein on colored paper, 5.25 × 7 in., signed l/r. Private collection. Photo: Martin A. Folb, PhD.

Cowboy (the artist's grandson at Slab Lakes - Sierra National Forest, California), 1959, tempera and casein on paper, 8.75 × 11.5 in., unsigned. Private collection.

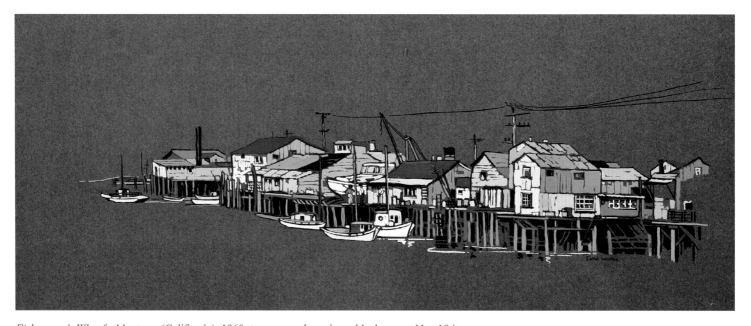

Fisherman's Wharf - Monterey (California), 1960, tempera and casein on black paper, 11 × 18 in., signed l/r. Private collection. Photo: Martin A. Folb, PhD.

Carmel Valley - July, '63, 1963, watercolor and pen on paper, 8 × 11 in.,
unsigned. Private collection. Photo: Martin A. Folb, PhD.

Eva Blanche Whelan
1889–1974

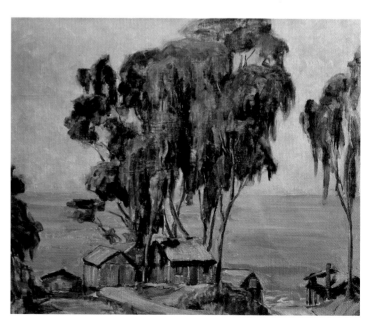

Eva Blanche Whelan was born in Los Angeles, California, on October 31, 1889, the daughter of Weldon D. and Emily (Cruise) Whelan. Her early years were spent in Los Angeles; in 1909 she enrolled at Stanford University, Palo Alto, California, graduating in 1912–13 with a bachelor of arts degree. Afterward she studied at the Art Students League of New York and later at the Los Angeles School of Art and Design as a pupil of Boardman Robinson and Nicholas Haz.

Primarily a resident of Los Angeles, she also maintained a residence in New York during her schooling and for a brief time afterwards. She frequently went on painting excursions throughout the American Southwest. Her subjects include American Indians, portraiture, landscapes, and seascapes.

Eva Blanche exhibited mainly in Southern California, and occasionally in Arizona and New Mexico. Her exhibitions included the California Liberty Fair, 1918; Kanst Gallery, Los Angeles, 1918; New Mexico Thirteenth Annual Exhibition, 1926; California Art Club, 1918–1937, Los Angeles; Laguna Beach Art Association; West Coast Arts, Inc.; American Federation of Arts; Women Painters of the West; California State Fair, 1930, 1936; Arizona State Fair, 1931 (prize); Los Angeles County Museum of History, Science, and Art, 1931; Roosevelt Hotel, Hollywood, California, 1932; Gardena California High School, 1933; and J. W. Robinson with artist Edith Waldo, 1934. She was a member of California Art Club; Whitney Studio Club; Laguna Beach Art Association; Women Painters of the West; American Art Association, 1921–1933; and Western Women Art Association, 1936–1962.

Eva Blanch Whelan passed away on March 2, 1974, in Los Angeles, California.

Biographical information complied from: *An Encyclopedia of Women Artists of the American West*, Phil Kovinick and Marian Yoshiki-Kovinick, University of Texas Press, Austin, 1998; *Dictionary of American Painters, Sculptors, & Engravers*, Mantle Felding; *Artists of the American West: A Biographical Dictionary, volume III*, Doris Dawdy; *Dictionnaire des peintres, sculpteurs dessinateurs et graveurs*, v. 10, Emmanuel Bénézit; United States Census, 1900, 1910, 1920, 1930, 1940; California Biographical Index Cards, 1781–1990, and California State Library.

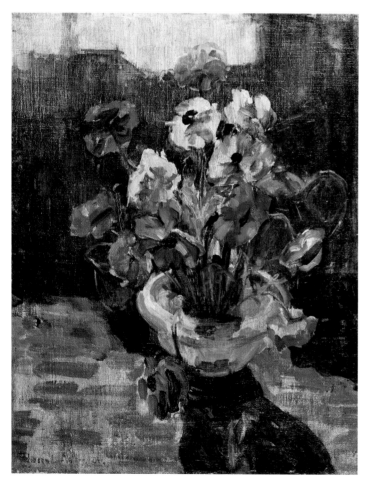

Untitled (Floral Still Life), n.d,, oil on canvas, 16 × 12 in., signed l/l. Private collection. Photo: Martin A. Folb, PhD.

Untitled (Coastal Shacks - Laguna Beach, California), n.d,, oil on canvas, 16 × 12 in., signed l/l. Private collection. Photo: Martin A. Folb, PhD.

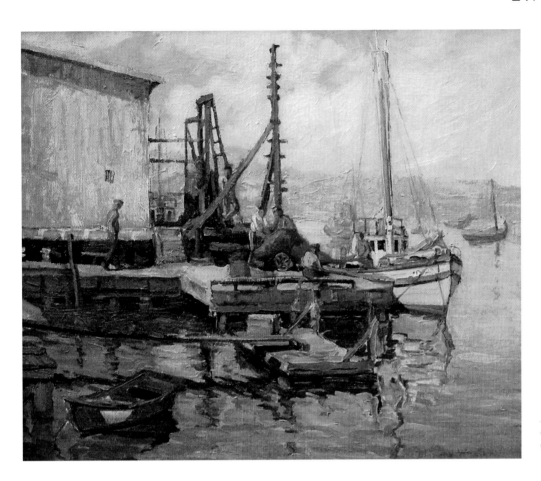

Harbor Dock, San Pedro (California), n.d.,
oil on canvas, 25 × 30 in., signed l/r.
Courtesy of Vander Molen Fine Art.

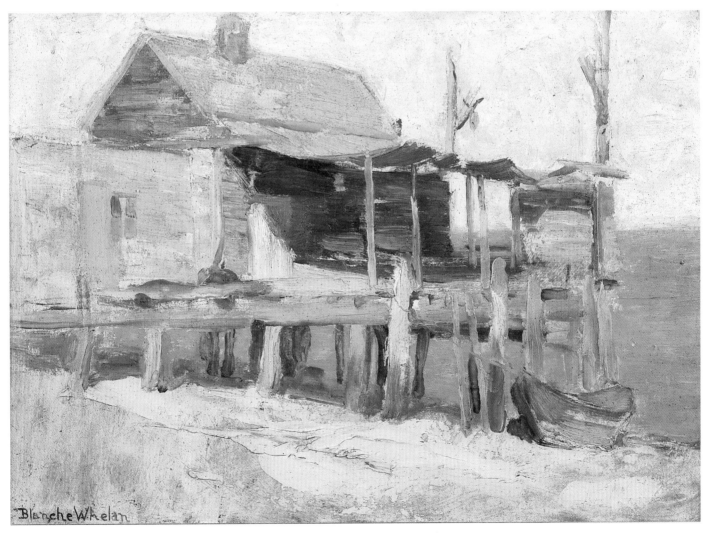

A Fish House, n.d., oil on board, 10 × 14 in., signed l/l.
Private collection. Photo: Martin A. Folb, PhD.

Lenora Whelan
1908–2003

Lenora Beatrice Neville was born on June 5, 1908, in Centralia, Washington, the daughter of William Austin and Floy (Pugh) Neville. Her family moved frequently while she was a child, spending brief periods in McMinnville and Corvallis, Oregon; Alberta, Canada; Walla Walla, Washington; Inglewood, California; and finally Oakland, California. She began drawing and painting by the age of six and at the age of twelve she enrolled in youth summer art classes at Whitman College in Walla Walla. By the mid-1920s, she had graduated from Inglewood High School in Southern California, where she was class valedictorian. Finally, the Neville family moved once again and settled in Oakland, California.

Unable to accept a scholarship to Mills College in Oakland, she went to work at the California Packing Company in San Francisco, where she met her future husband, Walter A. Whelan. The couple married in 1929 and had three children: Patricia, Susan, and Michael. In 1932, while living in Sausalito, California, she experienced her first, and only, job as a book illustrator. In 1934, the Whelan family moved to San Diego, where Lenora remained. Throughout the 1930s, 1940s, and 1950s, she continued to paint and pursued art classes at Balboa University and Fine Arts Gallery (later San Diego Museum of Art),

Lenora Neville (Whelan), c. 1928.
Private collection.

Untitled (Landscape - San Diego, California), n.d., oil on board, 16 × 20 in., signed l/r. From the collection of Valerie Lardner. Photo: Martin A. Folb, PhD.

Untitled (Landscape - San Diego, California), n.d.,
oil on board, 12 × 16 in., signed l/r. From the collection
of Valerie Lardner. Photo: Martin A. Folb, PhD.

San Diego Fine Arts Society, and Contemporary Artists of San Diego, studying under the artists Alfred Mitchell, Alson Clark, and Joseph Schrack. Many of these classes were taught during the summer and held in nearby Balboa Park. Always a devotee of group classes, she relished the input of her instructors and fellow students.

Her oeuvre includes oils and watercolors, with the majority of her work painted in the environs of San Diego County. A frequent traveler, in the late 1960s she spent six weeks in Cahors, France, participating in summer art classes, and later took courses at Cubertou, a farm in southwest France. During her lifetime, she occasionally exhibited and sold her work, participating in group shows and several solo exhibitions in the San Diego and La Jolla area.

Lenora Whelan passed away at the age of ninety-four on November 21, 2003, in San Diego, California.

Biographical information compiled from: United States Census, 1910–1940; San Francisco and San Diego City Directories; and California Death Index. Additional information and special thanks to Patricia Whelan Akin, daughter of the artist.

Untitled (River Valley Landscape - France), n.d.,
oil on board, 18 × 24 in., signed l/r. Private collection.

Edith White
1855–1946

Edith White was born on March 20, 1855, in Frankville, Winneshiek County, Iowa, the daughter of Elon and Mary (Stanton) White. As a child, she migrated west with her Quaker family by ox-drawn wagon to California in 1859, settling at a mining camp at French Corral in Nevada County. She remained there, except for a brief period in San Francisco (around 1863), until 1868, when she moved to the nearby town of North San Juan. In 1872, she enrolled at Mills Seminary (now Mills College), Oakland, where she studied art with Juan B. Wandesforde. After graduating from Mills in 1874, she returned to North San Juan, where she taught at a primary school for two years. Later, she attended the California School of Design, San Francisco, under Virgil Williams. Forced to leave school after her first year because of depleted finances, she returned for a second year after earning money copying paintings for a San Francisco firm.

Untitled (Still Life - Grapes), n.d., oil on canvas, 20 × 16 in., signed l/l. Collection of Gary M. Lang. Photo: Martin A. Folb, PhD.

Untitled (Still Life - Roses), n.d., oil on canvas, 10.5 × 14 in., signed l/l. Collection of Gary M. Lang. Photo: Martin A. Folb, PhD.

Untitled (Early Landscape with Structure on Point Loma looking toward
North Island and San Diego, California), n.d., oil on canvas, 11 × 16 in.,
signed l/l. Collection of Gary M. Lang. Photo: Martin A. Folb, PhD.

In 1882, Edith moved to Los Angeles and opened her first studio. She remained active in the city for ten years. She then studied at the Art Students League of New York in 1892 under Kenyon Cox and with Alexander van Laer and Clara McChesney. Upon returning to California, she resumed her art in Pasadena, where her career prospered; she was instrumental in the establishment of the Pasadena Art Association in 1896, and served on numerous local exhibition committees.

As Patricia Trenton wrote in *Independent Spirits*: "Edith White's wish to marry was discouraged by her father, who did not want suitors to interfere with her career in art, and Edith remained under the influence of her parents throughout her adult life."

In 1897, her mother urged her to join the Pasadena Theosophical Society. Five years later, in 1902, Edith and her parents moved to Point Loma (seven miles from downtown San Diego) to live at the headquarters of the commune of the Universal Brotherhood and Theosophical Society, the parent group of the Pasadena organization. For twenty-eight years Edith directed the art instruction at the Raja Yoga School and in her *Memories* she wrote: "I had ample time to continue in my chosen life work and was able to carry out original ideas in painting without considering the commercial side of it." Afterward, she moved to Oakland, and then to Berkeley in 1938, where she continued her career and taught art.

By her own admission, her principle work was in creating flower paintings, especially her realistic renditions of roses, which became her signature. While flowers continued to be major themes and a source of income throughout most of her career, she also painted portraits, many landscapes (first in Northern and then in Southern California), and studies of the missions. The Santa Fe Railway Company, Chicago, acquired Edith's paintings *San Luis Rey Mission* and *Pala Mission* in 1907.

Untitled (Landscape with Trees), n.d., pastels on board, 10.75 × 14 in., initialed l/l.
Collection of Gary M. Lang. Photo: Martin A. Folb, PhD.

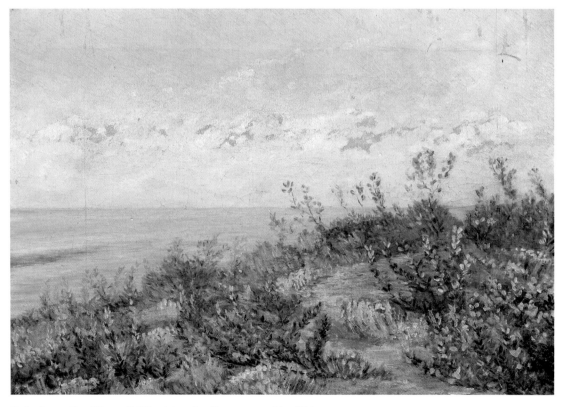

Point Loma (San Diego, California), n.d., oil on canvas, 14 × 20 in.,
initialed l/r. Collection of Gary M. Lang. Photo: Martin A. Folb, PhD.

Among Edith's exhibitions were those of the San Francisco Art Association, Mechanics' Fair, and California Midwinter International Exposition, all in San Francisco; California State Fair, Sacramento; Denver Artists Club; Arizona State Fair, Phoenix; and Oakland Art Gallery. She is represented in the collections of the California Historical Society, San Francisco; San Diego Historical Society; Mills College; Theosophical Society International, Pasadena; and Mount Holyoke College, South Hadley, Massachusetts.

Edith White passed away on January 19, 1946, in Berkeley, California.

Biographical information from: *An Encyclopedia of Women Artists of the American West*, Phil Kovinick and Marian Yoshiki-Kovinick, University of Texas Press, Austin, 1998; *Independent Spirits: Women Painters of the American West, 1890–1945*, Patricia Trenton, ed.; and *Oakland Tribune*, January 20, 1946 (obituary).

Lomaland (Point Loma - San Diego, California), n.d., oil on board, 11.5 × 6 in., signed and titled l/l. Collection of Gary Lang. Photo: Martin A. Folb, PhD.

Lomaland was a Theosophical community located on Point Loma in San Diego, California, from 1900 to 1942. Many of Edith's paintings had wild flowers or boldly colored hollyhocks in the foreground with a lush landscape and the restful cerulean ocean as the backdrop. These backdrops were the fulcrum of many of her landscapes; trees or architectural elements were placed in specific areas of the composition, persuading the eye to peek through and view her poignant subject in the distance. —Gary M. Lang

Emily H. White
1862–1924

Emily Howard White was born on February 4, 1862, in Morris, Illinois, the daughter of William and Caroline Margaret (Simmons) White, and was raised in Peoria, Illinois. She, like her sister Nona L. White, also an artist, studied at the Art Institute of Chicago under Jules Guerin and at the Peoria Art League under artists Frank Peyraud and H.G. Maratta. With Nona, she maintained a studio on North Jefferson Street, Peoria. For many years she and her sister taught oil, watercolor, and china painting in Peoria. In the late 1890s, she also maintained a studio in Chicago, Illinois. Emily would continue her association with Chicago throughout her life, often returning yearly to exhibit her work.

Beginning in 1905, she made the first of many annual expeditions with Nona to Southern California. Together they established a studio in Blanchard Hall and in the Blanchard Gallery they held their first Southern California exhibition in 1906. For a number of years Emily continued to divide her time between Illinois and California, eventually becoming a permanent resident of Southern California, living in Laguna Beach. In 1912, she traveled to study at the Ogunquit Art Colony in Maine, under Charles Woodbury. She was active throughout Southern California and was instrumental in the establishment of the Laguna Beach Art Association. Noted for her depictions of the rocky shoreline of the Pacific Ocean, her affinity for the sea drove her to capture the California coast in many of her paintings. As Antony Anderson stated in a 1915 *Los Angeles Times* review: "Miss White needs the tang of the sea in her nostrils, the sting of the spray on her cheeks, the flash of the sun, the threat of the breakers. For to all these she responds with a delightful spontaneity. . ."

Primarily a watercolorist, her oeuvre also included oils. Her subjects included marines, coastal, landscapes, American Southwest, missions, floral, ivory miniatures and portraits. She was a member of the Peoria Art League, Illinois; Palette and Chisel Club, Chicago; and Laguna Beach Artists Association, California. She exhibited at the Illinois State Fair; World's Fair: Columbian Exposition, Chicago, 1893; Blanchard Gallery, Los Angeles, 1906; Ebell Club, 1913; and Royar Gallery, Pasadena, 1915, 1916. Her work is found in the collections of the Peoria Women's Club, Illinois, and the Laguna Beach Art Museum, California.

Emily H. White passed away on May 1, 1924, in Laguna Beach, California.

Biographical information compiled from: *Peoria Women in the Arts through 1970*, Channy Lyons; *Los Angeles Times*, January 14, 1906, April 8, 1906, August 11, 1907, September 22, 1907, December 8, 1907, May 17, 1908, January 24, 1909, December 7, 1913, February 7, 1915, August 22, 1915, December 5, 1915, July 30, 1922, June 1, 1924; and California Biographical Index Cards, 1781–1990.

Gentle Surf (California Seascape), n.d., watercolor on paper, 5.75 × 23.25 in., signed l/l. Courtesy of Kaminski Auctions of Beverly, Massachusetts.

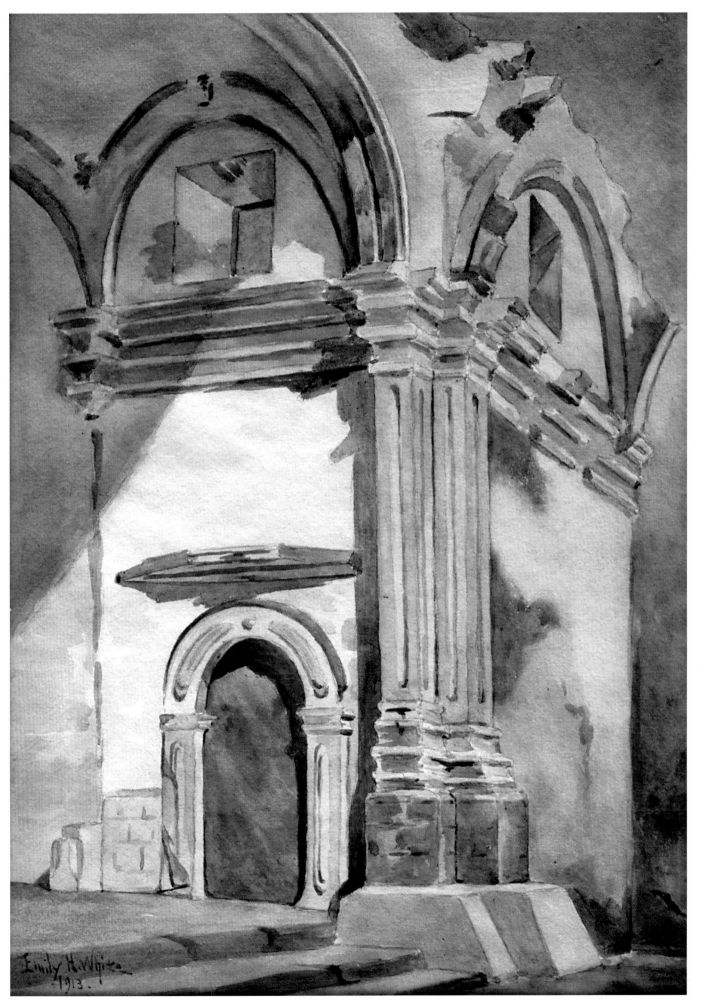

Untitled (Mission San Juan Capistrano, California), 1913, watercolor on paper, 13.5 × 9.5 in.,
signed and dated l/l. Courtesy of Peoria Women's Club of Peoria, Illinois.

Nona L. White
1859–1937

Sophronia (Nona) Louise White was born on October 4, 1859, in Morris, Illinois, the daughter of William and Caroline Margaret (Simmons) White, and was raised in Peoria, Illinois. Nona and her sister Emily, also an artist, studied at the Art Institute of Chicago under Jules Guerin and at the Peoria Art League under artists Frank Peyraud and H. G. Maratta. Her oeuvre included oils, lithography, and watercolor of landscapes and still lifes, and, early in her career, china decoration. She taught all these subjects with her sister Emily H. White in their studio on North Jefferson Street, Peoria.

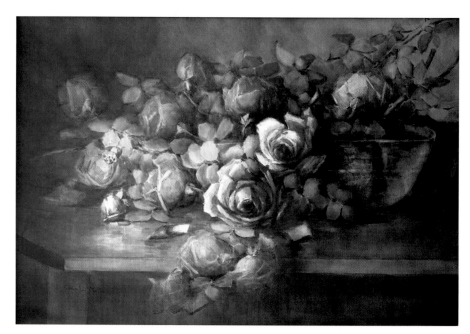

Roses, c. 1900, watercolor on paper, 10.5 × 19.5 in., signed l/l. Courtesy of Peoria Women's Club of Peoria, Illinois.

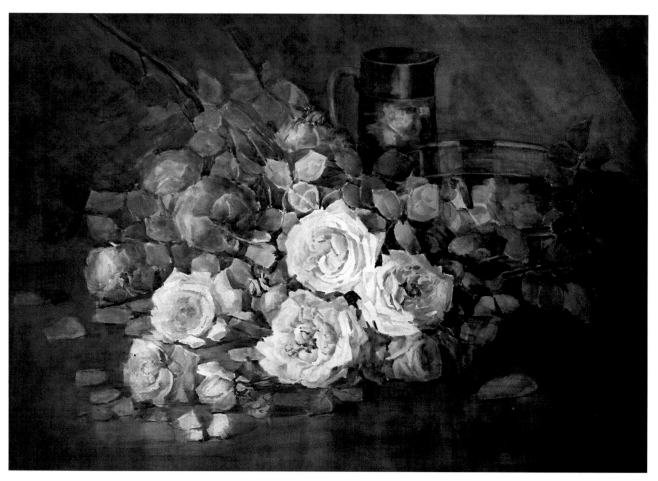

Yellow Roses (#5), c. 1900, watercolor on paper, 21.5 × 29.5 in., signed l/l. Courtesy of Peoria Women's Club of Peoria, Illinois.

Santa Ynez Mountains (California), n.d., oil on board, 12 × 16 in., signed l/l.
Courtesy of Vander Molen Fine Art. Photo: Martin A. Folb, PhD.

Beginning in 1905, she made the first of many annual expeditions with Emily to Southern California. Together they established a studio in Blanchard Hall, and in the Blanchard Gallery they held their first Southern California exhibition in 1906. For a number of years she continued to divide her time between Illinois and California, eventually becoming a permanent resident of Southern California, living in Pasadena.

In 1912, Nona studied at the Ogunquit Art Colony in Maine, under Charles Woodbury. She worked as a designer of book and magazine covers and for several years was an art critic for the *Los Angeles Evening News*. Beginning in 1924, she served as the art director of the South Pasadena Women's Club. She was active throughout Southern California and was instrumental in the establishment of the Laguna Beach Art Association and the Pasadena Society of Women Painters and Sculptors.

She was a member of the Peoria Art League, Illinois; Palette and Chisel Club, Chicago; Pasadena Society of Artists; Laguna Beach Artists Association; Shakespeare Club, Pasadena; San Gabriel Artists Guild; and Women Painters of the West, all in California. She exhibited at the Illinois State Fair; World's Fair Columbian Exposition, Chicago, 1893; Blanchard Gallery, Los Angeles, 1906; Ebell Club, 1913; Royar Gallery, Pasadena, 1916; Pasadena Society of Women Painters and Sculptors, 1928–1937; and San Gabriel Artists Guild, 1936.

Nona L. White passed away on March 11, 1937, in Los Angeles, California.

Biographical information compiled from: *Peoria Women in the Arts through 1970*, Channy Lyons; *Women of the West*, 1928, *Who's Who in American Art*, 1940–1941, *The American Federation of Arts*, 1940; *Los Angeles Times*, January 14, 1906, April 8, 1906, December 9, 1906, May 17, 1908, December 7, 1913, August 22, 1915, December 5, 1915, December 12, 1920, May 17, 1936; and California Biographical Index Cards, 1781–1990.

Ethel M. Wickes
1872–1940

Ethel May Wickes (a.k.a. Ethel Marian Wickes) was born February 13, 1872, on Long Island in Hempstead, New York. She was the daughter of Luther Carter and Margaret Elizabeth (Hunt) Wickes and from age fourteen grew up in San Francisco, where the family moved in 1886. There, she and her sisters Kate and Florence pursued a career in art. At age seventeen, Ethel traveled in a horse-drawn gig each week to the Guadalupe Ranch in San Mateo County, where she sketched animal subjects. Later she went to live on a ranch in Kenwood, Sonoma, where she began painting geese.

In 1897, Ethel traveled abroad and studied oil and watercolor portrait painting in Paris at L'Académie Colarossi with Gustave Claude Courtois, Louis Auguste Girardot, and Rene Francois Xavier Prinet, and briefly at L'Académie Julian with William Adolphe Bouguereau, Gabriel Ferrier, and Laureano Barrau. As part of her overseas sojourn, Ethel made a long sketching trip through England, Holland, and Ireland. About 1900, she returned to the United States and resumed her career as a California painter. With the exception of two brief periods, Ethel remained a resident of San Francisco for the rest of her life, living in Pacific Grove from 1907 to 1909 after the 1906 San Francisco earthquake.

Although Ethel painted various subjects in oil and pastel, she is best known for her watercolors of California wildflowers and of geese. She was also known to paint landscapes in oils. Ethel would sell her paintings through galleries or accept commissions for works, sometimes shipping the requested piece to the East Coast. She sold one of her California wildflower watercolors for two thousand dollars, an impressive sum at the time. In addition to traveling to out of state exhibitions, Ethel greatly enjoyed her yearly spring and summer painting trips between 1914 and 1939 to various locations around California, including the Mojave Desert and the Sierra Nevada mountains. Ethel was athletic and able to roam through the high Sierras in search of rare wildflowers to paint. She would make a point of keeping a diary listing distances, major landmarks, and wildflowers seen. During these painting trips, she collected eight specimens of wildflowers that are preserved in the University of California, Berkeley, Jepson Herbarium.

Untitled (Goose), n.d., watercolor on paper, 7 × 5.25 in., signed u/r. Private collection. Photo: Martin A. Folb, PhD.

Palace of the Legion of Honor (San Francisco, California), n.d., watercolor on board, 9 × 12 in., signed l/l. Private collection. Photo: Martin A. Folb, PhD.

Ethel combined her art with her love for the land by actively participating in conservation organizations. She was a member of the California Club, a women's club founded in 1897 in the wake of an abortive suffrage campaign. The California Club, which supported forest preservation, merged into the California State Federation of Women's Clubs in 1900. Prior to 1933, Wickes was chairman of the art section of the California State Federation of Women's Clubs.

The 1930s were a very difficult time for Ethel, as they were for most artists. The Great Depression and changing tastes in art caused her income from painting to drop significantly. However, she was more fortunate than most with a modest stipend of one hundred dollars per month coming in from a trust fund provided by her cousins. As most people did in the Depression, she scrambled to make a living. She sold an occasional painting, taught a student here and there, charged a modest admission for people to see her paintings in her studio (originally asking fifty cents but then lowering the price to twenty-five cents), and in 1937 she sent four of her watercolors to a publisher in Monterey, receiving forty-two dollars in royalties in 1939. Even with all the effort, she struggled to make ends meet and by the time she passed away, she was penniless.

Her paintings are held by the California Palace of the Legion of Honor, San Francisco; the Florence Henry Memorial Chapel, Seattle, Washington; The Huntington Library, Art Collections, and Botanical Gardens, San Marino; and the Shasta State Historical Monument, Shasta.

Ethel M. Wickes passed away on February 27, 1940, after being ill for about a year and a half. She was cremated and interred at the Mountain View Columbarium, Oakland, California.

Biography complied from: *An Encyclopedia of Women Artists of the American West*, Phil Kovinick and Marian Yoshiki-Kovinick, Austin: University of Texas Press, 1998; Ethel Marian Wicks, Douglas S. McElwain; *Who Was Who in American Art*, Peter Hastings Falk, ed.; Joseph A. Baird Collection; California Census Records; California Death Index.

Edna Marrett Wilcocks
1887–1969

Edna Louise Marrett was born on May 11, 1887, in Portland, Maine, the daughter of James E. and Sarah (Potter) Marrett. She studied at Vassar College, Poughkeepsie, New York, the Art Students League in New York City, the School of the Museum of Fine Arts, Boston, Massachusetts (diploma and advanced study), and the Summer School of the Art Students League of New York in Woodstock.

During World War I, while working with the Red Cross in France, she met her future husband, Frederick J. Wilcocks. After their marriage, the couple made their home in Calgary, Alberta, Canada, where she taught art in the public schools. She moved to Altadena, California, in the early 1930s, where she remained. Edna taught art at Pasadena's Flintridge School for Girls in 1934 and was art director at Anoakia School in Arcadia, California, from 1936 to 1956. She lived at 1310 Boston Street, Altadena, California, in 1945.

Edna Marrett, photographed in her studio, c. 1915.
Photographer unknown. Private collection.

Untitled (Rose Bowl - Pasadena, California), c. 1930, graphite on paper, unsigned.
Pasadena Museum of History, Pasadena, California. Photo: Martin A. Folb, PhD.

Untitled (City Hall - Pasadena, California), n.d., charcoal and colored pencil on paper, unsigned. Pasadena Museum of History, Pasadena, California. Photo: Martin A. Folb, PhD.

Edna Wilcocks was known as a painter, muralist, and teacher. She created landscapes of California and American Indian portraits. Her exhibitions included California Watercolor Society, 1928–1935; Pasadena Art Institute, 1930–1944; and the Women Painters of the West, 1933–1955. Her works are held by Bowdoin College, Brunswick, Maine (murals), and courthouses in Wilkes-Barre, Pennsylvania, and Edmonton, Alberta, Canada (murals and portraits). Edna worked in oil, pastel, watercolor, ink, and pencil and was active in Portland, Maine; Calgary, Canada; and Pasadena and Altadena, California.

Edna Marrett Wilcocks passed away on November 28, 1969, in Pasadena, California.

Biographical information compiled from: *An Encyclopedia of Women Artists of the American West*, Phil Kovinick and Marian Yoshiki-Kovinick, Austin: University of Texas Press, 1998; Pasadena Art Association Catalogue, 1945; Pasadena Museum of History Archives, Pasadena, California; Maine Birth Records; and United States Census, 1900, 1910, 1920, 1930.

Untitled (Street Scene - Pasadena, California), n.d., tempera and watercolor on colored paper, unsigned. Pasadena Museum of History, Pasadena, California. Photo: Martin A. Folb, PhD.

Untitled (Pasadena Central Library - Walnut Street, Pasadena, California), n.d., graphite on paper, unsigned. Pasadena Museum of History, Pasadena, California. Photo: Martin A. Folb, PhD.

Untitled (Pasadena Central Library - Walnut Street, Pasadena, California), n.d., tempera and watercolor on colored paper, unsigned. Pasadena Museum of History, Pasadena, California. Photo: Martin A. Folb, PhD.

The Huntington Gallery (San Marino, California), n.d., graphite on paper, initialed l/r. Pasadena Museum of History, Pasadena, California.

Untitled (Maryland Hotel - Pasadena, California), n.d., charcoal and colored
pencil on paper, initialed l/r. Pasadena Museum of History, Pasadena, California.
Photo: Martin A. Folb, PhD.

Untitled (La Vista del Arroyo Hotel - Pasadena, California), n.d., graphite on paper, unsigned.
Pasadena Museum of History, Pasadena, California. Photo: Martin A. Folb, PhD.

Untitled (Dodworth Building - Pasadena, California), 1940, n.d., watercolor on paper, 10 × 12 in., signed l/m. Courtesy of Susan and Michael Evans. Photo: Martin A. Folb, PhD.

This watercolor depiction of the Dodworth Building and Colorado Boulevard in Pasadena shows a radical style change from Edna's earlier detailed architectural drawings. The result is an unusual post-surreal modernist interruption of the building set in a cityscape view. The painting is somewhat unsettling and thought-provoking, with its cold blue/yellow palette and harsh black horizontal lines that intersect the foreground and continue into the sky.

Photo courtesy of Pasadena Museum of History

The Dodworth building was at the southwest corner of Colorado Boulevard and Fair Oaks Avenue. It was built in 1902 by Allen R. Dodworth and designed by architect J.J. Blick.

Photograph of the Dodworth Building. The Dodworth building was located at the southwest corner of Colorado Boulevard and Fair Oaks Avenue in Pasadena. It was built in 1902 by Allen R. Dodworth and was designed by architect J. J. Blick. Courtesy the Archives, Pasadena Museum of History, Pasadena, California.

The Old Barn on the Patton (George Smith Patton Sr.) Estate – sketched in 1931 the day before it was pulled down, graphite on tissue paper, 9 × 6 in., unsigned, annotated verso. Pasadena Museum of History, Pasadena, California. The barn depicted in this work was located on the 2,000-acre Patton family ranch in present-day San Marino, California, which was the boyhood home of United States Army General George S. Patton Jr.

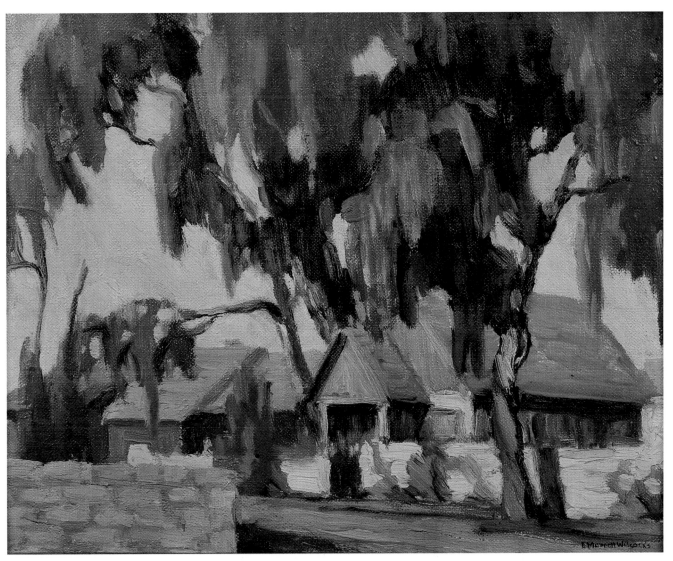

Untitled (House in Landscape), n.d., oil on board, 8 × 9.5 in., signed l/r. Private collection. Photo: Martin A. Folb, PhD.

Mary Belle Williams
1873–1943

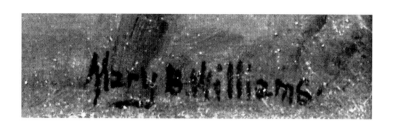

Mary Belle Williams was born in Massilon, Ohio, on December 13, 1873. The daughter of Henry Alonzo and Alwilda (Beazel) Williams, both Ohio natives, Mary Belle began her study of art as a child. She moved to San Diego about 1906 with her father and brother Howard, who established the Williams Gold Mining Company and owned and operated the Owens Mine in Julian for many years. Julian was the inspiration for several of her paintings. She worked in oils, watercolors, and pastels.

The city directories list her in San Diego at various addresses between 1906 and 1915. During this time, she frequently exhibited with the San Diego Art Association, of which she was a member. In 1909, she had an exhibit of ninety works at the Carnegie Library in downtown San Diego. It was the largest solo exhibition ever held in San Diego at that time. She received a silver medal for her work at the Panama-California Exposition in 1915, and a bronze medal for miniatures at the international extension of that exposition the following year.

There is no listing for Mary Belle in San Diego between 1916 and 1921, and perhaps her successes at the expositions encouraged her to take further study outside of San Diego. It is possible that she went to New York, since one source indicates that she studied with artists in that city and attended the Art Students League there, but whether this was before or after her initial arrival in San Diego is not known.

In the Patio (La Jolla, California), 1926, oil on canvas, 20 × 18 in., signed l/r. Collection of Leonard Hill.

Woman Tending her Garden, n.d., oil on canvas, 28 × 21 in., signed l/r.
Private collection. Courtesy of Traci McFarland Fieldsted.

Untitled (Cows Grazing in Field), n.d., oil on canvas, 12 × 16 in., signed l/r. Private collection. Photo: Martin A. Folb, PhD.

Returning to San Diego about 1922, Mary Belle once again became an active member of the local art community. A charter member of the San Diego Art Guild, founded in 1915, she resumed her association and frequently exhibited with the group, specializing in portraits. A list of her portraits reads like a "who's who" of San Diego society. Her paintings demonstrate a vivid palette and bold color sense. Her oeuvre also includes landscapes, still lifes, and miniatures.

Mary Belle's studio was in the basement of an Irving Gill–designed building she owned at Seventh and Beech streets. For a time in the 1920s, California artist Alfred R. Mitchell rented the upstairs for his home and studio. Mary Belle remained at this address until the last six months of her life.

She was a member of the San Diego Art Guild (charter member, 1915). Her exhibitions included Carnegie Library, San Diego, 1909 (solo); Panama-California Exposition, San Diego, 1915

Looking thru Park Growths to San Diego Bay, n.d., oil on canvas,
12 × 16 in., signed l/l and signed and titled verso. Private collection.
Photo: Martin A. Folb, PhD.

(silver and bronze medals); San Diego Fine Arts Gallery, 1927; California Pacific International Exposition, San Diego, 1935; and the California State Fair, 1936.

Mary Belle's last six months were spent in a hospital in Los Angeles. She passed away in Los Angeles, California, on June 21, 1943.

Bibliography compiled from: *The Journal of San Diego History*, San Diego Historical Society quarterly, Summer 1986, Volume 32, Number 3, Thomas L. Scharf, ed.; *100 Years of Art in San Diego: Selections from the Collection of the San Diego Historical Society*, Bruce Kamerling.

Anna Wilson
1904–unknown

Anna Wilson was a portrait and landscape artist. Little is known of this talented and dynamic artist. According to the 1940 United States Census for Los Angeles, she was born in 1904 in California. Earlier newspaper articles from the 1930s indicate that she moved to Los Angeles in 1933.

Arthur Millier, writing in a 1939 *Los Angeles Times* article, presented this description of Anna Wilson's art shown at an exhibition: "Twenty portraits vying with each other in vivacity and presentation of personality form the September exhibition which Miss Anna Wilson offers in the State Exposition Building at Exposition Park. They bring forward the most rewarding talent for portraiture disclosed here in recent years. Miss Wilson has shown here once before, but no such galaxy of good portraits as in the present display. She brings to her work draftsmanship, boldness and unconventionality in attack and arrangement, brilliant color keyed into schemes of exceptional luminosity, and—that all important thing—concentration upon character as expressed in the

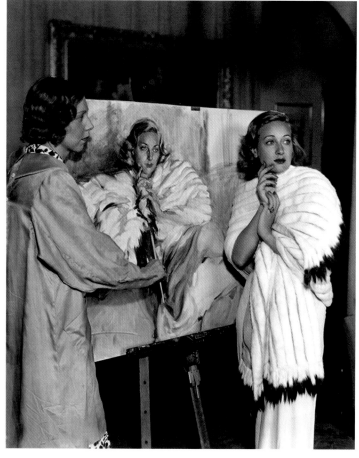

Anna Wilson (left), photographed with the actress Tala Birell and her portrait of Miss Birell, c. 1935. Photographer unknown. Private collection.

living head and figure. The majority of her sitters are women and most of these actresses. They naturally put their best attributes forward and lend themselves to pose and lively expression. But she can paint men too as witness the several represented here. And if the artist's weakness is to run a bit too far forward fashionably frou-frou as in the Mary Jordan, her strength is seen at the full in the rich and dignified likeness of Lucile Watson. The majority of her canvases lie safely between these two in a zone of freshness and capability. Miss Wilson was born in San Francisco, learned her craft at the Art Students League (New York), the National Academy Schools and in Paris. She has been painting in Hollywood for the last six years."

Additional articles from the 1930s and 1940s list other notable individuals and Hollywood personalities who had their portraits painted by Anna Wilson.

Untitled (a.k.a. *Portrait of a Woman in a Black Dress*), 1936, oil on canvas, 36 × 30 in., signed and dated u/l. Courtesy of The Hilbert Collection.

Portrait of Dorothy Rollins and her dog, Nosey, 1935,
oil on canvas, 44 × 34 in., signed and dated l/r. Private collection.
Courtesy of Edenhurst Gallery.

In recent years, the subject (and title) of this portrait has been incorrectly
identified as the Hollywood film actress Carole Lombard. The individual is
in reality Dorothy Schloetzer Rollins (Beyer). Although there is a slight
resemblance between the two women, at some point the subject of the
painting was misidentified. For years the existence and location of the
painting was a mystery to Dorothy Rollins Beyer's family. According to
the Schloetzer/Beyer/Edwards family, the painting's correct title is
Portrait of Dorothy Rollins and her dog, Nosey. Based upon our research
for *Emerging from the Shadows*, the painting's provenance and title is
being presented for the first time in this publication.

Dorothy Schloetzer Rollins (Beyer) and her dog,
Nosey, photographed in Los Angeles, California,
1935. Private collection of Spence J. Edwards.

She was a frequent exhibitor at the Frances Webb Galleries
in Los Angeles. In reviewing a 1937 Frances Webb exhibition,
Arthur Millier described Anna Wilson's work by saying: "Her
dashing style is convincing because she knows how to draw. The
landscapes (in this show) form a quiet contrast to the figures."

In addition to the aforementioned, Anna was a member and
frequent exhibitor with the Society for Sanity in Art (Logan Medal
recipient, 1940), the San Gabriel Artists' Guild, and the Laguna
Beach Artist Association. In 1940, she exhibited at the Oakland
Art Gallery and her entry titled *Dorothy* was described in the

Oakland Tribune as "a girl in red; an excellent exercise in vigorous,
spontaneous brush work." This painting *Dorothy* is in the collection
of the Chaffey Community Museum of Art, Ontario, California.

Biographical information compiled from: 1940 United States
Census; Los Angeles City Directory, 1934–1944; *Los Angeles
Times*, March 24, 1936, January 31, 9 1937, February 7, 1937,
February 14, 1937, September 10, 1939, October 1, 1939, April
7, 1940, April 21, 1940, April 13, 1941, August 21, 1941; *Oakland
Tribune*, March 17, 1940.

Alice Beach Winter
1877–1968

Alice Mary Beach was born in Green Ridge, Missouri, on March 22, 1877, the daughter of Edgar Rice and Frances Emeline Beach. She was raised and educated in St. Louis, Missouri, where her father was the editor of the *St. Louis Globe-Democrat* and a noted writer. At the age of fourteen, she entered the St. Louis School of Fine Art, studying under John Fry and Charles Von Saltza; her enrollment at the school continued for six years, during which time she was consistently awarded highest honors for her work. She continued her study for one year at the Art Students League in New York City with artists John Twachtman, George de Forest Brush, and Joseph DeCamp.

Early in her career, while living in St. Louis, she established her reputation as an artist, with some of her earliest illustrations included in books written by her father. In New York, in 1904, she married fellow artist Charles Allen Winter, whom she had met years earlier while attending the St. Louis School of Fine Art. Alice, known for her socialist views and as a supporter of women's suffrage, contributed illustrations to the New York regional journal of the suffrage movement called the *Women Voter*. In 1912, she joined with other writers and artists in New York to establish the publication *The Masses*. Seen as a radical magazine for the time period, she later became the magazine's art editor and was responsible for several of its front covers. The Winters' approach to socialism is believed to have grown more from their association with the arts and crafts movement than with the radical labor politics that would predominate the magazine's views by the end of its run.

Early in their marriage, the couple traveled to California, staying in Pasadena, where Alice first appears in local exhibitions in 1915. Later she is listed in the 1932 *California Arts & Architecture* artist directory, with her residence listed at 1330 Hillcrest Avenue, Los Angeles. She and her husband also were residents of New York City and later, Gloucester, Massachusetts. Her work includes commercial illustrations (many depicting images of children), as well as oil paintings of portraits, harbors, and landscapes.

Alice was a member of the National Association of Women Painters & Sculptors; the North Shore Art Association; and the Gloucester Society of Artists, Massachusetts. Her exhibitions included the 1904 Louisiana Purchase Exposition, Missouri; National Academy of Design, New York; Pennsylvania Academy of the Fine Arts; the Kanst Art Gallery, Los Angeles; and the Los Angeles County Museum of History, Science, and Art, California.

Alice Beach Winter passed away in April of 1968 in Gloucester, Massachusetts.

Biographical information compiled from: *Who's Who in American Art, 1938–1962*; *Publications in California Art*, Nancy Dustin Wall Moure; *California Arts & Architecture artist directory*, December 1932; Charles and Alice Beach Winter papers, Helen Farr Sloan Library, Delaware Art Museum (biography); and the Massachusetts Death Index.

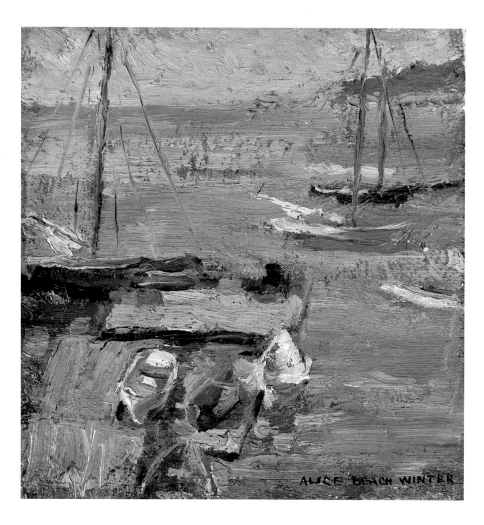

Gloucester Harbor (Massachusetts), n.d.,
oil on board, 6 × 6 in., signed l/r.
Courtesy of the Oltman Family Trust.
Photo: Martin A. Folb, PhD.

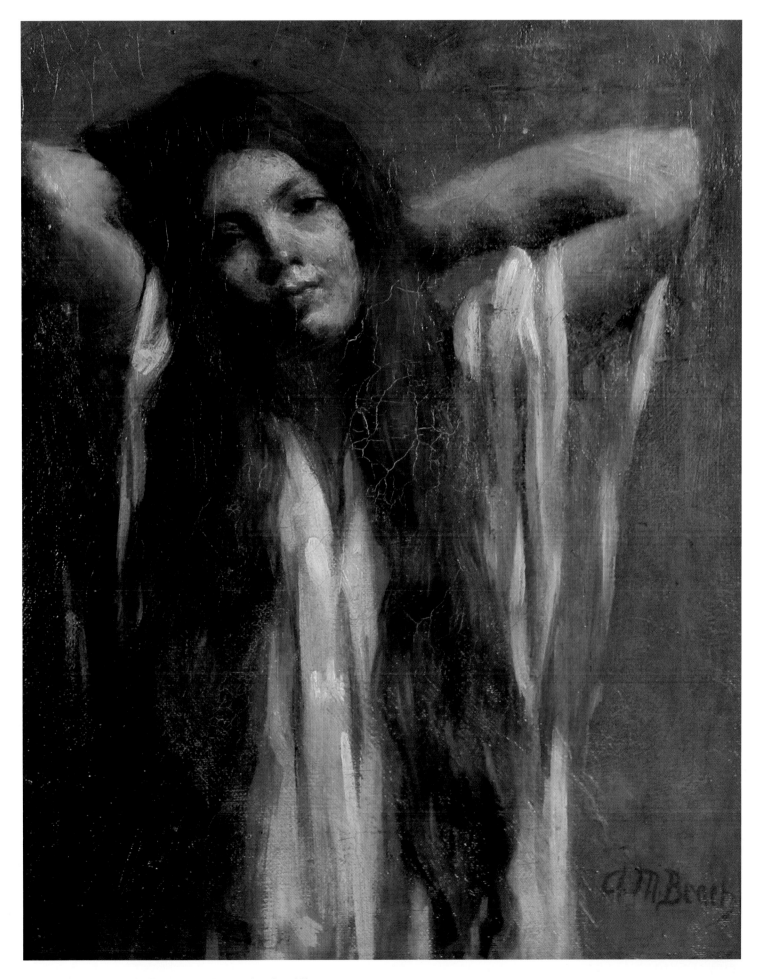

Red Headed Woman, n.d, oil on canvas, 20 × 16 in., signed l/r:
A. M. Beach. Courtesy of Beverly Sacks Fine Art.

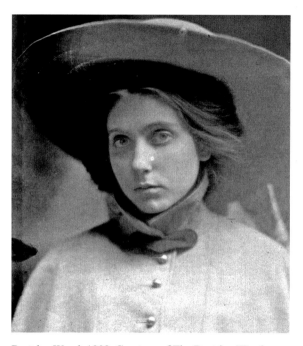

Beatrice Wood
1893–1998

Beatrice Wood was born on March 3, 1893, in San Francisco, California, the only child of wealthy and socially conscious parents Benjamin K. and Carrara "Carrie" (Rosencrantz) Wood. The family moved east to New York City when Beatrice was five years of age, where her mother concerned herself with preparing her daughter for her eventual "coming out" into New York society. This included a year in a convent school in France, enrollment in a fashionable finishing school, and summer trips to Europe, where she was exposed to art galleries, museums, and the theater.

Ultimately, it was this exposure to the arts that ruined her mother's plans for Beatrice. In 1912, Beatrice rejected plans for a coming-out party and announced that she wanted to be a painter. Her mother decided that, if this were the case, it would be accomplished properly. Supervised by a chaperone, Beatrice moved to France to study painting at L'Académie Julian in Paris, but found it tediously academic. She then studied in Giverny in northern France, but her time there was brief. Returning to Paris, Beatrice turned her attention to the theater and a career as an actress.

Beatrice Wood, 1908. Courtesy of The Beatrice Wood Center for the Arts and Happy Valley Cultural Center.

With political turmoil in Europe and the onset of World War I, her parents brought a reluctant Beatrice back to New York, where her mother did everything within her power to discourage her plans for a career on the New York stage. Despite her mother's objections, Beatrice pursued work on the stage and her fluency in French led her to join the French National Repertory Theatre, where she played over sixty ingénue roles under the stage name "Mademoiselle Patricia" to protect her family's name and reputation.

While working as an actress in New York City, a friend told Beatrice about a lonely Frenchman who was in the hospital with a broken leg, who had no one to talk to. It turned out to be the composer Edgard Varèse, and he in turn would eventually introduce her to the artist Marcel Duchamp. Beatrice's career as an artist began in earnest when she created an abstraction to tease Duchamp and to prove to him that anyone could create modern art. Duchamp, however, was impressed by the work. He arranged to have it published in a magazine and invited her to work in his studio. There she developed her style of spontaneous sketching and painting that continued throughout her life.

Following the formation of the Society of Independent Artists in 1917, she exhibited her work in their Independents exhibitions. Although her painting caused some amount of scandal, nothing could compare with the impact of Duchamp's *Fountain*, a work she later defended in an essay in the avant-garde journal *The Blind Man*.

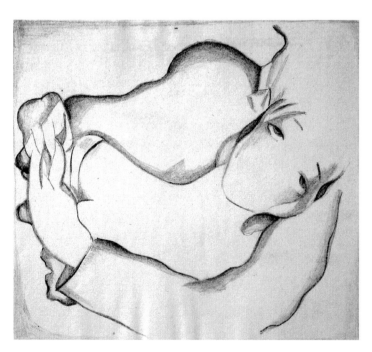

Lovers, 1933, lithograph on paper, 7 × 8 in., ed. 24, signed. Courtesy of Tobey C. Moss Gallery, Los Angeles, California.

Lovers, n.d., glazed ceramic tile, 7.25 × 7 x 5 in., signed in glaze l/r. Courtesy of Roadside America and Sandy Raulston and Ted Birbilis. Photo: Martin A. Folb, PhD. The image on this tile and in the lithograph of the same title is of the artist Beatrice Wood held in the arms of her lover, the artist Marcel Duchamp. Information provided by Sandy Raulston from an interview with Beatrice Wood.

Marcel Duchamp introduced Beatrice to the world of the Dada movement, including many of his artist friends, such as Henri-Pierre Roché, a French diplomat, writer, and art collector. Roché was to become her first lover, and he introduced her to the vibrant world of modern art and encouraged her creative pursuits. He was also the first man to break her heart. Claiming to be a "monogamous woman in a polygamous world," Beatrice found herself surrounded by bohemian men who thought little of bourgeois morality.

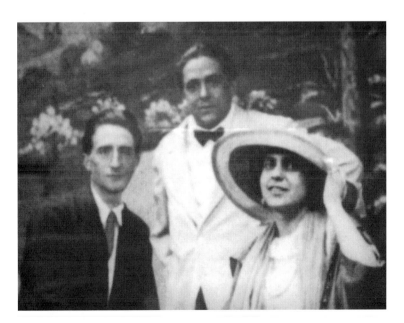

The artists (left to right) Marcel Duchamp, Francis Picabia, and Beatrice Wood photographed at Coney Island, Brooklyn, New York on June 21, 1917. Courtesy of The Beatrice Wood Center for the Arts and Happy Valley Cultural Center, Ojai, California.

Operation, 1933, color lithograph on paper, 8 × 13 in.,
ed. 18/22, signed l/r. Courtesy of Tobey C. Moss Gallery,
Los Angeles, California.

Still determined to be an actress, in 1918 Beatrice went to Montreal, Quebec, Canada, to work in the theater. This desire soon waned and after a brief, unconsummated, and ultimately dissolved marriage, she returned to New York. Back in New York, Beatrice found that the Dada movement had dissipated. Henri-Pierre Roché had gone back to France, Duchamp had gone abroad, and her friends Walter and Louise Arensberg had moved to California. Likewise, Beatrice would eventually move to California, settling in Los Angeles to be near friends, especially the Arensbergs.

In California, her work as an artist continued in various forms. In the early 1930s, during a trip to Holland, Beatrice purchased a set of baroque dessert plates with a stunning luster glaze. Unable to find a matching teapot, she decided that she could simply make one, and in 1933 enrolled in a ceramics course at Hollywood High School. She soon learned that making such a teapot was not so easy and that she was "not a born craftsman." She was, however, determined and attempted the study of glaze chemistry while learning to throw pots through trial and error. This led her to rent and open a small artisan shop in Hollywood where she demonstrated her craft and sold her work; the shop was located at the "Crossroads of the World" on Sunset Boulevard, which was a short distance from Hollywood High School. Beatrice later recalled that her work as a potter came about accidentally and that it was born out of necessity.

In the late 1930s, she studied ceramics with Glen Lukens, a leading artist and teacher. The two got along well, although Lukens was not one to inspire individuality in his students. She learned a lot from Lukens, as she did from Gertrud and Otto Natzler, who greatly influenced her. Although Beatrice treasured the experience with the Natzlers, and her early work was often compared to that of her mentors, her work ultimately proved considerably different from that of the Natzlers. While they sought control over their work through mastery of technique, her pieces were loose and unconventional by comparison, freely exploring form, glaze combinations, and happenstance, exhibiting an embrace of artistic naiveté and the unexpected results of the kiln.

By the late 1930s, her ceramics were included in exhibitions at the Los Angeles County Museum of History, Science, and Art and the Metropolitan Museum of Art in New York; she was receiving orders for her pieces from major department stores, including Neiman Marcus, Gump's in San Francisco, and Marshall Field's. In 1947, she moved to Ojai, California. There she established a studio and showroom and began a lifelong friendship with fellow ceramicists Vivika and Otto Heino, who helped her develop her throwing skills and shared techniques for working with luster glazes.

Beatrice became a noted ceramicist with her bowl and vessel forms and with her sculptural work, which she referred to as her

Muddled Brown Folded Bowl, n.d., wheel-thrown glazed earthenware, 4.5 × 7.75 in., signed underside. Courtesy of Roadside America and Sandy Raulston and Ted Birbilis. Photo: Martin A. Folb, PhD.

"sophisticated primitives." While the vessels represented the best of craft, design, and decorative art, her sculpture embraced an intentionally naïve sensibility. In addition to her ceramics, she continued to paint and draw, frequently featuring herself in her work as a young girl.

Throughout the decades, Beatrice exhibited her work around the world in galleries and numerous small exhibitions. Ultimately, her genius was in the marriage of wide-ranging influences in her life, which she incorporated into her work. The spirit of Dadaism, impact of modernism, embrace of Eastern philosophy, influence of folk art, and even the ornament of ethnic jewelry were all combined in her ceramics. Decades spent living what might be called a bohemian artist's lifestyle had not distanced Beatrice from her belief in "true love." Her life and relationships ran the course of the twentieth century. She was married twice, though both marriages were never consummated. She fell deeply in love seven times, but did not marry any of those men. When asked the secret of her longevity, she would simply offer "art books, chocolates, and young men."

Beatrice Wood passed away on March 12, 1998, in Ojai, California, at the age of 105.

Biography courtesy of The Beatrice Wood Center for the Arts, Ojai, California.

Turquoise Lava Bottle, n.d., wheel-thrown glazed ceramic, 3.5 × 2.25 × 2.25 in., signed underside. Courtesy of Roadside America and Sandy Raulston and Ted Birbilis. Photo: Martin A. Folb, PhD.

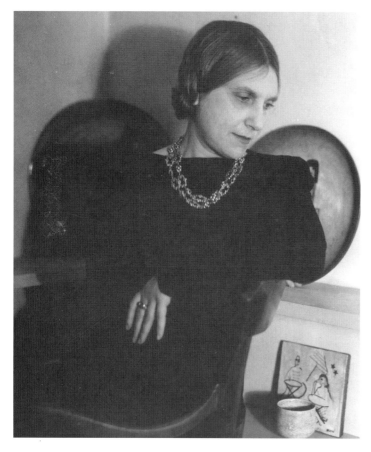

Beatrice Wood photographed in New York City at American
House (later renamed American Craft Museum), 1947.
Courtesy of The Beatrice Wood Center for the Arts and Happy
Valley Cultural Center, Ojai, California.

Gold Luster Bottle, n.d., wheel-thrown glazed ceramic, 6.5 × 3.5 × 3 in.,
signed underside. Private collection. Photo: Martin A. Folb, PhD.

Detail of the underside
of Luster and Matte
Footed Bowl with Abstract
Design with signature
"Beato/N" and attached
inventory label annotation
"57. B. Wood."

According to Nanci Martinez, Beatrice Wood's last studio assistant,
Beatrice indicated that the "Beato/N" marking found on the underside
of some earthenware vessels was from a short period in her career
(1950–1951) when she and Frank Noyes were working and experimenting
together with the luster technique. Frank Noyes' skill in that area was a
great help to her and she enjoyed his camaraderie in the workroom.
Confusion continues to exist regarding these markings as Beatrice had
studied with Gertrude and Otto Natzler and was particularly influenced by
their glazes. On rare occasions, such as doing experiments or glaze tests,
Beatrice would make notations on her work other than her signature.
When referencing a glaze influenced by or attributed to the Natzlers,
Beatrice would assign a notation that was always accompanied by a
number, i.e. N47 or N511, or sometimes just a number by itself.
Information courtesy of The Beatrice Wood Center for the Arts and Happy
Valley Cultural Center.

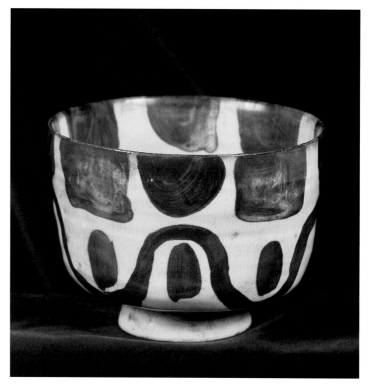

Luster and Matte Footed Bowl with Abstract Design, c. 1950–1951,
wheel-thrown glazed earthenware, 3.25 × 4.75 × 4.75 in.,
signed underside: "Beato/N" with attached inventory label
annotation: "57. B. Wood." Private collection.
Photo: Martin A. Folb, PhD.

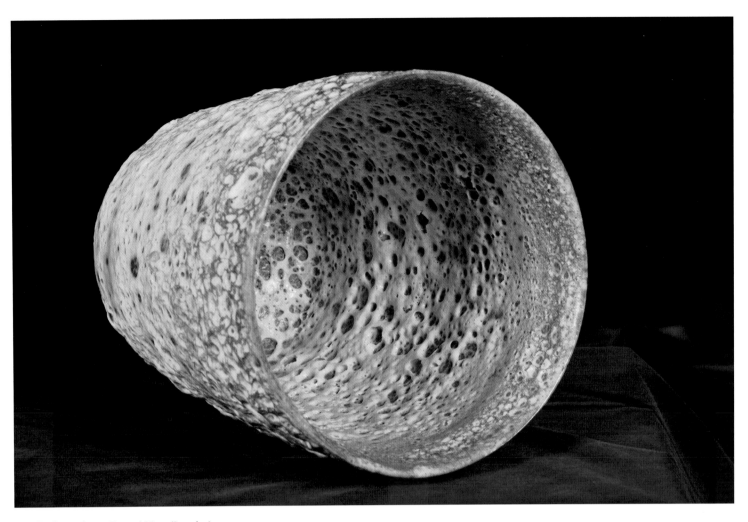

Detail of Raspberry Frappé Vase (Interior).

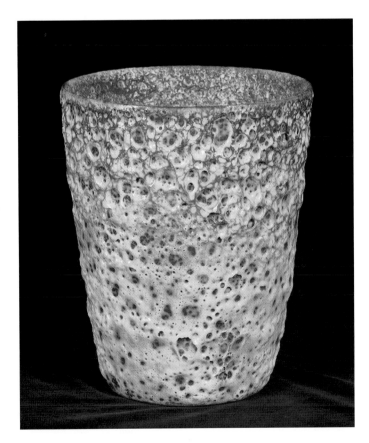

Detail of Raspberry Frappé Vase
(Underside with Artist's Signature).

Raspberry Frappé Vase (Exterior), n.d., wheel-thrown glazed ceramic,
9.25 × 7.75 × 7.75 in., signed underside. Courtesy of Roadside America
and Sandy Raulston and Ted Birbilis. Photo: Martin A. Folb, PhD.

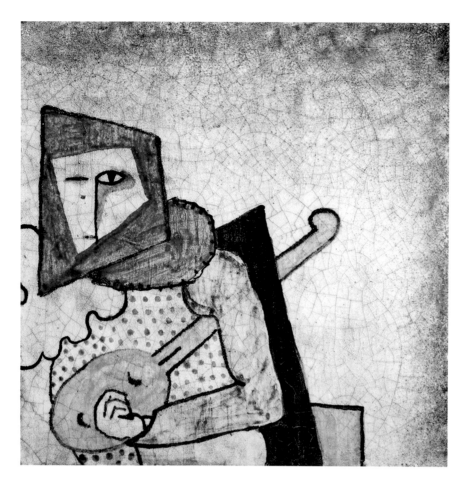

Cubist Plaque, 1949, glazed earthenware, 11 × 11 × 0.75 in. Private collection. Courtesy of Cowan's Auctions.

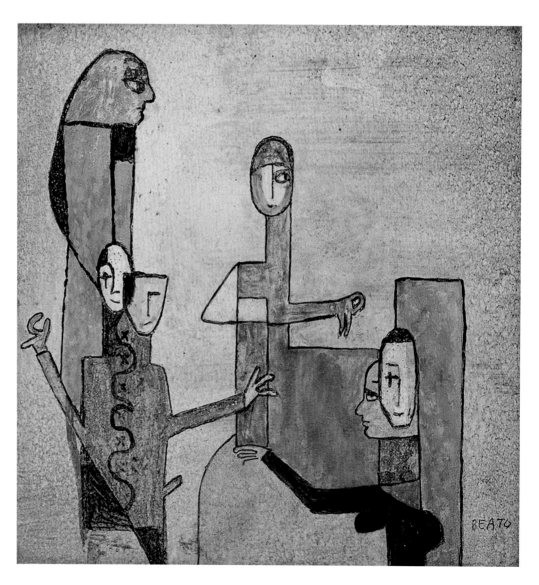

Untitled (Tile), 1952, glazed earthenware, 15 × 15 in., signed l/r. Private collection. Courtesy of Cowan's Auctions.

Beatrice Wood photographed holding her sculpture Untitled (Boat with Figures).
Courtesy of Steven Stoops. Stevens Fine Art.

Untitled (Boat with Figures), n.d., ceramic (iridized glazed figures
and matte black glazed boat), 7.75 × 39.5 × 4.5 in., signed underside.
Courtesy of Steven Stoops, Stevens Fine Art.

Ellamarie Woolley
1913–1976

Ellamarie Packard was born on May 19, 1913, in San Diego, California, the daughter of Phineas S. Packard, founder of the Arts and Crafts Press in San Diego, and Marie (Pittman) Packard. She was raised in San Diego and studied at San Diego College (later San Diego State University), under the artist Everett Gee Jackson. In 1936, she was given her first major art assignment while enrolled at the college, she was selected to paint two murals for the school as part of the Work Projects Administration, *Packing Oranges* and *Sailors Going to Hell*; each was installed on campus in the school's Hardy Tower.

After graduating, she remained in San Diego and began teaching art at the Francis Parker School, where she met her future husband Jackson Woolley, who was the school's drama teacher. The two were married in 1940. Although Ellamarie continued to paint and teach after Jackson returned home from serving in World War II, the couple began looking for a way to work together beyond teaching. They found their answer after attending an enameling workshop at Scripps College in Claremont, California, in 1947. Together the Woolleys were among the first to develop the art of modern enameling on the West Coast. Although they worked together on many projects, producing functional objects as well as large-scale wall panels and murals for both public and private clients, each individually produced his and her own singular body of work.

Untitled (Still Life with Birds and Fruit), n.d., enamel on copper, 15 × 10 in. (image), signed l/r, annotation verso: P110. Collection of Fat Chance, Los Angeles, California.

Untitled (Birds), n.d., enamel on copper, 9.25 × 27.5 in. (image), signed verso. Courtesy of Thomas Royal and Louis Cantabrana.

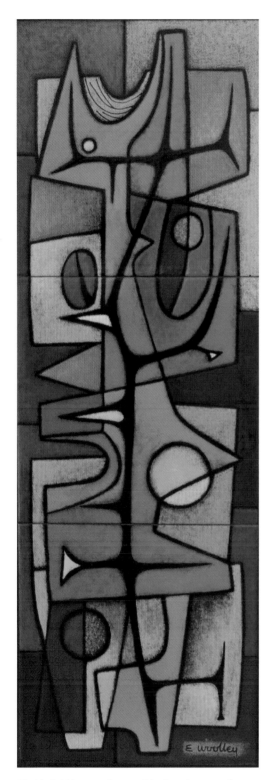

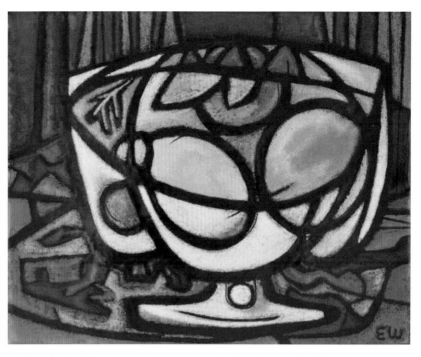

Untitled (Still Life), n.d., enamel on copper, 9 × 9 in. (image), initialed l/r, annotation verso: P53. Collection of Fat Chance, Los Angeles, California.

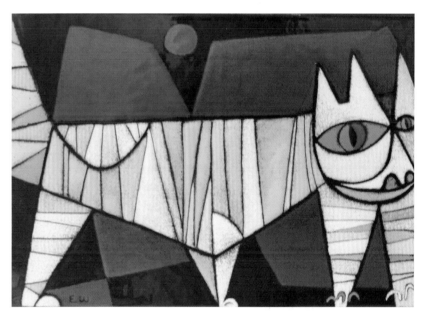

Untitled (Cat), n.d., enamel on copper, 7 × 10 in. (image), initialed l/l, annotation verso: P194. Collection of Fat Chance, Los Angeles, California.

Untitled (Abstract Composition), n.d., enamel on copper, 24 × 8 in., signed l/r. Collection of Fat Chance, Los Angeles, California.

In 1949, Ellamarie joined the Allied Craftsmen of San Diego and was active in the group for the remainder of her life. Over time, her work evolved from figurative designs and abstractions on small copper plates to large-scale architectural murals. In the late 1960s, Ellamarie produced reductive abstract compositions responding to the shaped canvas, pure color, and hard-edge movement of her contemporary West Coast painters.

Ellamarie Woolley passed away on October 4, 1976, in San Diego, California.

Biographical information compiled from: *Ellamarie Wooley: A Restrospective Exhibition at the Fine Arts Gallery of San Diego,* 1977; and *The Wooleys: Pioneers in Enamel,* Janice Keaffaber; and *Metalsmith*, Volume 13, Issue 1, January 1993. Additional information courtesy of Thomas Royal.

Virginia Woolley
1884-1971

Virginia B. Woolley was born on August 27, 1884, in Selma, Alabama, the daughter of Andrew Crittenden and Virginia (Baird) Woolley, and from the age of six was raised in Atlanta, Georgia. Although encouraged in art by her mother, she first studied the piano and played in concert before concentrating on painting. After spending a year, 1901–1902, at Agnes Scott College, Decatur, Georgia, she was determined to be an artist and studied at the School of the Art Institute of Chicago, Illinois, from 1904 to 1907 with Frederick Freer and John H. Vanderpoel. She spent the next three years in Europe, studying with Lucien Simon and Richard E. Miller in Paris. Returning to Atlanta, Virginia continued her career and was listed in the city directories of 1915 and 1916 as a teacher at Woodberry School.

Following a painting trip to France in 1920, she went to Los Angeles, then to Laguna Beach as a guest of fellow artist Julia E. Raymond. Attracted by the art colony and its scenic beauty, she returned regularly and became a permanent resident in late 1925.

Virginia's ouevre consists mostly of outdoor themes, with some emphasis on historic buildings in paintings of New Mexico, particularly Taos, Laguna Beach, and Monterey in California. She also created scenes of New England and the South, where she captured the patios and old houses of the French Quarter in New Orleans, and, at times, still lifes.

A founding member of the Laguna Festival of Arts in 1932. Virginia continued to participate in the event each year until 1970. Her other exhibitions included those of the Southern States Art League; Atlanta Art Association; Laguna Beach Art Association; California State Fair, Sacramento; Pasadena Art Institute; Artists of Southern California, San Diego; Arizona State Fair, Phoenix; Oakland Art Gallery; Santa Cruz Art League, Art Association of New Orleans; Riverside Art Association, California; and Springville Museum of Art, Utah. Los Angles exhibitions included Painters and Sculptors,

Artists Fiesta, Ebell Club, and Gardena High School, 1935, 1938, 1941, 1947, 1950, and 1953. In 1944, she had a solo show at the Laguna Beach Museum of Art, Laguna Beach, California.

Virginia, who also taught for many years, served as secretary of the Laguna Beach Art Association during its early years and was later curator of its gallery. She is represented in the collections of the Laguna Festival of Arts and the High Museum of Art, Atlanta, Georgia.

Virginia Woolley passed away on February 15, 1971, in Laguna Beach, California.

Biography, with thanks, from: *An Encyclopedia of Women Artist of the American West*, Phil Kovinick and Marian Yoshiki-Kovinick, Austin: University of Texas Press, 1998.

Reprint: *Laguna* by Virginia Woolley. *Artland*, Volume 1, Number 11, February, 1927. *Artland* was a monthly magazine of the arts in Southern California that was owned and published by the Artland Club, Fine Arts Building, Los Angeles.

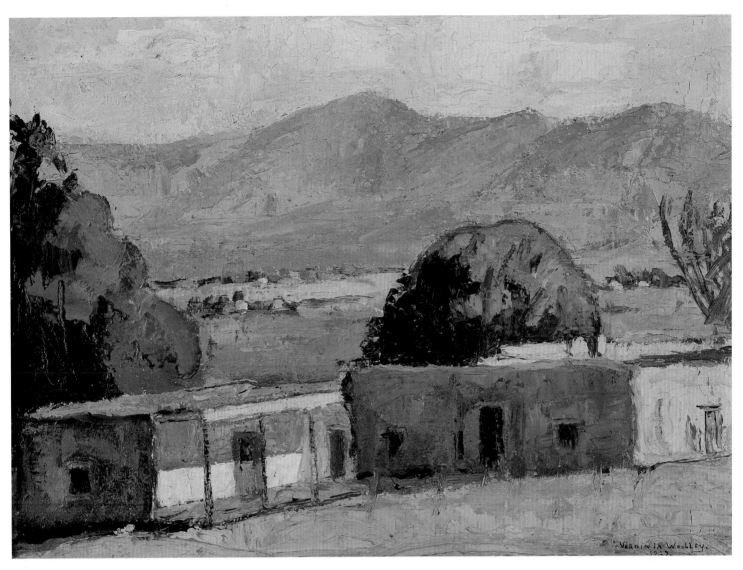

From the Hill - Taos, 1929, oil on board, 12 × 16 in., signed
and dated l/r. Private collection. Photo: Martin A. Folb, PhD.

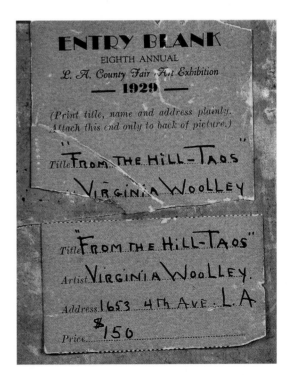

Exhibition label verso: *From the Hill - Taos.*
Exhibited at the Eighth Annual Los Angeles County
Fair Art Exhibition, 1929.

Federal Art Project in Laguna

THE home of Pirate LaFitte, famed in the story of Anthony Adverse, is the subject of Virginia Woolley's painting, here reproduced. The scene is typically Southern, a street in New Orleans, where plenty of local color is in evidence. The old adobe, with its halo of romantic interest, looks the part of a pirate's stronghold, though only a step away from it, across the street, is the neighborhood grocery store.

Miss Woolley is a member of the Laguna Beach Art Colony, a member of the board of directors of the Art Gallery and has charge of the Federal Art Project in the beach city, conducting classes in adult art education. Laguna Beach and the surrounding country is an ideal sketching ground, as many artists have discovered and Miss Woolley and her students are fortunate, indeed, in having this historic region as a field for their class work.

Miss Woolley is interested in street scenes and old architecture, so that the sketchers do much of their work in the open. Roofs of houses have a great fascination for her and under her treatment they take on definite character and individuality. It is remarkable, too, what a wealth of atmosphere she is able to bring into a picture by the introduction of one of her famous clotheslines!

Before going to Laguna Beach to live, Miss Wool-ley was a resident of Atlanta, Georgia, where she did regional work under the government. There were two especially interesting assignments given her there, one of them a drawing of the oldest frame house in Georgia — beautiful Jarret Manor, in the mountains of North Georgia, which was the scene of one of the early Indian massacres. The painting is now in Washington, D. C. The other assignment was a sketch of Talullah Falls, considered by some to be more beautiful than Niagara.

These Falls are now dammed to furnish water power for the state and the power house is in the bottom of a gorge 800 feet deep.

In order to complete her work it was necessary for the artist to make the descent in a cable car. This painting, listed under the head of industrial art, is hung in the Georgia Power Company's building in Atlanta.

Miss Woolley, after working three years in the Chicago Art Institute, studied for three years in Paris and exhibited her paintings in the Paris Salon. Also, her work has been shown in leading galleries of the United States.

———————————•———————————

Fine art is that in which the hand, the head and the heart go together. —John Ruskin.

PAINTING BY VIRGINIA WOOLLEY

Page Forty-four

Reprint: *The Western Woman*, Volume IX - Number 6, January, February, March, 1938.

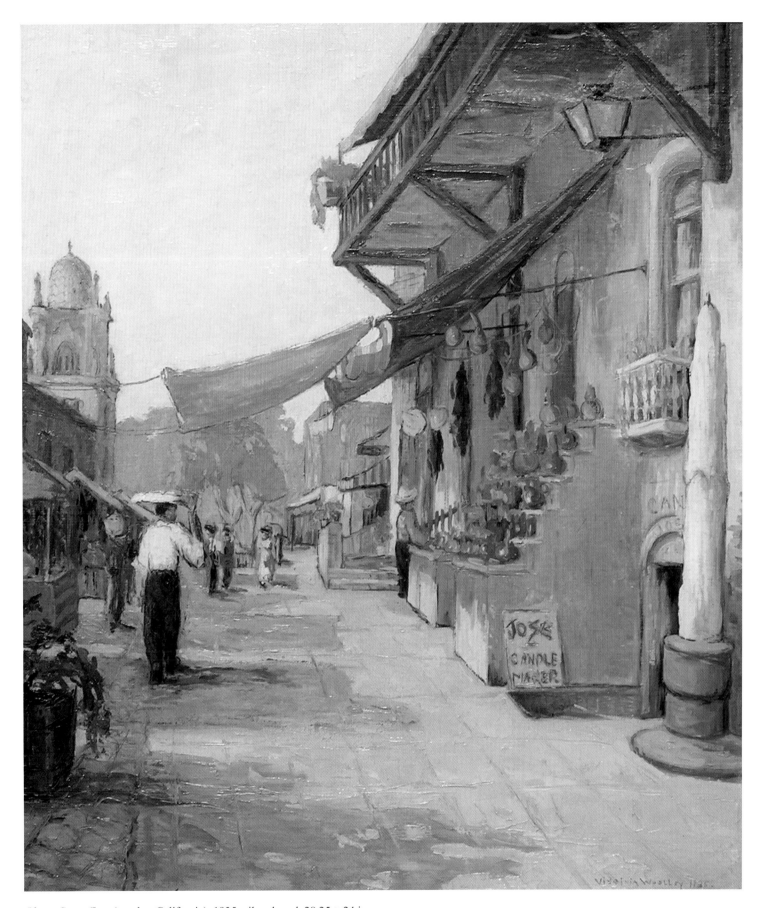

Olvera Street (Los Angeles, California), 1935, oil on board, 28.25 × 24 in.,
signed and dated l/r. Courtesy of George Stern Fine Arts.

Isobel Wurtele
1885–1963

Isobel Keil Wurtele
Exponent of
Broken Color
Technique

◆

Isabel Keil Wurtele

ISOBEL KEIL WURTELE, Los Angeles artist, is an exponent of what is known as broken color technique, a broken treatment of color —a mosaic in paint—entirely unique in character.

Her training in the art was received at the Glouster School of Painting under Hugh Breckenridge, an internationally known painter and himself a pupil of celebrated French impressionists. Other training was received at the Artzberger Art School in her native city of Allegheny, Pa., at the Darby School of Painting, Philadelphia and in Berkeley, Cal., where she studied modeling with Professor Bafanno.

In the "Little Shrine," reproduced on the opposite page, may be seen an example of her work, a notable painting which has been widely exhibited and has attracted much admiring attention. In a series of three exhibits of the work of California impressionists held in Los Angeles Mrs. Wurtele was the only woman represented, her entry "The Little New England Home." This work, which aroused general interest, was adjudged the most perfect specimen of the broken color technique in the extire exhibition.

Entries in three different Pennsylvania exhibits won the artist three gold medals and for her lovely floral study, "Giant Poppies," shown at a Glouster, Mass., exhibit, she was awarded a first prize.

Through the years she has had other honors bestowed upon her as examples of her work have been shown in leading art exhibits of the Coast and throughout the East. She was one of those who entered her paintings in the traveling shows featured at the army camps during the late war and received for her participation the "Service Honor" award.

For years Mrs. Wurtele was a member of the summer artist colony at Glouster, famous art center, and it is there that she has done much of her most interesting work. She has traveled widely in the United States and Canada, indulging her love of art and music and, incidentally, cultivating her literary tastes. ..As a poet, as well as an artist, she has won distinction. Her "Dawn after Tempest," prayer for a new world order and key poem of a sonnet sequence published in the American Bard, brought to her expressions of appreciation from Bard readers in all parts of the United States—"One of the few war poems," one admirer wrote, "rightfully deserving of the dedication of Prayer."

Mrs. Wurtele belongs to the California Art Club, the Laguna Beach Art Association, Women Painters of the West, The North Shore Arts Association of Glouster, Mass., and to the Los Angeles Poetry Guild.

"The Little Shrine," Study in Broken Color Technique by Isobel Keil Wurtele, Los Angeles

Page Seventy-one

Reprint: *The Western Woman*, Volume 14 - Number 2, 1945.

A Sunny Day at the Harbor (Broken Color Technique), n.d., oil on canvas, 16 × 18 in., signed l/r. Courtesy of Steven Stoops, Stevens Fine Art.

Isobel Pearl Keil was born on June 13, 1885 in McKeesport, Pennsylvania, near Pittsburgh, the daughter of Phillip and Elizabeth (Guice) Keil. Raised in the Pittsburgh area, she attended Artzberger Art School in nearby Allegheny, Pennsylvania. The school was operated by William H. Artzberger (1852–1936), an award-winning fresco artist who operated a large painting business in Allegheny and later ran the art school from his home. Additional instruction was at the Darby School of Painting, Philadelphia, Pennsylvania. Later art studies included at the California College of Arts and Crafts, Berkeley, California, and with the artist Hugh Breckenridge in Massachusetts. After her marriage to Episcopalian minister Reverend Arthur H. Wurtele in 1913, the couple lived in Rochester, Minnesota, prior to settling in Los Angeles, California in 1925. Rev. Wurtele served as rector of St. Thomas Episcopal Church in Hollywood until his death in 1946. Isobel married her second husband, John H. Schaefer, MD, in 1957.

Isobel was included in the *California Arts & Architecture* state-wide directory of working artists in 1932. Her work includes landscapes (areas of Gloucester, Massachusetts, and California), still lifes, and genre scenes.

Exhibitions included: Chamber of Commerce, Los Angeles, 1927; North Shore Art Association, East Gloucester, Massachusetts, 1929, 1946; California Art Club, 1930 and 1933; Hollywood Library, 1931; Laguna Beach Art Association, 1930s; Ebell Club, Los Angeles; California State Fair, 1934; Women Painters of the West, 1935–41 and more. A posthumous exhibition of her work was held in Los Angeles in August of 1963.

Isobel Keil Wurtele Schaefer passed away on July 11, 1963, in Los Angeles, California.

Biography compiled from: California State Library, Biographical Index Card; *American Art Annual*, volume XVI, 1919, and *California Arts & Architecture*, December 1932.

Mary Agnes Yerkes
1886–1989

Mary Agnes Yerkes was born in Oak Park, Illinois, on August 9, 1886, the daughter of Charles Sherman and Mary (Greenlees) Yerkes. Mary Agnes graduated from Oak Park and River Forest High School in 1906. From high school, she studied at Rockford College (later Rockford University), the Chicago Academy of Fine Arts, where she later taught, and the School of the Art Institute of Chicago, all in Illinois. She continued her instruction privately under Wellington Reynolds, John W. Norton, and Walter Marshall Clute. She established a reputation as an accomplished artist and participated in numerous exhibitions in Chicago, including the American Water Color Society at the Art Institute of Chicago, 1912–1915.

In 1917, Mary Agnes married Naval Commander Archibald "Archie" Nelson Offley. The couple had one child, Mary Yerkes Offley, who was born in 1918 and died at the age of fifteen in 1933. The couple was frequently transferred to many of the Navy's port communities in the East and along the California coast. In the late 1930s, they settled permanently in San Mateo, California. Mary Agnes remained a resident of Northern California for the rest of her life.

Mary Agnes spent all of her adult life painting. With California as a base, she took frequent camping trips throughout the western United States devoted to painting. Her favorite subjects were scenes of the American West and its national parks. Throughout her life, she participated in numerous exhibitions, not only in her native Illinois, but also in California and across the Western United States. Although she did not remarry after her husband's death in 1945, she did have a lengthy relationship with her partner Albert Cobb.

Mary Agnes Yerkes Offley passed away in San Mateo, California, on November 8, 1989, at the age of 103.

Biographical information courtesy of Craig H. Yerkes, grand-nephew of the artist, and Marian Yoshiki-Kovinick.

Santa Monica, Calif., 1922, oil on canvas, 10 × 14 in., signed & dated l/r: M. A. Yerkes-Offley.
Yerkes Family Collection. Courtesy of Phil Kovinick and Marian Yoshiki-Kovinick.

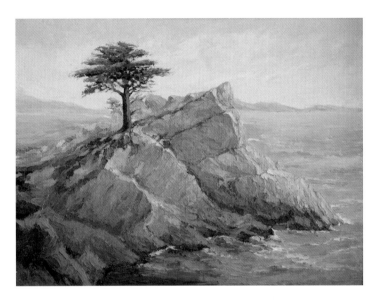

Mid-day Cypress (Monterey, California), c. 1950, oil on panel, 12 × 16 in., signed l/r. Yerkes Family Collection, Courtesy of Phil Kovinick and Marian Yoshiki-Kovinick.

Broken Arrow Falls, Yosemite (California), n.d., oil on canvas, 21 × 19 in., signed l/r with monogram. Yerkes Family Collection. Courtesy of Phil Kovinick and Marian Yoshiki-Kovinick.

Autumn in Monument Valley, Oct. 1951, oil on canvas, 14 × 18 in., signed l/r with monogram and dated. Yerkes Family Collection. Courtesy of Phil Kovinick and Marian Yoshiki-Kovinick.

Florence Young
1872–1974

Florence Young was born on November 6, 1872, in Fort Dodge, Iowa, the daughter of Issac Marshall Young and Harriett M. (Hutchinson) Young. After graduating from high school in Fort Dodge, she studied at the Art Institute of Chicago with John Vanderpoel and at the Art Students League in New York. At various times she was a pupil of Kenyon Cox, James Carrol Beckwith, Frank Du Mond, William Merritt Chase, Wilbur Reaser, and Nicolai Fechin. In 1900, while living in Iowa, she identified herself as an artist on the United States Census. By 1920, she was a resident of California, living in Long Beach with her parents. She remained a resident of the state for the rest of her life, relocating to Alhambra, California, by 1930 where she remained.

Untitled (Harbor Scene), n.d., oil on canvas, 24 × 20 in., initialed l/r. Courtesy of Rudy and Jo Ann Summers. Photo: Martin A. Folb, PhD.

Untitled (Mexican Genre Scene), c. 1928, oil on canvas on board, 8 × 6 in., signed. From the collection of Maureen R. Siegel Sprowles. Photo: Martin A. Folb, PhD.

Florence Young, a painter, engraver, and teacher, is frequently confused in print with the artist Frances Upson Young, who was active in Laguna Beach during the same period. They were, however, two separate and distinct individuals, as well as artists. The confusion may have begun as early as 1932, when both artists were listed in the December 1932 *California Arts & Architecture* statewide artists directory. A typographical error in the listing for Frances, inadvertently giving her first name as Florence, may be the root of decades of confusion. Although their respective signatures are very similar, which further complicates proper identification; there are distinguishing features for each. Frances' signature is like a printed script, letters separated with an elongated tail on the "g" of Young extending left under the name. Frances often signed her work "F.U. Young," "F. Upson Young," or just "Young";

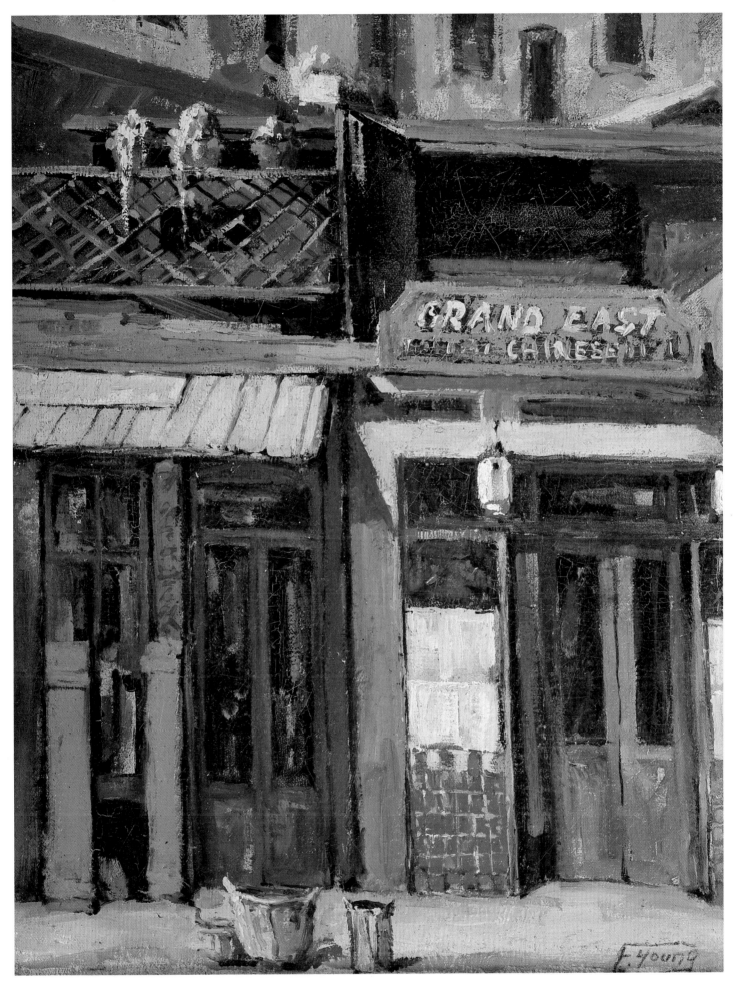

Chinatown, Los Angeles (California), n.d. oil on canvas on board, 20 × 16 in.,
signed l/r. Courtesy of Barbara Mann Steinwedell. Photo: Martin A. Folb, PhD.

Laguna Beach (California), n.d. oil on canvas on board,
16 × 20 in., signed l/l. Courtesy of Rudy and Jo Ann Summers.
Photo: Martin A. Folb, PhD.

Florence signed "F. Young," "Florence Young," or just "F.Y." With Florence, almost always, the top line of the "F" extends far to the right over the Young, while the tail of the "g" on Young extends to the left under the name; the extended letters almost form a rectangle around the name.

Florence was a member of the Women Painters of the West, the Valley Artists Guild, and the Society for Sanity in Art. She exhibited frequently throughout her career with numerous art organizations and galleries in New York, Iowa, and California, including Palos Verde Library, 1938 (first prize); California State Building Exposition Park, Los Angeles, 1938 (first prize); San Gabriel Artists Guild; Golden Gate International Exposition, 1939; Los Angeles Public Library; Ebell Club; Los Angeles County Museum of History, Science, and Art, 1943 (prizes); Friday Morning Club; Artists of the Southwest, 1951; and City Hall, Los Angeles;

Greek Theatre, 1955 (award), 1958, Los Angeles, all in California. Her work is in the collections of the Orange County Museum of Art, California and Pomona College, California.

Florence Young passed away on February 10, 1974, in San Gabriel, California.

Biographical information compiled from: *An Encyclopedia of Women Artists of the American West,* University of Texas Press, Austin, Phil Kovinick and Marian Yoshiki-Kovinick, 1998; *Who Was Who in American Art*, Peter Hastings Falk, ed.; *Who's Who in American Art*, The American Federation of Arts, 1940–1959; *Dictionary of Women Artists: An International Dictionary of Women Artists Born Before 1900*, Chris Petteys; *California Arts & Architecture* artist directory, December 1932; and United States Census, 1900, 1920, 1930.

Untitled (High Sierras, California), c. 1928, oil on canvas, 25 × 30 in., signed l/r.
From the collection of Valerie Lardner. Photo: Martin A. Folb, PhD.

Frances Upson Young
1870–1950

Frances Upson was born on January 11, 1870, in Cleveland, Ohio, the daughter of Joseph Edwin and Cornelia (Lyman) Upson. Raised and educated in Cleveland, she attended the Cleveland School of Art, and according to her biographical index card on file at the Laguna Art Museum, also studied with H.S. Gibb in Alnwick and Oxford, England.

In 1892, she married Robert Young, an attorney, and after several years of marriage, in the late 1890s, the couple moved to California and settled in Hollywood. In Hollywood, Robert Young served as the first city attorney, beginning in 1903, before that community was annexed to Los Angeles. The couple had two children: Clarence Upson Young, who became a motion picture screenwriter, and Frances Mary Young Salazar.

According to her own account, in California, Frances studied with fellow artists Paul Lauritz, Lorenzo Latimer, Anna Hills, and Beatrice Whittlesey. Although an accurate history of the years of her study is lacking, it is documented that she was a member of the Ruskin Art Club, West Coast Arts, and the Laguna Beach Art Association. She joined the latter organization in 1924 and is listed as an associated artist on that group's 1935 Festival of Arts brochure, *Exhibiting Painters in the Festival of Arts*, 1935. There is also a record of her participation in the Laguna Beach Art Association Spring Prize Exhibition of 1939. For many years, she and her husband frequented Laguna Beach, and upon his retirement, they settled there in the early 1930s. With her husband's death in 1938, she continued to live in Laguna Beach, and on the 1940 United States Census, she lists her occupation as "artist."

It should be noted that the artists Frances Upson Young and Florence Young, are frequently mistaken as being one and the same. They are, however, two separate and distinct individuals, as well as artists. The confusion may have begun as early as 1932, when both artists were listed in the December 1932 *California Arts & Architecture* magazine's state-wide directory of artists. A typographical error in the listing for Frances, inadvertently giving

The Edge of the Desert, c. 1940, oil on canvas, 25 × 30 in., signed l/l. Courtesy of Linda Sorensen and Dan Rohlfing and Bodega Bay Heritage Gallery.

Untitled (Mountain Landscape), n.d., watercolor on paper, 7 × 5 in., initialed l/r and signed verso. From the collection of Maureen R. Siegel Sprowles. Photo: Martin A. Folb, PhD.

Untitled (Monterey, California), n.d., oil on canvas, 25 × 30 in., signed l/l. From the collection of Maureen R. Siegel Sprowles. Photo: Martin A. Folb, PhD.

Cypress Cove (California), c. 1940, oil on canvas, 25 × 30 in., signed l/r. Courtesy of Linda Sorensen and Dan Rohlfing and Bodega Bay Heritage Gallery.

her first name as Florence, may be the root of decades of confusion. Although their respective signatures are very similar, which further complicates proper identification; there are distinguishing features for each. Frances' signature is like a printed script, letters separated with an elongated tail on the "g" of Young extending left under the name. Frances often signed her work "F.U. Young," "F. Upson Young," or just "Young"; Florence signed "F. Young," "Florence Young," or just "F.Y." With Florence, almost always, the top line of the "F" extends far to the right over the Young, while the tail of the "g" on Young extends to the left under the name; the extended letters almost form a rectangle around the name.

Frances Upson Young passed away on August 23, 1950. in Laguna Beach, California and is buried at Rose Hills Memorial Park, Whittier, California.

Biographical information compiled from *Who's Who on the Pacific Coast,* 1913; *Holly Leaves*, Hollywood, California, August 8, 1924; California Arts & Architecture artist directory, December 1932; *Los Angeles Times*, November 25, 1938, August 24, 1950 (obituary); United States Census, 1880, 1900–1940; and *Southwest Blue Book, 1923–1924,* Lenora H. King, ed. Special thanks to Janet Blake at the Laguna Art Museum, Laguna Beach, California, and Linda Sorensen and Dan Rohlfing at Bodega Bay Heritage Gallery, Bodega Bay, California.

Enid Zacharias
1914–2000

Enid Elizabeth Zacharias was born in Stanislaus County, California, outside the town of Patterson on February 7, 1914. Her parents were Ralph Howard and Adelaide (Smith) Zacharias. She had one sister, Virginia Adelaide. Her family was part of the early migration west in the mid-1800s, and her grandfather started the Charles Zacharias Company, which consisted of a large ranch/farm in Stanislaus County.

Enid loved the outdoors and grew up very much a tomboy, riding horses at an early age. When she was 14 years old she was stricken with polio and did not walk or attend school for over a year. During that time her mother gave her paints, and she started painting the landscape around their home. She discovered both a facility and a love for painting. After graduating from high school she attended a year of art school in Berkeley and continued her studies at the University of California, Berkeley, along with fellow artists Ynez Johnston and Leonard Edmondson; Enid was also a member of Delta Epsilon (art honor society). She graduated

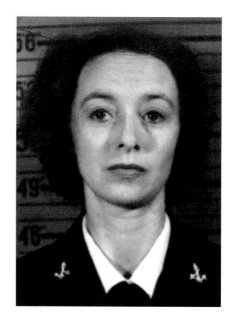

Enid Zacharias photographed in uniform while serving in the United States Navy, c. 1943. Courtesy of Sally Mason.

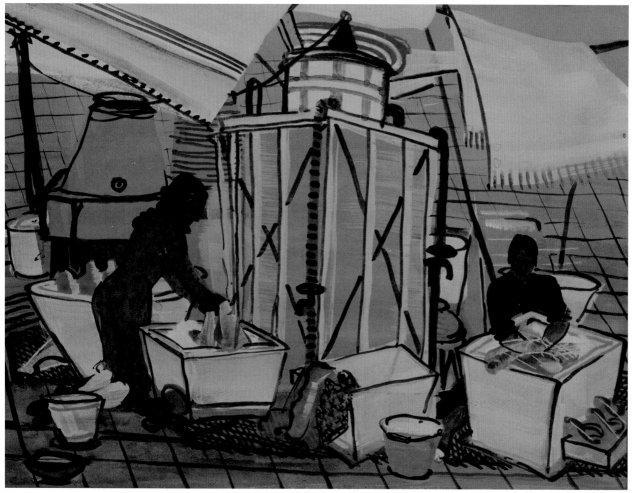

A Laundry (Mexico), c. 1935, gouache on paper, 9 × 12 in., signed verso. Courtesy of Sally Mason. Photo: Roylee Duvall.

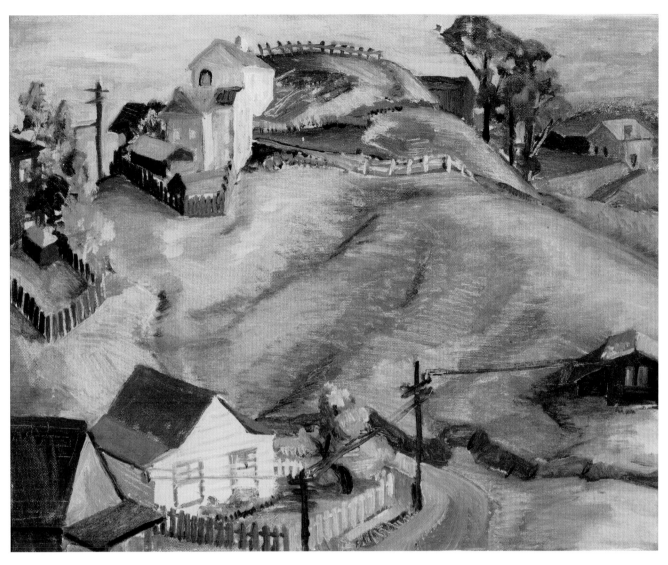

Foothills - Early Berkeley (California), c. 1938, oil on canvas, 16 × 20 in.,
signed verso. Courtesy of Sally Mason. Photo: Roylee Duvall.

Phi Beta Kappa in 1938 from the College of Letter and Science with a degree in philosophy. While attending Berkeley she lived at the International House and enjoyed many friends who shared her artistic talents. She completed numerous paintings of the Berkeley campus and the surrounding countryside.

In 1940, she traveled to Mexico with the anthropologist George Foster and his wife and produced gouache paintings of the towns and landscapes she encountered.

Upon her return to the Berkeley area, she spent one year teaching high-school level English and working for the Greneker Mannequin Company designing mannequins. During the ensuing years she continued her studies in fine art at Columbia University School of the Arts in New York City. At the outbreak of World War II, she joined the Navy, as an early member of the WAVES, serving as a recruiter in Minneapolis, Boston, and New York. During this time she met her future husband, Alexander Nicholas Mason, who was also serving in the Navy as an officer. After her marriage in 1946, she painted less frequently, devoting most of her time to her husband and four children.

Man with Donkeys (Mexico), c. 1935, gouache on paper, 9 × 12 in.,
signed verso. Courtesy of Sally Mason. Photo: Roylee Duvall.

Berkeley (California), c. 1938, gouache on paper, 20 × 27 in.,
signed verso. Courtesy of Sally Mason. Photo: Roylee Duvall.

After moving East in 1968, she started teaching art and art history at Staples High School in Westport, Connecticut, where she also continued to create prints and paintings during her years as a teacher. After her retirement in 1979, she started seriously painting again, doing many watercolors of the Maine and New Brunswick shoreline. In the early 1980s, arthritis in her hands kept her from holding her brush in a way that satisfied her intensely high standards and she stopped painting. A few years before her death she chose to destroy most of the artistic works she had in her possession. Fortunately, her children were in possession of some of her early artwork along with her later watercolors. She exhibited with the San Francisco Art Association at the San Francisco Art Museum in 1939. However, a complete list of her exhibitions is lacking. A number of her earlier works can be found in private collections in California, many of which were gifts to friends and family or sold early in her career.

Enid Zacharias Mason passed away in Andover, Massachusetts, on April 28, 2000.

Biography courtesy of Virginia Mason and the Mason family.

North Berkeley (California), 1938, oil on canvas, 24 × 18 in.,
signed l/r. Private collection. Photo: Martin A. Folb, PhD.

Exhibition Label verso: *North Berkeley*.
Exhibited at the Fifty-Ninth Annual Exhibition of
the San Francisco Art Association, San Francisco
Museum of Art (California), 1939.

Paula Zen
Twentieth Century

Portrait of Gladys. Exhibited: Painters & Sculptors of Los Angeles, Los Angeles County Museum of History, Science and Art, 1938.

The provenance behind *Portrait of Gladys* and the artist who created it is a mystery. After all of my many years of research, digging through archival newspapers, auction and art gallery catalogues, and Los Angeles city directories, I am still searching and asking: Who was Gladys, and more important, who was the artist Paula Zen? Was there in fact an actual person named Paula Zen or was that a pseudonym for another artist? Although, why would an artist who could paint this professionally, living in Los Angeles in the 1930s, not want to be known? This is obviously not the first and only work by this artist; the style is complex, as is the composition. And the painting was accepted and exhibited by a major institution (Los Angeles County Museum of History, Science, and Art) at the time. This was not a show for unknown or amateur artists. It would have been difficult to be accepted and included into this type of exhibition, regardless if you were female or male.

While it has been suggested the portrait was painted by a male artist due to the sexual symbolism and bold figurative form, this seems unlikely. With the difficulty women faced in being included and accepted and in gaining recognition, why would a male want to masquerade as a female artist? And furthermore, as we have attempted to demonstrate in *Emerging from the Shadows*, sexual symbolism and boldness of subject were certainly not limited to the men.

Gladys possesses elements of the surrealists. Symbolically, she holds a book usually associated with learning and intelligence. The white flowers (calla lilies, which were quite popular during the 1930s) depict innocence and the bold red table depicts passion and lust. The flatness and strange angle of the table is unusual and very modern. The flower, hat, her hand, and the architecture are all phallic. Her stylish outfit looks similar to fashions made famous by designer Adrian (active at the time with Metro-Golden-Meyer studios). The tall black hat, which in folklore represents authority and power and is frequently associated with witches, is a bold statement. The architectural forms in the background, constructed from children's painted building blocks, are reminiscent of forms created by surrealist artist Giorgio de Chirico (1888–1976). In all, Gladys tells a story . . . but what story?

Paula Zen remains a mystery. We have found so many wonderful histories for the women included in *Emerging from the Shadows*, and I will remain positive that one day, I will find the answer to my questions. Until then, I will continue to search for Paula Zen, Gladys, and many others, who will certainly come my way looking for their lost identities. —Maurine St. Gaudens

Exhibition Label attached verso: Exhibited at the 19th Annual Painting and Sculpture Exhibit, 1938. Los Angeles Museum, Exposition Park, Los Angeles, California.

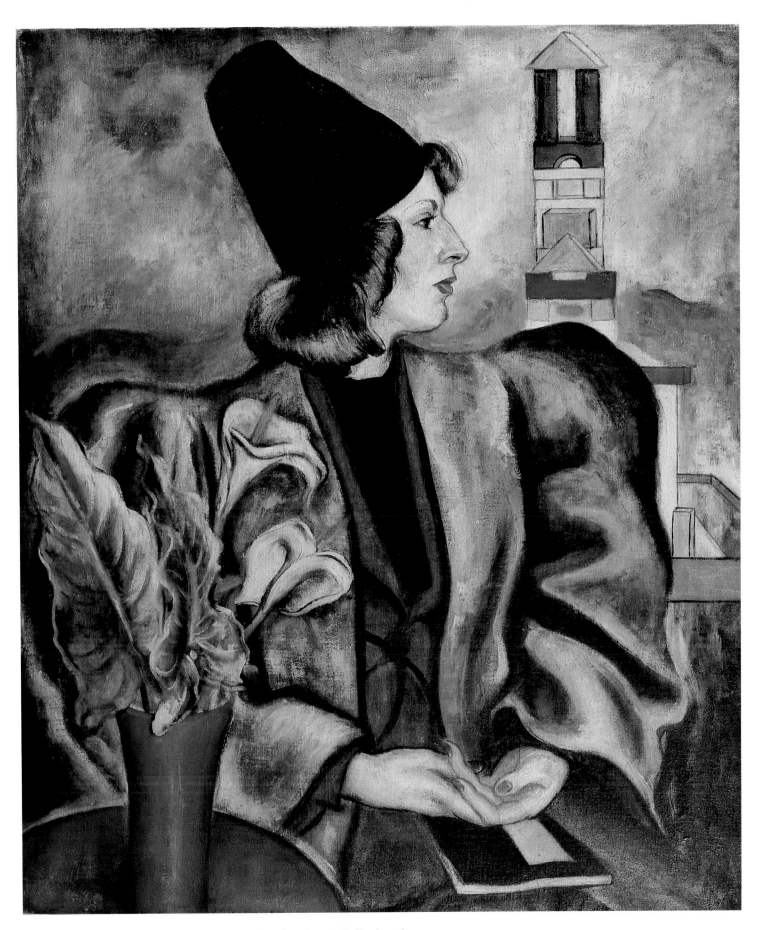

Portrait of Gladys, c. 1938, oil on canvas, 40 × 34 in., signed verso. Collection of
Maurine St. Gaudens. Photo: Martin A. Folb, PhD. Exhibition label verso: *Portrait
of Gladys*. Exhibited at the 19th Annual Painting and Sculpture Exhibit, 1938.
Los Angeles Museum, Exposition Park, Los Angeles, California.

Lenders & Contributors

The artworks and related material included in this publication were provided by many wonderful, generous individuals and organizations—this project could not have been created without you. To our lenders and all of the contributors who have assisted in the creation of *Emerging from the Shadows: A Survey of Women Artist Working in California, 1860–1960*, we want to thank you for your gift of sharing.

Robert Van Horn Adams
Patricia Whelan Akin
Albrect Collection
H. Doreve Alde-Cridlebaugh
Melodie Almond
American Art Review
Bob Anderson
Ruth Asawa
Chase Ashley
Darryl Atchison
Autry National Center of the American West, California
Mojgan B. Azimi
Nicole Back
Pamela Baptist
Helen J. Barnes
Allan Barry and Joan Barry Liebmann
Craig and Gigi Barto
Glenn Bassett
Sandy Bath
The Baumhoff-Macon Collection
Linda Belanger
Belvedere-Tiburon Landmarks Society, California
Hattie Beresford
Eric Berg
Elana Berman-Shrira
Jacob Berner
Margie Beyer
Robert Bijou
William M. Bilsland III
Ted Birbilis and Sandy Raulston
Janet Blake
Jayne Blatchly
Brian and Pam Bliss
Melody Boatright
Bolinas Museum, California
Bonhams Auctioneers
Philip A. Bowers
Dennis M. Boyer and Carole Renfrow
Robin Brailsford
Bob Breen and Clare Graham
Jonathan Brown
Gerald Buck
Richard and Candice Burge

Catherine E. Burns
Hal Burroughs
Steve Cabella
Dennis K. Calabi
California Art Club
Campo de Cahuenga Historical Memorial Association, California
Dru Canoose
Harry and Miriam Carmean
City of Carmel-by-the-Sea, California
Rosaleta Fullerton Carnahan
Paul Casebeer
Kevin J. Casey
Gerbrand Caspers
Gala Chamberlain and Daniel C. Lienau
Christian Chaffee
Armand Chavez
Chazen Museum of Art, University of Wisconsin-Madison
Roger L. Christiansen
Clark's Fine Art & Auctioneers, Inc.
Courtney S. Clarkson
Dale Coleman
Greg Colley
Jan Cook
Bruce Coonan
Patrick J. Corbiere
Cowan's Auctions
Craig Cramer
Constance Crawford
Crocker Art Museum, Sacramento, California
Aiko Cuneo
Laurence Cuneo
The Imogen Cunningham Trust and Meg Partridge
April and Ron Dammann
Peter K. Danner
Eric M. Danner
Betty Davenport Ford
Morgan Davies David
Thomas De Doncker
Stephen C. DeLap
Teresa and Eric Del Piero
Stuart Denenberg
Nora Dewey
Robert Dewey

William B. Dewey
Gary Diamond
Gerald Dodig
Craig Doerr
James Douglas
Denis Dowd
Jessie Dunn Gilbert
Martin Durante
Roylee Duvall
Linda and Kirk Edgar
Spence J. Edwards
El Camino College, California
David R. Evans and Marcus A. Penninton
Susan and Michael Evans
Peter M. Fairbanks and Philippa Fairbanks
Maymanah Farhat
Naim I. Farhat
Sylvia Fein
Nancy A. Ferreria
The Feitelson/Lundeberg Art Foundation
Fine Arts Museums of San Francisco,
 California
Bonnie and Lou Fisher
Kathy A. Foley
Ilene Susan Fort
Lori Rute Fortner
John Foxley
Jay Franklin
Fred Jones Jr. Museum of Art, The University
 of Oklahoma, Norman
Freeman's
Richard C. Frey
Bernard Friedman
Michael Frost
Susan Thomas Fullmer
Mary Burton Fussell
Paul Galli
Jo Ann and Julian Ganz, Jr.
Whitney Ganz
Hector Garcia and Steve Reyes
Muriel Saint-Gaudens Gee
Catherine and Dan Gellert
Roger Genser
Florence Gharibian
Thom Gianetto
Desiree Saint-Gaudens Gill
Ivan Godwin
Scott Goldstein
The Goodloe Family
Frank Goss
David M. Gotz
Cathy Gowdy
Graphic Arts Workshop Archive,
 San Francisco, California
Maxine and Clifton Graves

Millie Greene
Gilliam Greyson
Donald Griesbach
Timothy Gurley
Karen and Paul Hackett
Heather and Paul G. Haaga, Jr.
John G. Hagan
Carolyn Torrey Hannah
Phyllis Hansen
Josh Hardy
Althea Harper
Alfred C. Harrison, Jr.
Sarah Coonan Hart
Marjorie Harvey
Richard Hassel
Coryn Abe-Haupt and Dennis Haupt
Art Hazelwood
Spencer Jon Helfen
Petra Heller
Andrew Herrera II
Mark and Janet Hilbert
Douglas Hill
Leonard Hill
Douglas Himmelfarb
Hugh Martin Hinds
Hirschl and Adler, New York
Norman Hodgson
Sara S. "Sue" Hodson
Stuart Holman
Kelley Fitzgerald Holmes
John and Susan Horseman Collection
Howard "Chip" W. Hosek, Jr.
David Hoy
Thomas H. Hunt
The Huntington Library, Art Collections and
 Botanical Gardens, San Marino, California
William Harrison Inman
Jerry Jackson
Jackson's International Auctioneers
 and Appraisers
Jo Jay
Julie Jenssen
Sally Joaquin
Erik Johnson
Michael and Amanda Johnson
Nick Johnson
Norma Palmer Johnson
The Jonathan Art Foundation
 and Richard W. Reitzell
Michael Jost
James D. Julia, Inc.
Rick Just
Bruce Kamerling
Kaminski Auctions
William A. Karges

Lenders & Contributors CONTINUED

Norman Karlson

Kurt Kasten

Kirubel Kebede

Jon M. Keith and Kathy M. Keith

Thomas R. Kellaway and Jill Redmond

Michael Kelley

Paula Kelly

Flavia and Nadia Kennedy

Anne T. Kent California Room, Marin County
 Free Library, California

David Kessler

Pauline Khuri-Majoli

Philip J. Kieffer

Wayne Kielsmeier

Roger Kintz

Susan Kirk

Jim Konoske

Phil Kovinick and Marian Yoshiki-Kovinick

Hannah Kully

Amy Landrum

Gary M. Lang

Valerie Lardner

Betty Lasky

John Le Bourgeois

Martin Ledford

Mary Lehman

Scot M. and Erica Levitt

Little Landers Historical Society, Tujunga,
 California

The Lockard Family

Jackie Lockington

Beverly Morgan Lohman

Maureen Long

Diana L. Loomis

Alex Lopez

Los Angeles County Museum of Art, California

Michael Lynott

Channy Lyons

Larry Lytle and the Art Gallery, Los Angeles
 Valley College, California

Steve MacFarlane

Bruce and Laurie Maclin

James Main

Malibu Lagoon Museum, Adamson House,
 California

The Family of Marian Curtis Manning

The Marks Family

Reg Martin

Sally Mason and The Mason Family

Charles N. Mauch

Dan and Fif May

Austin D. McClelland

Gordon T. McClelland

Kerry and Victoria McCluggage

Traci McFarland Fieldsted

Bryan Mead

Don Merrill

Michaan's Auctions

Mark and Jesse Milano

Donald Miller

Jim and Virginia Moffett

Laura Moniz

Robert Monson

Monterey Museum of Art, Monterey, California

Robert Montgomery

Jeffrey Moran

John Moran Auctioneers

Cheryl and Jeffrey Morseburg

Tobey C. Moss

Nancy Dustin Wall Moure

Phyllis Mueller

Catharine Muskus

Peggy Names

Jan Napolitan and the Estate of Mildred Walker

C. Kris Nelson

Sherryl L. Nelson and The Forward Family

The Neville-Strass Collection

Fred Nicholson

Dan Nicodemo

Shauna Novotny

Shannon O'Dunn

Ed and Karen Ogul

Shawn O'Keefe

The Oltman Family

Kerstin O'Mara and the Ullberg Family

Camille M. Palmer

Kristy W. Palmer

The Park Family

Moe Parniani

Pasadena Museum of History, California

Nina Paskowitz

Lorraine Passero

Heather Peck

Thom Pegg

Joel Peña

Peoria Public Library, Peoria, Illinois

Peoria Women's Club of Peoria, Illinois

Thomas Petruno and Laura Dominick

Rick and Anne Petteford

The Pletsch Family

Martha Duncan Pope

Greta Pruitt

Rancho Santa Ana Botanic Gardens,
 Claremont, California

Eleanor Randall
Charles Rasor
Rick and Lucy Rawlins
Robert Raynolds
Reading Museum of Art, Reading, Pennsylvania
Ray Redfern
Charles F. Redinger
John and Christine Reeder
The Deborah Remington Trust Foundation,
 New York
Roger Renick
Thomas Reynolds
Robert T. Richardson
Debora Richey
Roberts Art Gallery, Santa Monica High School,
 California
Nancy Rockwell
Wendy Rodriguez
Elaine Rosenthal
The Rousseau Family
Thomas Royal and Louis Cantabrana
Beverly Sacks
Saint Mary's College Museum of Art, Moraga,
 California
San Diego History Center, California
Emily Anne and Jojie Santos
Sarasota Estate Auctions
Eric Sarbib
Rob Scanland
Lida Scarborough
Ted Schredd
Robert Schmid
Caroline Sheckler
Nina Sheldon
Jeffrey Schuerholz
Bill and Chantal Shapiro
Keith Sheridan
Scott A. Shields
Carol Singer and the Singer Family
The Smith Family
James Snidle
Society of California Pioneers, San Francisco
Robert Sommers
Linda Sorensen and Dan Rohlfing
Steven and Debra Soukup
Spencer Museum of Art, The University
 of Kansas, Lawrence, Kansas
Springville Museum of Art, Utah
Maureen R. Siegel Sprowles
Barbara Mann Steinwedell
Stendahl Galleries (Archives),
 Los Angeles, California
Bill Stern
George Stern
Diane and Sam Stewart
Kevin Stewart
Julie Stires

Karen Stocksdale and Judy West
Susan M. Stockton and Chris B. Walther
Susan Cooper Stoffel
M. Lee Stone
Steven Stoops
The Stringfield Family
Reggie Sully
Rudy and Jo Ann Summers
Stephen and Linda Sundvold
Claudia Surratt
Betsee Seegert Talavera
Dr. & Mrs. W. Michael Tannyhill
Susan Teller
The Templeman Family
Steven Thomas
J.T. Thompson and Lotz House, Franklin,
 Tennessee
The Travis Family
Terry and Paula Trotter
Edwin Turlington, Jr.
Larry Underhill
Ron Vander Molen
The Vandevere Family
Laura Verlaque
Margaret von Hake
William Warmboe
Patricia Wauben
The June Wayne Collection
Mark D. Webb
Emily Weintraub
The Weston Family
Scott Wells and Nancy Mancuso
Janet B. Wentworth
Mark A. White
Travis Wilson
Mitchell Wolfson, Jr.
The Wolfsonian - Florida International University,
 Miami, Florida
The Beatrice Wood Center for the Arts
 & Happy Valley Cultural Center and Kevin
Wallace, Ojai, California
Dorinda Woodley
Crystal Wyatt
The Yerkes Family
The Stuart and Dayle Young Family
Mark Zaplin and Richard Lampert
Joseph Zondlo

We thank you,
Maurine St. Gaudens and Joseph Morsman

THE ARTISTS, A–D

THE ARTISTS, E–K

THE ARTISTS, L–R

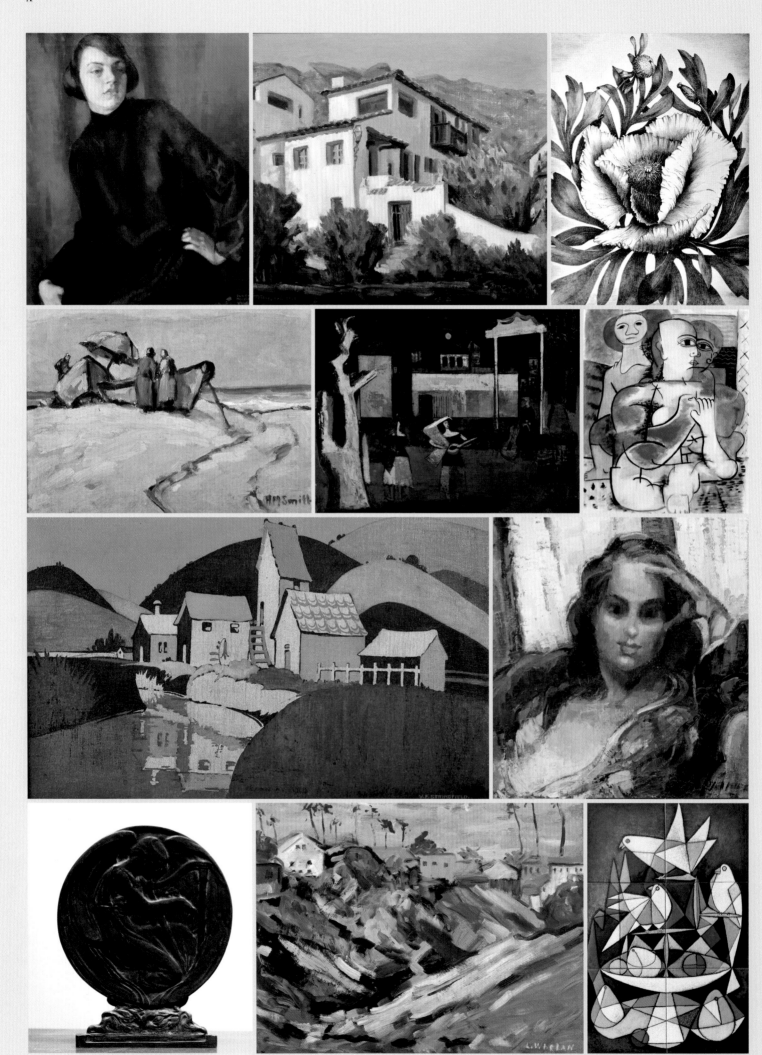

THE ARTISTS, S-Z

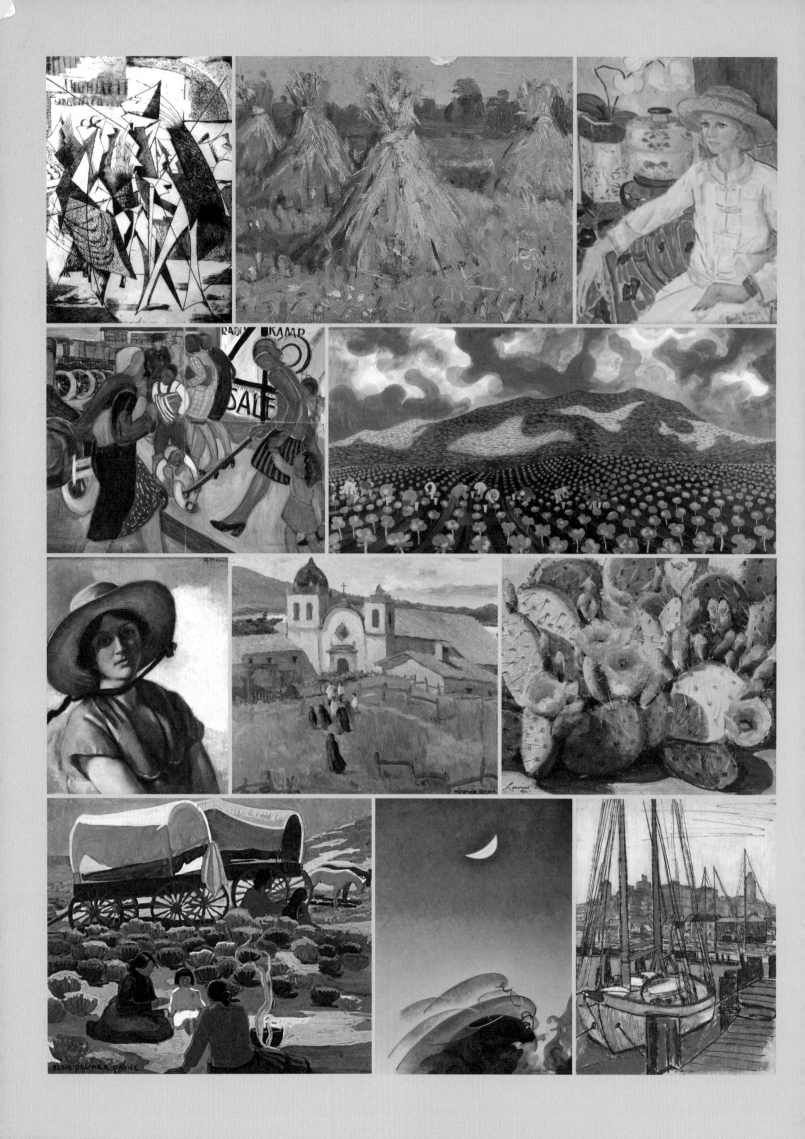